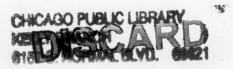

Native American Art

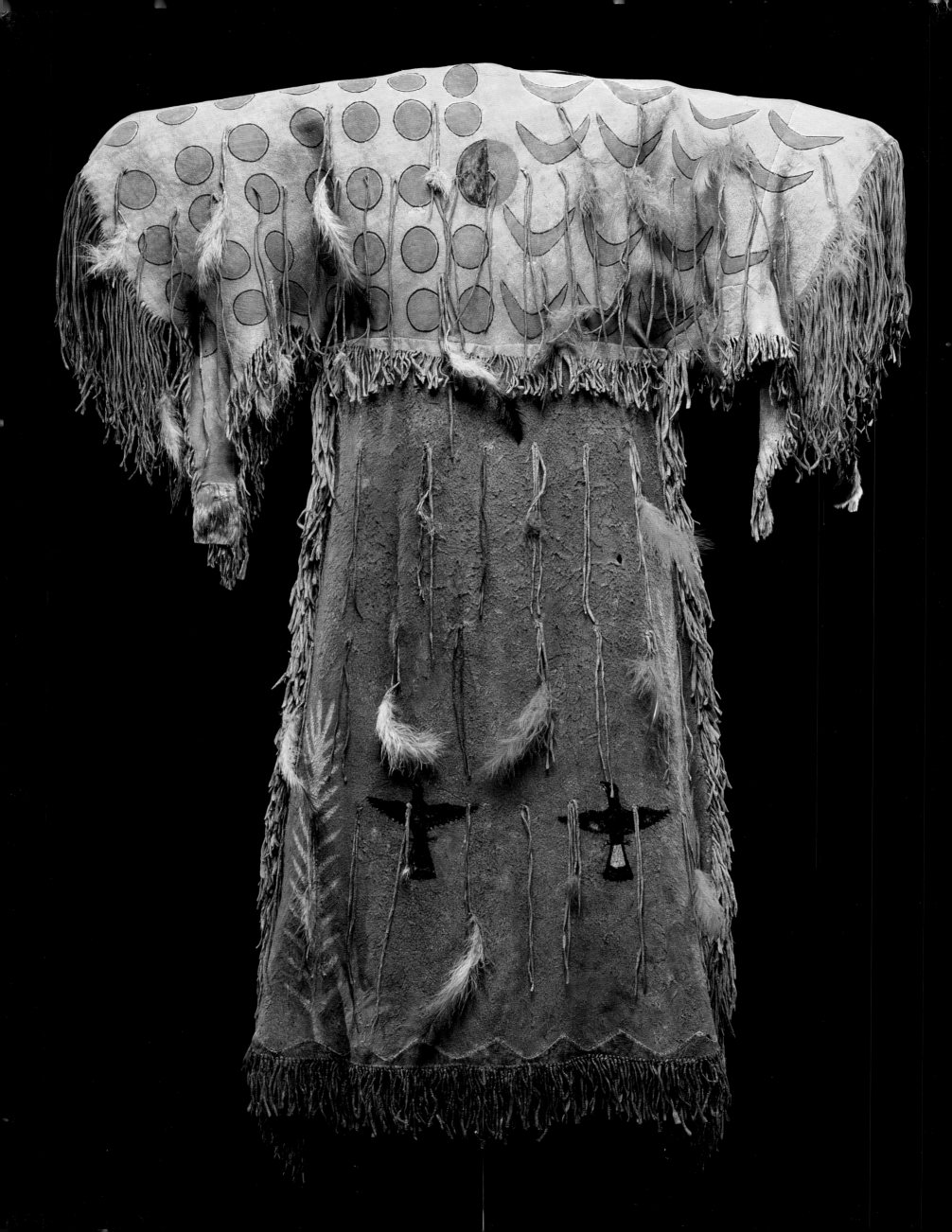

Native American Art

David W. Penney
George C. Longfish

HUGH LAUTER LEVIN ASSOCIATES, INC.

Design by Nai Chang
Photo research by Ellin Yassky Silberblatt
Editorial production by Deborah Teipel Zindell

I dedicate this book to my wife,
Jeanne Z. Penney,
whose love, patience, and support is fundamental to anything I do.
Thanks.

FRONTISPIECE: *Ghost Dance Dress.* Southern Arapaho. 1890s.
Region of the Fort Sill Agency, Oklahoma. Deerskin, feathers, paint. Length: 58 in.
Buffalo Bill Historical Center, Cody, Wyoming

ACKNOWLEDGMENTS

The opportunity to work on this book came as an unexpected but most welcome treat. Hugh Lauter Levin is to be credited with the inspiration to conceive of this ambitious project and the commitment to see it to completion. At the onset, Hugh agreed that copies of the book would be donated to tribal colleges, libraries, and cultural centers all over the country. I think this is some measure of his vision and sensitivity. Throughout the process, the staff of his small but accomplished publications team dedicated their extraordinary talents and abilities: Deborah Zindell as editor, Michael Ruscoe as editorial assistant, Nai Chang as designer, and most of all, Ellin Silberblatt, without whose energy and hard work this volume would not be possible.

To prepare the entries, I am indebted to colleagues too numerous to mention, many of whom are my friends. Those who read this book will find the fruits of their research, although I am to be faulted with any errors of interpretation. In particular, I would like to mention Craig Bates, Jonathan Batkin, Ted Brasser, Steve Brown, Marvin Cahodas, Richard Conn, John C. Ewers, Diana Fane, William Fitzhugh, Bill Holm, George P. Horse Capture, Ira Jacknis, Ruth Phillips, Benson Lanford, Dennis Lessard, Richard Pohrt, Dorothy Ray, Allen Wardwell, Andrew Whiteford, and Robin Wright. I would also like to thank Tony Berlant, Gordon Hart, Toby Herbst, George Lois, Richard Manoogian, Jim and Kris Rutkowski, Eugene Thaw, and Jan and Bill Wetsman for making their collections available by providing splendid transparencies. Marianne Letasi provided an indispensable service in organizing the lion's share of illustrations for the volume. Although many photographers contributed to the visual impact of the book, and they are listed elsewhere, I want to acknowledge in particular the work of Dirk Bakker, Robert Hensleigh, and Jerry Jacka who made special efforts on behalf of this project.

DAVID W. PENNEY

I wish to acknowledge David Penney, who asked me to write the chapter on modern Indian Painting, and to Ellin Silberblatt and Deborah Zindell, who showed great patience and direction in the creation of this chapter. I also wish to acknowledge all the artists, particularly G. Peter Jemison, who contributed their time and talents to this chapter. I would like the chapter to be dedicated to three artists: Sylvia Lark, James Schoppert, and Larry Beck. My thanks also go to all of the Native American artists whose continuing efforts have placed Native American art among the "fine arts" of the world.

GEORGE C. LONGFISH

Printed and bound in Hong Kong
ISBN 0-88363-694-8

CONTENTS

INTRODUCTION

ISSUES OF ART AND HISTORY

The traditions of making things and the issues of visual expression, symbolism, and metaphor involved with these traditions, developed in North America independent of any consciousness of the aesthetic philosophies of the Old World. Insulated from European "art history," it is fair to say that the peoples of North America possess their own art histories—separate, different, and based upon unique cultural and historical issues. And yet, even when one speaks the word "art," its very definition and frame of reference is rooted in European tradition. It is a linguistic issue, since there is no word in any Native American language that is an exact translation of the word "art."

So what is it we speak of when we use the word "art" to refer to things made by native North Americans? The matter is further complicated by the fact that the meaning of the European word has changed drastically over the last five hundred years since it came into use in North America. The distinction between the "high" and "low" arts in Europe, with all the race and class distinctions these categories implied, was obscured by the revolution of modernism. As the search for new forms of expression progressed, people of European descent began to use the word "art" to describe things made by Native Americans.

At that moment, as the twentieth century dawned, the separate art histories of North America and Europe began to merge. People of native descent began to train themselves as artists in the media and philosophies of their European counterparts. At the same time, people of European descent began to evaluate the traditional products of native people—ceramics, baskets, sculpture, and other media—according to the shifting definitions of art that were responding to a quickly changing modern world. In so doing, however, there was the danger of imposing upon native creativity an aesthetic viewpoint rooted in European-derived distinctions with regard to what was art and what was not. As a consequence, the unique and independent art histories of North America may be obscured in an effort to universalize the qualities of American Indian creations.

This process of conceptually unifying all the creative, visual traditions of the world as "art" is precisely the experience offered by modern art museums, as they "frame" art in galleries and cases; even art books like this one display art by evenly lit and neutrally situated color reproductions of isolated objects. This is how the modern world experiences art as we understand it. As a consequence, the unique and culturally rooted ways of thinking about visual expression are lost in favor of art's universal and "transcendent" qualities.

This book seeks to stretch the reader's perception beyond these modern conventions of publication and museum display to address the cultural matrix of art-making. In so doing, it may be better to put aside, for now, the word "art" with its roots in the sensibilities of the European world until we encounter that historical moment when Indian people began to call themselves artists and started to make art in the modern sense of the term.

In the following chapters, American Indian traditions of visual expression are discussed within regional and historical parameters up through the early twentieth century, when American Indian artists began to involve themselves in the "art system" of the larger, modern world. The book concludes with a discussion by George Longfish of these more recent efforts. This is certainly not meant to imply that twentieth-century works are in any way less rooted in cultural tradition. The relationship between the importance of tradition and the impact of historical experience upon that heritage is a recurring theme throughout these texts. Throughout their history, native North American artists strived to create images, symbols, and visual metaphors that renewed tradition for their own time and place. This was no less true for the painters of Mimbres bowls at A.D. 1100 than it is for today's Native American painters, sculptors, photographers, print makers, and performance artists.

The experience of history conditions and defines the artist's perception of "tradition," and the artist, in turn, recreates "tradition" in his or her work. These pages reflect this concept as is evident in the extraordinary degree of innovation and change seen in the history of North American Indian art. The great regional diversity of form, media, and design is testimony to the inventiveness and creativity of North American visual traditions. Moreover, it becomes clear that each succeeding generation of artists found ways to enrich their visual culture with personal creativity.

There is a shallow, and perhaps widespread perception among outsiders that the best of American Indian art is conservative, firmly anchored in the past, and unchanging in its restatement of "traditional" form. Nothing could be further from the truth. Native ideas and values are ancient; ways and means of expressing them visually remained on the cutting edge of the historical present, from the earliest handworks dating to 3000 B.C. through to the striking images of the 1990s. The visual arts, like the cultures they reflect, must change with the times in order to remain alive. The

continuous record of invention, innovation, and creativity visible in American Indian art affirms two related ideas: the central importance of the visual arts in the expression of culture in North America; and the ability of the visual arts to absorb and accommodate cultural change, even when that change is forced upon them from the outside world.

Art as it is experienced today occupies a fairly marginal position in life. Art consists of those objects isolated for aesthetic enjoyment and contemplation. At best, art today makes you think and makes you feel. Beyond that, it functions in life like a commodity—our society buys and sells it, we own it, display it in our homes, or see it in museums and in illustrated art books. When reading about the myriad ways in which the visual arts were involved in the very fabric of Native American society, one may perhaps begin to sense that the word "art" is an inadequate term to describe the remarkable objects created by a unique group of people.

DAVID W. PENNEY

Native American Art

EARLIEST TRADITIONS: THE ANCIENT WOODLANDS

The artistic traditions of Native Americans reflect a rich and diverse culture that reaches back to the earliest peoples who inhabited this continent. Differing theories exist concerning the origins of human life in North America. The Ojibwa of the Great Lakes recall how the great hero Minibozo formed the earth with mud that Muskrat scooped up from the sea bottom. The Great Manitos of the Underworld and Sky then fashioned the island's people out of clay. According to the Tewa of the southwestern pueblos, their ancestors once lived in a dark lake below the soft and unformed earth and were brought up to the present world by Father Sun.

Scientists look to archaeological evidence and geographic phenomena in an effort to pinpoint the earliest appearance of people in North America. Archaeologists have verified that ancestors of American Indians hunted mastodon and other extinct species of big game on the plains of North America at least fifteen thousand years ago. Scientists cannot say whether the region supported human life prior to that period. The emergence of the land bridge that joins present-day Alaska to Siberia resulted from geographic activity during the last Ice Age when much of the world's water was trapped in the frozen polar ice caps, causing the bottom of the shallow Bering Strait to become land mass. Dozens of species of animals traversed this intercontinental highway and, with them, people, dependent upon the animals for survival. Was this the beginning of human habitation in North America? Scientists think so; many Indian people disagree.

THE LATE ARCHAIC PERIOD

When the ice receded fifteen thousand years ago and the melt water drained away, sculpting the landscape in its present form, Indian people were in North America, fashioning their lives to fit comfortably with the changing environment. It was during these first several thousand years after the Pleistocene era that the great diversity of traditions represented among America's first peoples were formed and developed. Archaeologists refer to this long episode of slow and gradual diversification of early North American culture from approximately 8000 to 1000 B.C. as the Archaic period.

East of the Mississippi, people tended to settle near rivers and lakes. By the Late Archaic period (3000–1000 B.C.) communities had established themselves in well-defined territories to harvest seasonally available wild plant foods and game. Many families might congregate in a summer village along the bottom-lands of a river valley or lake-shore fishing camp, but then disperse into smaller groups and move inland for fall and winter to gathering and hunting camps.

The most impressive manufactured objects that survive from these early Indian cultures were made of stone. Meticulously chipped and miraculously large stone blades made of colored chert, and ground and polished tools and ornaments made of speck-

OPPOSITE:
Mask with Antlers. Caddoan culture (Spiro phase), Mississippian period, A.D. 1200–1350. Craig Mound, Spiro site, LeFlore County, Oklahoma. Wood (possibly cedar). Height: 11½ in. National Museum of the American Indian, Smithsonian Institution, New York.

The Craig Mound covered the remains of the ancient Caddoan elite—their chiefs, priests, and warriors. Their remains had been preserved in state inside a temple until the event when they were brought to this final resting place together with all the sacred contents of the temple, wooden effigies and idols, marine shell ornaments and cups, cut engraved copper plates, stone pipes, clubs, blades, and hundreds of additional categories of objects. The Craig Mound was never properly excavated: it was "mined" of its treasures commercially during the 1930s. It is one of the few archaeological sites of the Mississippian period where wood sculpture was preserved. This nearly life-size "mask" of wood has its eyes and mouth inlaid with marine shell. This mask and other small wooden heads in the mound may have been intended to serve as effigies of human relics, the preserved heads of sacred ancestors.

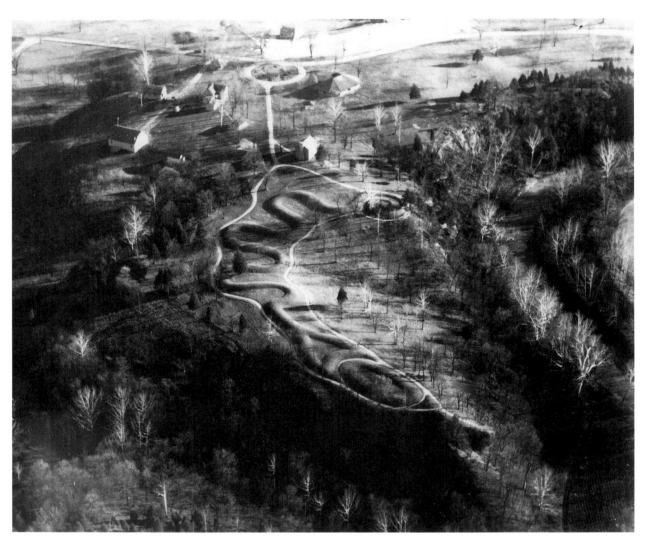

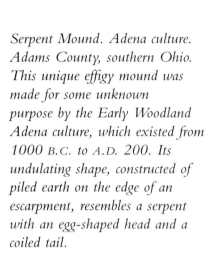

Serpent Mound. Adena culture. Adams County, southern Ohio. This unique effigy mound was made for some unknown purpose by the Early Woodland Adena culture, which existed from 1000 B.C. to A.D. 200. Its undulating shape, constructed of piled earth on the edge of an escarpment, resembles a serpent with an egg-shaped head and a coiled tail.

Courtesy of the National Archives of Anthropology, Smithsonian Institution, Washington, D.C.

led granite, banded slate, and other stone have been found in villages and campsites. Woodworking tools, such as adzes and chisels, indicate that these people carved wood and perhaps painted as well, although no painted products have survived in the archaeological record. The Old Copper cultures of the upper Great Lakes wrought blades and tools of raw, hammered copper. Bannerstones, which were weights for spear throwers, or *atlatls,* often received special attention in workmanship and were fashioned using particularly attractive materials. Many of these more elaborate Late Archaic implements, weapons, and tools were made of valuable, rare, or otherwise visually impressive materials and were not intended for utilitarian use. They were, rather, valued as trade items, exchanged between trade partners in different communities. Eventually, they were favored as offerings to the especially honored dead or buried in caches having never been used. Ornaments such as beads, pendants or gorgets made of copper marine shell, jasper, and other rare stone were made and worn by Late Archaic people and were often buried with their owners. Archaeologists have found that some burials include more ornaments than others, hinting at the existence of social distinctions within Late Archaic societies.

There is abundant evidence that tools, weapons, and ornaments circulated widely in trade prior to their interment with burials, crossing half the continent in some cases. Their exchange may have been tied to emerging social hierarchies among these village-based, egalitarian societies, where aspiring leaders cemented social bonds and earned prestige by the presentation of gifts to leaders of distant communities. Successful and perhaps socially dominant families elevated their status by honoring

their dead with lavish funeral offerings, feasts, and the distribution of valuable gifts. The exchange of ornaments and aesthetically enhanced implements was widely practiced among Late Archaic people and became a tradition that continued for thousands of years.

Smoking pipes appear for the first time in North America in the archaeological record of the Late Archaic period. The seeds of *nicotania rustica,* most likely the earliest species of tobacco consumed in pipes, have been recovered from Eastern Woodland archaeological sites over two thousand years old. While this tobacco was first domesticated somewhere on the eastern watershed of the Andes around 3000 B.C. and spread north through Mexico, the stone smoking pipe is a North American invention. By at least 1500 B.C., centuries before the cultivation of food plants, native North Americans were raising the tobacco plant and smoking it in pipes. Tobacco has always been considered a sacred substance by native North Americans, many different tribes recounting how the Creator gave tobacco to the people to use as offerings to the spirits in thanks for blessings. Tobacco smoking became a form of prayer; when tobacco smoke passed into the spirit world, it summoned spirit beings to witness and sanction significant events.

THE MIDDLE WOODLAND PERIOD

Many of the large and successful Late Archaic villages of the Midwest disbanded around the turn of the first millennium B.C., hinting at some kind of economic reorganization or series of ecological crises. The disappearance of these communities and the emergence of a distinctive, thick-walled, cord-impressed pottery found widely throughout the central states region (and slightly later in the South) mark the transi-

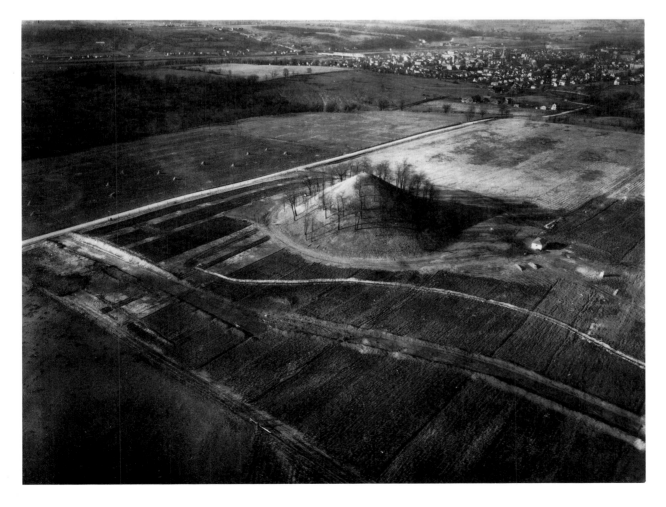

The Miamisberg Mound. Adena culture. Montgomery County, Ohio. This large burial mound was built up in stages by successive interments, beginning at ground level with a subfloor tomb excavated in the floor of a circular wooden structure that was burned and then buried beneath a primary mound.

Courtesy of the National Archives of Anthropology, Smithsonian Institution, Washington, D.C.

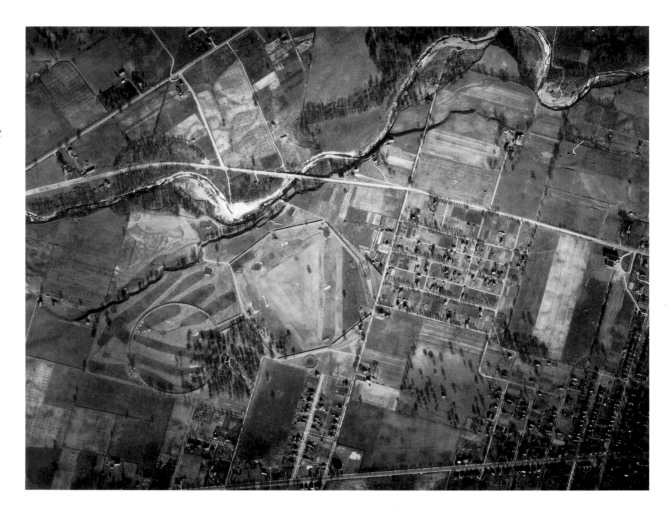

tion from the Late Archaic to the Early Woodland period (approximately 1000 B.C.). In terms of overall social organization, not a great deal changed. Villages still clustered around river bottoms, with the upland forest territories reserved for hunting and gathering camps. But by the Middle Woodland period, several independent cultures of the Eastern Woodlands had experimented with cultivating a variety of wild grasses for food, such as chenopod and amaranth, pointing to a growing interest in agriculture. Agriculture of any significant scale would not develop until after the sixth or seventh century A.D., however, when corn production would dominate Eastern Woodland economies.

One of the more remarkable cultural practices of the Woodland period was the erection of earthen mounds over the dead. Although some burial mounds date well back into the Late Archaic period, mound building became far more widespread during the Woodland period, with mounds being constructed from Florida to Minnesota, Georgia to Iowa. The Adena, an Early Woodland period culture that existed from 1000 B.C. to A.D. 200 in the middle and upper Ohio river region, buried their dead in oblong tombs dug in the floor of a circular house, perhaps the house where the deceased had lived. After the funeral ceremony, the house was burned and a conical mound of earth was erected over the remains. Additional interments added more layers to the mound, increasing its size. Some burial mounds such as the Grave Creek Mound in West Virginia and the Maimisberg Mound near Cincinnati, rise over seventy feet high. The Adena continued the Late Archaic custom of placing valuable ornaments and implements with burials, often exchanging these treasured pieces with distant communities; Adena-made sumptuary materials have been located by archaeologists at sites as far east as Delaware and eastern Ontario.

The Middle Woodland period culture known as Ohio Hopewell (200 B.C.–A.D. 600) of south-central Ohio created the most elaborate Woodland period earthworks. Massive earthen embankments bordered broad avenues and wrapped around circular or octagonal enclosures, forming configurations that sometimes stretched out over several square miles. These geometric earthworks defined ceremonial mortuary sites where charnel houses had been built to house the community's dead. Ohio Hopewell charnel houses were special, ceremonial structures, made with wooden support posts and bark walls enclosing several interior chambers. The dead were honored with offerings, rituals, and feasts while their remains were displayed inside. After many dead had accumulated over a span of time, the charnel house was destroyed and a mound erected over the site. A new charnel house was built near-by and the process began again.

The types of objects favored by the Ohio Hopewell as mortuary offerings resemble those made by earlier Late Archaic peoples—fine implements and ornaments—although these later pieces are far more elaborate and abundant. Ohio Hopewell funerary offerings usually consisted of chipped blades, copper axes, copper breast plates, shell beads, and a variety of other items. Many of them were fashioned from exotic and symbolically significant materials charged with powerful imagery. Copper breast plates from the Mound City and Hopewell sites were fashioned to represent falcons and eagles, serpents, fish, and other enigmatic forms. The Ohio Hopewell cut sheet mica and turtle shell into the graceful shapes of birds, eagle claws, a bear, and even a human hand. The carvings on distinctive effigy platform smoking pipes capture the gestures and characteristic poses of dozens of different animal species, all observed with remarkable detail. And human figurines made of fired clay record the customary dress and ornaments favored by these highly developed people.

Although archaeology can tell us relatively little about the religion and cosmologies of Middle Woodland people, their visual arts suggest that they shared many ideas still recognized by their descendants. The predominance of animal images in Hopewell art suggests that, like more recent American Indians, people of the Middle Woodland period considered animals to be potentially powerful spirit protectors and guardians. The great copper eagles unearthed at the Hopewell site, and the horned serpents

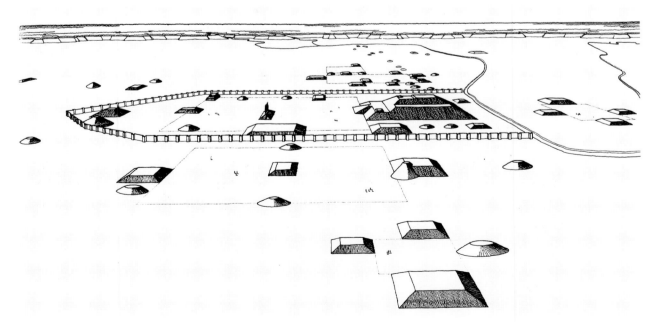

Schematic drawing of the Cahokia site, including Monks Mound. Cahokia was the largest city ever built in pre-Columbian North America and was home to more than twenty thousand people at its height. The site was dominated by a number of platform mounds that functioned as the foundations for temples and chiefs' residences.

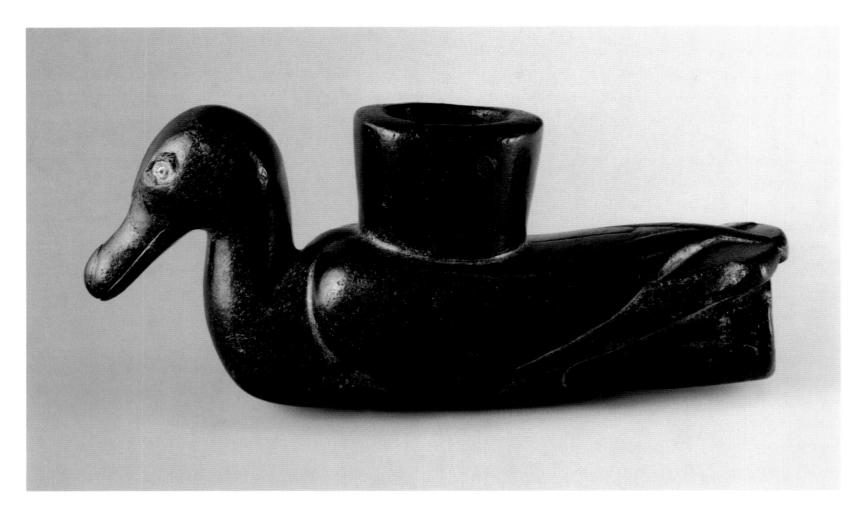

Duck Effigy "Great Pipe." Middle Woodland period, 200 B.C.–A.D. 400. Meigs County, Ohio. Steatite, fresh-water pearl. Length: 9½ in. The Gordon Hart Collection, Bluffton, Indiana.

The massive and ruggedly carved form of this steatite "great pipe" is typical of some 150 or more pipes that were produced by some unknown southeastern workshop, or set of workshops, during the Middle Woodland period. The graceful form of the seated duck is described with a reductive series of voluminous shapes and minimal detail.

made of stone and sheet mica found in a large crematory deposit at the Turner burial site in Ohio, are closely related to the images of Thunderbirds and Underwater Monsters produced by tribes of the Eastern Woodlands region nearly two thousand years later. Eastern Woodland cosmology held that the Thunderbird lived in the Sky World and produced thunder with its flapping wings and lightning with its flashing eyes, while the Underwater Monster inhabited the watery Underworld beneath rivers and lakes, stirring up tempests with its long, serpentine tail. Similarly, the effigies of animals on Ohio Hopewell smoking pipes resemble the images of animals on smoking pipes of the Iroquois, Ojibwa, and other, more recent tribes who implore these spirit guardians to respond to prayers for protection, success, and well-being.

Middle Woodland period cultures living in other parts of the Eastern Woodlands also practiced burial mound ceremonialism, but none achieved the level of artistry of the Ohio Hopewell. People of the Havana culture of the Illinois valley placed their dead in log crypts covered with sheets of bark until such time as the crypt was covered with a mound. The Marksville people of the lower Mississippi valley built large earthen platforms that received the prepared remains of the dead, often wrapped into bundles. The bones were arranged on the surface of the platform with a few gifts for the other world and then covered with a mound. Variations on these burial patterns have been noted by archaeologists in many different cultures of the Middle Woodland period, suggesting that these peoples engaged in the widespread exchange of ideas and customs.

The Middle Woodland period can be characterized as an historical episode involving extensive circulation of people and the objects and ideas that accompanied them throughout the Eastern Woodlands region. Archaeologists have named this intense

cultural interaction the Hopewell Interaction Sphere, named after the most active and elaborate regional tradition, the Ohio Hopewell. Traders circulated marine shell, copper, river pearls, mica, bear teeth, and a great range of additional materials from Florida to Nebraska, Louisiana to Minnesota. Quarried obsidian from cliffs located in what is now Yellowstone National Park was carried east to the Illinois valley and Ohio. These exotic, valuable objects were offered to the honored dead, placed with their bodies, buried in caches or burned in crematory pits that would lie beneath large conical mounds of earth.

Ideas about art, imagery, and presumably the spiritual concepts that the imagery reflected also circulated widely. Effigy platform pipes, similar to those found in the Ohio mounds, were also made by Havana artists in the Illinois valley, the Crab Orchard peoples of southern Illinois, and other cultural groups of the Southeast. Clay figurines, which very likely originated as a tradition in Florida and Georgia, spread northwest during the Middle Woodland period to Ohio, Indiana, Illinois, and as far west as central Missouri. Distinctive bird designs fashioned with identical incising and stamping adorn the ceremonial pottery of several Middle Woodland cultures. Because this period witnessed such a widespread dissemination of information of all kinds, the Hopewell Interaction Sphere is responsible for the first extensive, pan-regional arts tradition visible in the archaeological record of North America.

THE MISSISSIPPIAN PERIOD

The cultural achievements of the Middle Woodland period were accomplished without the benefit of intensive agricultural production. Agriculture had developed in other regions of the New World, however, with corn as its primary crop. The earliest corn domesticates were produced in the Valley of Mexico as early as 2000 B.C. Indian people of the Southwest began experimenting with corn agriculture by 300 B.C., and there is evidence that some eastern societies of the Middle Woodland period knew of corn, but it was not a staple in their diets. The adoption of corn and beans as the staff of life, the mainstay of Eastern Woodlands economies, marks the transition from the Woodland to the Mississippian period (about A.D. 900). With the development of communities that were dependent upon intensive farming, radical shifts in social and political organization occurred.

The earliest agricultural communities in the Eastern Woodlands emerged in the fertile bottom lands of the Mississippi valley by at least A.D. 700. By A.D. 900, the town of Cahokia, at the present site of East St. Louis, Illinois, approached the proportions of a full-scale city of some twenty thousand inhabitants, with thousands more living in satellite farming communities scattered throughout the adjacent American Bottoms region. Archaeological evidence suggests that the Mississippian cultural pattern, named after the location of origin in the Mississippi valley, expanded east into the river valleys of the Southeast and west up the tributaries of the Mississippi. By A.D. 1000, the Caddoan variant of the Mississippi lifestyle was established in the Arkansas and Red River valleys, followed by the Mississippian communities of Etowah in northwest Georgia, Moundville in Alabama, Angel in Indiana, and the Emerald site in Mississippi, all of which grew to maturity after A.D. 1100. Although less successful in the north, upper Mississippian cultures pressed into the southern Great Lakes area, as far north as the Aztalan site of Wisconsin.

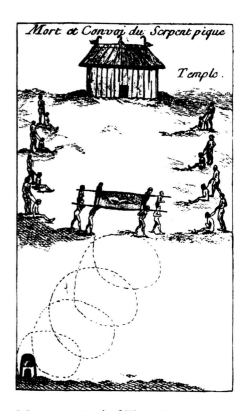

Mortuary ritual of Tatoo Serpent, a Natchez war chief. Early eighteenth century. Mississippi. The Natchez continued to carry out a variant form of Mississippian mortuary ceremonies into the early eighteenth century. The funeral of Tatoo Serpent was witnessed by the French memoirist, Le Page Du Pratz. Here, an illustration shows bearers carrying the chief's body up the ramp of a platform mound to the temple on top. His wives and retinue are killed as his body passes by so that they can accompany him to the land of the dead.

Mississippian societies established the most politically complex and economically successful cultural pattern in the prehistory of North America, and had a profound impact in shaping the modern cultural traditions of the Eastern Woodlands. Oral traditions and customs of those communities that survived into the historic period, such as the Natchez of the lower Mississippi valley, provide us with a great deal of information about the character of Mississippian societies.

Mississippians were ruled by a sacred king, a descendant of the Sun, the source of all life on earth. The king's relations, the members of his family and clan, made up an aristocratic class of priests. Warriors could also rise to positions of prominence through their accomplishments in battle, and they were organized into warrior societies who worshipped powerful spirit protectors such as the falcon and the Underworld monster. Warriors admired the bravery and aggressiveness of the falcon, who killed its prey by diving from a great height and striking another bird with its chest, knocking it from the sky. Prisoners taken by warriors in battle became slaves. Most Mississippian people, however, were farmers, many of whom lived in small communities or homesteads associated with a larger capital city or town. They contributed their labor to community projects, such as building protective palisades or erecting large earthen temple mounds. There was also a significant class of artisans and traders

John White. *"Charnel House of the Powhatan Chiefs."* *1580s. The bones and other remains of the Powhatan chiefs were cared for by priests in a charnel house, or temple, located atop a platform mound. This practice follows those observed by archaeologists at much earlier Mississippian sites.*

The British Museum, London.

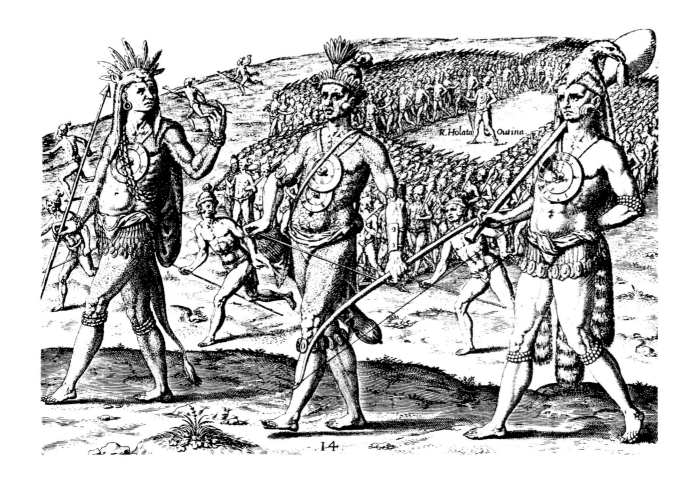

who produced and circulated a wide range of objects: hoes made of chipped stone for agriculture, ceremonial pottery with symbolic decoration, or esoteric carvings and ornaments for use by the Mississippian elite.

The town was the center of Mississippian spiritual life. Each town was dominated by two or more platform mounds flanking a large open plaza. Earthen platform mounds with ramps for access to their leveled tops served as the foundations for temples, residences for chiefs or charnel houses made of ephemeral materials. Mounds were enlarged during a cycle of renewal when the residence or temple was destroyed, the mound capped with a fresh mantle of earth, and a new structure built on top. Monks Mound at Cahokia, the largest Mississippian platform mound, was built to its final dimensions of 1040 feet long, 790 feet wide, and 100 feet tall at the highest of its four terraces through fourteen such rituals of renewal and enlargement enacted over a period of some three hundred years between A.D. 900 and 1200.

Mississippian art reflected the social stratification of Mississippian society. Large stone sculptures guarded the temples where priests cared for the remains of sacred kings and warrior chiefs who were eventually buried along the edges of the platform mounds with abundant offerings of regalia. The massive protective sculptures represented primordial culture heros who had descended from the sky to establish the lineage of sacred kings. The remains of leaders were thought to retain great power, particularly the skulls, long-bones, and hands, and were treasured long after death. Images of bones, skulls, and hands, often with an eye or a cross-within-a-circle symbolizing the sun, appear frequently in Mississippian art, constant reminders of the power of these sacred relics. Warrior chiefs wore images of dancing falcon warriors engraved on ornaments of shell and copper. Many images of warriors in Mississippian art include the "forked-eye" marking of a falcon on their faces.

Elaborate burial was reserved for the elite; most Mississippian people were interred in large community cemeteries. The most prestigious of these individuals received offerings of shell beads and ceramic pots at the time of burial. Mississippian funerary pottery was modeled into human and animal effigies, or was incised, engraved or painted with sacred designs. Mississippian ceramic arts display a tremendous range of form and decoration comparable to any of the great ceramic traditions of the world.

When Hernando de Soto journeyed through the American Southeast from 1539 to 1541, he encountered scores of Mississippian communities from Florida to Arkansas. According to the records kept by his scribe Garcilaso de la Vega, these towns enjoyed wealth and prosperity. At the Mississippi River, the explorers found towns with several thousand inhabitants surrounded by neatly arranged fields and orchards. A very different scene greeted Father Jacques Marquette when he descended the Mississippi in 1673. He found only a few villages on the Arkansas and small communities of refugees who had fled from the Iroquois to the east.

What had happened to the once flourishing Mississippian culture? The first great holocaust of North America was caused by the introduction of European diseases, common ones like influenza and dysentery, that proved deadly to native North Americans. It is estimated that nearly ninety-five percent of the native population of the Southeast died as a result of introduced diseases within the first one hundred years of contact. Very likely, the tightly nucleated Mississippian towns were hardest hit. The survivors dispersed and reorganized into the myriad bands of village dwellers known as the Creek, Choctaw, and Chickasaw. The Natchez of the lower Mississippi valley preserved the vestiges of Mississippian culture until their war with France in 1730, when the Natchez chief, or "Sun," and his family were captured and enslaved. Thereafter, the richness of Mississippian culture passed beyond memory until it was unearthed by modern archaeologists.

Butterfly-shaped Atlatl Weight. Late Archaic period, 3000–2000 B.C. Indian Knoll site, Ohio County, Kentucky. Chalcedony. Width: 3⅓ in. National Museum of the American Indian, Smithsonian Institution, New York.

The Indian Knoll site was once a large riverside summer village for a community of hunting and gathering people who harvested the abundant mussels from nearby shoals. Hunters used an "atlatl," or spear-thrower, to hunt game. Small stone weights like this one were attached to the shaft of the atlatl, increasing the weapon's flexibility. This atlatl weight was made with the laborious technique of pecking and grinding, and polishing. Indian Knoll artists procured aesthetically attractive stone for atlatl weights, and finished the objects with a fine polish to bring out the visual qualities of the material.

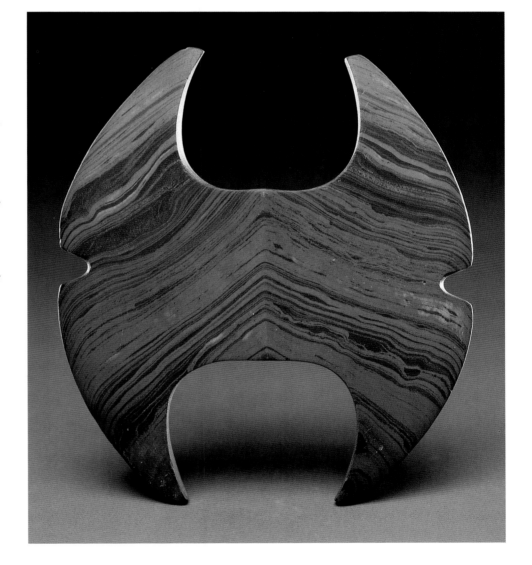

Atlatl Weight. Late Archaic period, 3000–2000 B.C. Michigan. Banded slate. Width: 5½ in. The Gordon Hart Collection, Bluffton, Indiana.

This large atlatl weight is made from slate with dark bands. This was a popular material for the creation of Late Archaic ground stone ornaments and sumptuary objects. The artist employed the natural markings in the stone when fashioning this piece so that the "crease" where the bands changed direction located the center of this "notched ovate" form. Large, heavy atlatl weights like this one, sometimes called "banner-stones," may not have had any practical purpose. Rather, they may have represented some cultural value when displayed, exchanged, or placed with the dead as a funerary offering. This might be better understood as an effigy—a symbolic replica—of an atlatl weight, just as a king's mace is an effigy of a weapon.

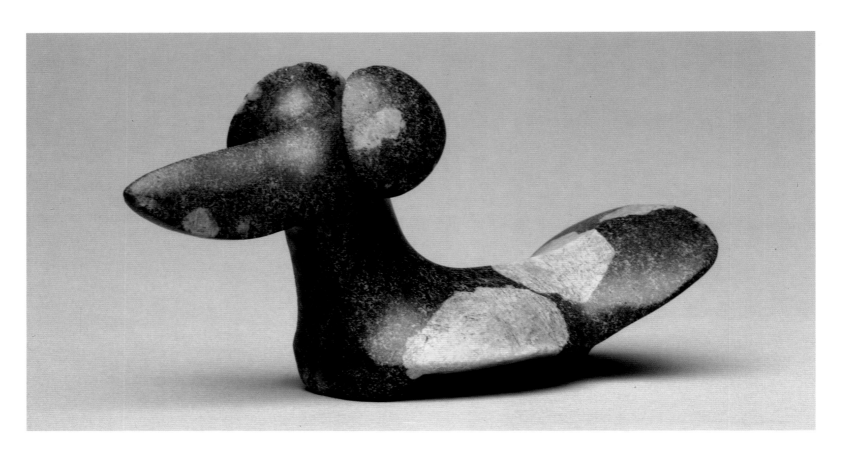

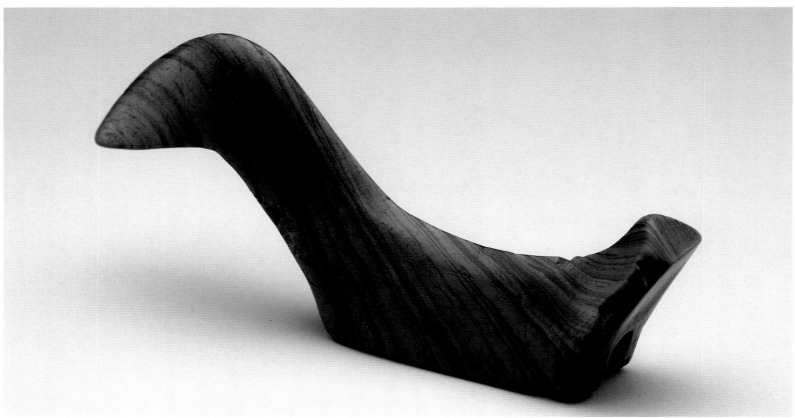

TOP: *Birdstone.* Late Archaic period, 1500 B.C.–A.D. 500. Michigan. Porphyry. Length: 4½ in. Thomas Gilcrease Institute of American History and Art, Tulsa, Oklahoma.

Collectors call this distinctively shaped birdstone form with its telescoping eyes a "popeyed" birdstone. It is made from a greenspeckled porphyry, which is harder and more difficult to work than banded slate.

ABOVE: *Birdstone.* Late Archaic period, 1500–500 B.C. Michigan. Banded slate. Length: 5½ in. The Detroit Institute of Arts.

Toward the close of the Late Archaic period, approximately 1500 B.C., the design for atlatl weights drilled longitudinally through the center to fit on the atlatl shaft gave way to "bar weights" designed to be lashed to the side of the atlatl shaft. Bar weights were made throughout the Woodlands region in a variety of forms, the most sculptural being the "birdstone" of the central Great Lakes area. The pecking and grinding technique did not permit detail, so that only the broad volumes of the form could be created by the artist. Birdstones circulated throughout the Woodlands region via exchange networks and they apparently functioned as one of the most valued funerary offerings.

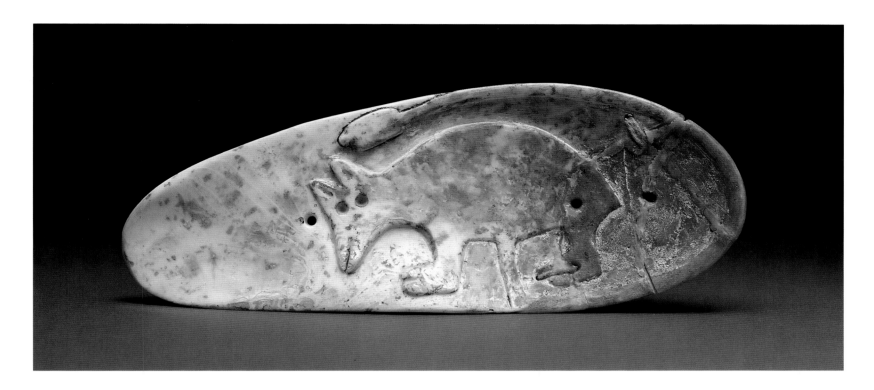

ABOVE: *Sandal Sole Gorget.* Late Archaic period, 1500–500 B.C. Glacial Kame Complex, Hardin County, Ohio. Marine shell. Length: 7¾ in. Ohio Historical Society, Columbus.

Ornaments like this one, made from marine shell in this distinctive foot-print shape, were among the most treasured funerary offerings of a Late Archaic people who lived in the central Midwest and buried their dead in glacial kames, natural mounds or ridges deposited by the retreating glaciers of the Ice Age. Only in rare instances are sandal sole gorgets carved or engraved, this, the only one yet discovered that includes an image of an animal. The creature with pointed ears — perhaps horns — and a tail that arcs over its body resembles the Underwater Panther of Great Lakes Indian mythology.

RIGHT: *Cincinnati Tablet.* Adena culture, Early Woodland period, 500–200 B.C. Cincinnati Mounds, Cincinnati, Ohio. Sandstone. Length: 5 in. Cincinnati Museum of Natural History.

This small, delicately carved sandstone tablet was found in a mound leveled to create the streets of an expanding Cincinnati in 1841. Earlier generations of interpreters saw its strange, otherworldly design as some kind of ancient hieroglyphic. It is one of fifteen similar engraved tablets found at Adena culture sites. This image appears to be some kind of four-limbed monster with a shaggy head. Other tablets include the images of long-beaked birds. There is good evidence that the engraved tablets, with their carefully leveled surfaces, were used to reproduce their designs on textiles or leather through a simple stamping process using red ocher pigment.

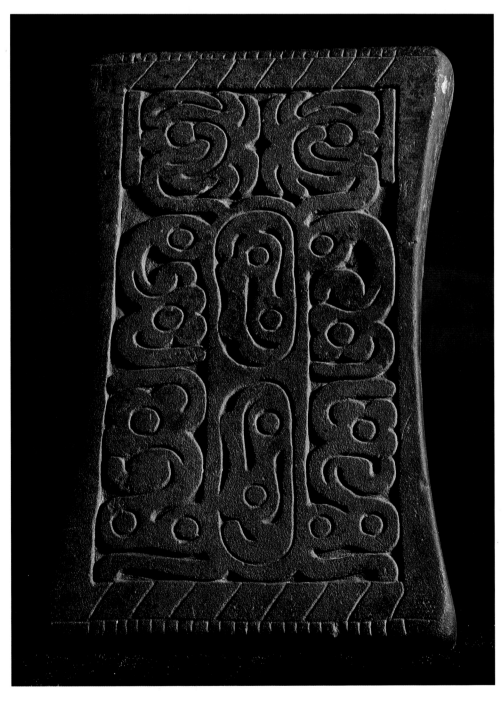

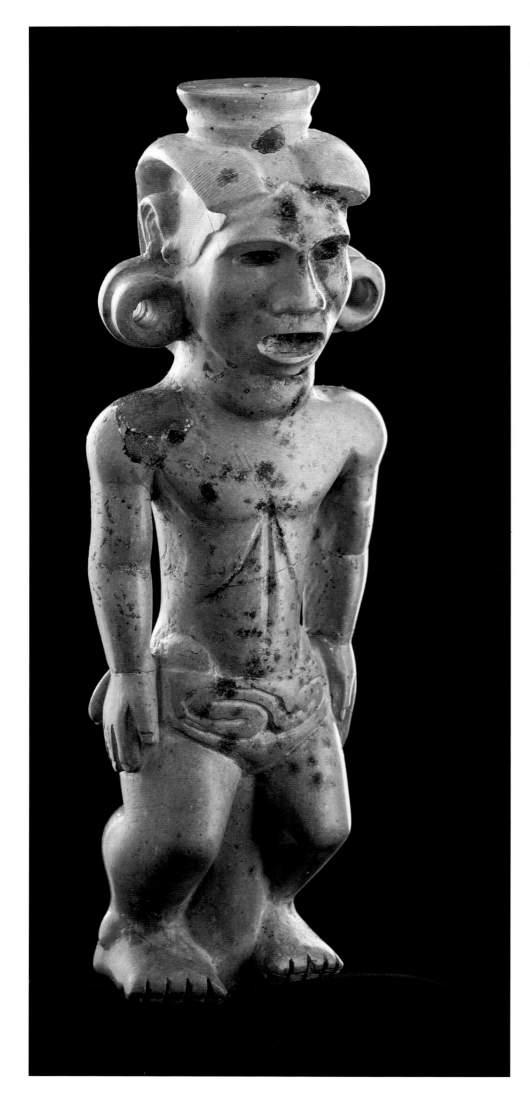

LEFT: *Adena Effigy Pipe.* Adena culture, Early Woodland period, 500–200 B.C. Adena Mound, Ross County, Ohio. Height: 8 in. Ohio Historical Society, Columbus.

This exquisitely carved tubular smoking pipe was found with an elaborately prepared burial in the Adena Mound, excavated in 1901. Over one thousand beads made of marine shell, fresh-water pearls, and bone adorned this individual, who was laid in a tomb made of massive logs along with a collection of chipped stone blades made of fine Flint Ridge chalcedony. The technical design of the pipe, a stone tube constricted at one end for the mouthpiece, is a fairly common Adena form, but the striking effigy carving is unique and without precedent. The figure wears crescent-shaped head ornaments and large ear spools. His wrapper is decorated in front with a curvilinear design, perhaps the image of a serpent; he wears a bustle that resembles a bird tail in back. Very likely, the owner of the pipe was a holy man or religious leader like the "pipe carriers" of the historic Plains and Woodlands tribes.

OPPOSITE: *Effigy of a Human Hand.* Ohio Hopewell, Middle Woodland period, 200 B.C.–A.D. 400. Hopewell site, Ross County, Ohio. Muscovite mica. Length: 11½ in. Ohio Historical Society, Columbus.

This elegant silhouette of a human hand accompanied a pair of individuals buried side by side at the Hopewell site, the repository of some of the most resplendent burial offerings ever found in North America. Both were draped with strands of shell beads and river pearls. Copper axes, chipped flint blades, and bone awls were placed close by. This effigy of a hand lay between them along with other cut mica effigies. The Ohio Hopewell recognized translucent mica as a spiritually potent substance. Large, irregular sheets of mica carpeted the floors of Ohio Hopewell charnel houses, where the dead were prepared for their journey to the other world. Here, the symbolism of the mica and the ancestral relic are artfully combined. The small holes perforated through the palm of the hand suggest that the mica "cut-out" was worn as some kind of ornament prior to its interment.

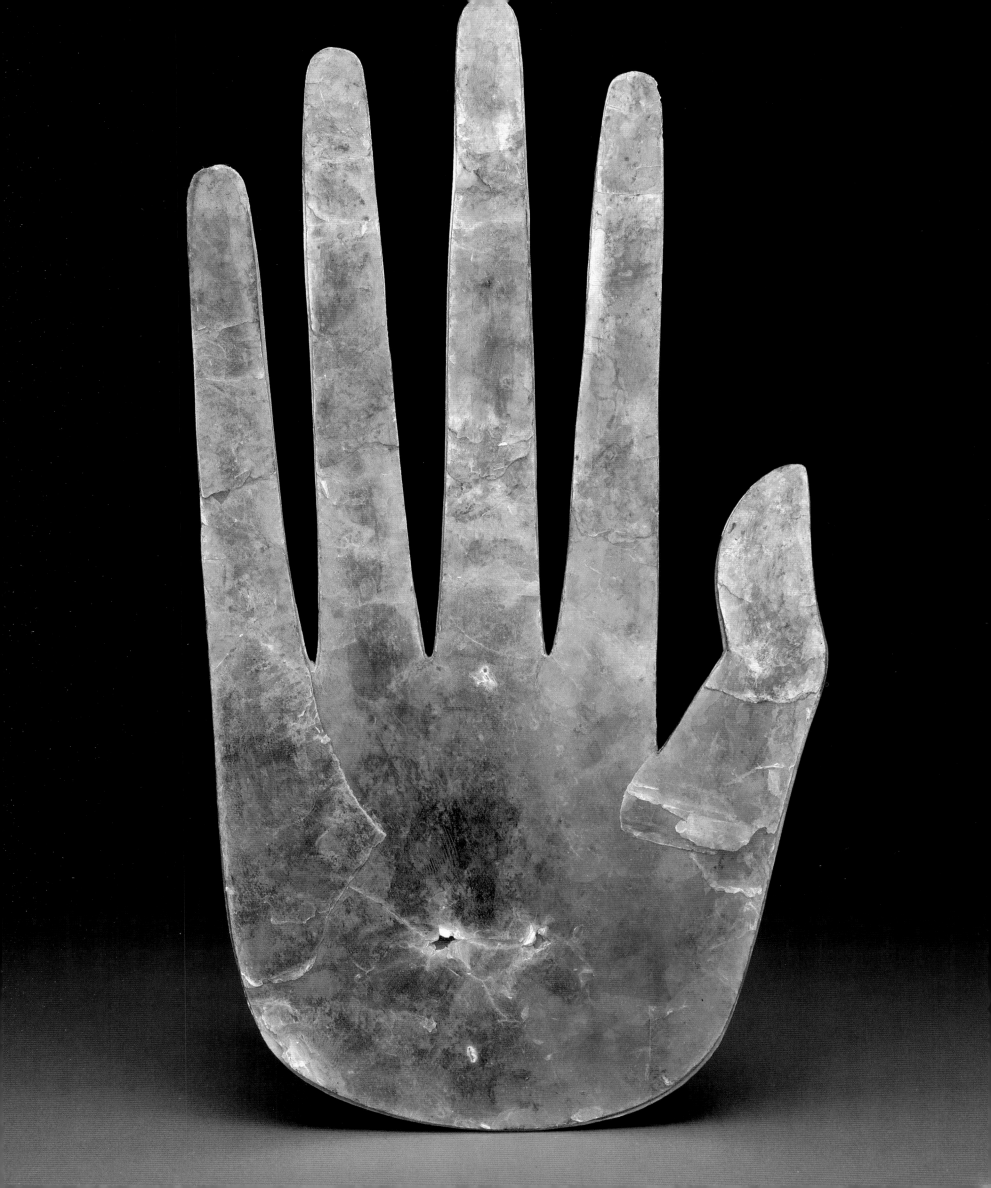

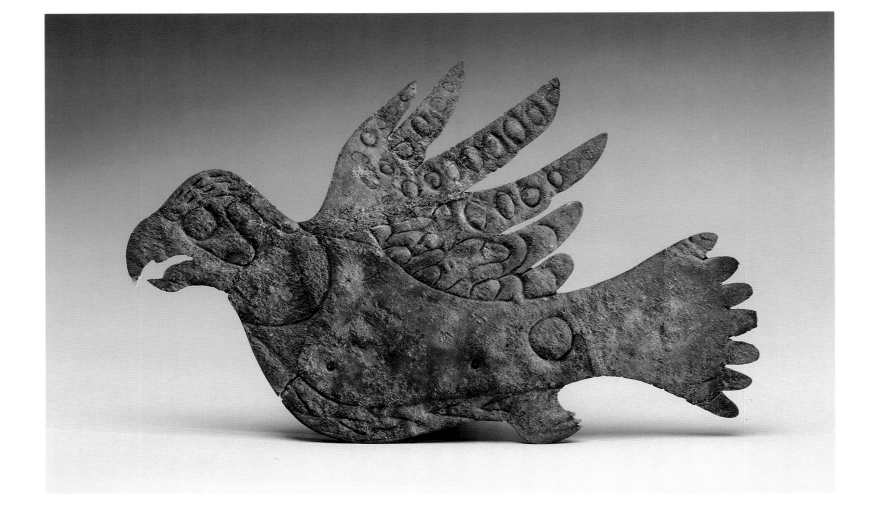

Falcon Effigy Cut-Out. Ohio Hopewell, Middle Woodland period, 200 B.C.–A.D. 400. Mound City site, Ross County, Ohio. Copper. Length: 8⅛ in. National Park Service, Hopewell Culture National Historical Park, Chillocothe, Ohio.

A number of copper objects like this one were arranged around a crematory pit in Mound City site. Ohio Hopewell worked copper without the technology of smelting or casting. Raw copper, collected as nuggets, was simply beaten into flat sheets, periodically heated to keep it from becoming brittle, and then cut into shape. This effigy includes engraved and repoussé details intended to represent the markings of the falcon and the textures of breast, wing, and tail feathers. This is one of two falcon effigies from the cache, which also included oblong copper plates with cut and engraved designs, and an animal headdress with thin copper horns. Copper was considered a valuable and highly spiritual material among the Ohio Hopewell and was the favored material for their most elaborate funerary offerings such as beads, oblong breast plates, ear spools and other ornaments, axes or "celts," and, more rarely, effigy cut-outs.

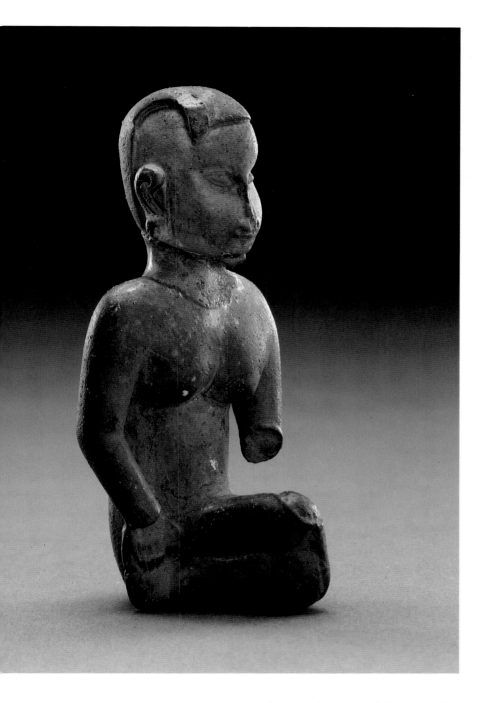

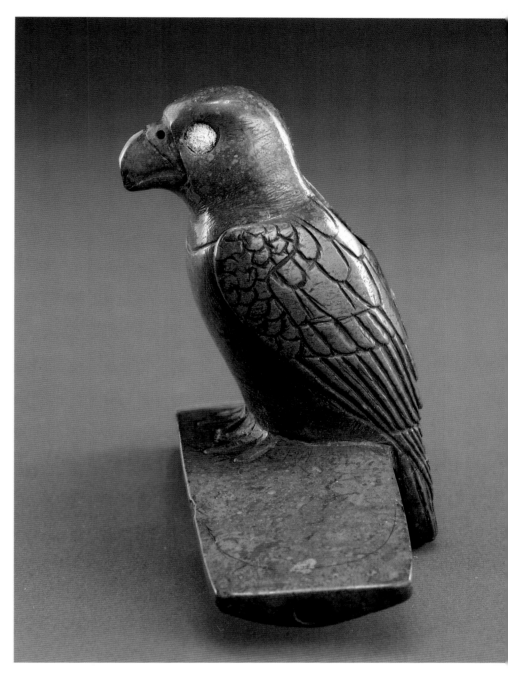

Seated Female Figurine. Crab Orchard culture, Middle Woodland period, 200 B.C.–A.D. 400. Twenhofel site, Jackson County, Illinois. Fired clay. Height: 3½ in. Illinois State Museum, Springfield.

Strikingly naturalistic Middle Woodland period figurines provide the earliest images of the native North Americans. They record many details of dress and ornament. This figurine shows a young woman, seated with her legs folded to one side, wearing a kilt or wrapper around her waist. One hand rests on her foot, the other on her knee, although one lower arm is now missing. Her hair is shaved from one side of her head, while a long gathered tress (not visible in the photograph) hangs down the other side. She wears ear spools. Over twenty-five fragmentary figurines have been found at this poorly excavated village site in southern Illinois.

Eagle Effigy Platform Pipe. Havana culture, Middle Woodland period, 200 B.C.–A.D. 400. Naples Mound, Scott County, Illinois. Green pipestone. Length: 3¼ in. The Brooklyn Museum, Guennol Collection.

This distinctive design distinguishes the smoking pipes of the Middle Woodland period. The upright bowl, carved in the form of an animal, sits upon a narrow horizontal "platform." The mouthpiece for drawing smoke from the pipe is drilled in one end of the platform, while the other end provides a cool grip for handling the pipe while smoking. This impressive pipe is carved with the stately form of a seated eagle and inlaid with galena for the eyes. Dozens of different species of animals and birds are found represented in Middle Woodland period effigy platform pipes, many observed with great attention to characteristic pose and gesture. Their lively naturalism is unparalleled in subsequent North American Indian art.

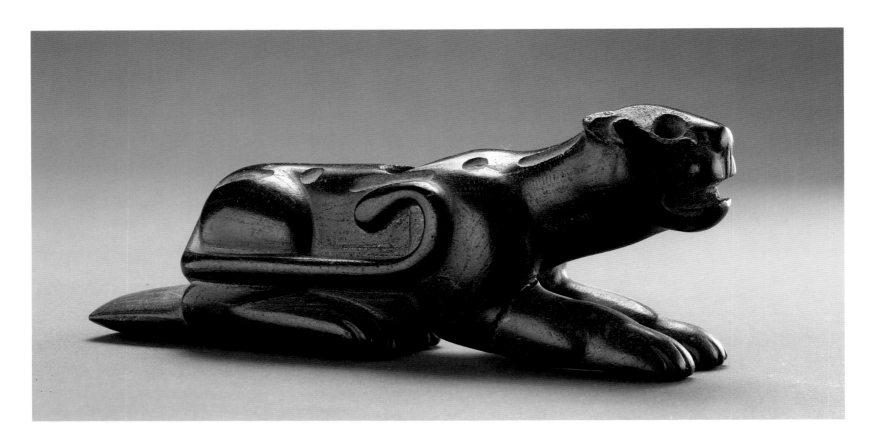

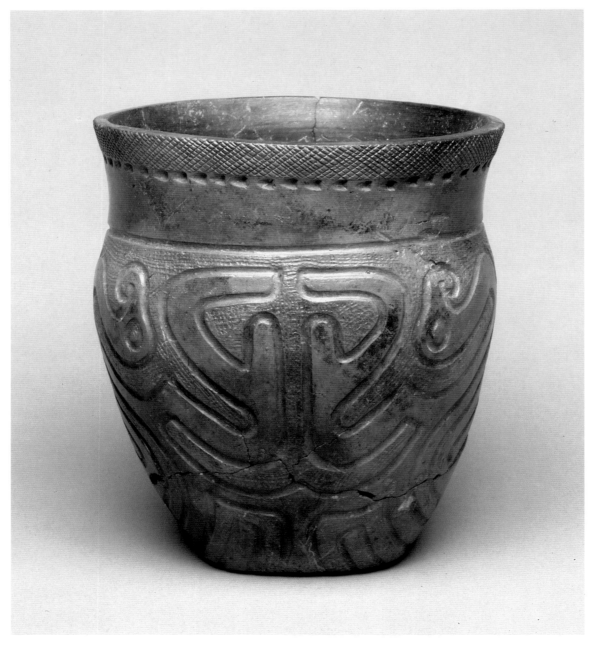

ABOVE: *Panther Effigy Pipe.* Allison culture, Middle Woodland period, A.D. 200–400. Mann site, Posey County, Indiana. Steatite. Length: 6¼ in. The Brooklyn Museum, Guennol Collection.

This panther or jaguar effigy pipe is carved from sleek black steatite. Steatite "great pipes," similar in style to this one, have been found at sites throughout the Eastern Woodlands region. They were produced by artists of some regional workshop or tradition and distributed through trade.

LEFT: *Bird Effigy, Zoned-and-Stamped Jar.* Havana culture, Middle Woodland period, 200 B.C.–A.D. 400. Klunk Mound Group, Calhoun County, Illinois. Ceramic. Height: 5½ in. Thomas Gilcrease Institute of American History and Art, Tulsa, Oklahoma.

The outlines of two birds with hooked beaks and serpentine bodies were incised into the body of this jar in a symmetrical arrangement. The background for the design was textured with delicate, dentate stamping. Although this jar was made in Illinois, similar kinds of jars with bird patterns were produced by other Middle Woodland period cultures as far away as Ohio and Louisiana.

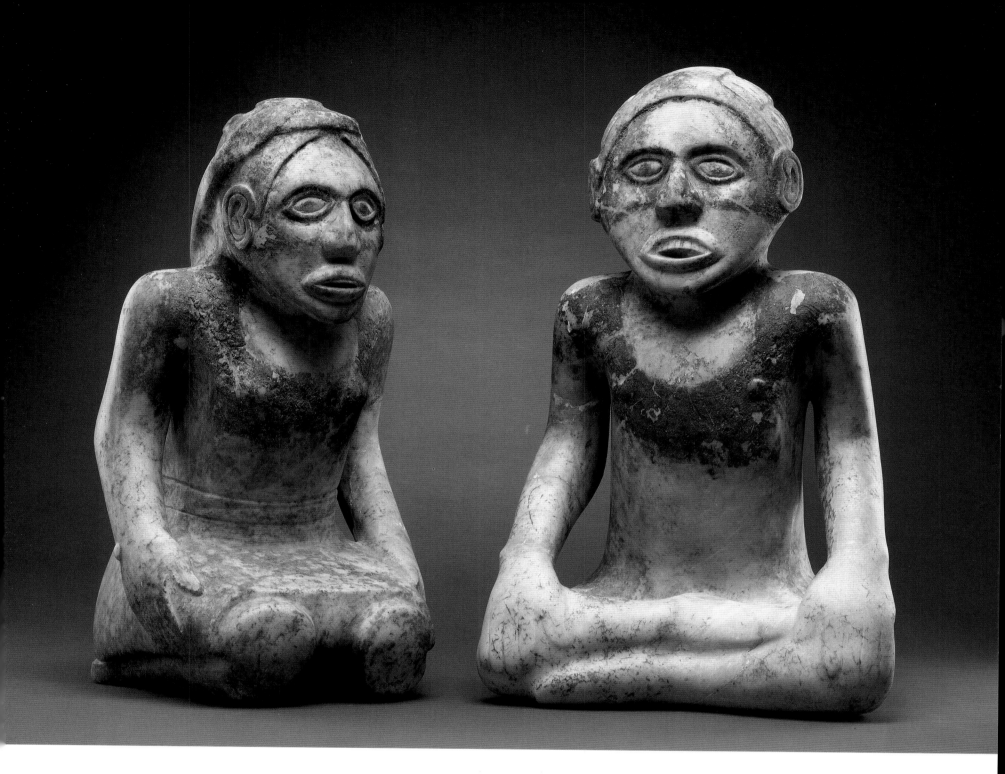

Male and Female Couple. Etowah culture (Wibanks phase), Mississippian period, A.D. 1200–1450. Etowah site, Bartow County, Georgia. Stone (Georgia marble). Height of each: 24 in. Etowah Mounds Archaeological Area, Parks and Historic Sites Division, Georgia Department of Natural Resources.

These sculptures represent the founding ancestors of the lineage of Etowah leadership, an ancestry that claimed descent from the sun itself. These Etowah ancestor sculptures are distinctive because they indicate descent from a primordial couple rather than simply a patriarchal male, a tradition evidenced by the singular, male ancestral sculptures of the western Mississippian cultures. Each of these figures, carved from lustrous Georgia marble, weighs over 150 pounds.

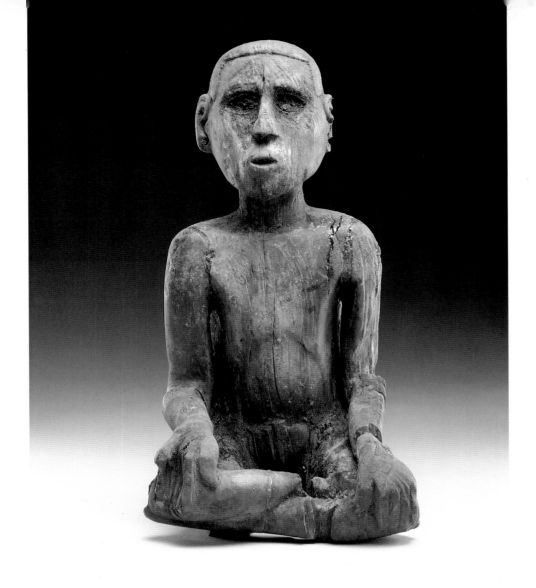

Seated Male Figure. Caddoan culture (Spiro phase), Mississippian period, A.D. 1200–1350. Craig Mound, Spiro site, LeFlore County, Oklahoma. Wood (possibly cedar). Height: 13¼ in. National Museum of Natural History, Smithsonian Institution, Washington, D.C.

Large seated figures like this one represented the ancestors of Mississippian chiefs. The relics of the high-born dead were preserved in temples and cared-for by priests. Their power benefitted the community. Other sculptured figures that were also kept in Mississippian temples represented ancestors of the chiefly lineage who guarded over their descendants. Eventually, the temple would be destroyed in a rite of purification and all its contents, like this figure, buried in a mound of earth. This unique sculpture is made of wood, a material rarely preserved archaeologically.

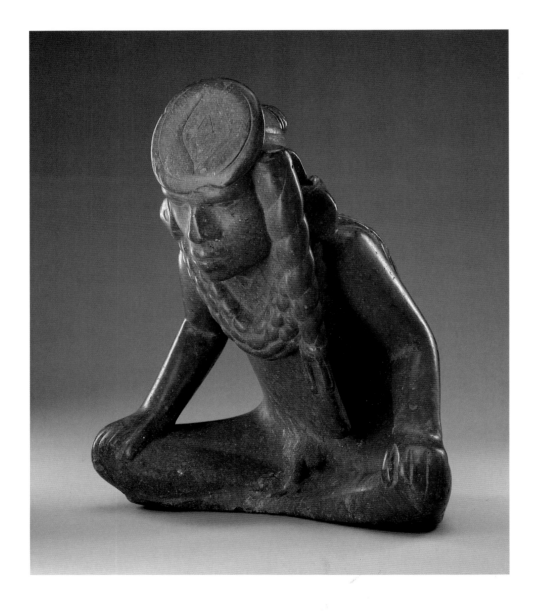

"Big Boy" Effigy Pipe. Caddoan culture (Spiro phase), Mississippian period, A.D. 1200–1350. Craig Mound, Spiro site, LeFlore County, Oklahoma. Stone (bauxite). Height: 11 in. University of Arkansas Museum of Natural History, Fayetteville.

Many different categories of artful object were buried with the Caddoan elite in the Craig Mound, some produced locally and others acquired through trade. This large pipe carved as a seated chief was made by a workshop active in southeast Illinois a hundred years or more prior to its burial in the Craig Mound. It was originally conceived as a figurine but later converted into a smoking pipe by drilling holes in the back for a bowl and stem. It shows an elaborately dressed chief wearing a cloak of ermine skins, a copper frontlet headdress, marine shell ear ornaments carved as miniature masks, and a massive necklace of shell beads.

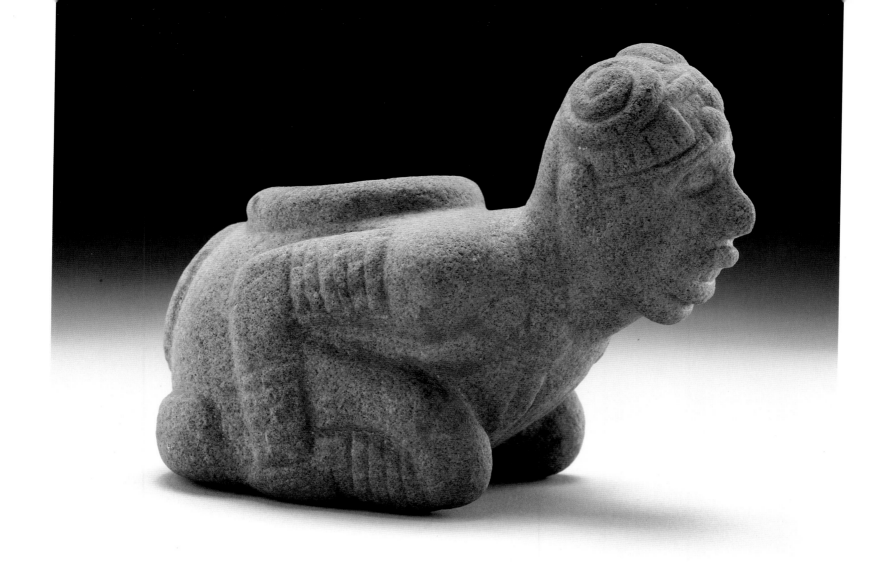

ABOVE: *Kneeling Prisoner Effigy Pipe.* Natchez culture, Mississippian period, A.D. 1400–1500. Possibly the Emerald site, Clairborne County, Louisiana. Sandstone. Length: 6¾ in. The Brooklyn Museum.

This pipe is carved in the form of a well-ornamented man bound with his knees against his chest. At first glance it would seem that he is a prisoner. But more likely this carving represents the decorated corpse of a Mississippian ancestor whose preserved body serves the community as a repository of spiritual power.

RIGHT: *Kneeling Hunchback Effigy Jar.* Mississippian period, A.D. 1400–1500. Southeastern Missouri or northeastern Arkansas. Ceramic. Height: 9½ in. The Detroit Institute of Arts.

Mississippian individuals suffering the advanced stages of tuberculosis—symptoms such as the "hump" on this mortuary jar figure—seem to have been regarded as powerful, even sacred.

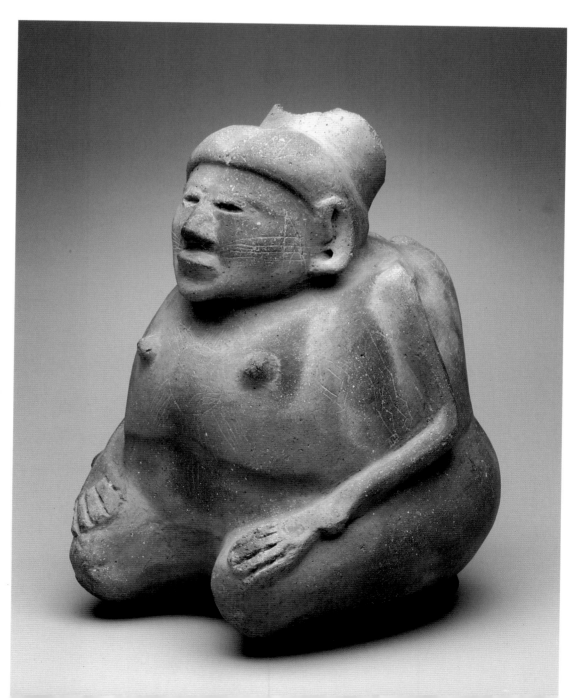

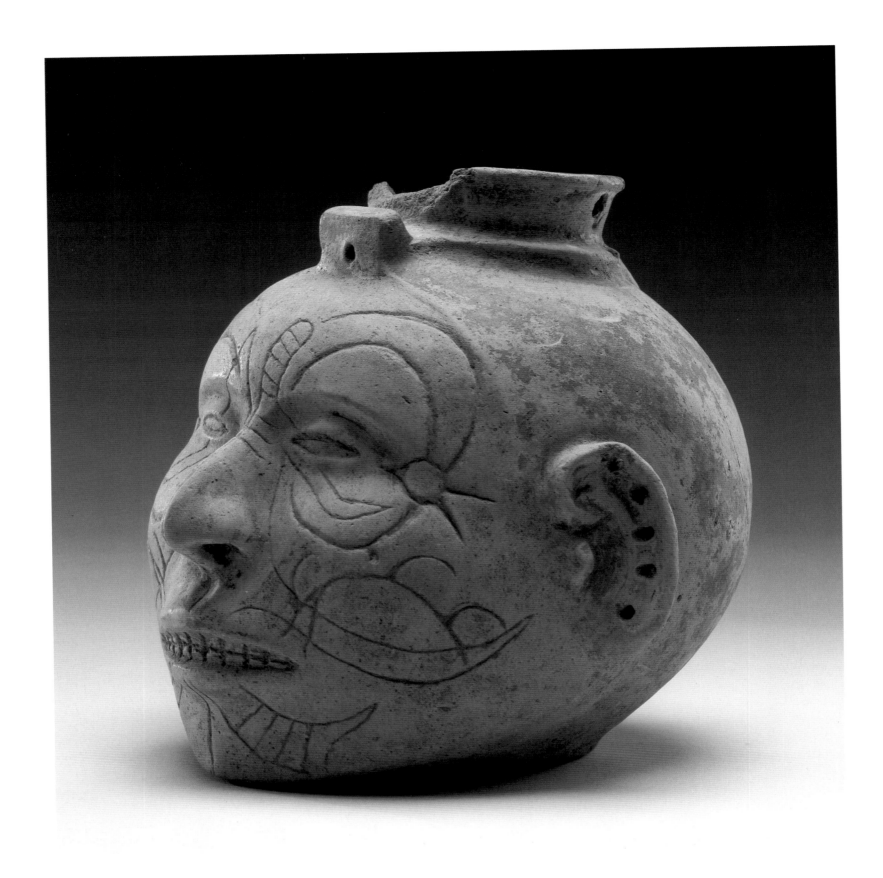

Head Effigy Jar. Mississippian period, A.D. 1400–1550. Southeastern Missouri or northeastern Arkansas. Ceramic. Height: 6⅜ in.; width: 7 in. The Detroit Institute of Arts.

This strikingly naturalistic portrait, given form as a ceramic jar, represents a Mississippian chief. His distinctive facial painting or tatoo appears on several other ceramic portraits. The preeminent symbol of power in Mississippian societies was the ancestral relic, the fragment of an ancestral chief preserved by the priesthood. Images of ancestral relics are found in several categories of Mississippian art, particularly images of the heads, leg bones, or hands of Mississippian chiefs. This head effigy jar is not a portrait of the chief in life, but in death.

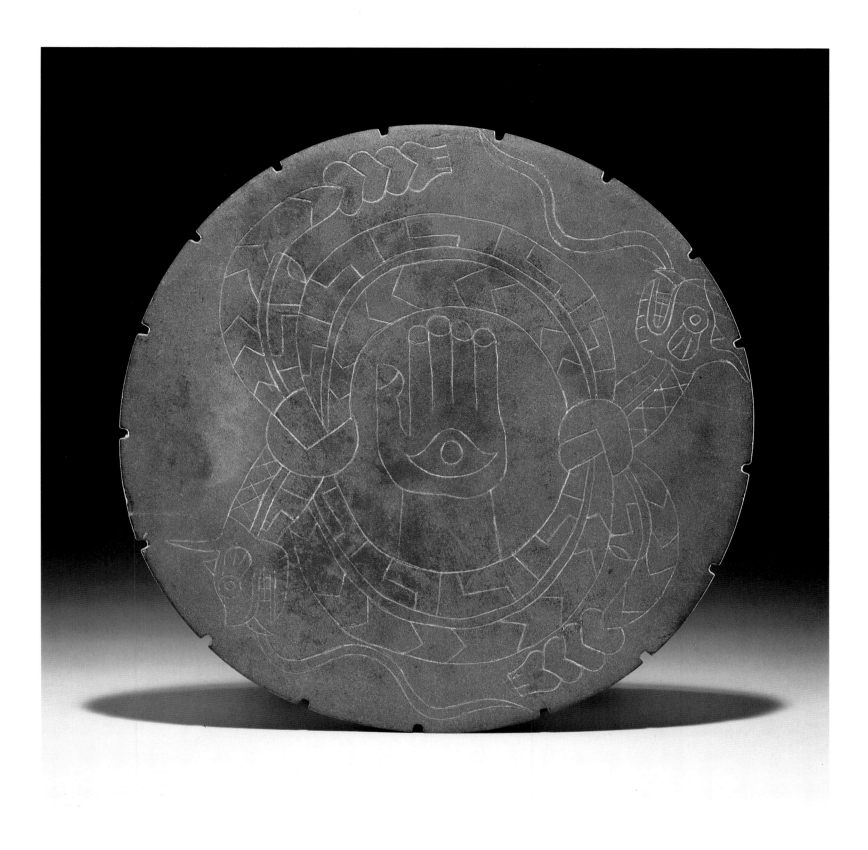

Engraved Palette. Moundville culture (Moundville phase), Mississippian period, A.D. 1200–1500. Moundville site, Hale County, Alabama. Stone. Diameter: 12½ in. University of Alabama Museum of Natural History.

This large stone disk was used for grinding and the preparation of pigments and paints for ceremonial use. One face is engraved with a design that consists of a human hand, with an eye in its palm, surrounded by two horned rattlesnakes knotted together. The hand represents a relic or part of the human remains of a Mississippian chief. The eye in the palm is the sun—the eye that looks down from heaven—who is the original ancestor of the chiefly lineage. The circular arrangement of the horned serpents shows the Underworld passageway of the dead which the Mississippian chief must traverse in order to join his ancestors. The funerary rituals of the Mississippian elite were intended to prepare the dead for this journey.

Gorget. Dallas culture, Mississippian period, A.D. 1300–1500. Hixon site, Hamilton County, Tennessee. Marine shell. Diameter: 4½ in. Frank H. McClung Museum, The University of Tennessee, Knoxville.

This cut shell gorget was worn by a member of the Mississippian elite as an ornament. It shows two warriors who are locked in ritual combat as if performing a dance. Areas cut out of the background isolate the silhouettes of the two figures whose dress and ornament is represented with additional engraved detail. They wear antler headdresses, bird-wing cloaks, and feather bustles representing a bird's tail; their feet are rendered as raptor's talons. Grasping each other by the ear, they brandish clubs or pikes as if to strike. Ornaments like this may have identified a sacred class of Mississippian warriors.

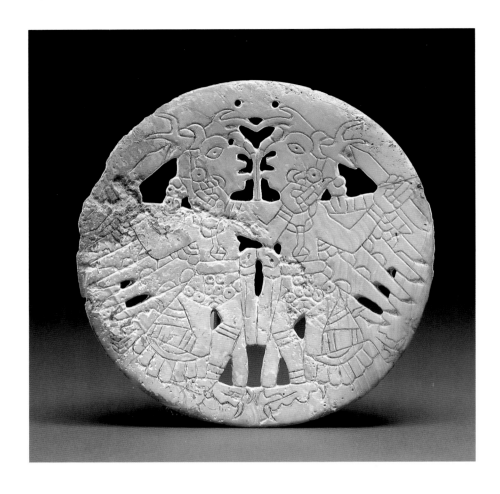

"Spaghetti style" Gorget. Dallas culture, Mississippian period, A.D. 1300–1500. Tennessee. Marine shell. Diameter: 6½ in. The Detroit Institute of Arts.

Stylized images of dancing warriors depicted in Dallas culture shell gorgets are rendered amidst a swirling matrix of coils and volutes. The simple profile form of the head of this piece is dominated by a large, beaklike nose. The arms and legs, posed as if the figure is running or dancing, become immersed in the highly patterned background.

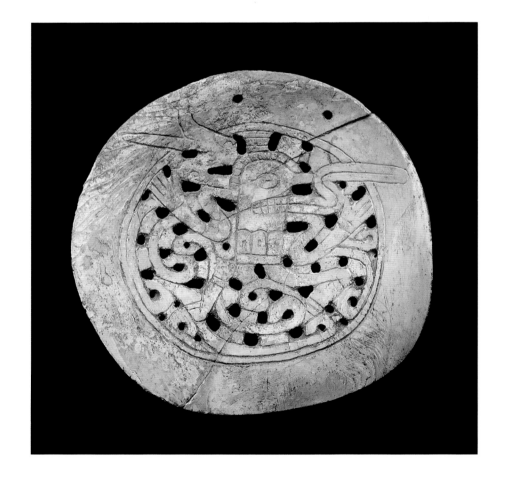

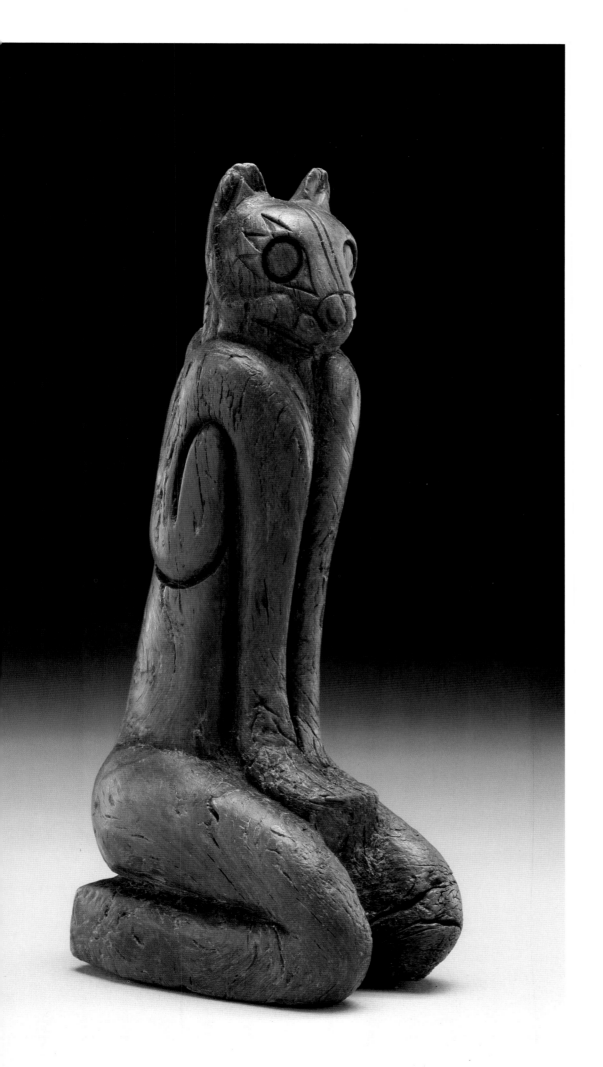

Kneeling Cat Effigy. Calusa culture, Late Mississippian or early historic period, A.D. 1400–1600. Key Macro site, Collier County, Florida. Wood. Height: 6 in. National Museum of Natural History, Smithsonian Institution, Washington, D.C.

The depleted oxygen environment of thick Florida muck preserved an enormous number of wooden objects from the Late Mississippian village located at the Key Macro site. Frank Hamilton Cushing, one of America's finest anthropologists, excavated the site in 1895. Cushing recovered some eleven barrels and fifty-nine boxes of artifacts from the site, now disbursed among several museums, but none so beautiful as this small, kneeling figure with a mystical, feline head.

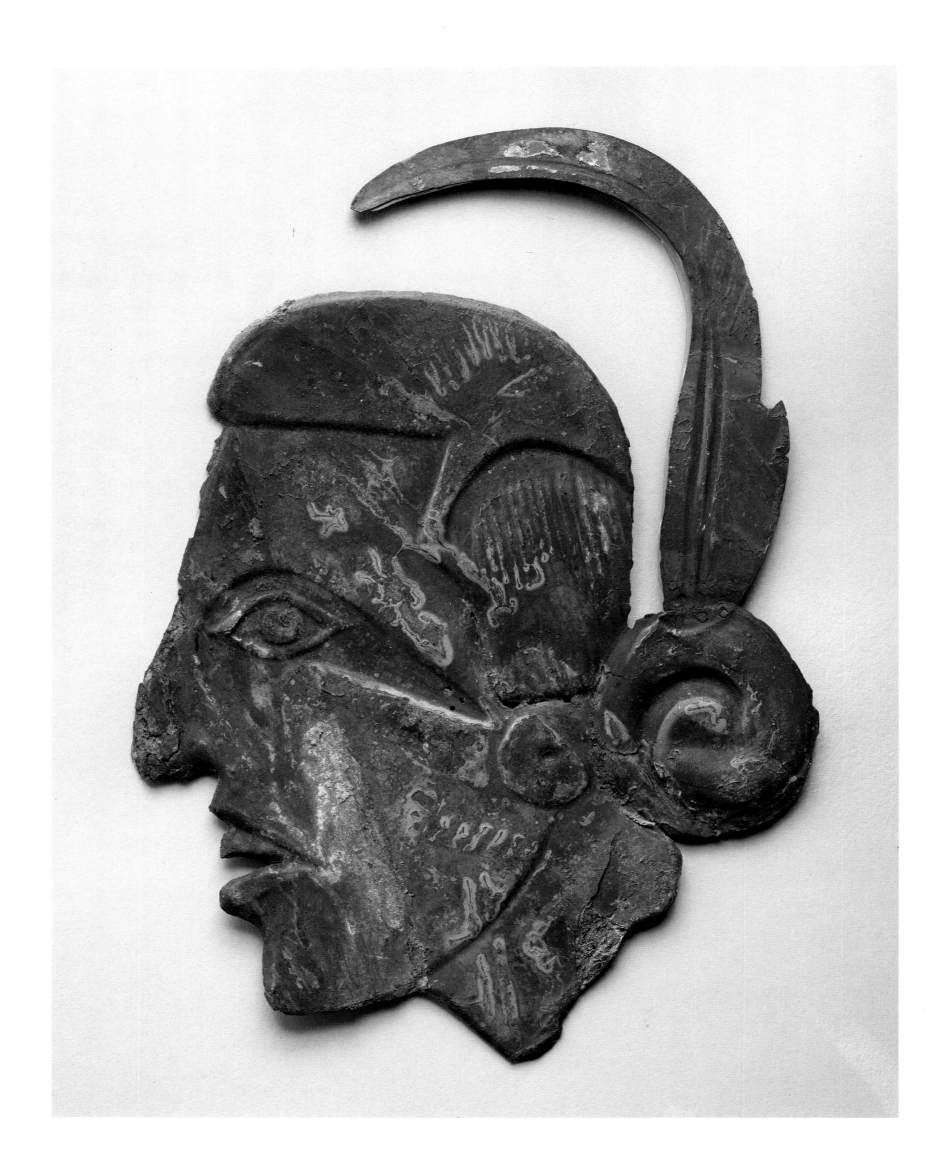

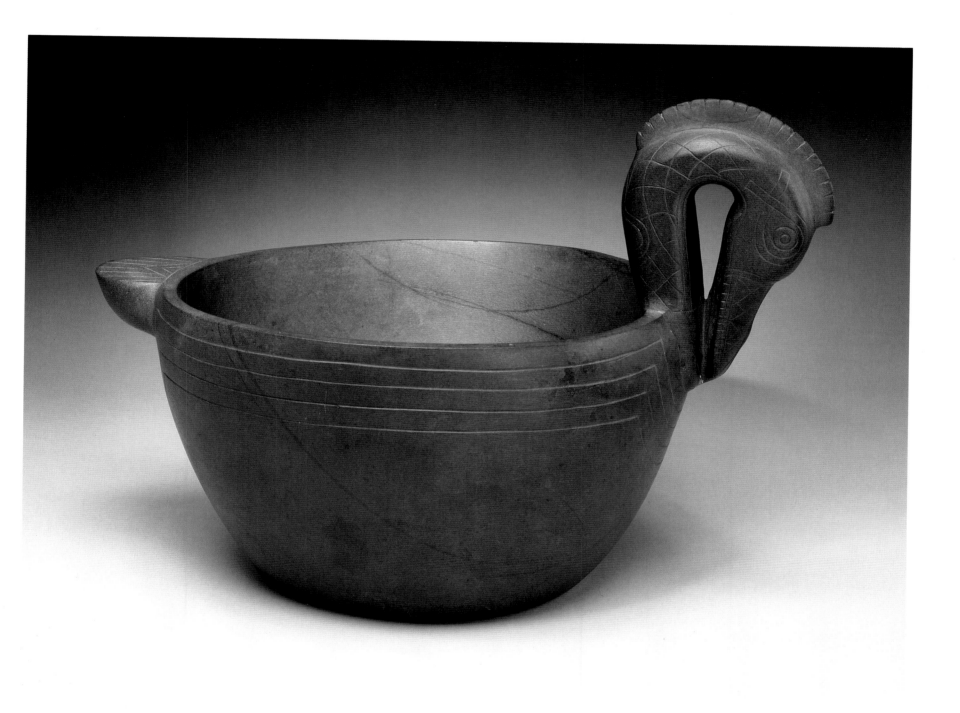

OPPOSITE: *Profile Head Effigy Cut-Out.* Caddoan culture (Spiro phase), Mississippian period, A.D. 1200–1350. Craig Mound, Spiro site, LeFlore County, Oklahoma. Height: 9½ in. Ohio Historical Society, Columbus.

Copper objects buried in the Craig Mound included several thin plaques cut into the form of falcon-human composites with details worked in repoussé. The falcon was an important symbol of a warrior's prowess during the Mississippian period. Falcons are fiercely aggressive predators of other birds. They dive from great heights to literally knock their prey from the sky. The "forked-eye" marking on the face of this cut-out identifies the figure as a falcon impersonator, perhaps the member of an elite Mississippian warrior's society.

ABOVE: *Crested Duck Effigy Bowl.* Moundville culture (Moundville phase), Mississippian period, A.D. 1200–1500. Moundville site, Hale County, Alabama. Stone (diorite). Height: 12 in. National Museum of the American Indian, Smithsonian Institution, New York.

This large and elegant bowl is conceived as the body of a crested duck, with its tail on one side of the rim and its arching neck and head on the other. The broad shoveler bill indicates it is a diver. The Creek and Choctaw descendants of southeastern Mississippian cultures thought of the underwater realm as a potential source of great power. The importance of water creatures in Mississippian imagery may stem from these notions.

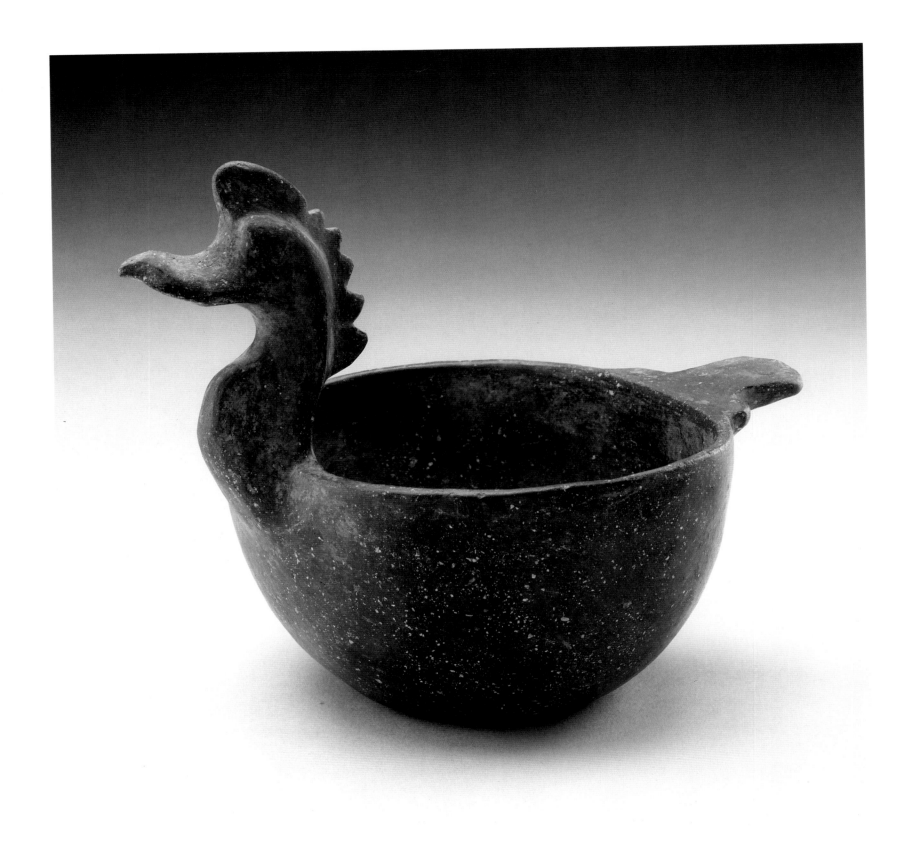

Crested Bird Effigy Bowl. Mississippian period, A.D. 1300–1500. Central Mississippi valley region. Ceramic. Height: 5½ in. The Detroit Institute of Arts.

Mississippian ceremonial bowls were often made with adornos, or effigy heads, applied to the rim, transforming the vessel into an animal, in this case a fantastic crested bird whose head rises from one side of the bowl. The shell-tempered bowl was made by hand with a "paddle and anvil" method. The surface is not painted or washed with a slip, but simply burnished.

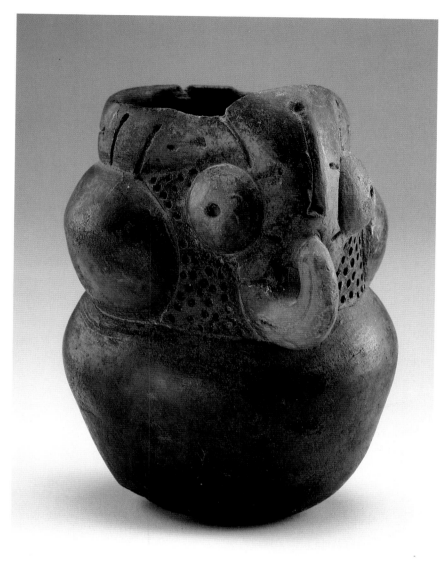

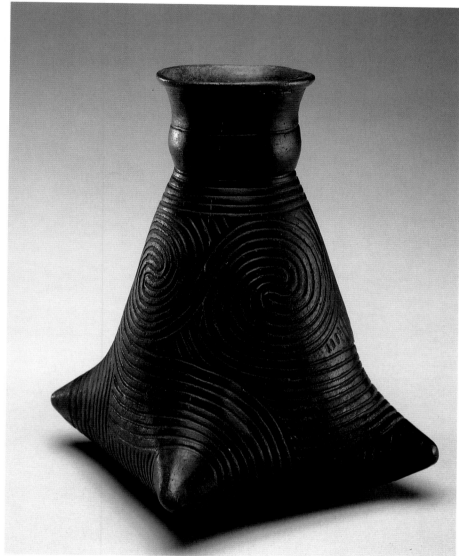

Owl Effigy Vessel. Weeden Island culture, Late Woodland period, A.D. 400–900. Florida panhandle region. Ceramic. Height: 7¼ in. The Detroit Institute of Arts.

The elaborate Middle Woodland period burial mound complexes of the Florida were followed by those of the Weeden Island cultural tradition. Weeden Island burial mounds covered large communal assemblages of the dead accompanied by caches of highly decorated ceramics, like this small jar. The stylized owl with its beak curled upward is a common image among effigy vessels. This vessel displays characteristic "dot-and-drag" incised markings and areas of punctate stamping.

Keno-Incised Bottle. Caddoan culture, Mississippian period, A.D. 1500–1800. Oklahoma. Ceramic. Height: 5½ in. National Museum of the American Indian, Smithsonian Institution, New York.

The elaborate web-work of spiraling designs that wraps around this ingeniously shaped bottle was incised into the surface with a broad stylus before the vessel was fired, after it had dried to leather hardness. The precision of line and the calculated way the complex pattern repeats around the bottle form makes clear the masterful accomplishment of the Caddoan ceramic tradition.

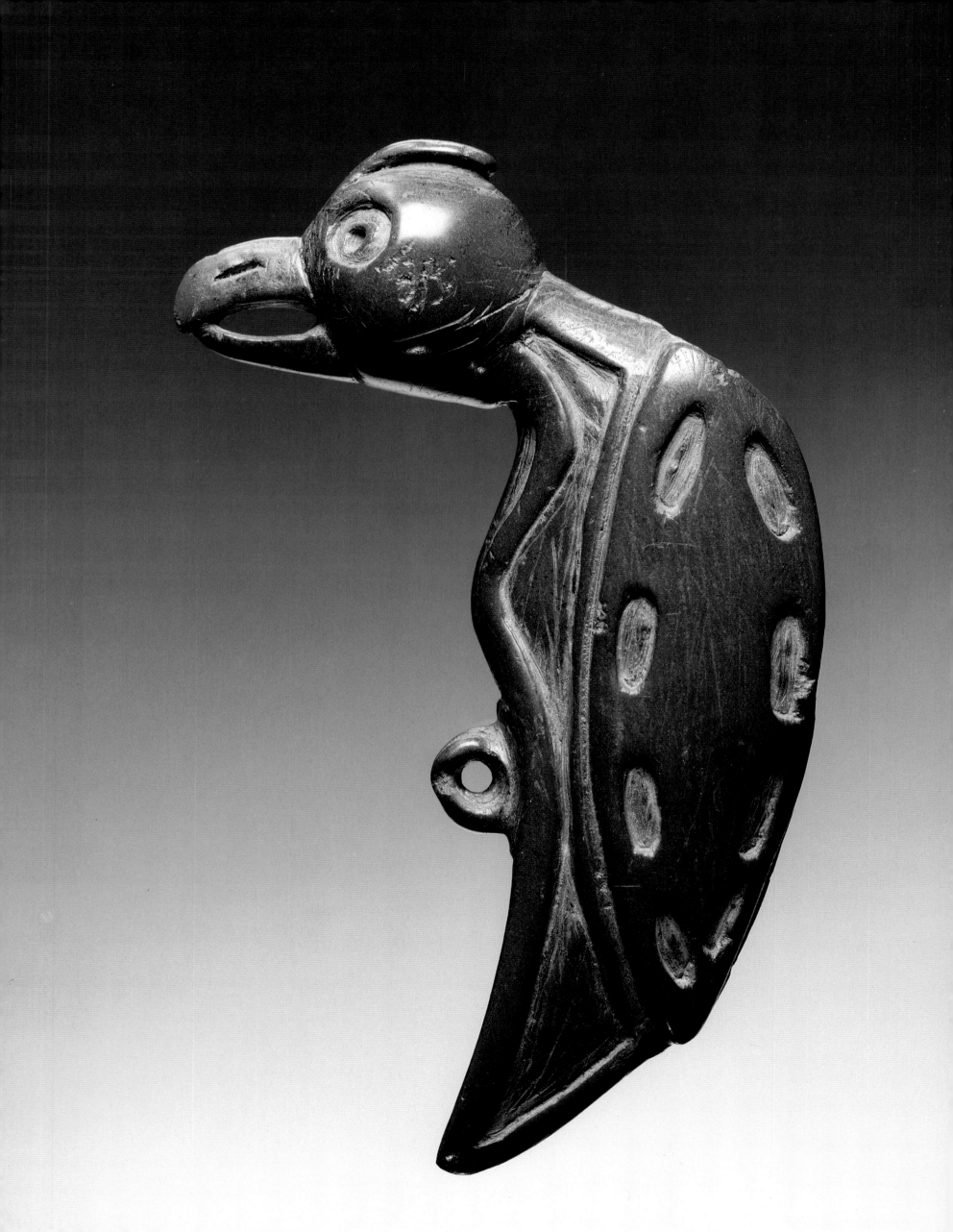

OPPOSITE: *Parakeet Effigy Pipe.* Proto-Iroquois, c. 1500. Onondaga County, New York. Stone. Height: 5 in. The Gordon Hart Collection, Bluffton, Indiana.

This small and exquisitely carved pipe bowl was found near Apulia station, New York, in 1888. It is a rare style of proto-Iroquoian pipe bowl carved with the image of a bird rendered as if perched with wings folded. The pipe would have been smoked with a stem inserted in a hole in the bird's back.

RIGHT: *Nodena Polychrome Bottle.* Nodena culture, Mississippian period, A.D. 1400–1500. Maynard site, Arkansas. Ceramic. Height: 9½ in. National Museum of the American Indian, Smithsonian Institution, New York.

The creators of ceremonial ceramics of the Late Mississippian period of the central Mississippi valley experimented with a variety of decorative techniques. Orange- and cream-colored slips create the design against a buff paste on this graceful bottle. Ceremonial pottery wares may have functioned in temples or household rites prior to their burial as offerings to the dead.

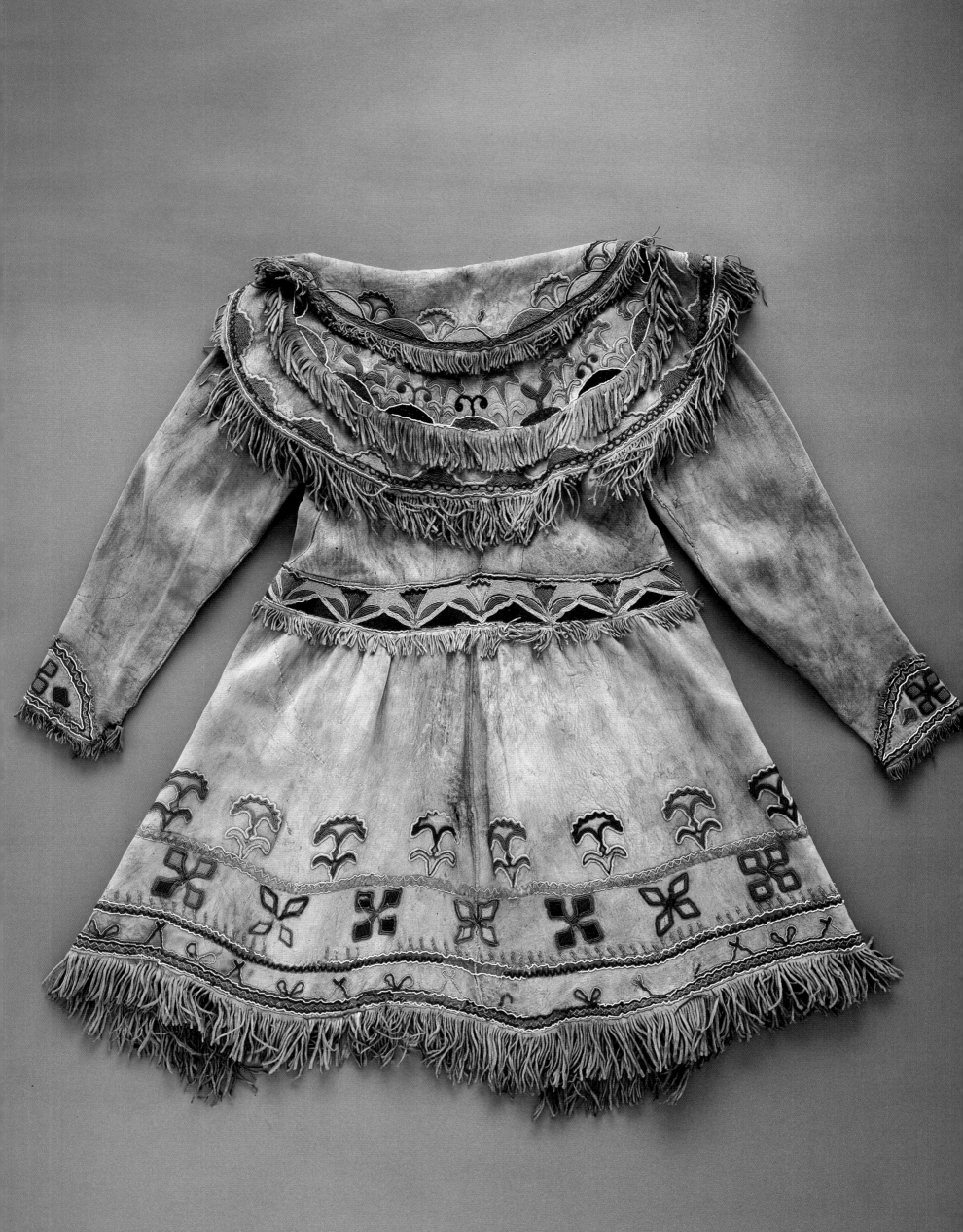

THE EASTERN WOODLANDS

The European "discovery" of North America around the beginning of the sixteenth century marks the transition from "prehistory" to history and signaled the advent of a period of vigorous exploration and expansion into uncharted territories. Consciousness of the Americas forced people of European descent to stretch what had become comfortable perceptions about the world they lived in. Suddenly, there was a large new piece to the puzzle of the cosmos and these people struggled to find a place for it to fit within their abilities of comprehension.

In 1492, when Columbus sailed west in search of "India," his destination was the unknown lands beyond the Middle East. What he found was indeed *terra incognita*, a land of untold promise and plenty, inhabited by a people so foreign to the European cultural tradition as to seem not only different, but somewhat disturbing. Ferdinand and Isabella, Columbus's sponsors, had only just expelled the Islamic Nasirids from the Iberian peninsula, the final event in a conflict that had been perceived within the European cultural tradition as the triumph of light over darkness, the blessed over the damned, Deity over the Devil. The late medieval mind struggled with the identity of New World inhabitants in similar cosmological terms. Were they infidels like the Muslims? Had they simply been forgotten by the Lord? Were they human beings at all and capable of salvation? The notion that Native Americans possessed a complete and satisfactory cultural tradition that should retain the privileges and rights of self-determination was impossible for Europeans to understand five hundred years ago. Many people of European descent still have trouble with the idea today.

EUROPEAN TRADE AND CONFLICT

One thing Europeans had little trouble comprehending when considering this "New World" was its potential for personal gain. Since gold could not be located in sixteenth-century North America, Europeans looked for other opportunities. Off the North Atlantic coast, Basque, English, and French fishermen began to exploit the rich Grand Banks early in the sixteenth century, establishing processing camps on Prince Edward Island and Newfoundland. Here, contact was made with the Algonquian-speaking Penobscot, Malecite, and Micmac; the visitors bartered for the fur garments worn by the locals in exchange for iron nails and axes, and ornaments made of glass and porcelain. The transactions were simple enough, but this pattern, later called the "fur trade," became vital to Europeans and natives alike, enduring for the next four hundred years because it permitted both parties to interact for their mutual benefit while maintaining their own cultural frames of reference.

Both cultures valued trade and willingly entered into trade relationships with new, albeit unfamiliar, partners. European entrepreneurs were quick to recognize the potential profit from marketing furs in Europe and various kinds of simple European manufactured goods in North America. Traders became, therefore, a vital part of a

Hunting Coat. Delaware or Shawnee. Early nineteenth century. Indiana or Ohio, southern Great Lakes Region. Deerskin, silk ribbon, glass beads. Length: 39½ in. The Detroit Institute of Arts.

The deerskin "hunting coat" was a prestigious men's garment popular among the southern and central Woodlands tribes early in the nineteenth century. It is loosely based on the European military jacket, with its fitted waist and cuffs, but with the addition of a short fringed cape or tippet. This garment is decorated with an early style of glass bead embroidery.

developing economy. The native perception of the trading process was quite different, however. For them, trading established alliances between peoples that involved additional social obligations. Goods were exchanged not to gather capital for personal wealth, but rather to distribute capital throughout native communities for personal recognition. Whereas the native trader dealt with a European individual, or at best, his company, the European trader dealt, at least indirectly, with the entire native community.

It was trade that spurred seventeenth-century European penetration into the Eastern Woodlands: trade in beaver pelts in the north and in deer skins to the south. Colonization and its attendant conflict followed. Successful trade required undisturbed hunting territories, and the immigration of European settlers onto these lands was not tolerated. It has been said that Native Americans were convinced to surrender their lands because they did not recognize ownership of land in the first place. Nothing could be further from the truth. While Indian cultures traditionally have not recognized individual ownership of land, tribal rights to territory have been and still are of primary concern. Conflicting land claims between tribes were contested heatedly, and when settlers of European descent attempted to establish communities in North America it was no different. Indian societies welcomed colonies of traders as allies, but conflicts arose when those allies overstepped prudent boundaries. While negotiation and compensation averted some hostilities, these agreements were viewed differently by each culture. Europeans considered treaty disbursements as payments for real estate; many native participants thought of payments as recompense for resolving hostilities and did not recognize the sale of land. In most cases, however, European land claims were ultimately pursued in a manner everyone understood—through force of arms.

The history of European and native interaction in the Eastern Woodlands is long and complex, but only recently have historians begun to examine seriously the story from the Indian point of view. Previous generations of historians have focused on how the imperial aspirations of England, France, Spain, and the Netherlands clashed in the New World. Indian people were portrayed as passive witnesses and helpless victims, savages hovering at civilization's edge, adhering to no coherent policy and participating only marginally as allies or enemies of European interests. More recent assessments have concluded that Indian people were, in fact, actively involved in promoting their own welfare, and, therefore, only by understanding native motivations can we understand the behavior of European powers in North America at that time.

For peoples of the Eastern Woodlands, the history of life after the arrival of European traders and settlers was one of increasing social instability and, often, community displacement. The Algonquian agricultural tribes of New England and the southern Atlantic seaboard chiefdoms were either destroyed or dissipated before the close of the seventeenth century. The Iroquois of New York State subsequently formed a confederacy, or "League," for protection from their displaced eastern neighbors. During the seventeenth century, aggressive Iroquois raiding destroyed the French-allied Huron confederacy to the north and forced the Algonquian villagers of the southern Great Lakes to flee west of Lake Michigan to Green Bay. The southern Great Lakes heartland of Indiana and Ohio was resettled only gradually early in the eighteenth century with Miami and Potawatomi returning from the west, Delaware

and Shawnee migrating from the east, the Ottawa from the north, Wyandot refugees of the Huron confederacy from southeast Ontario, and emigrant families of Iroquois from western New York. The many different communities of Muskogean and Algonquian language speakers that had been decimated by the post-Mississippian pandemic resettled in western Georgia and Alabama and later would become known by English traders as the Upper and Lower Creek and the Seminole of Florida.

The upper Ohio "frontier," the point of intersection between the conflicting interests of the French, English, Iroquois, and central and western Algonquians, was the site of heated conflict throughout most of the eighteenth century. The western Indian combatants in The Seven Years War (1753–1760), Pontiac's Rebellion (1763–1764), the War of the Revolution (1776–1783), as well as the several military expeditions to the west mounted by the young American republic under Generals St. Clair (1786) and Anthony Wayne (1794), and the War of 1812, sought simply to hold rights to lands north and west of the Ohio. The 1795 Treaty of Greenville and the death of Tecumseh at the Battle of the Thames in 1813 dashed these hopes. The devastating defeat suffered by the Indians in the Creek War of 1813–1815 culminated several decades of tension between European and Native Americans of the Southeast, and shook loose the Indian grip on land rights in that region as well.

With the eastern tribes intimidated by military power, European-American emigrants streamed into the newly formed territories of the Northwest and the Southeast interior during the first decades of the nineteenth century. The question remained, what was to happen to the Indian people who lived there? Many suffered from severe poverty and social debilitation as a result of the collapse of self-sufficient economies. The government thought it best to segregate Indian people from whites and signed into law the Indian Removal Act of 1830. The act forced Indian people remaining in the east to leave their homes for resettlement in "Indian Territory" west of the Mississippi. Enforcement of the act was particularly brutal in the Southeast, where Creek and Cherokee were rounded up and forced at gun-point into mass migrations westward, grim journeys marked by starvation and death known today as the Trail of Tears. Some members of the Creek and other tribes retreated into the everglades of Florida where they resisted deportation during the Second Seminole War of 1837–1842. In the north, Kickapoo, Miami, Ottawa, Shawnee, Delaware, Potawatomi, Mesquakie, Sauk,

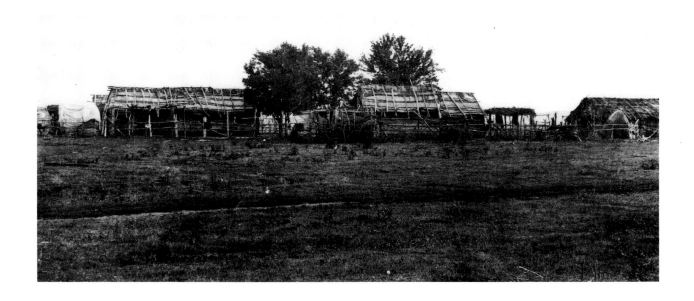

These Mesquakie bark houses were photographed at the Tama, Iowa, settlement. Mesquakie who had been forced to leave Illinois and Wisconsin as a result of the Indian Removal Act purchased a settlement tract at Tama during the 1850s.

Courtesy of the National Archives of Anthropology, National Museum of Natural History, Smithsonian Institution, Washington, D.C.

and Winnebago, among others, were also moved west to reservations in Kansas and Oklahoma. A few managed to stay behind; others returned, but quietly. The Mesquakie, for example, purchased a settlement tract in 1857 at Tama, in Iowa territory, not far from their homeland. Far to the north, in northern Michigan, Wisconsin, and Minnesota, European-American penetration and settlement lagged until after mid-century, when the region's logging and mining interests were organized. Indian residents were then restricted to smaller and smaller reservations. The Dawes Allotment Act of 1887 limited residence even further, dividing tribal reservations into family allotments in order to, in the words of Theodore Roosevelt, "break up the tribal mass." The result was further coercive land sales and loss.

The net sum of United States policy toward American Indians nearly ruined many thriving cultures: self-sufficient economies were destroyed, land rights disenfranchised, and cultural identity undermined through acculturative education. The great populations of eastern native peoples were relocated to the west, far from their homelands, or simply tolerated at the edges of European-American society in reservation communities. But, despite centuries of oppression and despair, Indian people struggled to preserve a sense of self, a sense of cultural identity. Strong oral traditions derived from an intensely spiritual world view continued to maintain cultural values. As the Acoma scholar Paula Gunn Allen wrote, "The oral tradition is vital; it heals itself and the tribal web by adapting to the flow of the present while never relinquishing its connection to the past." The same can be said of the visual arts that have also proved to be an integral part of cultural survival.

THE PRESERVATION OF TRADITION

SPIRITUALITY

Religious ritual in the native cultures of the Eastern Woodlands often focused on the issues of purification and the restoration of balance and stability. Social life, with all its inconsistencies, contradictions, and potential for conflict, unleashed dangerous forces that required control and reconciliation. Part of the Creek "busk" or Green Corn ceremony included a ritual cleaning of the town square and rekindling a sacred fire as a means of ridding the community of the residue of bad feeling, jealousy, and other negative by-products of social life that could cause disease and death if left unattended. The Iroquois False Face Society also conducted a ritual purification of the community, performed during the spring and fall equinoxes, to remove the pollution of sickness and death that had accumulated. False Face members also cured the sick. Disease was not thought of as a medical problem, but, rather, a symptom of spiritual imbalance whose equilibrium required restoration. The Midewiwin society of the Great Lakes peoples, for example, was primarily an organization of healers, "priests" (or "Mide"), trained in the arts of curing the sick through the use of spiritual power.

Spiritual power accessible to human beings also possessed the potential for danger and evil. Those individuals who manipulated power for socially unproductive ends, to inflict disease and death on rivals, to coerce affection from the opposite sex or to benefit from others' misfortunes, were considered witches from whom the Midewiwin and other healing societies provided a measure of protection.

The Green Corn ceremony and the False Face and Midewiwin societies were, in a sense, "spiritual technologies" that used their knowledge of the spirit world to help preserve the health and well-being of human society. Ultimately, the ceremonies that signified the alliance between the spiritual and physical worlds were gifts of the Creator. Intermediary spirit beings, like the "Great World Rim Dweller" of the False Face Society, or Otter of the Midewiwin, brought these gifts to mankind and taught them how to use them. For example, a being known to the Delaware as "The Great Stone Face" appeared to two young Delaware men when they were hunting and taught them the "Big House Ceremony," which became the Delaware ritual of annual renewal.

Native tradition holds that any encounter between human and spirit beings may involve a gift of power, if the human is ready and worthy to receive it. Those who sought this power embarked on a "vision quest," a four-day fast in isolation, away from the community, during which a man prayed for blessings. If his supplications were successful, a spirit being would appear in a dream or a vision and offer instruction about how to assemble powerfully charged materials in a "sacred bundle" and use these things in combination with songs and prayers to heal the sick or injured, or to insure protection in war and success in hunting. Some bundles were considered so powerful that they were passed down through generations of family members and became "clan bundles" whose spiritual power benefitted the entire clan. Others might be sold or exchanged for payment. Bundles often consisted of objects collected from many different spiritual encounters, each element of the bundle serving a slightly different purpose. Spiritual knowledge was privileged information, accessible only to those who were taught to possess the objects and enact the rituals properly. This knowledge in the wrong hands could be dangerous. Secrecy surrounding issues of spirituality was, therefore, extremely important and protected it from impurity and inappropriate use.

Religious objects were, and still are, central to the spiritual life of the American Indian and, like the sacred knowledge itself, these works of art are often purposefully ambiguous. Through the use of metaphor and esoteric symbolism, many religious objects reveal their secrets only to those who have acquired the ability to interpret them through religious teaching, while shielding their meanings from those without the right to know. There is much we do not know about interpreting American Indian sacred art, but that is because we are not supposed to know.

ART AND GENDER ROLES

In Eastern Woodland societies, as in most traditional societies, there existed a fundamental distinction between the social roles of men and women. Community responsibilities were divided, with men and women performing separate tasks that often complemented one another. In the Eastern Woodlands, men cleared land for agriculture; women often tended the fields. Men hunted wild game and went to war. Women harvested food plants and processed game for use as food, clothing, and other necessary items. When it came to making objects for practical or religious use, men and women made things for different and often separate purposes employing very different means of visual expression and symbolism. Therefore, when speaking of American Indian art, it is possible to talk of men's art on the one hand, women's art on the other.

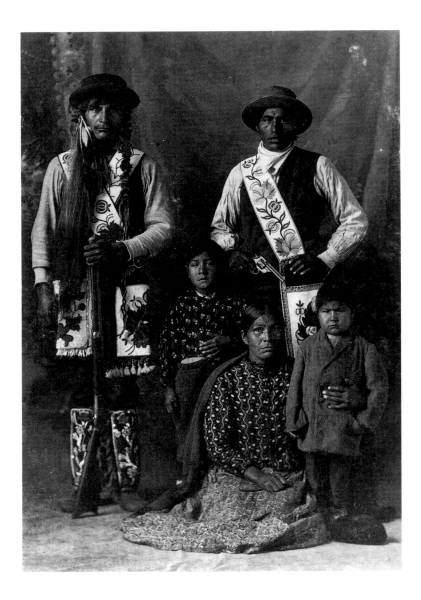

This David F. Barry photograph of the 1890s shows a Minnesota Ojibwa family group in formal dress. Note the shoulder bags decorated with floral-style, glass bead appliqué worn by the men.

David Penney Collection.

Men worked with stone, bone, and wood to create objects that reflected their areas of concern: hunting, warfare, health and well-being, and the spiritual support for these kinds of endeavors. Their art often represented a personal experience or expressed some aspect of their identity. Men's visual language was representational, although often spare and reductive in form, and was tied closely to the function of conveying specific kinds of information or ideas. Its symbolic content referred to the life experiences of men, or with men's relationships to the spirit world, which, for these deeply religious people, were inextricably linked. The image of an animal carved on the handle of a wooden spoon, for example, might refer to the owner's source of spiritual power. Engraved symbols on weapons represented spiritual protectors or stood for enemies killed in battle, and painted or engraved pictographs on trees or cliff faces visible from trails publicized a warrior's accomplishments. Symbols were engraved on "song boards" or "prayer sticks," which functioned as mnemonic devices to insure the proper recitation of prayer for the efficacy of ritual.

Women made pottery, fashioned simple and decorative clothing, and practiced several kinds of textile arts and basketry. Women's art tended to be nonrepresentational, less tied to the concrete than men's, and more broad ranging in its philosophical implications. While the designs woven into textiles may have referenced powerful spiritual images, like the Thunderbird and Underwater Panther, these images rarely referred to an individual's personal relationship with the spirit being. According to tradition, Sky and Underworld creatures were antithetical and opposed; they were

often thought to fight one another in perpetual conflict. Together they personified the opposing spiritual realms of the Sky and the Underworld that hold the earth between them. The metaphor of Thunderbird and Underwater Panther, Sky and Underworld, refers to a broad-based philosophical view held by many native peoples of North America: the reconciliation of polar opposites, or more simply put, harmony and balance. This concept often informed the composition of women's decorative art of the Eastern Woodlands. Eighteenth-century pouches, bags, and clothing accessories combined images or symbols of Underwater Panthers and Thunderbirds as metaphors for balance and reconciliation of these potentially dangerous powers.

These broad philosophical ideas about profound and deeply felt cultural values were also revealed through the many less representational designs developed by nineteenth-century women that often employed radial symmetry, like pinwheels, the equal-arm cross, or X's, all of which connote the number four. The number four symbolized the four sacred directions of the terrestrial earth. Women often split these designs in half with asymmetrical shifts in color, the color patterns further signifying the reconciliation of opposing forces.

It is often said that the fur trade transformed native economies of the Eastern Woodlands, beginning a process of acculturation and dependency upon European goods and technologies. In fact, the increased availability of trade goods only enhanced the lives of the native peoples, since their use of European-made materials

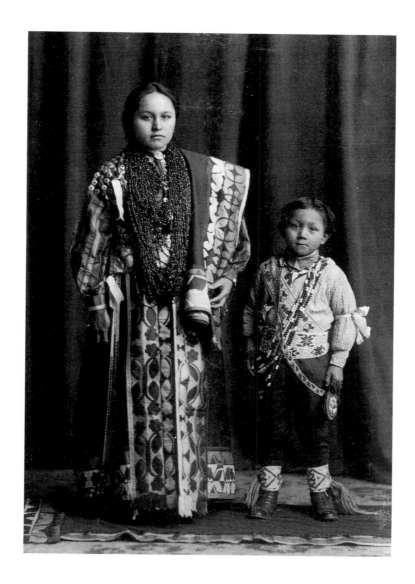

This cabinet card print of a Potawatomi girl and boy was produced by a small, commercial studio at Mayetta, Kansas, probably during the last decade of the nineteenth century. The young girl and boy are dressed in their finest regalia.

Courtesy Richard A. Pohrt.

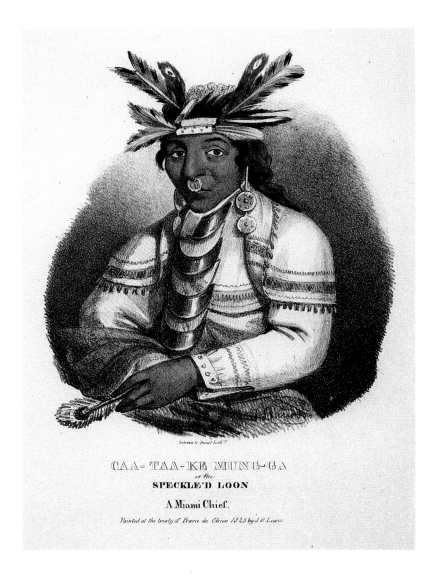

CAA - TAA - KE MUN-G-GA
or the
SPECKLE'D LOON
A Miami Chief.
Painted at the treaty of Prarie du Chien 1825 by J.O.Lewis.

did not interfere with traditionally held values. Many of the goods native partners received in trade made life easier: iron blades and axes, brass kettles, and guns.

By the nineteenth century, however, the greater part of trade goods sought by Indian people were those materials that could be transformed into dress and ornament: wool and cotton cloth, silk ribbon, glass beads, silver ornaments, and other such items. Successful native hunters and "captains of the trade" distributed these materials to family relations and other community members in accordance with their long-held belief that such gestures signified their authority and esteem. It was often said that the "chiefs" or social leaders were the poorest in the community because they had given all they had away. Women, using a variety of needlework techniques, transformed these European products into exquisite expressions of their own cultural values. Formal dress, or "regalia" as it is called by many Indian people today, honored both those who wore it and those who participated in certain events and social occasions. For the people of the Eastern Woodlands, wealth meant the gathering, distribution, and display of regalia worn by community members during formal and ritual events.

The availability of new materials and new techniques during the early nineteenth century stimulated a period of unprecedented innovation and creativity in women's textile arts. By adapting a variety of different weaving techniques using small glass beads with the heddle and box loom, women designed garters, shoulder bags, shirt bibs, and sashes with startling new complexity and color. Using scissors, cotton

thread, and paper patterns, women developed complex patterns of silk ribbon appliqué to decorate leggings, moccasins, skirts, and shawls. Native women improvised on the designs they saw on printed cotton fabrics and the embroidery patterns taught by nuns in mission schools by using the techniques of glass bead embroidery and bead weaving to create works of singular beauty and intricacy.

Indian clothing represented, in the estimation of missionaries, government agents, and hostile neighbors, primitive ways and a resistance to progress. The pressure to adopt outside values and customs was summed up in the familiar epithet, "give up the blanket." After the development of the reservation system during the late nineteenth century, many Indians were encouraged to forget their cultural traditions and become more like white people. Amidst an increasingly threatening social environment of coercion, violence, displacement, conversion, and discrimination, nineteenth-century women of the Eastern Woodlands continued to renew the culture of each generation using the traditional arts of needlework and dress. Although everyday clothing changed, regalia and the special occasions when it was worn—social dances, religious ceremonies, and other formal events—continued as a means to retain the solidarity of cultural identity. Here, in a very real sense, art insured cultural survival.

The modern powwow is an outgrowth of the traditional relationship that unites song, dance, and regalia in a celebration of ancient values. Today's Native Americans are surrounded by a cultural environment alien to their traditional values, and the powwow is the time and place to remember and celebrate the legacy of tribal traditions and the promise of new generations for the future. The songs, dances, and regalia have changed with the passage of time because living culture constantly renews itself. But, like oral tradition, the powwow and its arts of regalia "never relinquish [their] connection to the past."

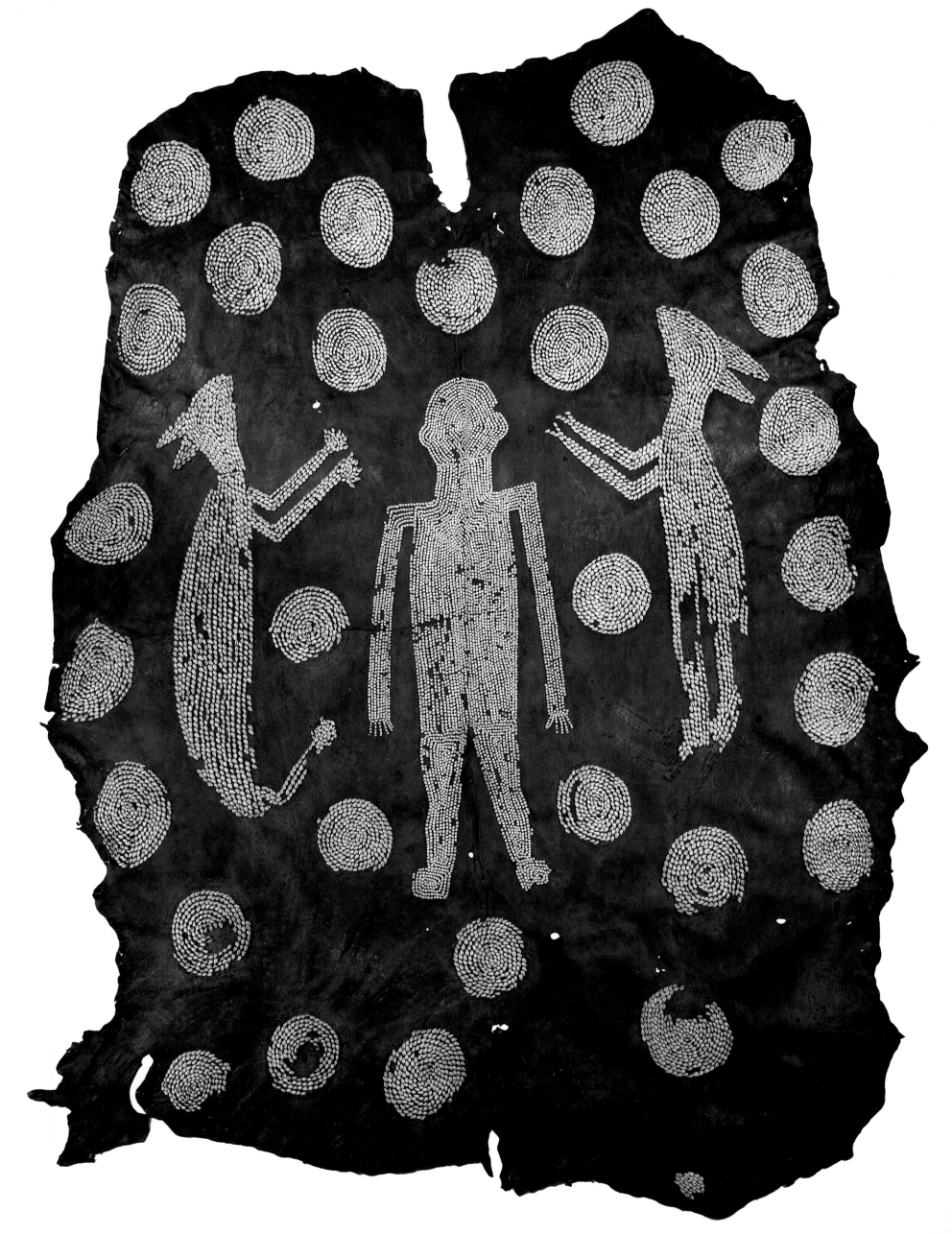

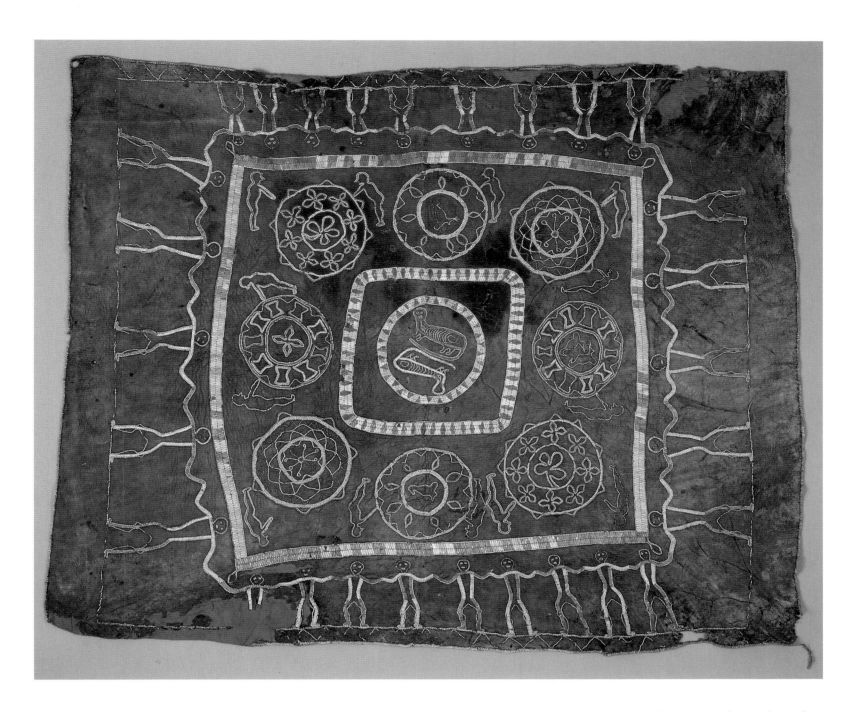

OPPOSITE: *Powhatan's Mantle.* Powhatan chiefdom. Collected in Virginia before 1638. Deer hide, *marginella* shell. Length: 83⅞ in. Ashmolean Museum, Oxford, England.

Although this "robe" does not resemble any garment, it has been referred to customarily as "Powhatan's mantle." It was probably part of the temple treasure of the Powhatan chiefdom first encountered by the colonists of Jamestown, Virginia, in 1607. At that time the sixty-year-old chief Powhatan ruled a territory of some 8,500 square miles along the Virginia and North Carolina coastal plain. Powhatan's daughter, Pocahontas, holds a permanent place in American history and folklore as the diplomatic intermediary between Powhatan and the fledgling Jamestown colony.

ABOVE: *Mat or Wrapper.* Ottawa (?). Late eighteenth–early nineteenth century. Michigan. Deerskin, porcupine quills. Width: 33 in. National Museum of the American Indian, Smithsonian Institution, New York.

This square of blackened deerskin decorated with a perplexing scheme of designs and images has puzzled scholars for a long time. Early collection notes suggest that it "covered an idol," which probably means that it functioned as the wrapper for a sacred bundle. The outer coverings of such bundles were often made of deerskin and painted or embroidered on the inside with sacred images. When the bundle was opened to release the powers kept within, the wrapper served as a mat upon which the sacred objects were arranged. A pair of Underwater Panthers are at the center of the design and are surrounded radially by cosmological symbols (fragments of Thunderbirds, equal-armed crosses, and chain-link "otter tail" patterns). Human figures joined hand-in-hand and arranged around the outer margin frame the composition.

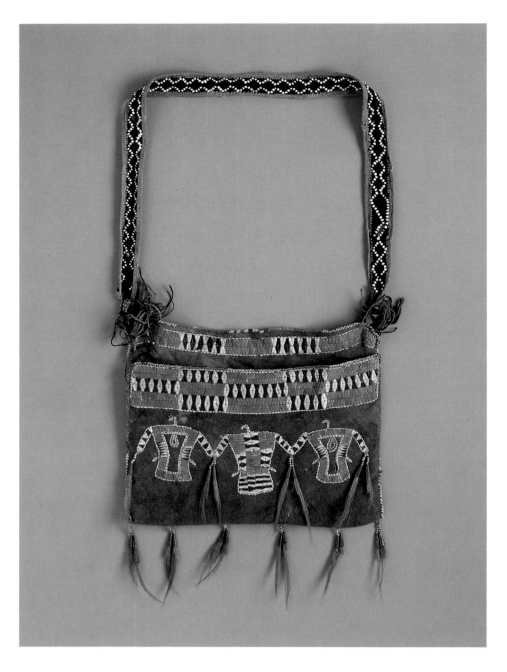

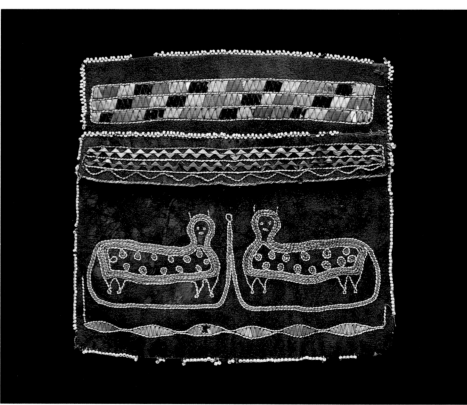

TOP LEFT: *Pouch with Strap.* Eastern Ojibwa or Ottawa. Late eighteenth century. Eastern Great Lakes region. Blackened deerskin, wool, porcupine quills, glass beads, tin cones, deer hair. Width: 11¼ in. The Masco Art Collection.

This fairly large pouch featuring three images of Thunderbirds is made with deerskin and decorated with bands of porcupine quill embroidery. The porcupine quills are dyed, flattened, and stitched to the surfaces of the hide, either folded back and forth to fill in areas of color or wrapped around a piece of sinew to create thin, linear elements. The pendants hanging off the Thunderbirds' wings and the bottom of the pouch consist of tin curled into a cone shape around a narrow bunch of red-dyed deer hair, often taken from the tail or neck of the animal. The strap is made of braided wool with glass beads strung at intervals, braided to make the distinctive zig-zag patterns. The edges of the strap have been bleached to create a different color to border the strap patterning.

BOTTOM LEFT: *Pouch.* Ottawa. Late eighteenth or early nineteenth century. Cross Village area, Emmet County, Michigan. Blackened deerskin, porcupine quills, glass beads. Width: 6⅞ in. Cranbrook Institute of Science, Bloomfield Hills, Michigan.

This small bag is missing its strap. The design is created with porcupine quill embroidery against deerskin darkened with dyes probably made from the hulls of black walnuts. The bag is edged with white glass beads. The images of two Underwater Panthers are the focus of the design. These beings are monstrous, mythic creatures who live on the bottoms of lakes and rivers, and whose long, serpentine tails whip up storms and tempests.

OPPOSITE: *Cradle Board.* Sioux. c. 1830. Probably near Falls of St. Anthony, upper Mississippi River. Wooden blackboard, buffalo (?) skin, porcupine quills. Length: 31 in.; width: 17½ in. National Museum of Natural History, Smithsonian Institution, Washington, D.C. Gift of Mrs. Sarah Harrison.

George Catlin—explorer, artist, and author— acquired this cradle during his travels among the North American Indians between 1832 and 1839. According to Catlin's notes, the cradle "was purchased from a Sioux woman . . . as she was carrying her infant in it."

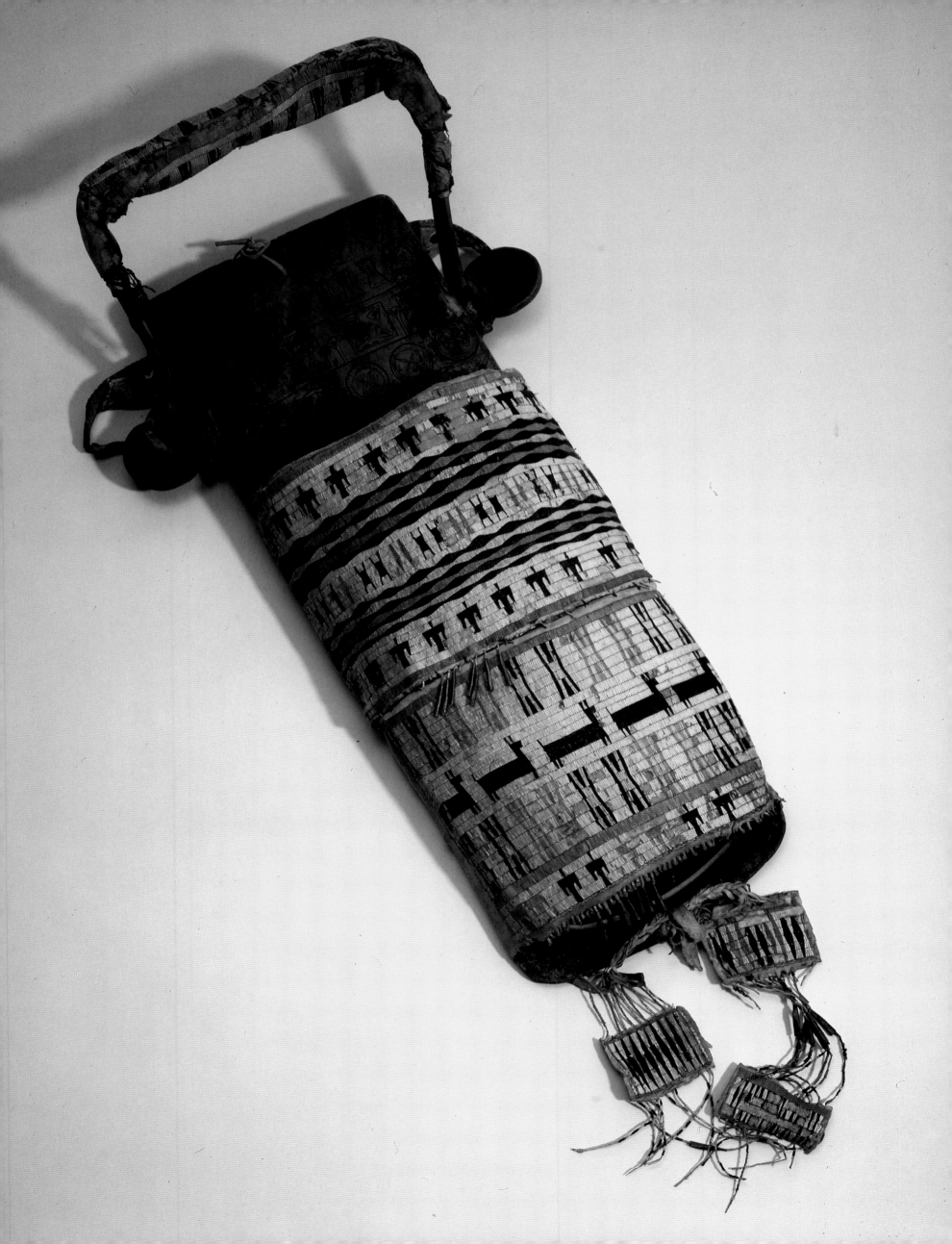

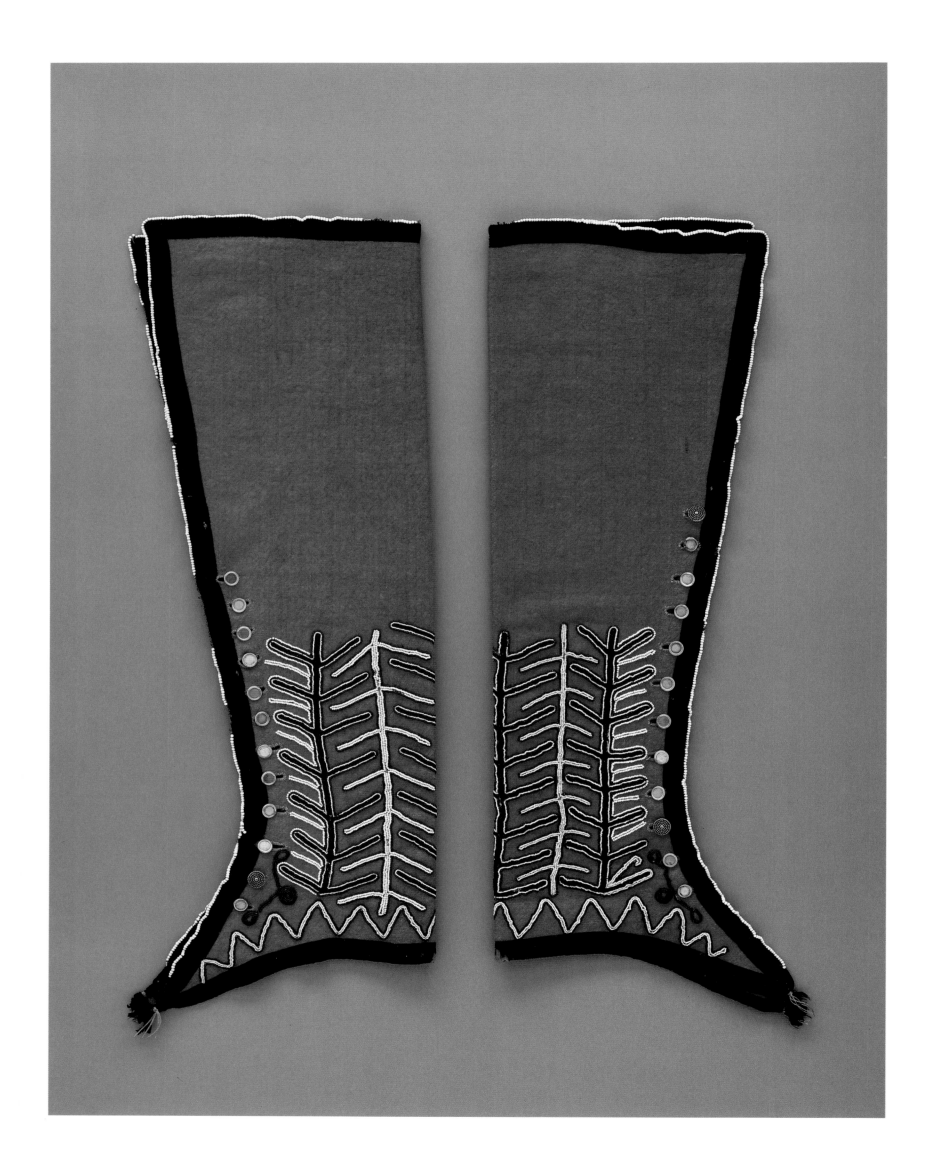

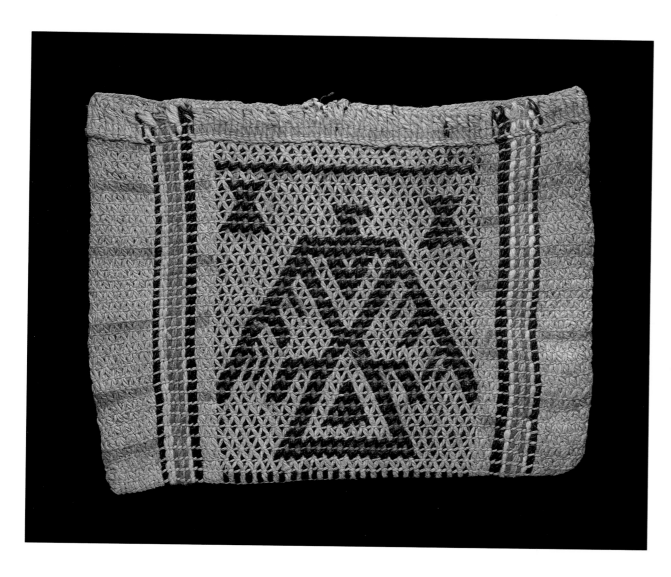

This twined bag at one time held personal spiritual objects that were among the private possessions of its owner. It is made with an ingenious twining technique with two colors of yarn for the warps, or vertical elements, one a brown cotton cord and the other, dark wool. The warps alternate as the dominant color on the outer surface while the other color remains hidden beneath. One side of the bag is decorated with images of Thunderbirds, the other with images of two Underwater Panthers. The design symbolizes the Ottawa conception of the cosmos, the Sky above and the Underworld below the earth.

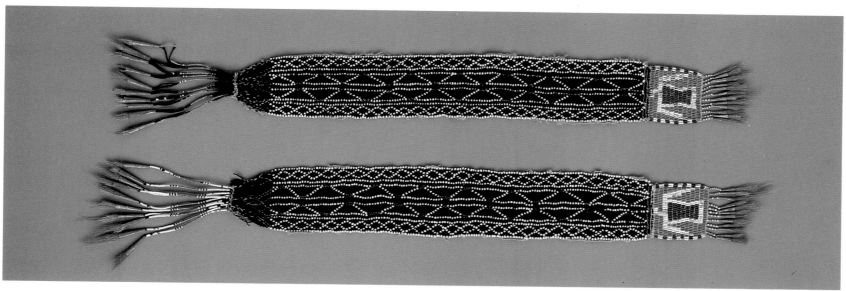

These red cloth man's leggings would have been worn with a breechcloth and a long, loose cotton shirt so that the beaded designs were visible. The zig-zag and linear elements in contrasting white and black beads characterize the so-called Seminole style of the early nineteenth century. The Seminole are Creek and other Muskhogean speakers who resisted removal from their homelands in the Southeast during the 1830s and 1840s by moving into Florida.

Garters like these were made with a braiding technique using wool yarn and glass beads, but the tabs on the ends display "netted" quillwork in which dyed porcupine quills were wrapped around alternating pairs of a deerskin fringe. The resulting pattern creates the image of a Thunderbird whose hourglass form echoes the hourglass shapes created by the white glass beads of the finger-woven garters.

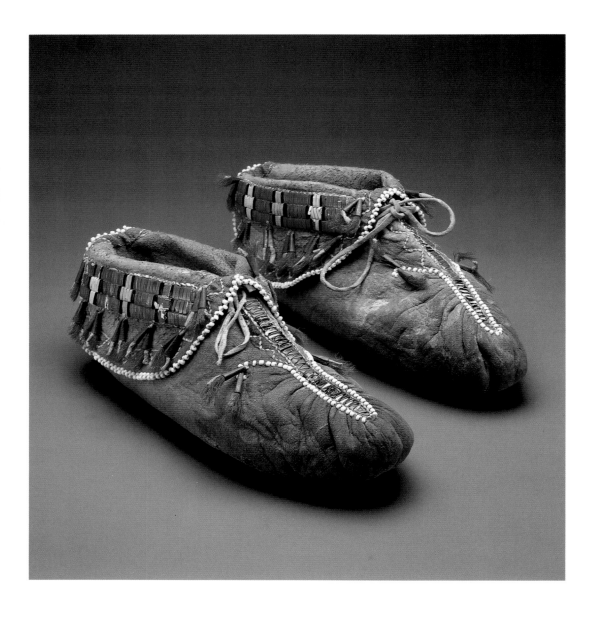

LEFT: *Moccasins.* Eastern Ojibwa (?). Late eighteenth century. Eastern Great Lakes region, Michigan, or southeastern Ontario. Deerskin, porcupine quills, birch bark, glass beads, tin cones, deer hair. The Masco Art Collection.

Each of these moccasins was made with a single piece of deerskin. A seam runs up the heel and the toe, "puckering" the toe to join both sides together. Porcupine quill ornament decorates the seam and cuffs. Beaded linear elements curve outward from the vamps and terminate with tin cone and red-dyed deer hair pendants that dangle on either side.

BELOW: *Moccasins with Ribbon Appliqué Cuffs.* Potawatomi. 1840–1860. Mayetta, Kansas. Deerskin, silk ribbon, glass beads. Length: 11½ in. The Field Museum of Natural History, Chicago.

The cuffs on each of these moccasins have asymmetrical designs—until the moccasins are worn together, when symmetry is restored. Lengths of four or more delicate silk ribbons of contrasting colors are sewn together along one edge, and then cut and folded to create patterns.

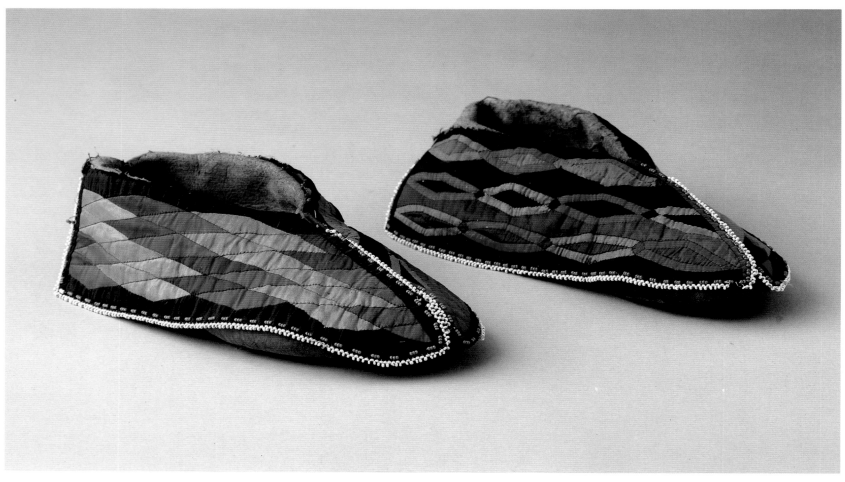

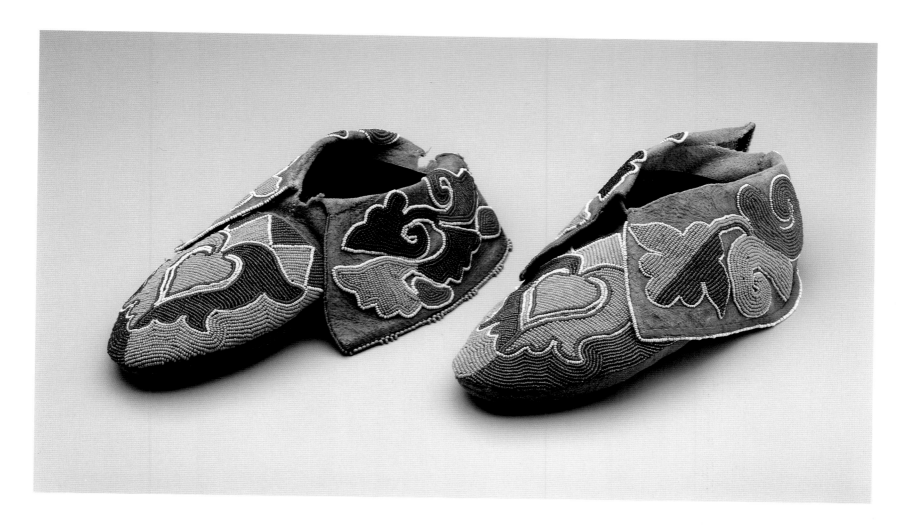

ABOVE: *Moccasins.* Iowa. c. 1860. Nebraska. Deerskin, buffalo hide, glass beads. Length: 10½ in. The Detroit Institute of Arts.

When peoples of the Woodlands region were removed to reservations in Kansas, Nebraska, and Oklahoma, they came into close contact with the tribes that already inhabited the region. Part of a resulting cultural synthesis was the "prairie style" of glass bead embroidery, characterized by bright and lively color contrasts and abstract floral elements. This style became equally popular among both emigrant and indigenous tribes of the prairie region.

RIGHT: *Moccasins.* Cherokee. Early nineteenth century. Georgia or Oklahoma. Deerskin, glass and metallic beads, silk ribbon. Length: 9¾ in. The Masco Art Collection.

Like many other Creek and Seminole designs, the linear elements of the design on these moccasins are created with multiple colors creating strong contrasts. An active, almost vibrating pattern results. When most of the Cherokee were forced to leave Georgia as a result of the Indian Removal Act of 1830, they brought this aesthetic to Indian territory in Oklahoma, where it became an integral element in the "prairie style."

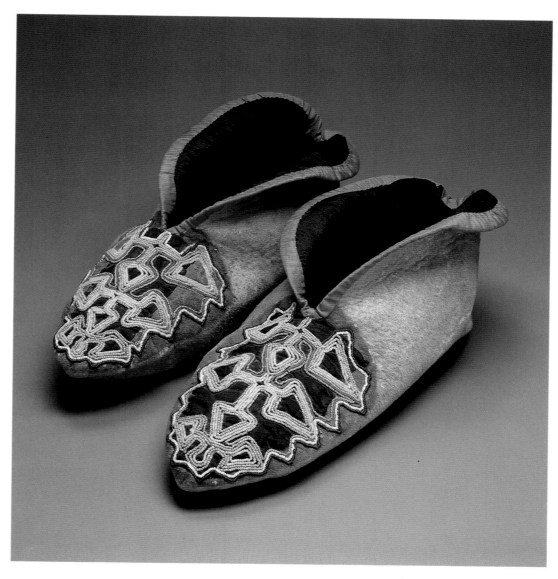

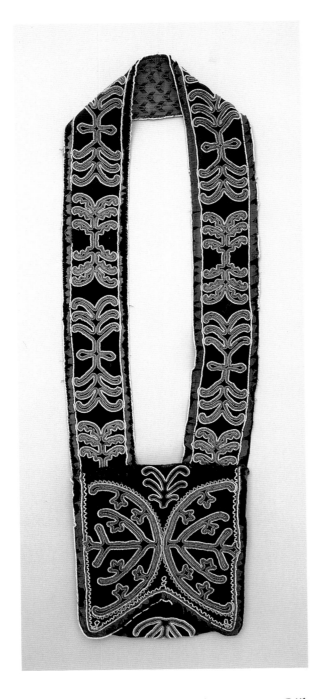

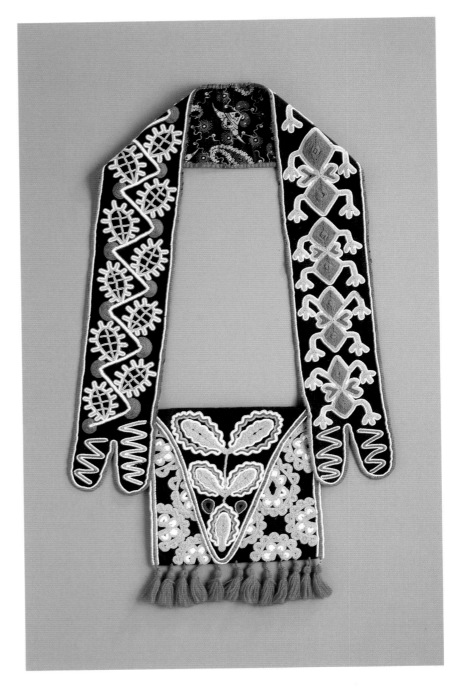

Shoulder Bag with Bead Embroidery. Eastern Ojibwa. c. 1830. Walpole Island, Ontario. Wool and cotton fabric, glass beads, cotton thread. Length: 29 in. Cranbrook Institute of Science, Bloomfield Hills, Michigan.

This rare and early style of Eastern Ojibwa shoulder bag was made with a double pointed flap that hangs over the opening, and was decorated with a curvilinear style of glass bead embroidery. Bags like this were not intended to function as practical pouches but were worn as part of a formal dress ensemble with other, highly decorated garments. The design employs a number of nested "double curve" motifs, an ancient design element that is visible in prehistoric art of the Eastern Woodlands. The construction and decoration of this shoulder bag relates closely to those produced by people of the Southeast, like the Creek and Cherokee, prior to their exile to Oklahoma during the 1830s.

Shoulder Bag. Creek. Early nineteenth century. Western Georgia or Alabama. Wool and cotton fabric, glass beads. Length: 28 in. The Masco Art Collection.

Creek and other Muskhogean tribes wore ornamental "bandolier bags," named for the broad "bandolier" strap that is worn diagonally across the shoulder. Creek shoulder bags are distinguished by the large triangular flap that covers the opening and by the vibrant, active bead embroidery.

OPPOSITE: *Shoulder Bag.* Delaware c. 1850. Kansas. Wool and cotton fabric, glass beads, silk ribbon. Length: 23 in. The Detroit Institute of Arts.

By the time this shoulder bag was made, Delaware women had synthesized their complex history of movement and relations with other tribal peoples using a distinctive and innovative style of beadwork embroidery. The combination of hot colors and dense patterning of abstract floral elements initiated the "prairie style" of beadwork decoration that became popular among many of the reservation tribes in Iowa, Kansas, and Oklahoma.

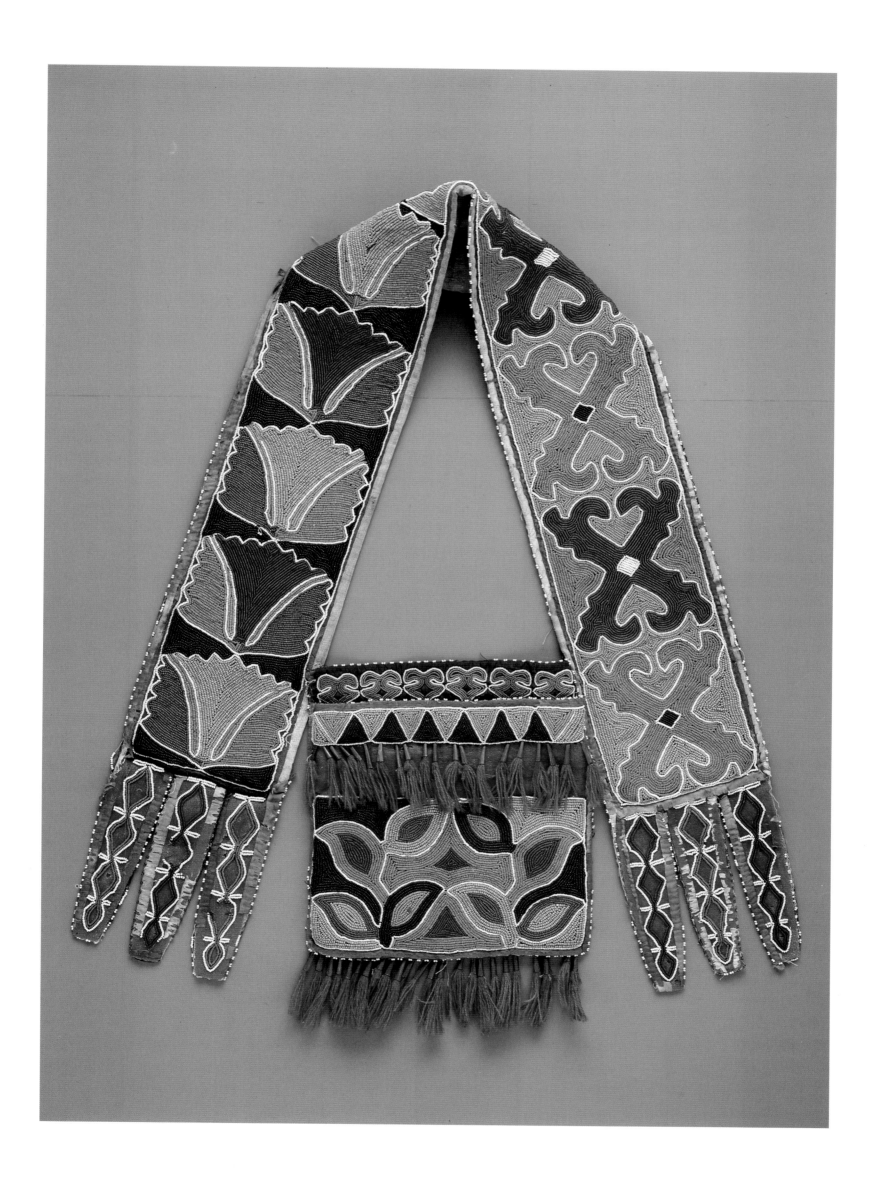

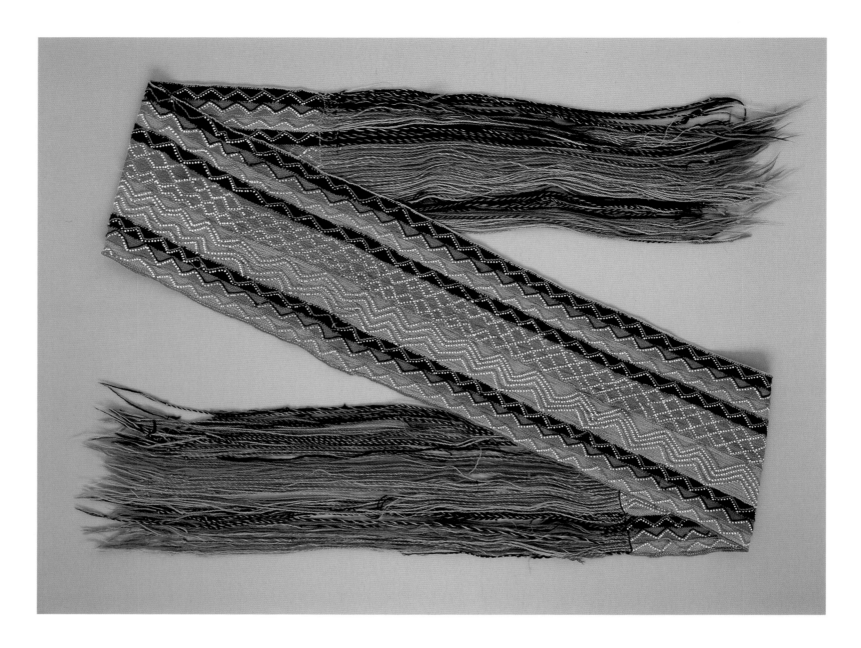

ABOVE: *Finger-Woven Sash.* Ottawa. Early nineteenth century. Cross Village area, Emmet County, Michigan. Wool yarn, glass beads. Length: 84¼ in. The Detroit Institute of Arts.

This large and impressive sash is made with a technique that does not require a loom, hence the generic term "finger weaving," a method of braiding known more technically as "oblique interlace." All of the elements in the weaving run diagonally across the fabric. Large, white glass beads strung on the yarn while weaving create chain-link and zig-zag patterns. A large sash like this was wrapped around the waist with ends hanging down the side, or was worn over one shoulder diagonally across the chest and secured with a belt.

OPPOSITE TOP: *Sash.* Osage. c. 1890. Oklahoma. Commercial wool yarn, glass beads. Length: 84⅛ in. The Detroit Institute of Arts.

The bright, vibrant colors of this finger-woven sash parallel the color preferences of "prairie style" beadwork and ribbonwork of the late nineteenth century. The lavender with hot crimson and green produces a shimmering intensity. White glass beads heighten the effect created by this range of color.

OPPOSITE BOTTOM: *Pair of Garters.* Ojibwa. c. 1850. Northern Michigan–northeastern Minnesota. Glass beads, cotton thread, wool yarn. Length: 31½ in. The Detroit Institute of Arts.

By 1850, Ojibwa women had begun to produce woven beadwork items using a box loom and a technique in which the weft passed through each row of beads twice, once above and once below the warp. The earliest practitioners of this kind of bead weaving seem to have been located in northern Michigan or northeastern Minnesota at the head of Lake Superior. These women used very small beads arranged in extremely intricate patterns, like those visible on these garters. Garters were tied around leggings just below the knee.

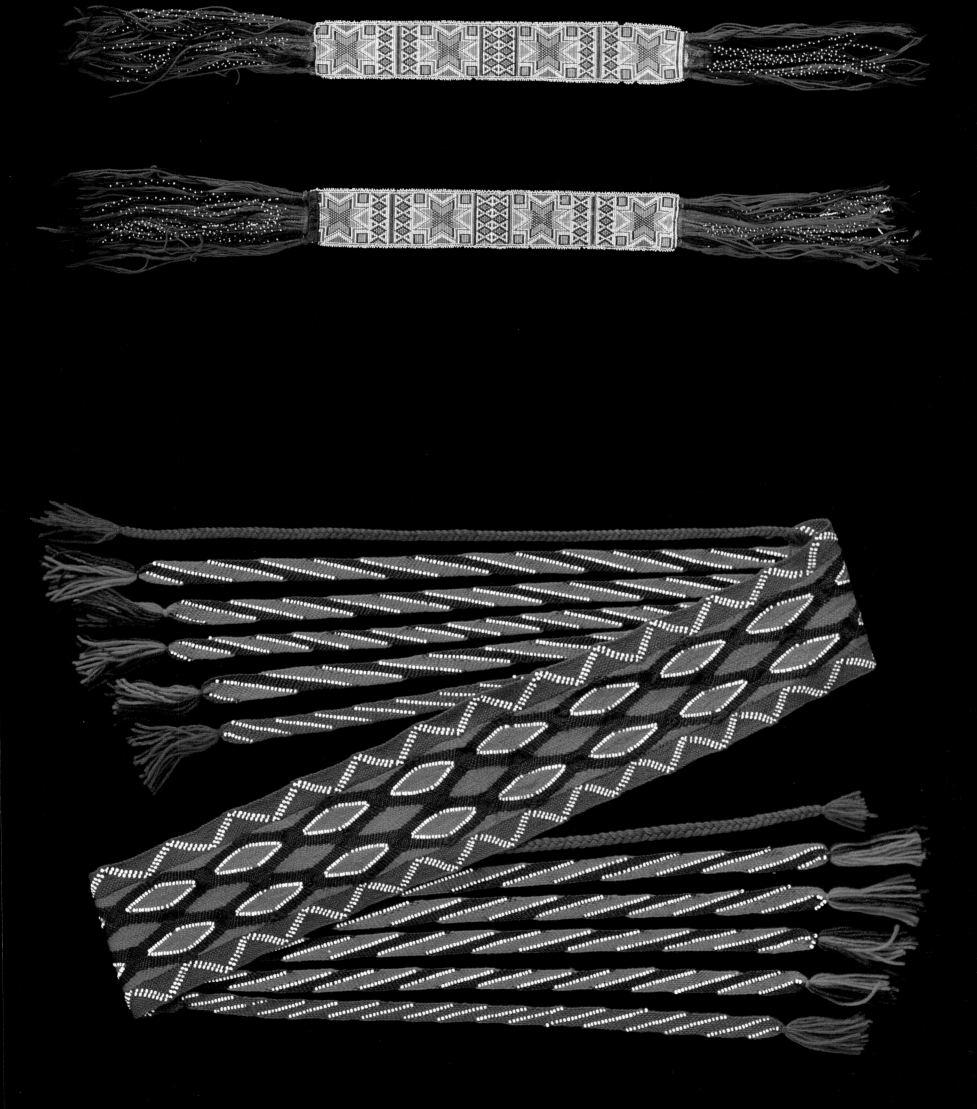

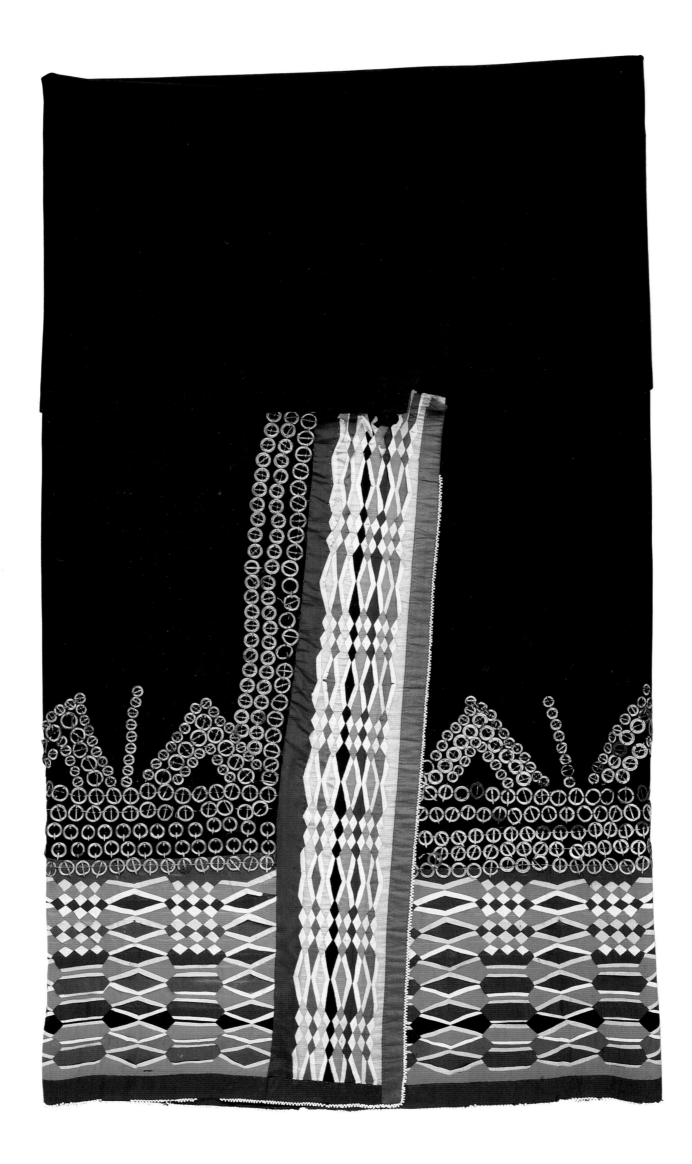

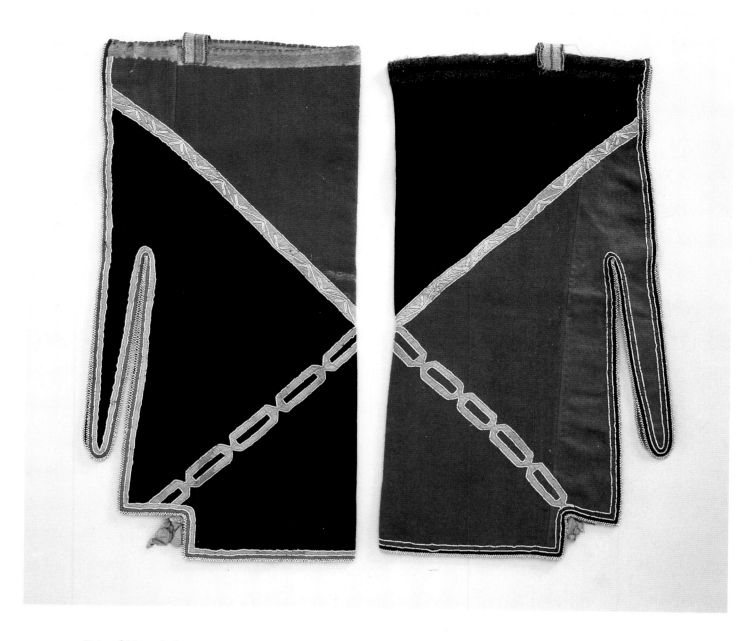

ABOVE: *Pair of Two-Color Leggings.* Ojibwa. Early nineteenth century. Michigan. Wool fabric, silk ribbon, glass beads, cotton thread. Length: 24½ in. The Detroit Institute of Arts.

Leggings made with red and blue cloth divided diagonally were popular among the Ojibwa people during the early and mid-nineteenth century. In most cases, both leggings of the pair had identical arrangements of blue or red on the top or bottom. This pair is unusual because the position of the red and blue elements alternates from top to bottom. The leggings are further enhanced with silk ribbon appliqué in a yellow chain-link pattern that runs diagonally, and pale blue stripes embroidered with a delicate pattern in white glass beads. Note also the silk ribbon edging and the way it changes colors when bordering either blue or red. These pervasive asymmetries of color relate to an aesthetic based upon a cosmological principle: the balance and harmonization of antithetical elements.

OPPOSITE: *Ribbonwork Skirt.* Miami. c. 1820. Peru, Indiana. Wool fabric, silk ribbon, cotton thread. Length: 55½ in. Cranbrook Institute of Science, Bloomfield Hills, Michigan.

This skirt is made from a simple oblong of dark blue wool cloth that a woman wrapped around her waist, tied with a belt, and folded so that the upper edge of the skirt hung down, as illustrated. The hem of the skirt and the vertical side edge left visible when the skirt was worn were decorated with elaborate patterns of silk ribbon appliqué. Miami women of Indiana excelled at this fastidious technique during the early nineteenth century. Lengths of silk ribbon were stitched together at the edges and then cut and folded to create the complex arrangements of diamond and triangle elements of many colors.

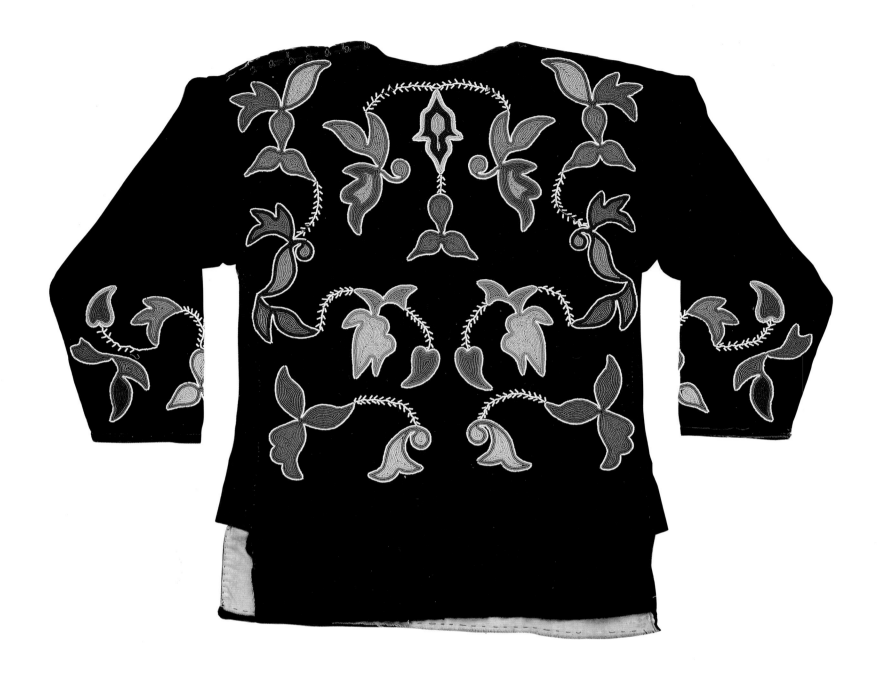

ABOVE: *Man's Shirt.* Winnebago. c. 1900. Wisconsin. Wool and cotton fabric, glass beads, cotton thread, brass shoe hooks. Height: 27⅛ in. The Detroit Institute of Arts.

Formal clothing of the Woodlands and prairie tribes of the late nineteenth century was elaborately decorated. Here, abstract floral designs spread across the shirt on the front and back. The heavy dark wool fabric offers a suitable support for the bead embroidery and provides a dramatic contrast for the brightly colored designs. The shirt was part of a formal clothing ensemble that would also include embroidered leggings, a breechcloth or apron, garters, one or more shoulder bags, sashes, and a turban or roach headdress. This was clothing reserved for special occasions such as social dances and religious ceremonies.

OPPOSITE: *Man's Leggings.* Ojibwa. c. 1900. Minnesota. Cotton velveteen, polished cotton, glass beads, wool twill. Length: 29⅜ in. The Detroit Institute of Arts.

These wool leggings are decorated with glass bead embroidery with floral designs. Serpentine stems twist through the pattern providing a support for leaves and blossoms. Missionary teachers taught the Ojibwa women of Minnesota floral embroidery at school using the patterns of European-style decorative arts. Women adapted these patterns for their own beadwork designs when creating leggings, shoulder bags, and other items of regalia for wear at dances and ceremonies.

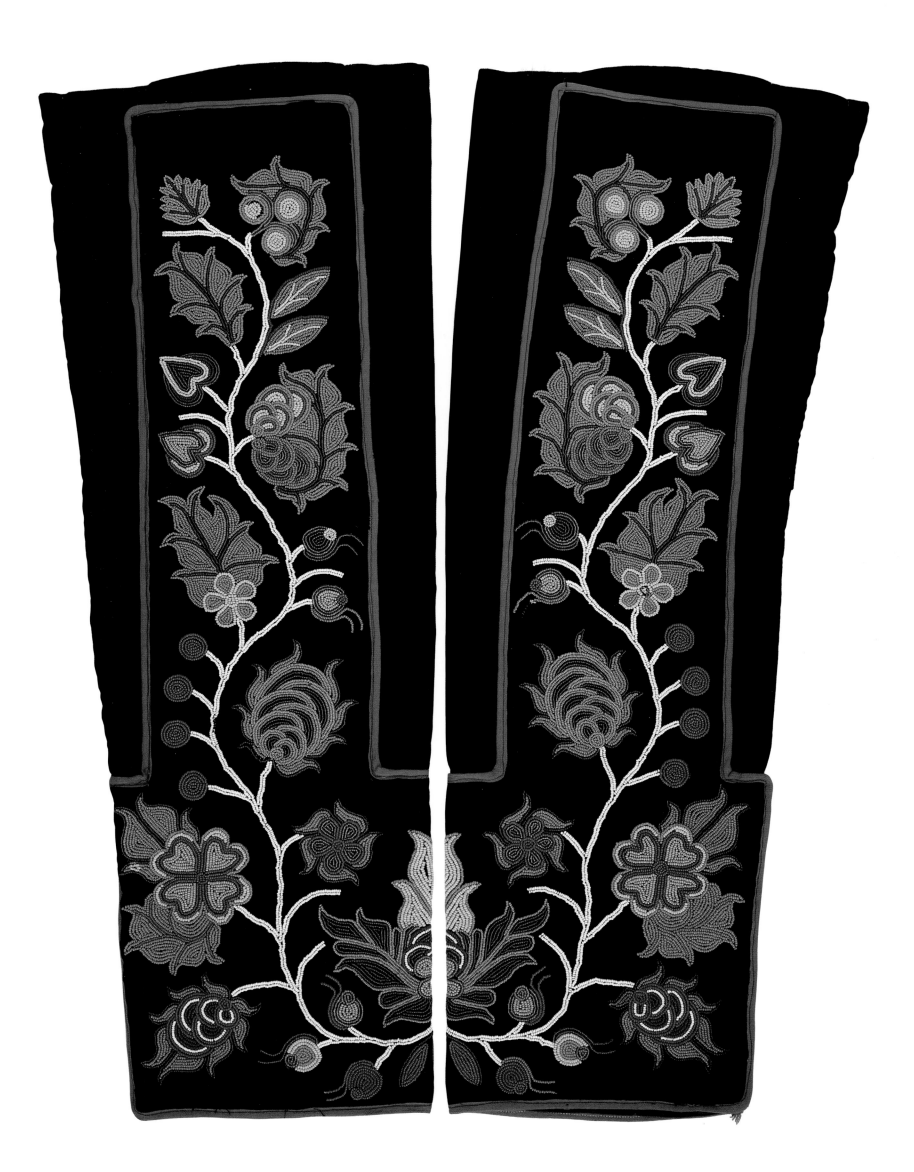

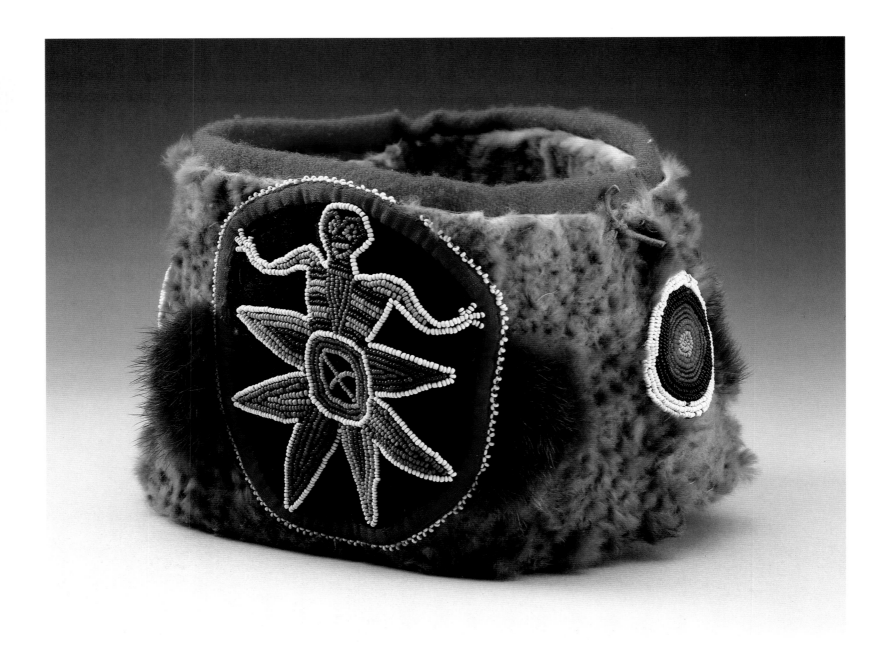

ABOVE: *Wabeno Turban*. Winnebago. Mid–nineteenth century. Nebraska. Otter fur, wool cloth, glass beads. Height: 8 in. National Museum of the American Indian, Smithsonian Institution, New York.

This fur turban belonged to John Hill ("Rock Standing Up"), a Winnebago who served in the military as a government scout. The fur is clipped save for patches like bear's ears that flank either side of the cloth medallion that is beaded with a "star dream" design. The design motif is associated with the religious teachings of the Wabeno, a group of powerful sorcerers who derived their powers from relationships with spirit helpers.

OPPOSITE: *Bear-Claw Necklace*. Mesquakie. c. 1860. Tama, Iowa. Grizzly bear claws, otter fur, glass beads, silk ribbon. Length (with pendant trailer): 49 in. The Detroit Institute of Arts.

A necklace made of grizzly bear claws was one of the preeminent symbols of manhood and accomplishment among the prairie tribes. Grizzly bears resided in the river valleys and prairies of the eastern Plains during the early nineteenth century, and their fore claws grew to great lengths in that environment. Men collected the claws for their necklaces, but only those with special, ceremonial prerogatives had the right to assemble them into a necklace, a skill for which those so privileged were well paid. Two whole otter skins were used: one to wrap the necklace and the other to hang in back as a pendant. The oblong beadwork panel of this bear-claw necklace exemplifies the vibrant qualities of the "prairie style" of glass bead embroidery.

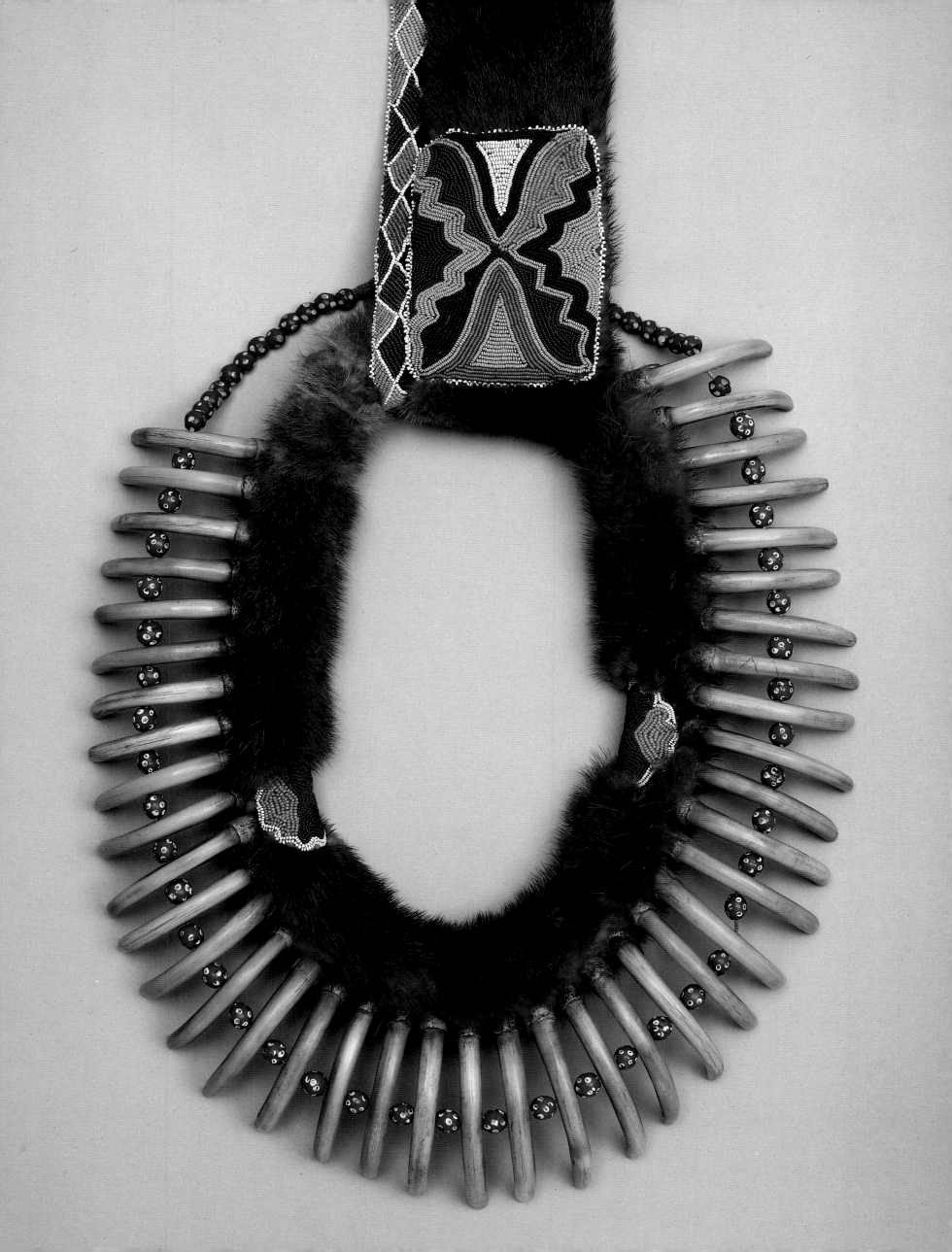

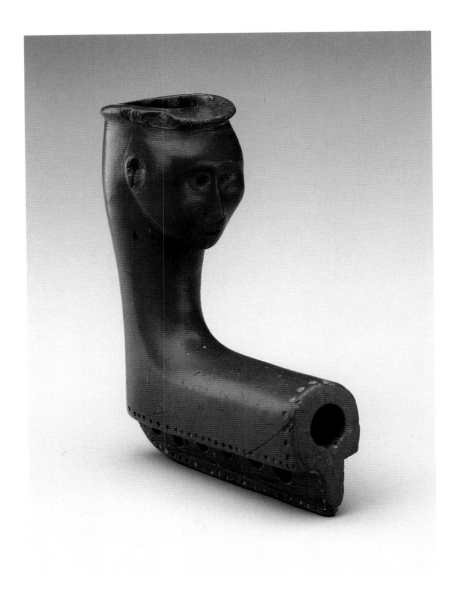

LEFT: *Pipe Bowl.* Miami. Eighteenth century. Indiana. Stone (catlinite). Height: 3⅛ in. The Detroit Institute of Arts.

The family traditions of this pipe bowl recount how it had once been part of a war bundle owned by a powerful warrior named Hard Strike. The contents of the bundle and its rituals protected Hard Strike and the members of his war party from their enemies and brought them strength in battle. The pipe bowl was carved from Minnesota pipestone and was smoked with the help of a wooden stem.

OPPOSITE TOP: *Trumpet Pipe.* Susquehannock (Conestoga). Seventeenth century. Marsh site, Ontario County, New York. Stone (steatite). Length: 8 in. The Gordon Hart Collection, Bluffton, Indiana.

The Marsh site was a community of Susquehannock, originally from the Chesapeake Bay area, who had chosen to live among the Iroquois of New York State during the 1670s. This stone pipe is made in the customary style of an Iroquois "trumpet pipe," its conical bowl and long tapering stem combined in one piece of stone, this particular example carved of southern steatite. The figure grasping the bowl in a gesture of offering is a familiar theme of southeastern pipes of the Late Mississippian period. The sculptural treatment confirms that tobacco is considered by Eastern Woodlands people to be a sacred substance given to Man by the Creator so that he would have something to offer to spirit beings in thanks for their blessings.

OPPOSITE BOTTOM: *Pipe Bowl and Stem.* Eastern Ojibwa. Late eighteenth or early nineteenth century. Michigan or southeastern Ontario. Stone (steatite) and wood (ash). The Detroit Institute of Arts.

Little is known about the cultural origins of this massive pipe bowl and stem. Four human faces are carved on the four sides of the bowl, a sacred number referring to the four cardinal directions, and the reductive forms of two birds sit on the shank portion of the bowl. Black pipestone, the material used here, was used by several pipe makers of the eastern Great Lakes. The stem is carved in a characteristic "twisted" pattern that cannot be accomplished by steaming and bending the wood. The sacred power of the tobacco smoke as it travels through the stem from the bowl to the smoker is rendered visible by the undulating line of the twisted stem.

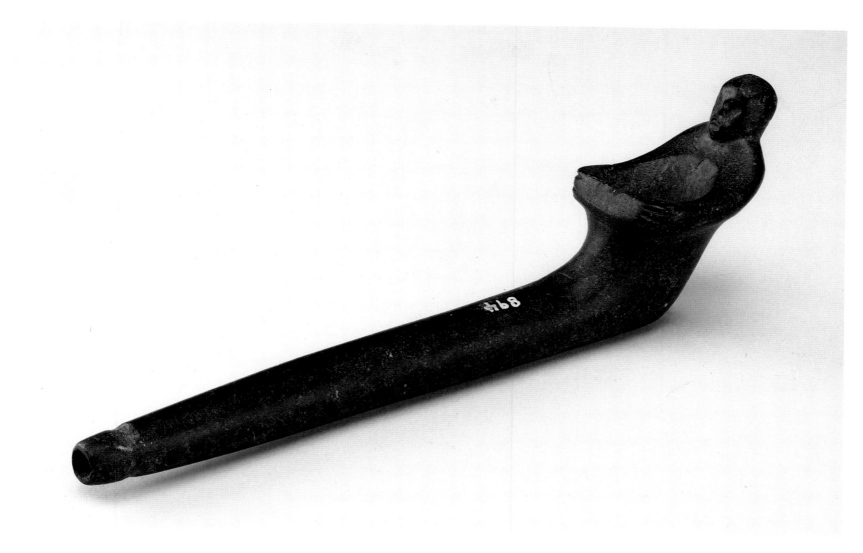

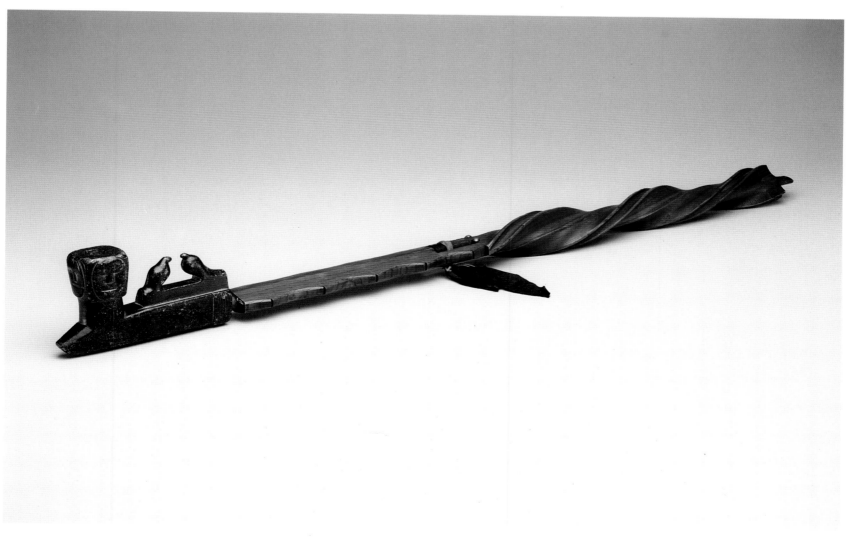

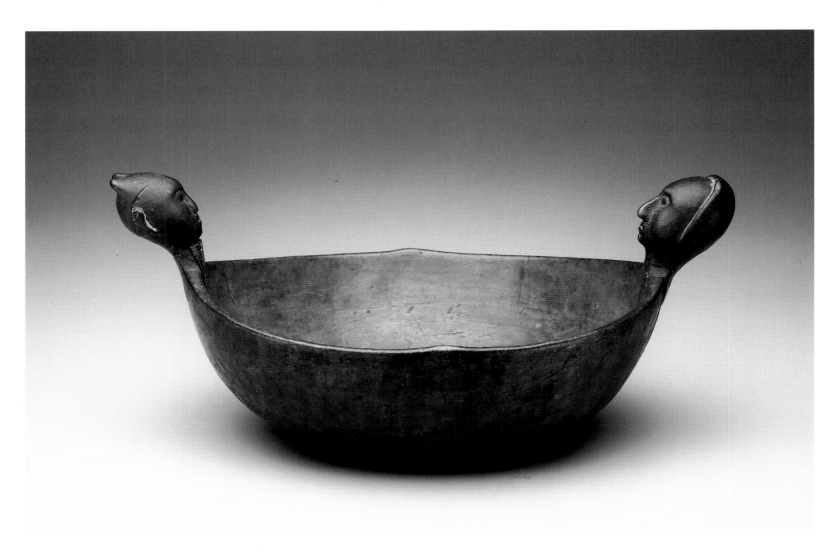

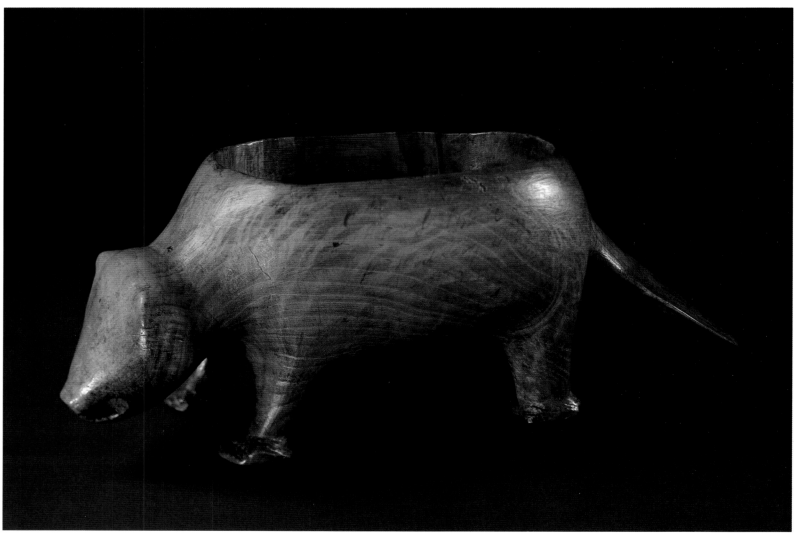

OPPOSITE TOP: *Feast Bowl*. Iroquois (?). Eighteenth century. New York State (?). Wood with metal repair. The Detroit Institute of Arts.

This extraordinary wooden bowl resembles a category of bowls, often attributed to the Iroquois, that have two human heads carved on the rims facing one another. Differences in the headdresses suggest a male with the short, stubby horns and a female who wears a hood. The unusually large heads are carved with great detail and expression, even to the depiction of the female's furrowed brow.

OPPOSITE BOTTOM: *Beaver Bowl*. Catalogued "Kaskaskia," but more likely Shawnee or Miami. Late eighteenth century. Northern Ohio region. Wood. Length: 15 in. Peabody Museum of Archaeology and Ethnology, Harvard University, Cambridge, Massachusetts.

This bowl carved in the form of a standing beaver is one of the great masterpieces of Woodlands Indian wood sculpture preserved from the eighteenth century. Its origins are unclear beyond the fact that it was collected at the signing of the Treaty of Greenville, near present-day Toledo, Ohio, in 1795. The large villages of the Ohio region included mixed groups of people from many different tribes, Shawnee and Miami the most numerous among them. Tribal identification of the carver, therefore, may not be possible.

BELOW: *Feast Bowl*. Eastern Ojibwa (?). Late eighteenth or early nineteenth century. Eastern Michigan or southeastern Ontario. Wood (maple). Length: 25½ in. The Detroit Institute of Arts.

This large feast bowl crafted as a beaver was collected by Alexander Harrow, a veteran of the British Navy who served during the War of 1812. After the war, he built an estate in eastern Michigan, just north of Detroit. The beaver was the pillar of the fur trade in Michigan, the source of wealth and well-being for all who participated in this form of exchange. Here, the beaver becomes, in a sense, the "father of the feast" when food is served from its body. Nearly all ritual and social events among Eastern Woodlands people included feasts sponsored by those who conducted the ceremony.

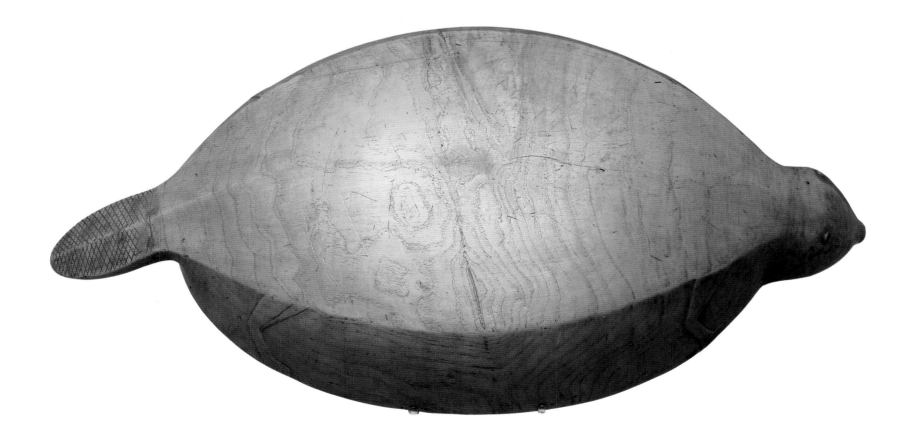

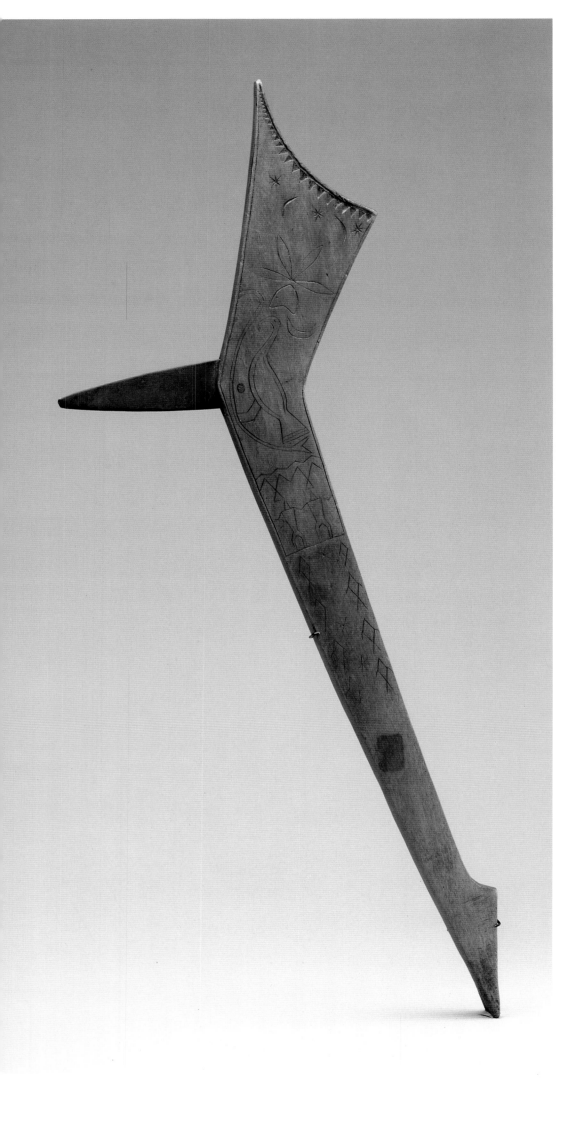

LEFT: *Gunstock Club.* Ojibwa. Early nineteenth century. Northern Peninsula, Michigan. Wood, iron. Length: 25 in. Collection of Richard and Marion Pohrt.

The engraved images on this "gunstock" club were interpreted by the owner for George Joann Kohl, who saw it while traveling in the Lake Superior region in the 1840s. As seen in a vision by the owner, there is an image of the Thunderbird sitting in its nest beneath the moon and stars. There are also figures of men whom the owner had killed. The club is shaped like a bolt of lightning symbolizing the Thunder powers that the owner wields in battle. The blade is made from a filed piece of an eighteenth-century mason's square.

BELOW: *Awl.* Ojibwa or Potawatomi. Nineteenth century. Walpole Island, southeastern Ontario. Deer antler, iron. Length: 5¾ in. The Detroit Institute of Arts.

The handle of this small leather-working tool is carved from a piece of elk antler. The image of the leg is shown ornamented with markings that may represent tatoos. Similar kinds of awls with carved handles and smaller points were used to punch holes for making birch-bark boxes embroidered with porcupine quills. The size of the iron point is the only factor that distinguishes one awl from another. Needles, filed pieces of iron, steel points, and a variety of other kinds of found and adapted metal might have been hafted to an antler handle for an awl.

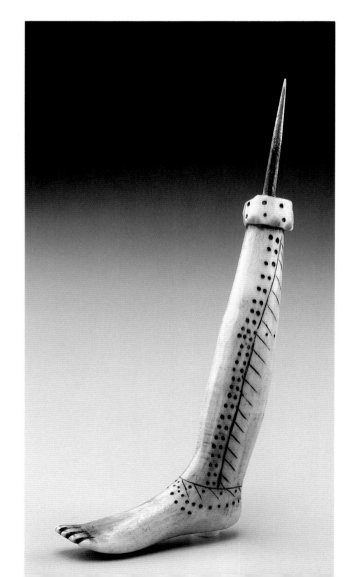

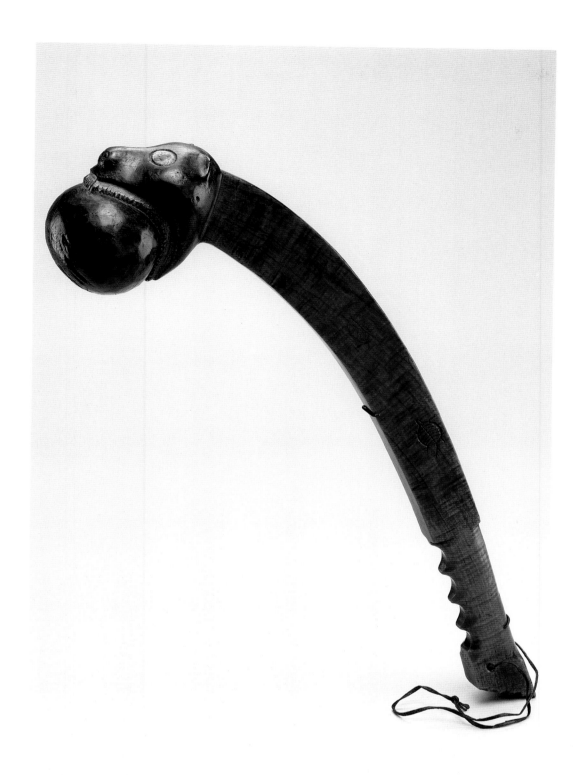

Ball-Head Club. Iroquois. Nineteenth century. New York State. Wood. Length: 19¾ in. Cranbrook Institute of Science, Bloomfield Hills, Michigan.

This war club is carved with the head of a monstrous creature who holds the spherical striking end of the club in its jaws. Such weapons were considered charged with spiritual power, and although made somewhat obsolete by firearms, their use by a warrior merited special honor and esteem. The ball-head form is related, conceptually, to powers derived from spirit beings of the watery Underworld. The image of a turtle is engraved on the shaft of this weapon.

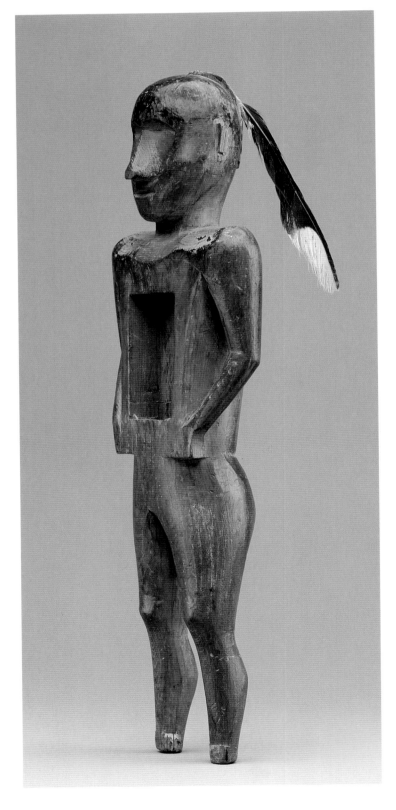

BELOW: *Figure.* Ojibwa. Early nineteenth century. Probably northern Michigan or Minnesota, Great Lakes region. Wood. The Thaw Collection, Fenimore House Museum, Cooperstown, New York.

Those initiated into the Ojibwa Midewiwin, a society of healers, demonstrated the powers derived from their study during meetings and initiations. A small figure like this, with special substances placed in the cavity located in its abdomen, could be made to move and dance.

ABOVE: *Charm Bag.* Mesquakie. c. 1880. Tama, Iowa. Wool yarn, cotton cord, glass beads. Width: 5⅜ in. The Detroit Institute of Arts.

This bag was made with a twining technique in which beads strung on double wefts substitute for the customary "twist" in the wefts. The red yarn warp is visible between each bead. Small bags like this contained personal charms or "medicines." Mesquakie men sometimes wore this kind of diminutive bag with a strap across the shoulder, although this bag does not have one. The beaded design represents the powerful Underwater Panther. Its composition, particularly the way the image is framed by two vertical bands, is reminiscent of twined bags of nettle fiber.

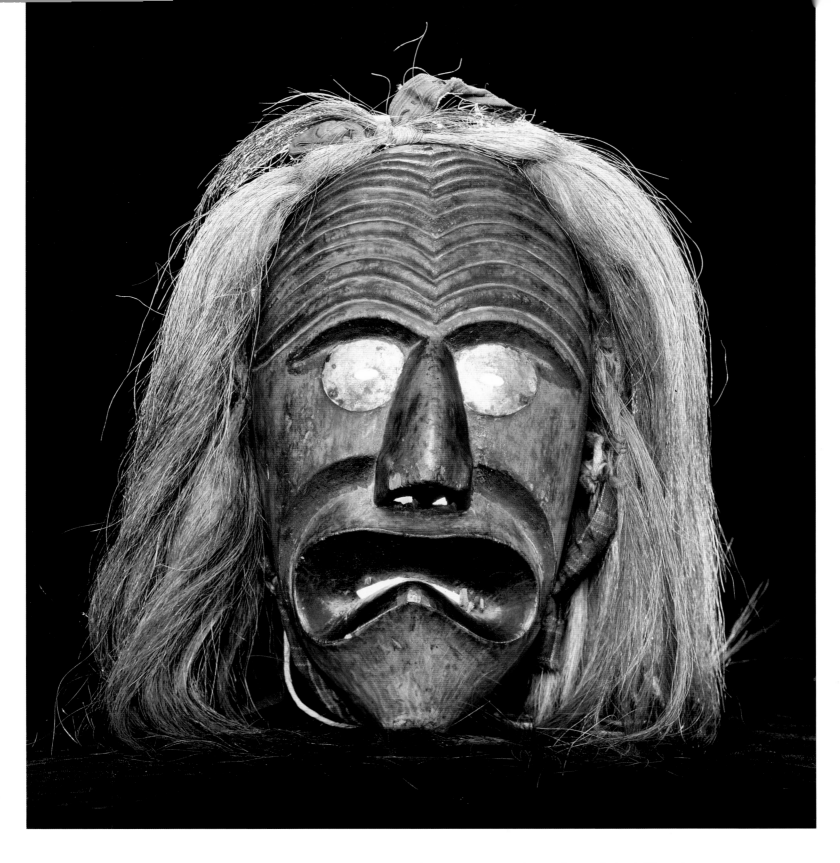

False Face Society Mask. Iroquois. Nineteenth century. Wood, tin, horse hair. Milwaukee Public Museum.

The Iroquois False Face Society was an association of healers. Their masks were living things that required care and nourishment, such as offerings of tobacco. The shaggy, contorted faces represent forest beings who gave gifts of healing to human beings. The most senior of the False Face masks represent the Great World Rim Dweller, a primordial being as old as the world itself.

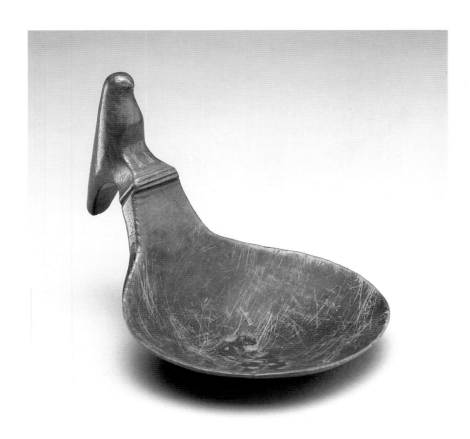

LEFT: *Spoon.* Late eighteenth or early nineteenth century. Central Great Lakes area. Wood (maple). James and Kris Rutkowski Collection.

Great Lakes people brought their own utensils to feasts. Those who belonged to religious societies like the Midewiwin were given special utensils for use on ritual occasions. An eagle or hawk, perhaps a metaphor for the Thunderbird, perches on the handle of this spoon.

BELOW: *Hand Drum.* Ojibwa or Potawatomi. Nineteenth century. Northern Michigan, Minnesota, or Wisconsin. Wood, deerskin, paint. Diameter: 20¾ in. The Detroit Institute of Arts.

This hand drum was very likely owned by a "sucking doctor," a healer who cured the sick by seeking out and removing alien objects and substances that caused illness in the body. While the curer sang songs that summoned his protective spirits when performing a cure, an assistant accompanied him with the drum.

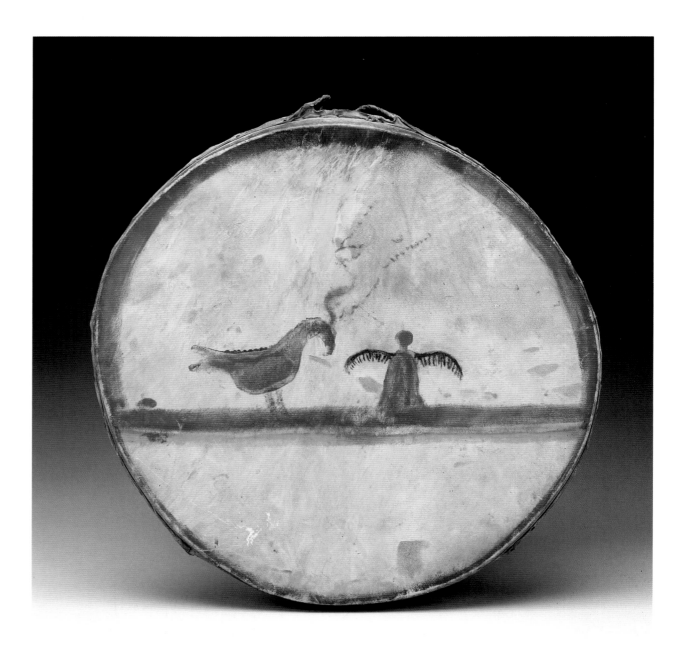

JOHN YOUNG BEAR

John Young Bear was born in 1883 and lived until 1960. He was the son of an accomplished Mesquakie sculptor who had accompanied his people to the settlement at Tama during the late 1850s. Growing up in Tama, John Young Bear worked with visiting collectors and ethnologists early in the twentieth century. He was best known as a carver, however, and many museum collections include examples of his work.

John Young Bear made traditional categories of Mesquakie wood carving, like the bowl and spoon illustrated here. He carved heddles for bead-weaving, awl handles, pipestems, feather boxes, and dolls for sale to non-Indian buyers. The Mesquakie of Tama never developed an extensive non-Indian market for craft work, however, so that most of Young Bear's carvings were made for friends and family. Among the effigies that grace the details of these carvings, Young Bear favored the horse and the bear. Like all carvers of the Eastern Woodlands tradition, Young Bear's principle tool for carving was the crooked knife, a knife used with one hand like a draw knife, with a curved tip to hollow out bowls and spoons. Small knives and chisels finished the detail.

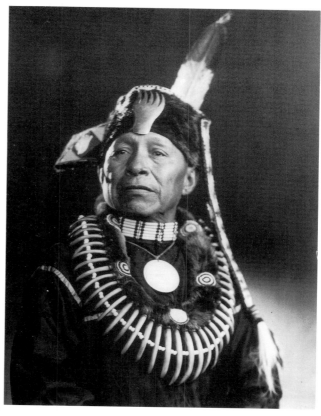

John Young Bear (Mesquakie)
Buffalo Bill Historical Center, Cody, Wyoming.

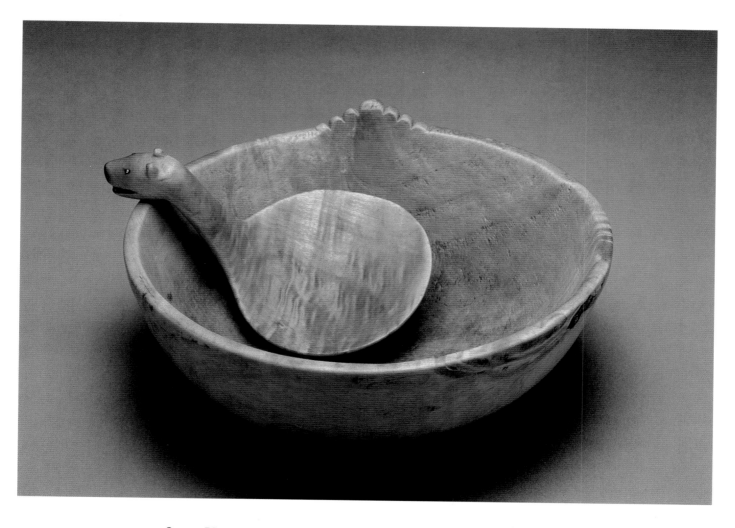

JOHN YOUNG BEAR. *Bowl and Spoon*. Twentieth century.
Tama, Iowa. Wood, metal nails. Bowl, diameter: 8½ in.;
spoon, length: 6 in. Robert Hobbs Collection.

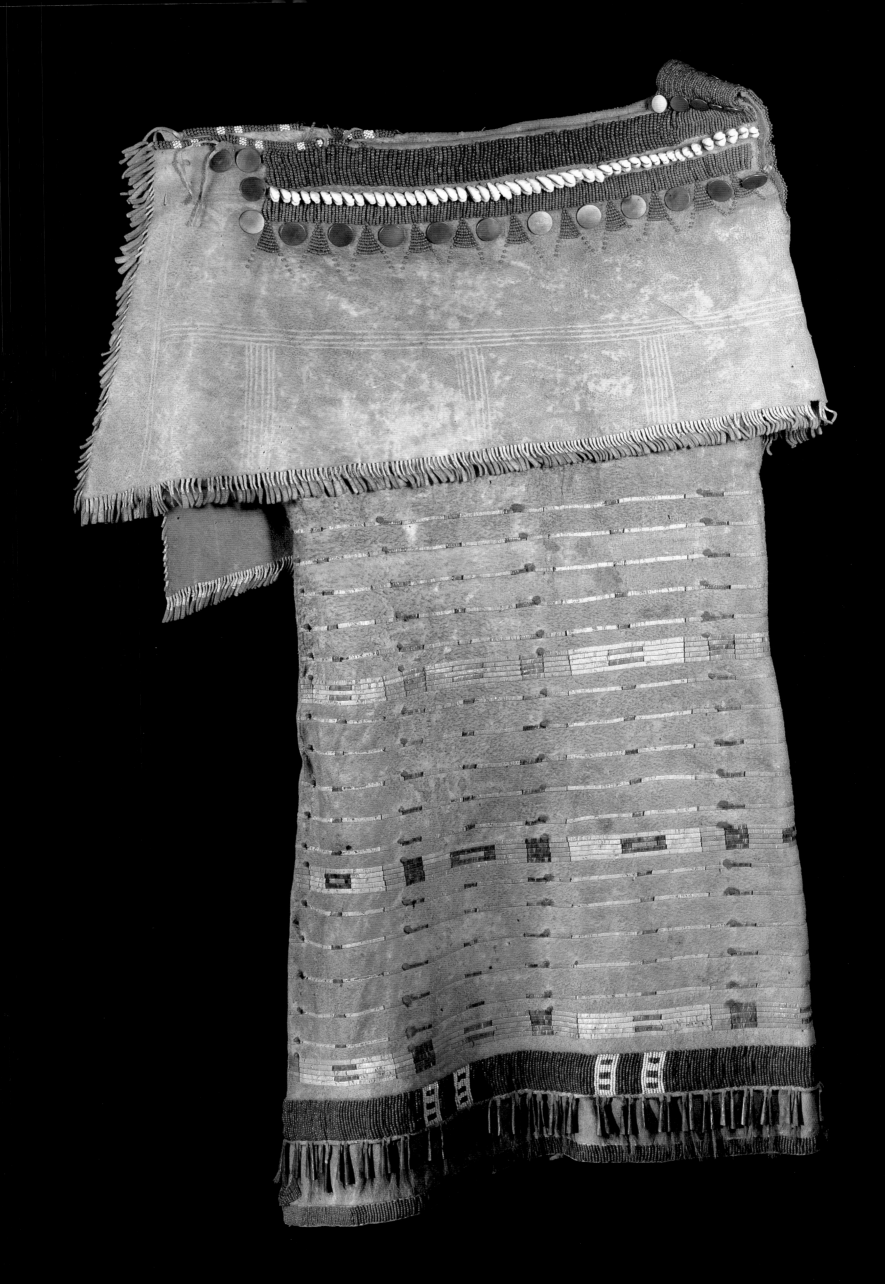

THE PLAINS

The great central Plains of North America roll westward from the Mississippi basin, interrupted by the Mississippi's western tributaries with their headwaters in the Rockies. The Plains offered less opportunity for community life than the landscape that nurtured the great centers of culture to the east. The native population was widely dispersed and far more sparse than in regions to the east. Significant parallels do exist, however, between pre-Columbian history of the Plains and that of the Eastern Woodlands. Prior to 1000 B.C., Archaic hunters roamed the regions' river valleys. During the Woodland period, some communities of the lower Missouri built burial mounds and were familiar with platform pipes, clay figurines, and Hopewell zoned-and-stamped pottery. And the Mississippian agricultural revolution initiated growth of villages in the sheltered river valleys of the Plains as well as in eastern regions; the people lived in clusters of pit houses with sod roofs supported by four central posts, some villages protected against outsiders by palisades and other kinds of fortifications. Unlike their neighbors to the east, however, the central Plains villagers never built platform mounds and did not seem to emulate the complex Mississippian social hierarchies. Over the centuries, nomadic bands of hunters traveled across the Plains on foot, trading and fighting with the agricultural earth-lodge villagers, but they did not often remain longer than a few generations. They were wanderers looking for a homeland and the Plains offered little. The Plains required hardy, conservative ways from its people, and cultural practice there changed only slowly over thousands of years of history prior to the arrival of Europeans.

THE HORSE AND "BUFFALO CULTURE"

Europeans brought with them the seed of cultural revolution on the Plains: the horse. The horse was one among several other domestic animals such as cows, pigs, and chickens that arrived with the Spanish when they colonized the Rio Grande of New Mexico in the sixteenth century. Apache and Navajo acquired horses from *rancheros* and traded them to their neighbors to the north. Knowledge of equestrian technology traveled rapidly from one tribe to the next, north along the front range of the Rockies and to the earth-lodge dwellers of the Platte and Missouri.

By 1700, the revolution had begun. Hunting societies, previously limited to relatively brief excursions against the buffalo, could now track the herds out into the less accessible areas of the Plains and live there among them. Hunting the buffalo on horseback was far more productive, allowing dramatic growth in the size of the community. Migratory buffalo hunters like the Algonquian-speaking Blackfeet, who had moved across the Plains from the Great Lakes region to their homeland at the foothills of the Rockies, had used dogs as beasts of burden prior to the arrival of the horse. Horses allowed far more expansive movement of large communities, turning the once difficult terrain of the Plains into a land that offered new promise.

OPPOSITE:

Side-Seam Dress. Northern Plains. Collected in the upper Missouri territory during the Lewis and Clark expedition of 1804. Deer or antelope hide, glass beads, brass buttons, brass cones, porcupine quills, wool cloth. Length: 42 in. Peabody Museum of Archaeology and Ethnology, Harvard University, Cambridge, Massachusetts.

This type of northern Plains dress is extremely rare, made from a single hide folded in half to form the front and back, with the fold descending down the right side of the garment and the seam stitched down the left. The broader bands of quillwork are reminiscent of early Lakota work seen often on shirt and legging strips. Within a few decades after Lewis and Clark's visit to the upper Missouri territory, this kind of dress was no longer made by the people of the northern Plains.

"Buffalo culture," made possible by the horse, unleashed the vast potential of the Plains, and many diverse cultures responded by expanding their territories, thereby enjoying unprecedented growth during the eighteenth century. In the northern and central Plains, Algonquian speakers with ancestral ties to the regions north of the Great Lakes, such as the Cheyenne, Arapaho, Gros Ventre, and Blackfeet, established new hunting territories, followed by Plains Cree and Ojibwa (Bungi) in the nineteenth century. The Crow broke away from their earth-lodge dwelling relations, the Hidatsa, on the upper Missouri, and rode west with the buffalo into Wyoming and Montana. By the 1800s, the westward expansion included bands of Lakota, or Western Sioux, as they moved across North and South Dakota, eastern Wyoming, and into Montana. The Kiowa and Comanche migrated east from a homeland in the central plateau region west of the Plains, and by the nineteenth century Rocky Mountain groups such as the Nez Perce, Salish (Flathead), and Northern Shoshone brought their horses onto the northwest Great Plains as well. The earth-lodge dwellers—the Pawnee of the Platte, the Oto, Osage, and Iowa of the lower Missouri, and the Arikara, Mandan, and Hidatsa farther up river—enhanced their agricultural ways with the new equestrian culture. Even the Caddo, Wichita, and Quapaw, with their roots firmly grounded in Mississippian culture, adopted many of the advantages of "buffalo culture" when they acquired knowledge and skill in riding horses.

With so many different peoples jostling one another for access to the buffalo herds during the eighteenth and nineteenth centuries, skirmishing to protect hunting territories was frequent and intense. The Eastern Sioux continued their conflict with their age-old enemies, the Ojibwa, in the forests to the east, while their Western Sioux relations pressured the Crow west. The Crow allied themselves with the Northern Shoshone and fought with the Western Sioux, Gros Ventre, and the Blackfeet. Cheyenne, Arapaho, and Lakota (Western Sioux) forged an alliance to protect their southern flank in Kansas and Arkansas and raided the Pawnee, Oto, and Osage earth-lodge dwellers of the eastern Plains river valleys. The Kiowa had been driven south during the eighteenth century by Cheyenne and Sioux and so formed alliances with the Comanche and Plains Apache in Oklahoma and Texas. Mesquakie, Sauk, Potawatomi, Creek, Winnebago, Delaware, and Shawnee arrivals from the east at mid-century added further tensions and created new alliances.

European-American interests in the central Plains quickly became engaged in this volatile and shifting situation. Spanish in the Southwest found it difficult to maintain the security of their *haciendas* against raids by mounted warriors seeking booty, captives for ransom, and livestock, including horses. The introduction of guns by the Canadian fur trade pushing west across Manitoba and Saskatchewan further influenced the balance of power on the Plains. The United States struggled to comprehend and control what was happening west of their frontier of settlement while looking for opportunities for economic and domestic expansion. Lewis and Clark's expedition of exploration up the Missouri River early in the nineteenth century helped open trade for buffalo hides from St. Louis to the earth-lodge villagers and itinerant tribes with access to the Missouri. Tribal attempts to control trade sometimes led to violence, such as when thirteen St. Louis traders, while attempting to continue up river, were killed at the Arikara villages in 1823, provoking a punitive expedition of the U. S. military that cannoned the native villages.

With the state of Texas joining the Union in 1845 and the war with Mexico in 1846, former Spanish possessions in North America were laid open for settlement from the east. European penetration of the Plains accelerated. Settlers had trickled across the Plains on the Oregon Trail during the 1840s, but tens of thousands of European Americans crossed the Plains on the Platte River road after the California gold rush of 1849 and severely disrupted hunting, effectively dividing the range of buffalo into northern and southern herds. The U.S. government negotiated treaties with the Plains tribes—the Treaty of Fort Laramie in Wyoming of 1851 and Fort Atkinson in Oklahoma of 1853—to allow unfettered travel through tribal-held territories. These documents were also supposed to define tribal territories. The increasing pace of westward expansion by European-American settlers was sowing the seeds of conflict.

The rolling kettle boiled over during the 1860s with both the northern and southern Plains erupting into episodes of fierce violence that continued well into the late 1870s, interrupted only briefly by negotiated settlements. Periods of sustained, often bloody, conflict weakened and further disrupted the Plains tribes.

Ultimately, however, it was the virtual extinction of the buffalo that defeated Plains people. By 1880, the last of the great northern herd was located between the Missouri and the Yellowstone rivers in Montana. Gros Ventre, Blackfeet, Assiniboine, Shoshone, Crow, Plains Cree, Metis, and even the last of the free Sioux in Canada, crowded into the northwest Plains to hunt for hides to trade as well as food to eat. By the following year, the dwindling buffalo could no longer sustain all the people who depended on them. The southern herds disappeared even earlier. Professional hunters with high-power, long-range rifles killed hundreds of thousands of buffalo every year for their hides. Federal authorities, well aware that the Plains Indian way of life would die with the buffalo, gave tacit approval to commercial over-hunting. By 1878, the southern herd was gone and with it the once-thriving "buffalo culture." Thereafter native people had to depend upon payments of annuities and government issues for their food and clothing. The Plains way of life linked to the horse and the buffalo had lasted scarcely 150 years.

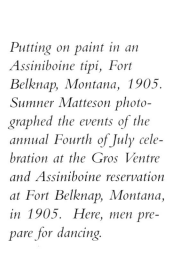

Putting on paint in an Assiniboine tipi, Fort Belknap, Montana, 1905. Sumner Matteson photographed the events of the annual Fourth of July celebration at the Gros Ventre and Assiniboine reservation at Fort Belknap, Montana, in 1905. Here, men prepare for dancing.

Milwaukee Public Museum.

Indian people of the Plains now faced the difficult task of finding substitute economies. Issues of annuities and supplies by reservations agencies were erratic at best. Many people starved during the first decades of reservation life, after 1880. Men hired themselves out to Wild West shows; women produced arts and crafts for sale. Some made a successful transition to farming and cattle raising; others sank into depression and alcohol. Mandatory education for children often separated them from their families and forbade the use of their traditional language. The government promoted the idea that Indian culture was obsolete, backward, and hindered the pursuit of a successful, modern life.

But amid this almost overwhelming pressure to change, Indian people of the Plains found ways of renewing traditional culture. Even though the Bureau of Indian Affairs discouraged and even outlawed traditional dances and ceremonies, Independence Day celebrations, for example, encouraged by government agents because they promoted patriotism, became for many Plains reservations an opportunity for social dances, "sham battles" in which warriors reenacted their triumphs of Plains warfare in the past, and even the most sacred of Plains religious rituals, the Sun Dance. As one generation passed to the next, it became increasingly difficult to preserve and celebrate ancient ways. But the people persisted, and the regeneration of cultural values through ceremony, celebration, oral tradition, and the visual arts continued into the twentieth century.

ART IN SOCIETY AND RELIGION

Like their neighbors to the east, Plains people recognized different and yet complementary social responsibilities for men and women. Their visual arts, so tied to social and religious traditions, responded to these gender roles. Men and women worked in different media, making very different kinds of things for purposes that addressed their separate, yet related, areas of concern.

Men accepted responsibility for the tribe's security. Boys learned from an early age that bravery and selflessness in the protection of their people was highly esteemed. The community recognized those who performed courageously in battle. A man's

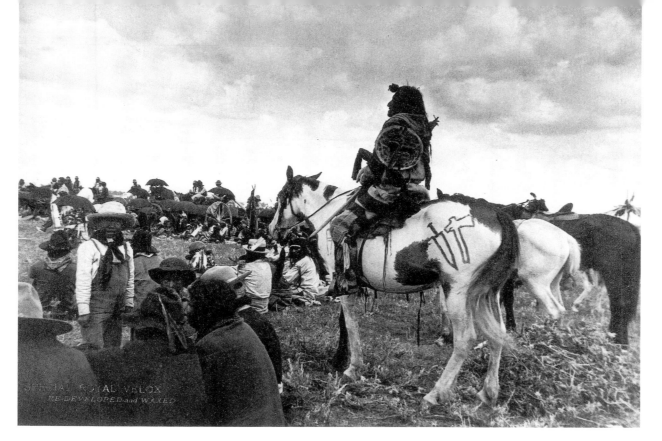

Billy Jones singing at the Grass Dance, Fort Belknap, Montana, 1905. Billy Jones, whose Gros Ventre name translated roughly as "Goes to the Enemy and Brings Something Back," sits on his horse singing. He is dressed in his old-time regalia, with the symbols of battle victories painted on his horse's flanks.

Courtesy Richard A. Pohrt.

military accomplishments became part of his identity among his peers and supported the authority with which he spoke and acted as a member of the community. Particularly strong warriors often emerged as powerful and influencial community leaders. Sitting Bull and Crazy Horse of the Lakota, for example, climbed to such prominent positions of leadership because they were proven warriors—strong, courageous, and selfless.

When a man performed a noteworthy feat in battle, he then had the right to speak of it publicly to support his position as a socially prominent man. Painted figures on his dress clothing, a decorated shirt, leggings, and buffalo robe might represent the heroic act, and be embellished with symbols, such as black stripes if he had killed an enemy, or a red smudge for a wound received in battle. These garments, worn during public events, reminded everyone who saw them of the sources of this man's authority. When he spoke, he spoke as a man whom everyone understood had accomplished great things.

The "pictographic art" used by men to represent their battle accomplishments was a reductive, figurative art form in which the artist simply indicated, often with an economy of visual means, who had done what to whom. The earliest examples known of these kinds of visual expressions employed abbreviated stick figures brandishing weapons, the vanquished bleeding from their wounds. When men of the central Plains became more familiar with some of the visual conventions of European-American artists such as Karl Bodmer and George Catlin, who traveled in that country during the 1830s, they painted figures in a more fleshed-out manner, with greater detail and sense of movement. After the 1850s, many men began to record their battle accomplishments with pencils, ink, and paints on paper in notebooks or ruled ledger books that had been captured or acquired in trade. "Ledger book art," as it is often called, became even richer in narrative and historical detail later in the nineteenth century. Illustrations of ceremonial practice, social and political events, and even cultural reminiscences reaching back to an earlier way of life, fill the pages of ledger books kept by men of the reservation period. Those young men who had not participated in warfare or buffalo hunting recorded the stories of their elders, thereby helping to insure the preservation of some of their most treasured traditions.

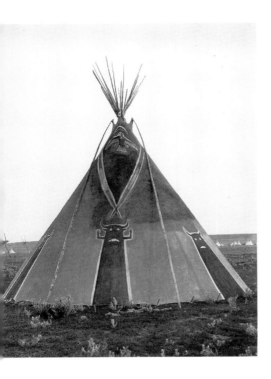

Medicine Lodge, Fort Belknap Reservation, 1905. The tipi photographed by Sumner Matteson is painted with the image of a horned, underwater monster, with the Thunderbird and a crescent moon hovering overhead. The painting is a kind of cosmological diagram illustrating the structure of the sacred universe: the earth bracketed between the dome of the sky above and the watery Underworld that is below.

Milwaukee Public Museum.

Success in men's endeavors depended upon spiritual strength and preparedness. All ambitious men sought to form a personal relationship with the spirit world. The four-day fast of a vision quest and even the most powerful and sacred of Plains ceremonies, the Sun Dance, demonstrated a man's earnest wish to be blessed through the gift of his suffering; fasting, prayer, self-sacrifice, and physical hardship confirmed his sincere desire to give of himself. Spirit beings bestowed upon men who had proven their worth the gifts of strength and protection in battle, the ability to heal the sick and injured, good health, and the overall well-being of the community. There was no priesthood in the strict sense, but the powerful spirits did entrust sacred responsibilities to "holy men," those whom by prayer, reverence, or through having been chosen, had been blessed. Plains tribes recognized a wide range of sacred objects, all of which originated as gifts from the spirit world. Some of these objects descended through a clan; others were meaningful to the entire tribe; still others could be owned only by individuals. "Pipe bundles" were sacred smoking pipes whose ritual sustained an entire tribe. The bundles were cared for by "pipe keepers," holy men who had learned the bundle's rituals, and, when the time was right, passed on the bundle and its ceremony to a member of the younger generation.

Blessings from the spirit world sometimes took the form of a special design to be painted on a horse to keep it from tiring in battle, or an image on a shield to keep the owner safe from the bullets and arrows of his enemies. If the owner proved successful and powerful, he might share his blessings with others by gift or through payment as recompense, allowing another to reproduce the designs with appropriate ceremony. The images often possessed a visionary quality representing the spiritual sources of power. Thunderbirds or related symbols such as hailstones, lightning or the crescent moon might embellish shield designs derived from a warrior's spiritual relationship with Thunder Beings. Bears, buffalo, watermonsters, and other kinds of powerful animals were also powerfully charged images, and might adorn not only shields, but also lodges or tipis, drums, and ceremonial garments. In all such cases, the design was the privileged possession of the man who owned the rights to the power represented by the design.

Plains women, like the women of the Eastern Woodlands, produced and decorated clothing and accessories for formal dress. They tanned the hides of animals hunted by the men and fashioned them into garments. Skilled hands, taught from childhood by older female relations, ornamented shirts, dresses, buffalo robes, moccasins, tobacco bags, baby carriers, and skin lodges, or tipis, with porcupine quill embroidery, paint, cloth appliqué, and glass beads. Cheyenne women organized a kind of guild or society of quillworkers to control quality and reward excellence. The Cheyenne recognized women for the number of robes and other objects they had produced, just as it recognized men for their accomplishments in battle. Among the northern Arapaho, seven sacred quillworkers' bags were passed down from generation to generation of senior women who were entrusted to teach and supervise younger women in the techniques of their art.

Early in the nineteenth century trade goods were somewhat scarce. Therefore, women used large glass "pony beads" in white, blue, and black, or, more rarely, red and yellow, in addition to porcupine quills, to decorate strips on shirts or robes or to

ornament the yoke of a dress or the vamps of moccasins. By the mid-nineteenth century, smaller, glass "seed beads" in a broader range of colors became more widely available. The women of some communities preferred to sew rows of beads in parallel "lanes," sometimes called "lazy stitch" or "parallel stitch." Others preferred to fill in designs with flat, even fields of color with "spot stitch" or "overlay." Plains beadwork and quillwork designs all tended to be nonrepresentational and constructed with geometric elements: oblongs, triangles, diamonds, and bars. Women named the designs often using terms for the earth or the animal world, such as "mountains," "clouds" or "stars." The elements of a design were rarely arranged to convey any kind of narrative or scene, but, rather, referred to the larger cosmos in which the community lived and the community's relationship to it.

Shifts in design and technique at mid-century tended to emphasize tribal identity. When considering beadwork made before 1850, it is often difficult to determine the tribe of origin. Allied peoples often exchanged garments in trade and it seems as if women frequently experimented with technique and design during that period. After the 1860s, women began to produce beadwork with stronger tribal preferences in technique, color combinations, and design composition. Historically, the 1860s represent that moment when tribal security came under sustained threat from the outside world, and formal, decorated clothing and beadwork responded to this historical dilemma by emphasizing the identity and the viability of the community and its traditions of self-definition.

It is no wonder, then, that the early reservation period, after around 1880, represents a high point of beadwork production, with beadwork embellishing many new categories of garment, and those items traditionally decorated with beadwork receiving heavier and more elaborate ornament. Women produced beaded leggings, vests, and shirts for their male relations in Wild West shows; beaded pants, vests, and dresses for their children; and heavily ornamented dance outfits for their entire families. Craft work became an economic venture with a market for beadwork among outsiders and collectors. Mail order businesses for beadwork purchase proliferated, with advertisements appearing in sporting and boys magazines. Women expanded the range of their designs, incorporating floral patterns and representational "pictographic" images of warriors, horses, and buffalo adapted from men's art. Above all else, the beadwork produced by Plains women of the reservation period stressed the continuity of craft traditions preserved from the past, the viability of traditional women's roles in native society, and the survival of tribal and ethnic identity in spite of the formidable challenges of the early twentieth century.

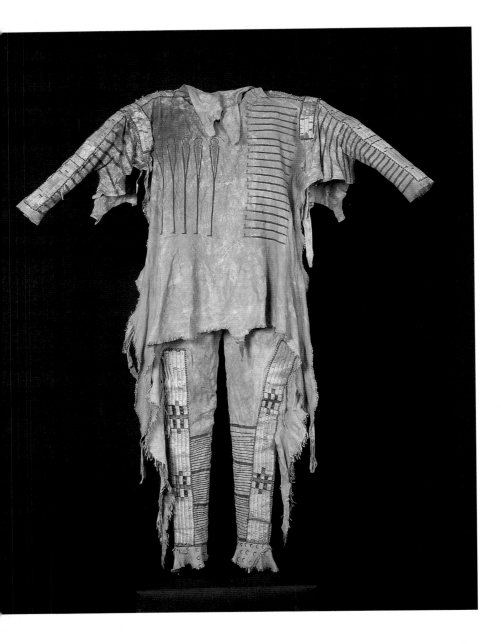

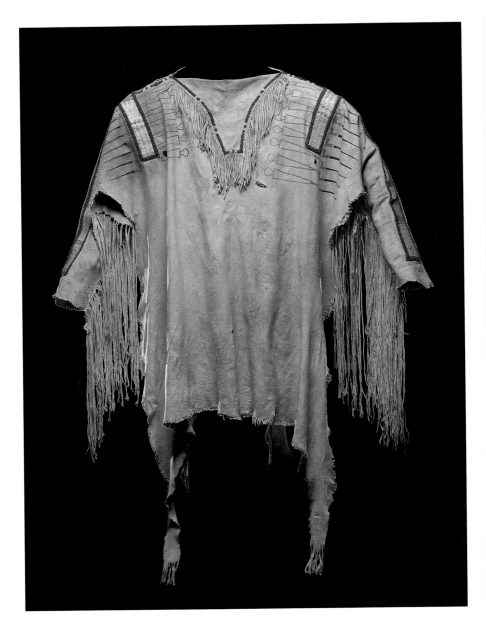

Man's Shirt and Leggings. Early nineteenth century. North Dakota or Montana, Upper Missouri region. Deerskin, porcupine quills, buffalo hide, glass beads (?). Height: 65 in. America Hurrah, New York.

The shirt and leggings were made by a woman of one of the upper Missouri tribes during the early days of the buffalo hide trade prior to 1840. The plaited quillwork strips relate to other garments dating to the same period that have been attributed to the North Dakota earth-lodge tribes, the Mandan and Hidatsa. The images of abbreviated figures attached to smoking pipes identify the owner of this shirt as a war leader; he "carried the pipe," meaning that he led war parties.

Man's Shirt. Possibly Mandan. c. 1830. Upper Missouri River region, North Dakota. Deerskin, buffalo hide, porcupine quills, glass beads, paint. Length: 49 in. The Detroit Institute of Arts.

The smoking pipes and reductive figures painted on this shirt may refer to the owner's war expeditions. The smudge of red ocher on one shoulder records a wound received in battle. The strips on the shoulders and sleeves were made with porcupine quills plaited in two broad "lanes" and bordered with blue glass "pony beads."

OPPOSITE: *Man's Shirt.* Cheyenne. c. 1860. Colorado and Kansas region. Deerskin, buffalo hide, glass beads, ermine skins, wool fabric, human hair, paint. The Detroit Institute of Arts.

This extraordinary shirt is decorated with strips of glass bead embroidery stitched to buffalo hide. The remarkable deep blue stained color of the upper part of the shirt was sacred among the Cheyenne because it was associated with the spiritual identity of the earth. The ermine skins and images of dragonflies on the sleeves refer to the owner's prowess as a warrior: the ermine because of its fierce, predatory character and the dragonfly because of its almost effortless ability to avoid harm.

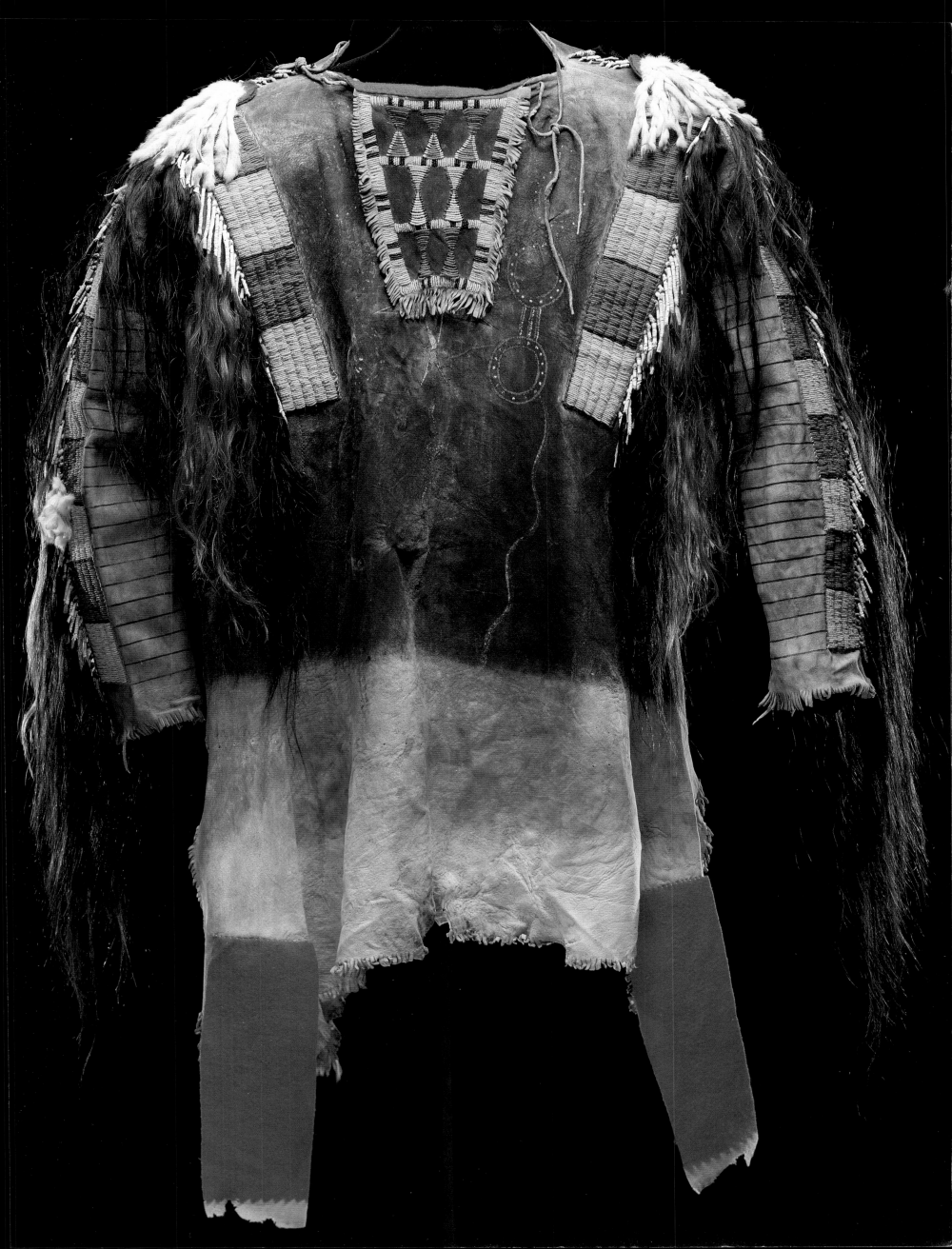

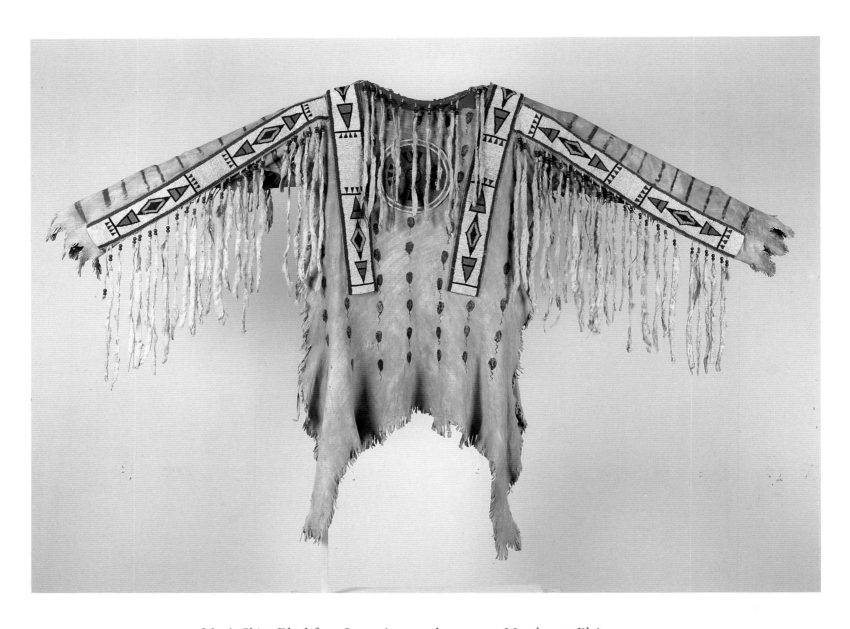

Man's Shirt. Blackfeet. Late nineteenth century. Northwest Plains, Montana, or Alberta, Canada. Deerskin, buffalo hide, glass beads, ermine skins. Height: 34 in.; width at shoulder: 20 in. America Hurrah, New York.

Strips of white ermine skin hang as fringe from the shoulder and arm strips of this shirt. The ermine, or weasel, is one of the most ferocious and tenacious of predators, making it an appropriate symbol for the cultural values of a Blackfeet warrior. The "polliwog"-shaped designs painted on the shirt are spent bullets to which a courageous and powerful warrior remains impervious and unmindful while facing the enemy.

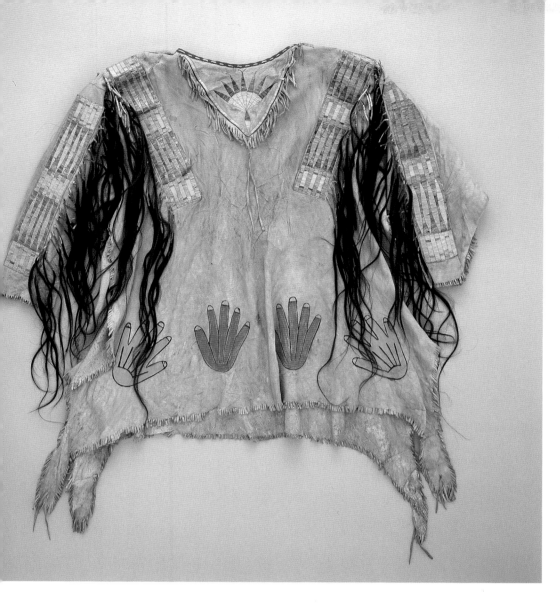

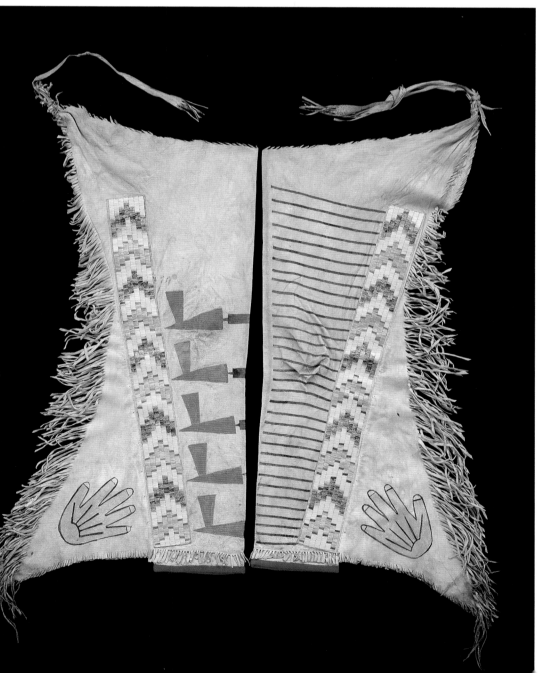

TOP LEFT: *Man's Shirt*. Mandan. Nineteenth century. Fort Berthold, North Dakota. Deerskin, wool cloth, porcupine quills, human hair, paint. Height: 42 in. Collection of Richard and Marion Pohrt.

BOTTOM LEFT: *Man's Leggings*. Mandan. Nineteenth century. Fort Berthold, North Dakota. Deerskin, porcupine quills. Length: 32 in. Collection of Richard and Marion Pohrt.

The hands and black stripes painted on the shirt signify blows struck against an enemy. The pipe bowls painted on the leggings stand for war expeditions in which the owner of this outfit participated. The porcupine quill decoration on the applied strips was done in the distinctive style of Fort Berthold women, who continued the technique of porcupine quill embroidery up through the nineteenth and twentieth centuries.

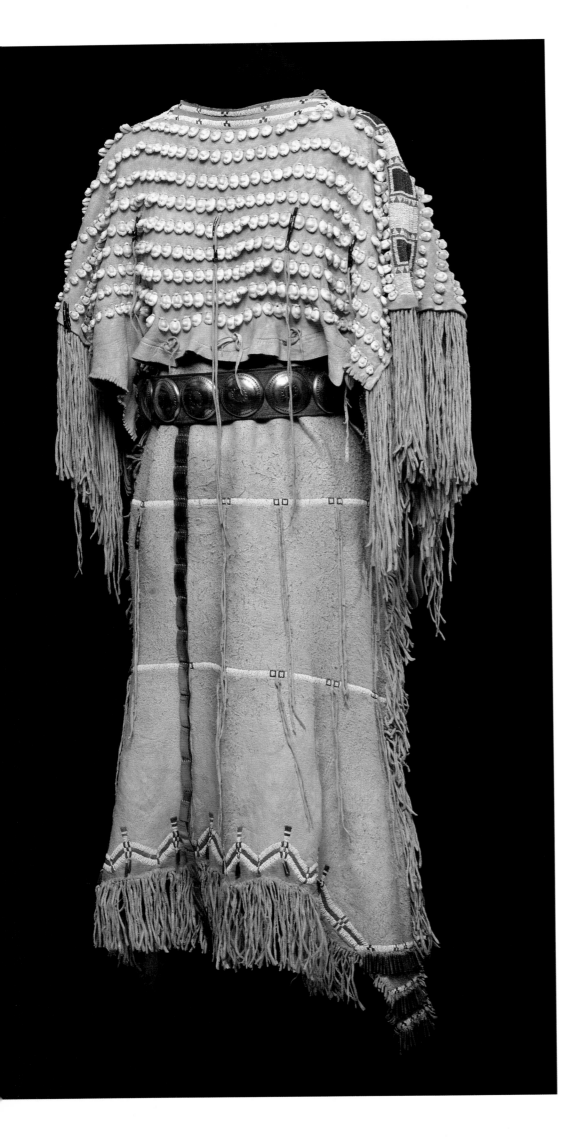

LEFT: *Dress.* Southern Cheyenne. c. 1880. Region of the Fort Sill Agency, Oklahoma. Deer hide, cowrie shells, glass beads, tin cones, paint. Buffalo Bill Historical Center, Cody, Wyoming.

This style of dress, with minor variations, became popular among girls of the southern Cheyenne, southern Arapaho, and Kiowa during the first few decades of reservation life after 1880. It is made in two parts from three deerskins, two sewn together lengthwise for the skirt and laced to the third hide for the bodice. The laces that join the two parts are customarily hidden beneath a belt, as seen here. Many dresses of this style were decorated with cowrie shells, suggesting that local traders had a good supply of this exotic item. The sparse but very refined bead embroidery, yellow stain for the hides, and additional use of decorative paint are all hall-marks of the southern Plains dress of this era.

OPPOSITE: *Dress.* Nez Perce or Salish. Late nineteenth century. Plateau region. Deerskin, glass beads, wool cloth, cowrie shells. Length: 50 in. The Masco Art Collection.

Dresses of the plateau region were made with two large hides sewn with the tail portion folded down beneath the neck, suggesting the form of the large beaded yoke of this dress. The extensive beaded embroidery of the yoke area is fringed with pendants of large glass beads and cowrie shells.

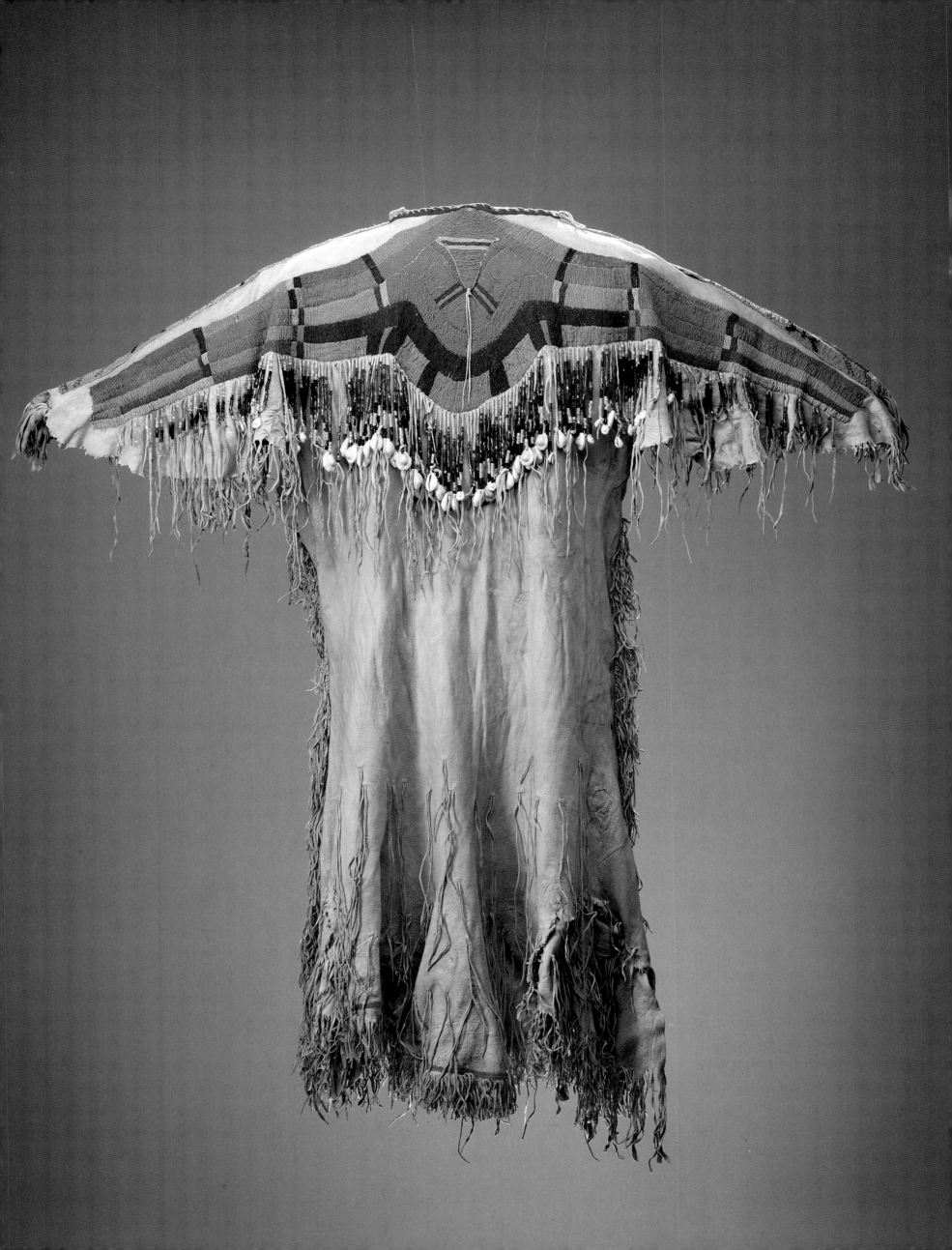

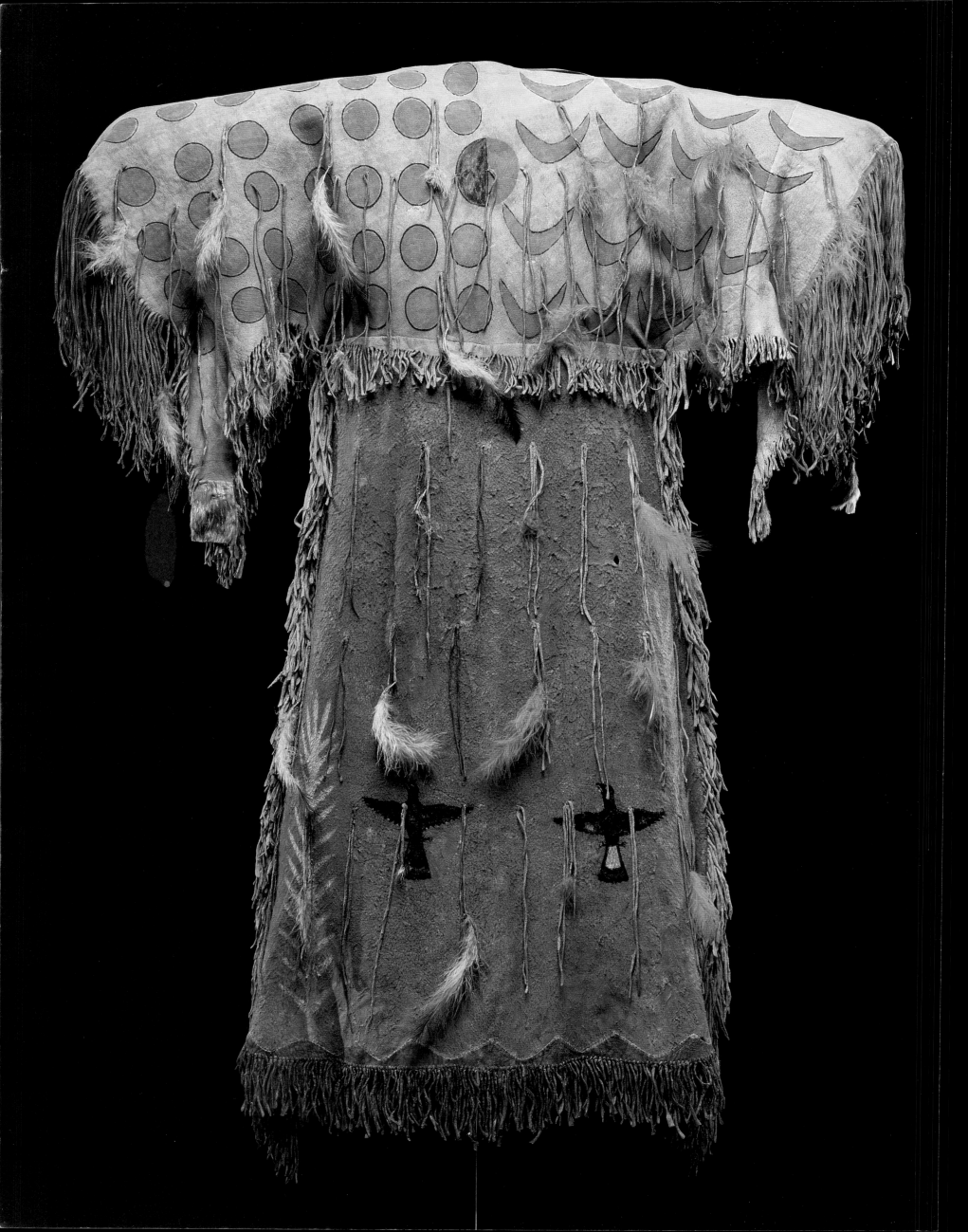

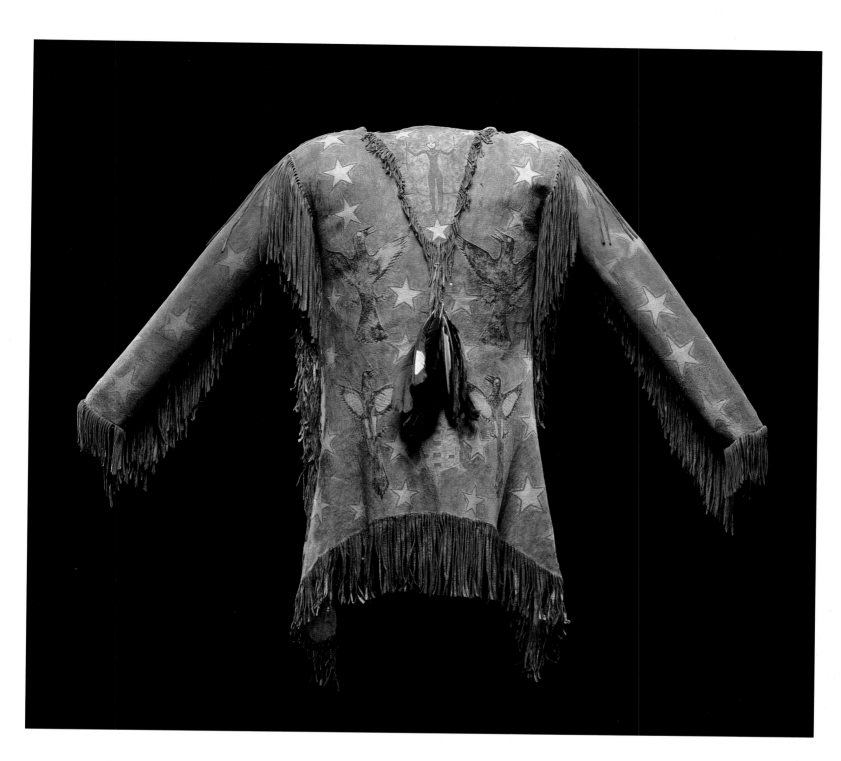

OPPOSITE: *Ghost Dance Dress.* Southern Arapaho. 1890s. Region of the Fort Sill Agency, Oklahoma. Deerskin, feathers, paint. Length: 58 in. Buffalo Bill Historical Center, Cody, Wyoming.

The religion of the Ghost Dance, inspired by visions experienced by Wovoka, a Paiute prophet and holy man, promised the return of the buffalo and a restoration of the traditional world prior to the arrival of European Americans. Emissaries from reservations all over the Plains visited Wovoka during 1888 and 1889 to bring his teachings and knowledge of the Ghost Dance back to their people. When people danced and sang Ghost Dance songs, they were transported by visions to the land of the dead where ancestors reinforced Wovoka's promise. Southern Arapaho women made special garments for performing the Ghost Dance. Their painted images refer to Ghost Dance teachings, but also borrow freely from traditional Arapaho cosmology.

ABOVE: *Ghost Dance Shirt.* Arapaho. Late nineteenth century. Oklahoma. Deerskin, crow feathers. Length: 37 in. Buffalo Bill Historical Center, Cody, Wyoming. Gift of the Searle Family Trust and the Paul Stock Foundation.

The turtle and the red figure holding a pipe painted on this garment are traditional symbols drawn from Arapaho cosmology synthesized with the teachings of the Ghost Dance. The turtle supports the earth in the Arapaho cosmos. The red figure may relate to one of the Arapaho sacred pipes—the Feather Pipe or the Flat Pipe.

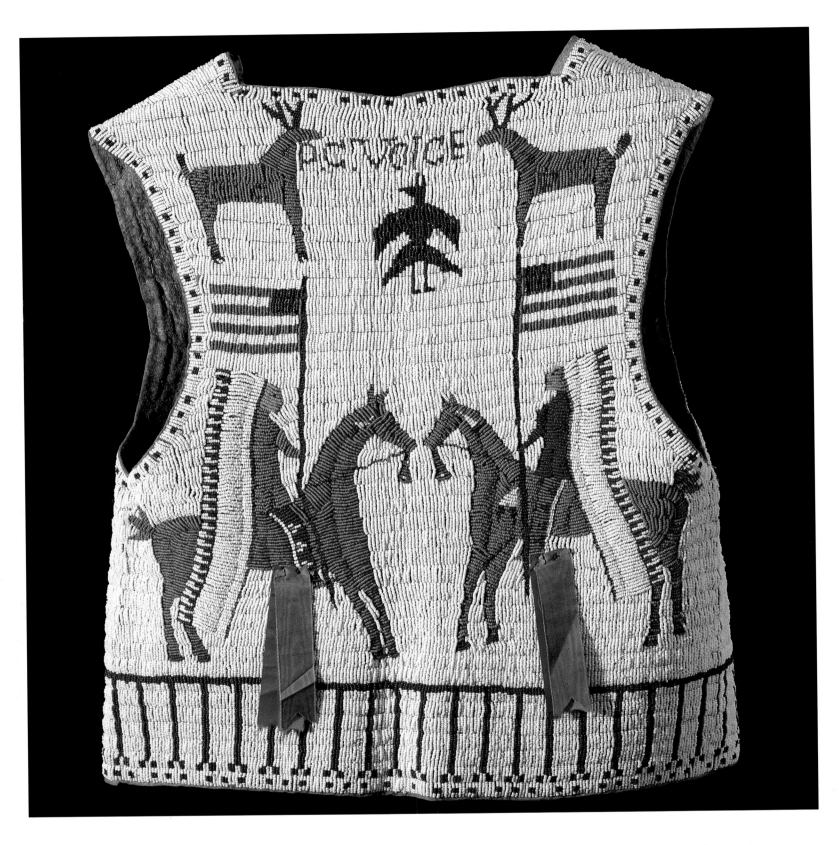

ABOVE: *Beaded Vest*. Lakota. 1880–1900. North or South Dakota. Cowhide, glass beads. Height: 20 in.; width: 16½ in. America Hurrah, New York.

Lakota men originally fashioned vests by simply removing the sleeves of government-issue jackets. The beaded vest became especially popular among young men who participated in the Wild West shows that recruited among the Lakota during the early reservation period. Women added "pictographic" images of warriors on horseback and American flags to their customary geometric designs.

OPPOSITE: *Girl's Dress*. Lakota. 1890–1910. North or South Dakota. Cowhide, glass beads. Height: 24 in.; width: 16½ in. America Hurrah, New York.

The beaded decoration on Lakota garments became increasingly elaborate late in the nineteenth century. Here beaded embroidery covers the entire dress with florid patterning. Children's garments were given the greatest attention by Lakota women artists. This garment was worn only for social dances and tribal celebrations.

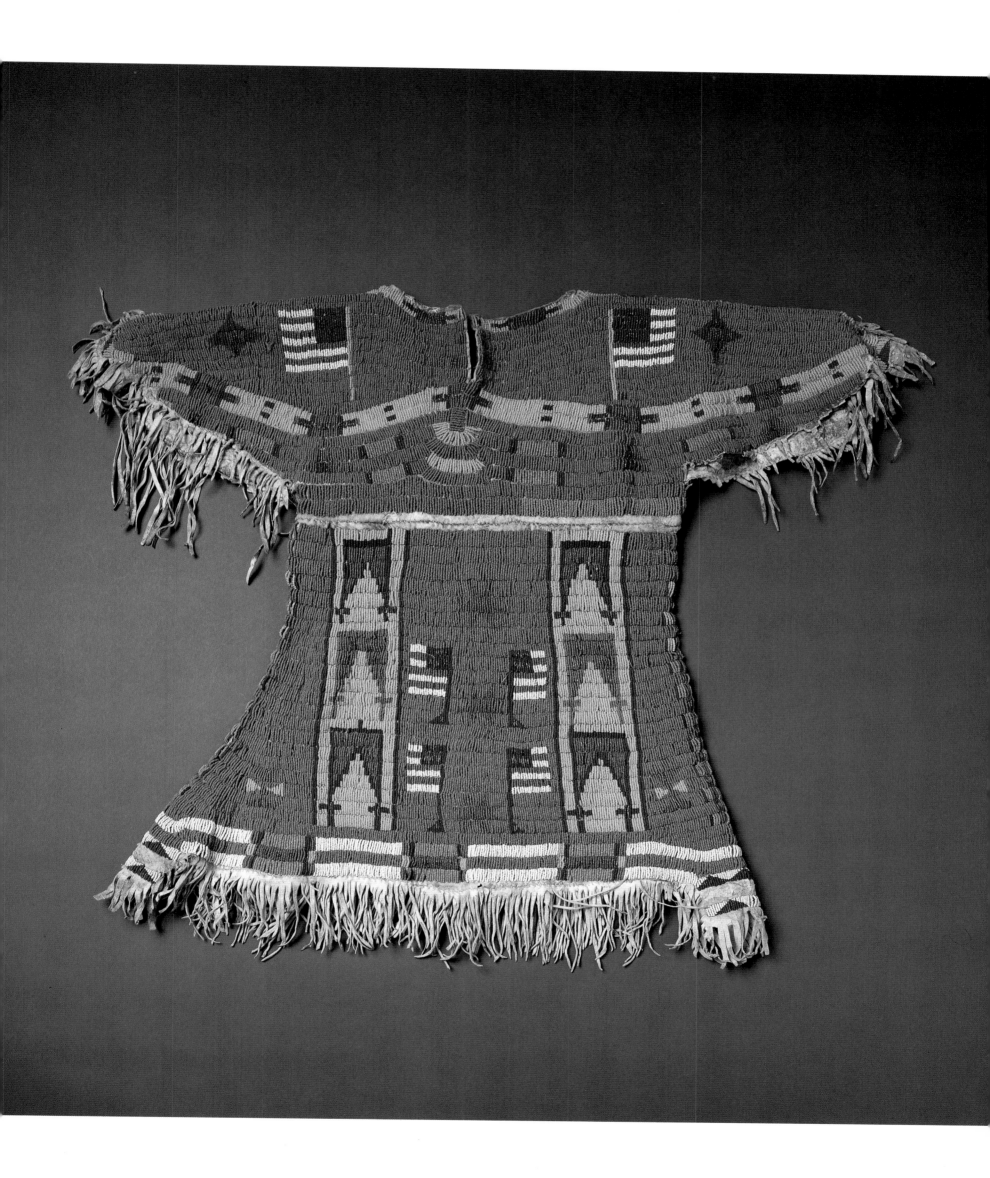

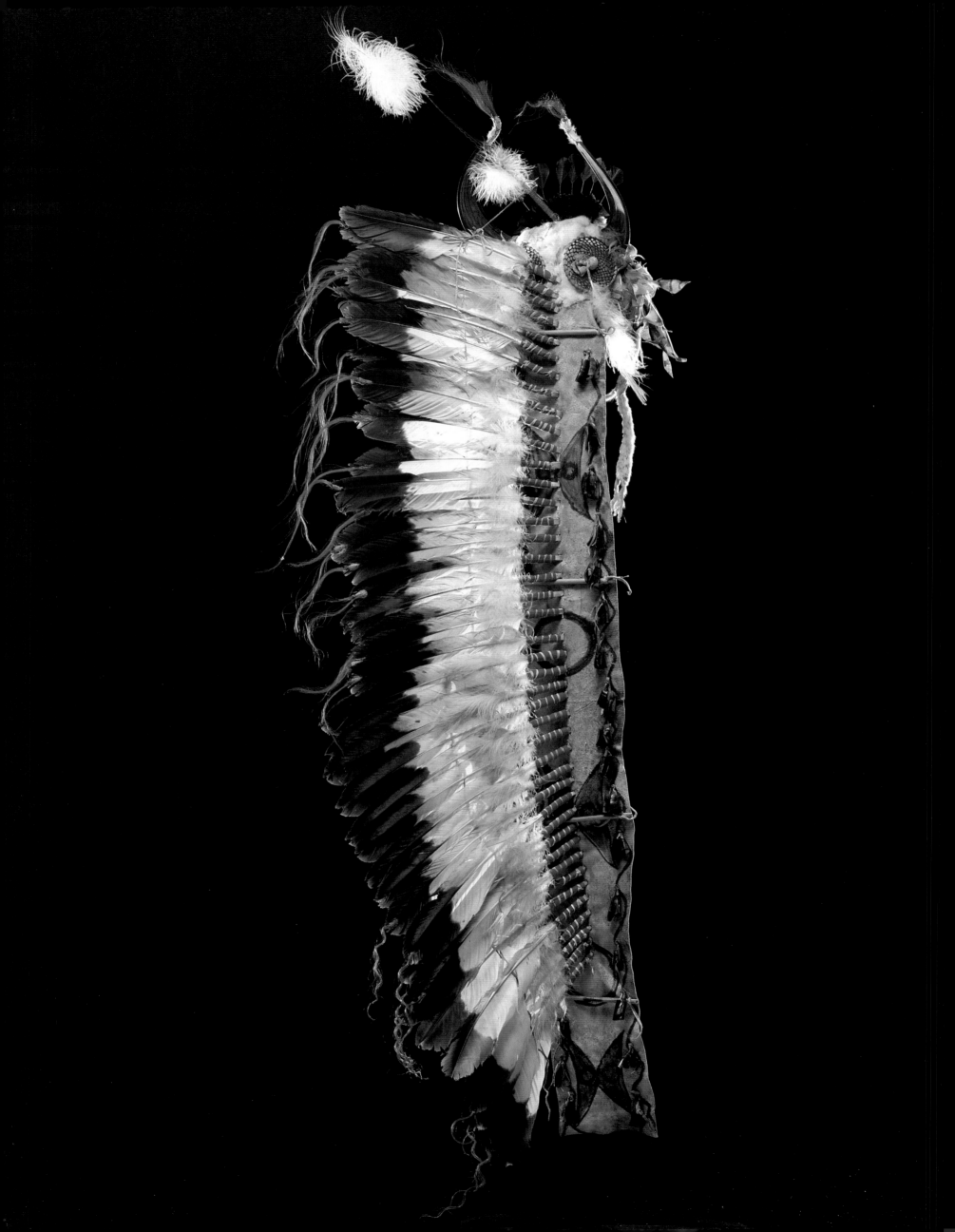

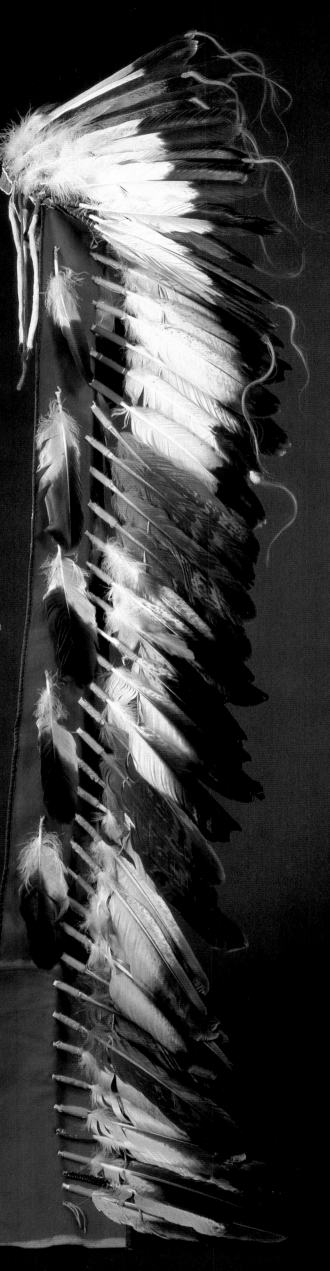

OPPOSITE: *Split-Horn Bonnet with Trailer.* Deer hide, eagle feathers, buffalo horn. Buffalo Bill Historical Center, Cody, Wyoming.

This style of headdress with split buffalo horns and a band of clipped eagle feathers arranged across the brow is a very early type found on the northern Plains. Karl Bodmer's 1833 watercolors feature warriors wearing this kind of headdress. The trailer with its long row of eagle feathers that hangs down the back when worn was most likely a later addition to this headdress. Important regalia was often reinvigorated with additions and elaborations by succeeding generations of owners.

RIGHT: *Eagle Feather Headdress and Trailer.* Cheyenne. 1880s. Oklahoma. Eagle feathers, deerhide, wool cloth, glass beads. National Museum of the American Indian, Smithsonian Institution, New York.

The war bonnet with eagle feathers is the consummate symbol of a Plains warrior's prowess and accomplishment. Generally speaking, only men who had proved themselves in battle and had struck a blow (counted "coup") against an enemy would wear one. These headdresses had no protective power, but as Sitting Bull's son White Bull explained, if he were to be killed in battle, he would want to die in fine war cloths. Cheyenne warriors frequently favored swept-back style bonnets with long double-trailers that, because of their length, could only be worn on horseback.

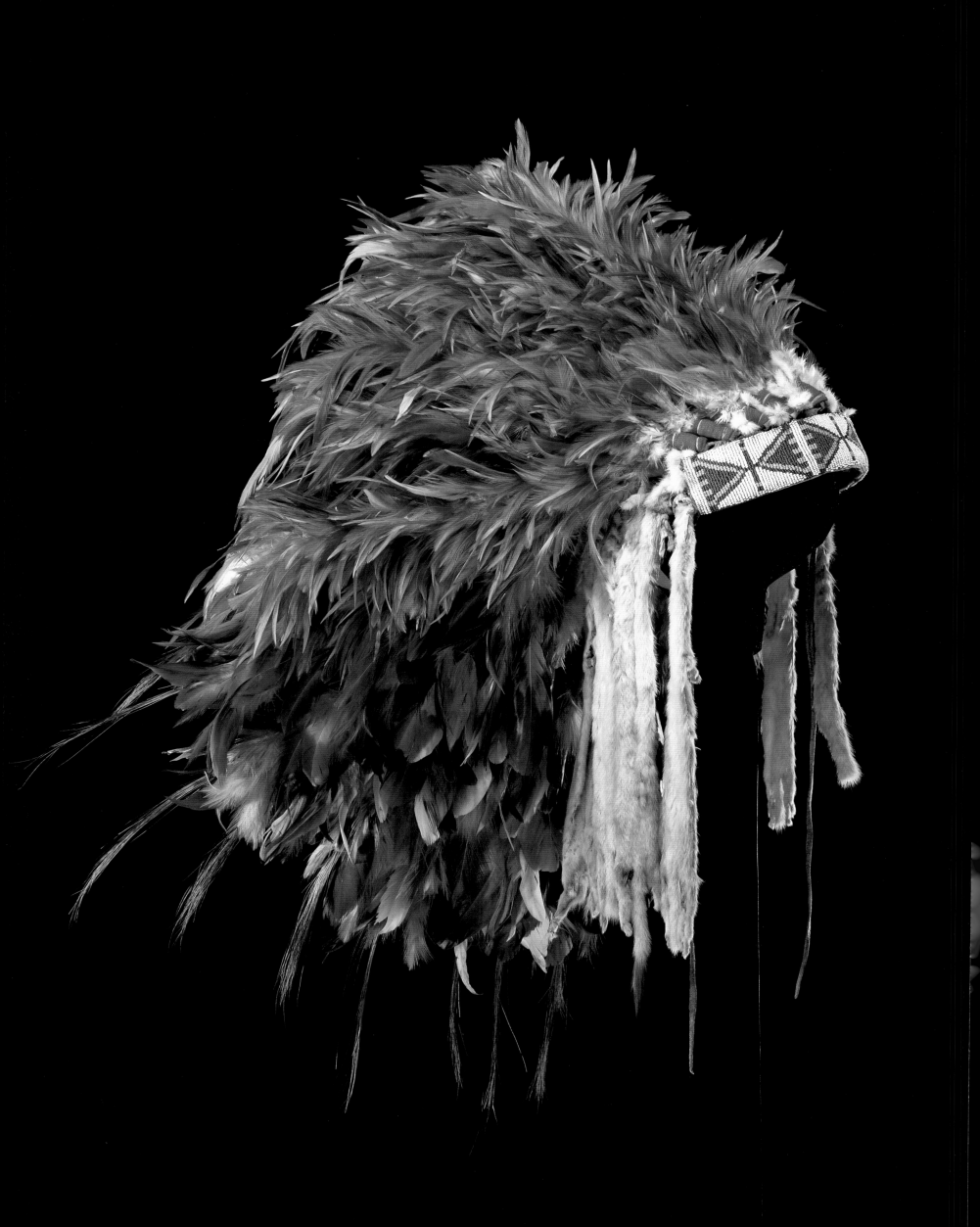

OPPOSITE: *Feather Bonnet.* Northwestern Plains. Late nine-teenth century. Rooster hackles, wood rods, porcupine quills, ermine skins, horsehair, deerskin, glass beads. Length: 33 in. Collection of Richard and Marion Pohrt.

This swept-back style feather bonnet is unusual because it is made from rooster hackles lashed to wooden rods instead of the customary eagle feathers. The visual effect of the iridescent, copper-colored feathers is nevertheless remarkable. Most likely this inventive head-dress was made for dancing during the reservation period.

BELOW LEFT: *Pipe Bag.* Northern Cheyenne. c. 1860. Montana. Deerskin, glass beads, porcupine quills. Length: 28½ in. The Detroit Institute of Arts.

This pipe bag is a classic example of Cheyenne beadwork of the prereservation days on the northwestern Plains. It was collected by a member of the construction crew for Fort C. F. Smith, Montana Territory, on the ill-fated Bozeman Trail.

BELOW RIGHT: *Pipe Bag.* Southern Arapaho. 1880s. Region of the Fort Sill Agency, Oklahoma. Deerskin, glass beads, paint. Length: 21⅛ in. Buffalo Bill Historical Center, Cody, Wyoming.

This unique pipe bag with its pictographic imagery of a figure holding a pipe has long been regarded as related to the Ghost Dance, the millenarian religious revival that inspired great hope among the southern Plains tribes around Fort Sill after 1888.

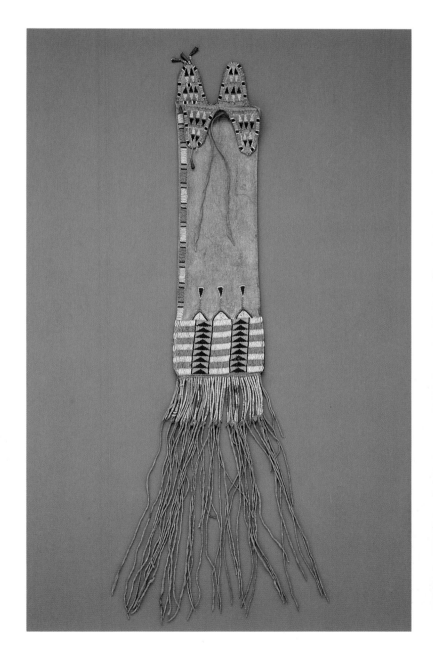

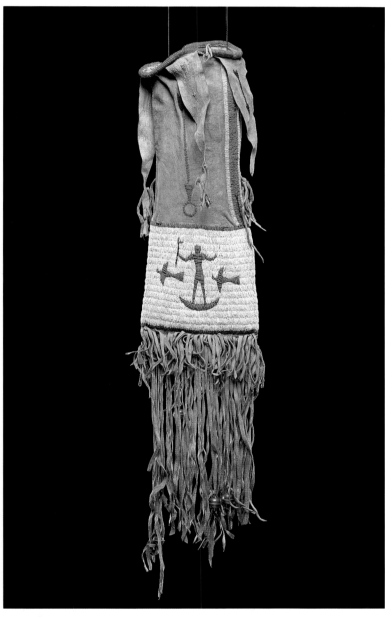

BELOW: *Moccasins.* Crow. c. 1880. Montana. Deerskin, rawhide (cowhide), glass beads. Length: 10 in. The Detroit Institute of Arts.

The beadwork designs on these moccasins exhibit the refined attributes of classic Crow style. The U-shaped design motifs filled with pale blue and framed by bars of red and navy are customarily understood as horse tracks, a reference to a war trophy.

OPPOSITE: *Parfleche.* Cheyenne. c. 1875. Oklahoma or Kansas. Rawhide, paint. Length: 26½ in. The Detroit Institute of Arts.

A parfleche is a simple kind of envelopelike container for storing food or other materials. The long sides of an oblong shape of rawhide are folded inward and then the ends folded to meet in the center where they are lashed together. The ends are often painted by women using nonrepresentational designs. Cheyenne parfleche painting is characterized by delicate and rather open designs outlined with thin dark brown lines, such as on this example.

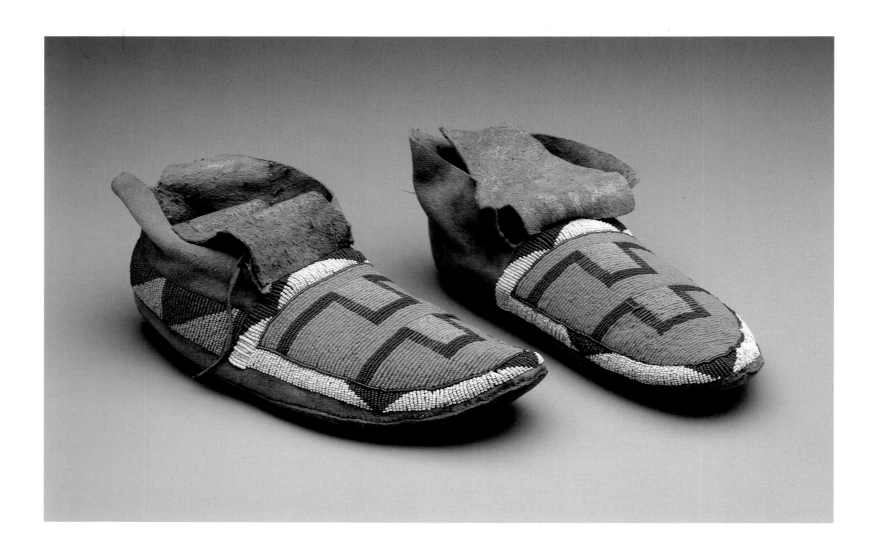

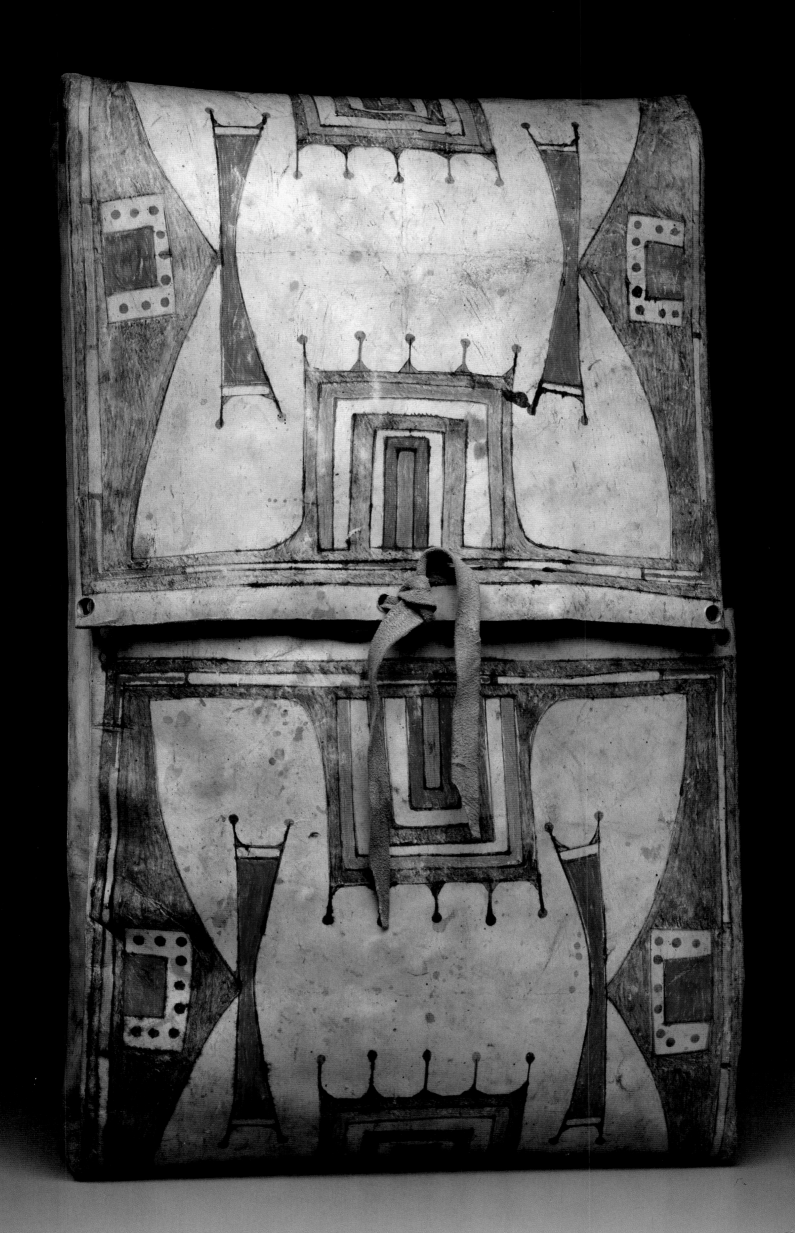

Lance Case. Crow. c. 1880. Montana. Rawhide, deerskin, glass beads, wool yarn. The Detroit Institute of Arts.

The Crow "lance case" is actually an effigy of a lance—it was never intended to hold anything. Women customarily carried their husbands' armaments and shield during reservation period parades in which the Crow emulated the panoply of moving camp. The heavily decorated lance case is part of an equestrian woman's regalia, mounted on the saddle so that the triangular head angles back behind the rider.

OPPOSITE LEFT: *Knife Case.* Cheyenne. c. 1870. Wyoming or South Dakota. Rawhide, deerskin, glass bead. Length: 12¼ in. Collection of Richard and Marion Pohrt.

This knife case that holds a steel knife with a wooden handle illustrates the classic style of Cheyenne beadwork embroidery, with its narrow bars of alternating colors and the pale blue and pink accent colors used around the border and for the narrow stripe down the middle.

OPPOSITE RIGHT: *Knife Case.* Plains Cree. Mid-nineteenth century. Northern Plains (Alberta, Saskatchewan, or Manitoba). Deerskin, glass beads, tin cones, wool cloth, wool, yarn, silk ribbon. Length: 12¾ in. The Masco Art Collection.

This knife case was worn around the neck so that it hung against the breast. Its original strap is missing. A fringe of pendants made up of white and blue beads, strips of red cloth, and tin cones decorates the tapering edges of the knife case. Both faces are beaded, the front with a series of ascending triangles that underlie a white, rectangular panel containing two skirted figures in red.

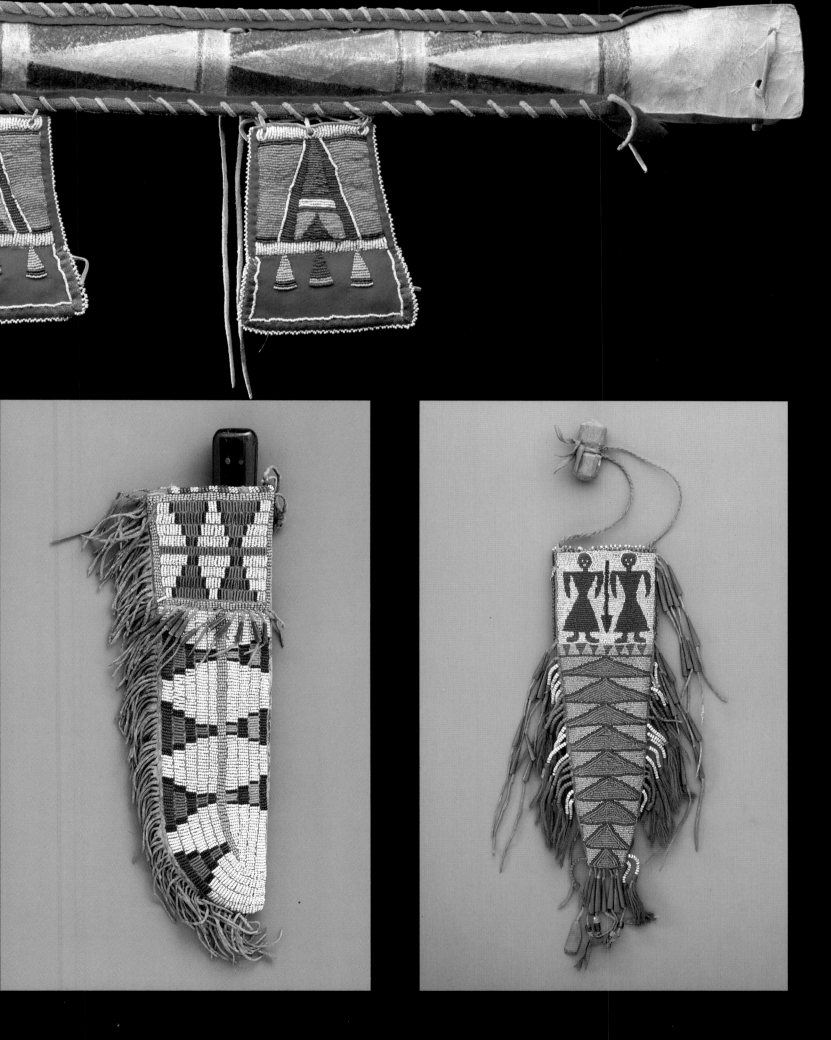

Bull Lodge's War Shield. Gros Ventre. c. 1850. Montana. Rawhide, deerskin, wool cloth, eagle feathers, brass hawk bells, glass beads, porcupine quills. Diameter: 21 in. Collection of Richard and Marion Pohrt.

This shield belonged to the famous Gros Ventre holy man and feather pipe carrier, Bull Lodge. It was given to him by Thunder Beings from the Sky World during the first of his seven visions. An image of the Thunderbird was painted on the deerskin cover of the shield, which was customarily attached with drawstring laces. The cover was lost long ago. The buffalo rawhide material of the shield itself, visible here, was painted with a central circle surrounded by three concentric rings, a reference to the sacred number four and perhaps the three ascending levels of the sky. Eagle feathers and small hide bundles, perhaps filled with tobacco offerings, were attached to the shield.

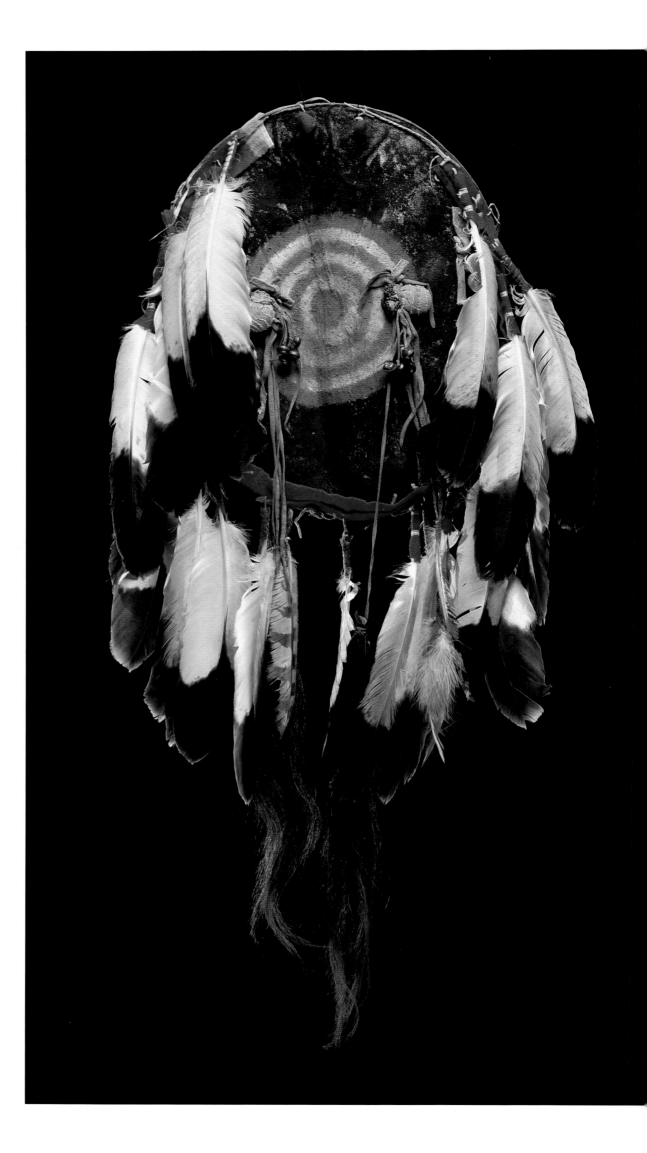

Little Rock's War Shield. Southern Cheyenne. c. 1850. Kansas. Rawhide, deerskin, eagle feathers, owl feathers, brass hawk bells, porcupine quills. Diameter: 19½ in. The Detroit Institute of Arts.

This shield belonged to Little Rock, a prominent chief of Black Kettle's band of southern Cheyenne. The shield illustrates a vision of spiritual power residing in the dome of the sky. A central Thunderbird, outlined in red, is surrounded by four additional Thunderers, one for each of the four cardinal directions. Each has a hawk bell pendant hanging from its breast. The crescent moon is visible above and the constellation Pleides below. The horizon of the earth, punctuated by four sacred mountains, frames the sky around the outer edges of the image. George Armstrong Custer captured this shield after his Seventh Calvary killed Little Rock during their 1868 raid on Black Kettle's village at Washita Creek.

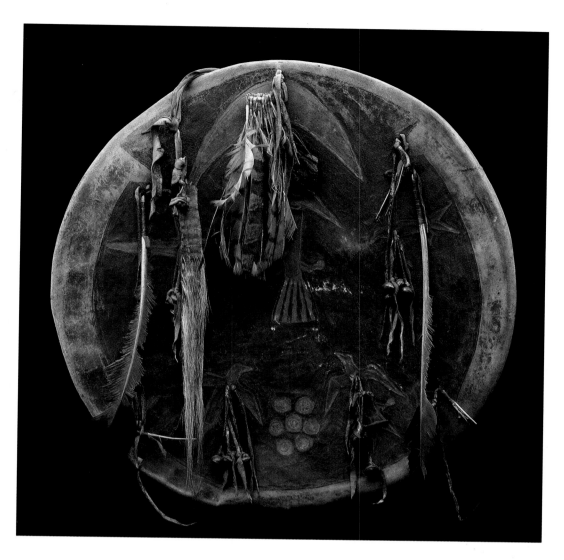

War Shield. Crow. Late eighteenth or early nineteenth century. Montana. Buffalo hide, deerskin, crane head, feathers, wool cloth, various fragments of animal pelts. Diameter: 22 in. National Museum of the American Indian, Smithsonian Institution, New York.

This shield belonged to the formidable Crow chief Arapoosh, who lived at the close of the eighteenth century. The figure represents the moon as a powerful spirit being of the sky. The crane's head and other objects attached to the face of the shield relate to Arapoosh's war medicine.

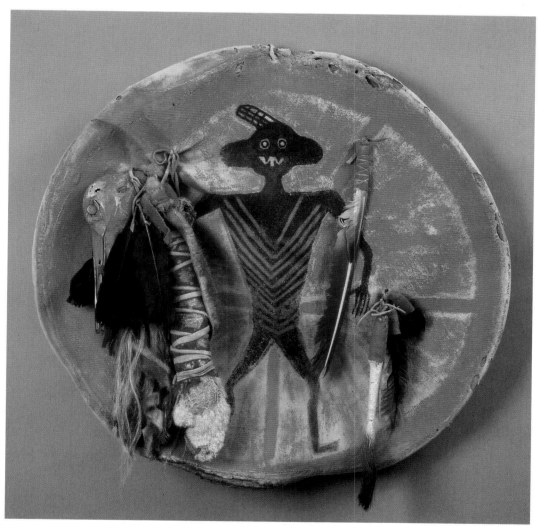

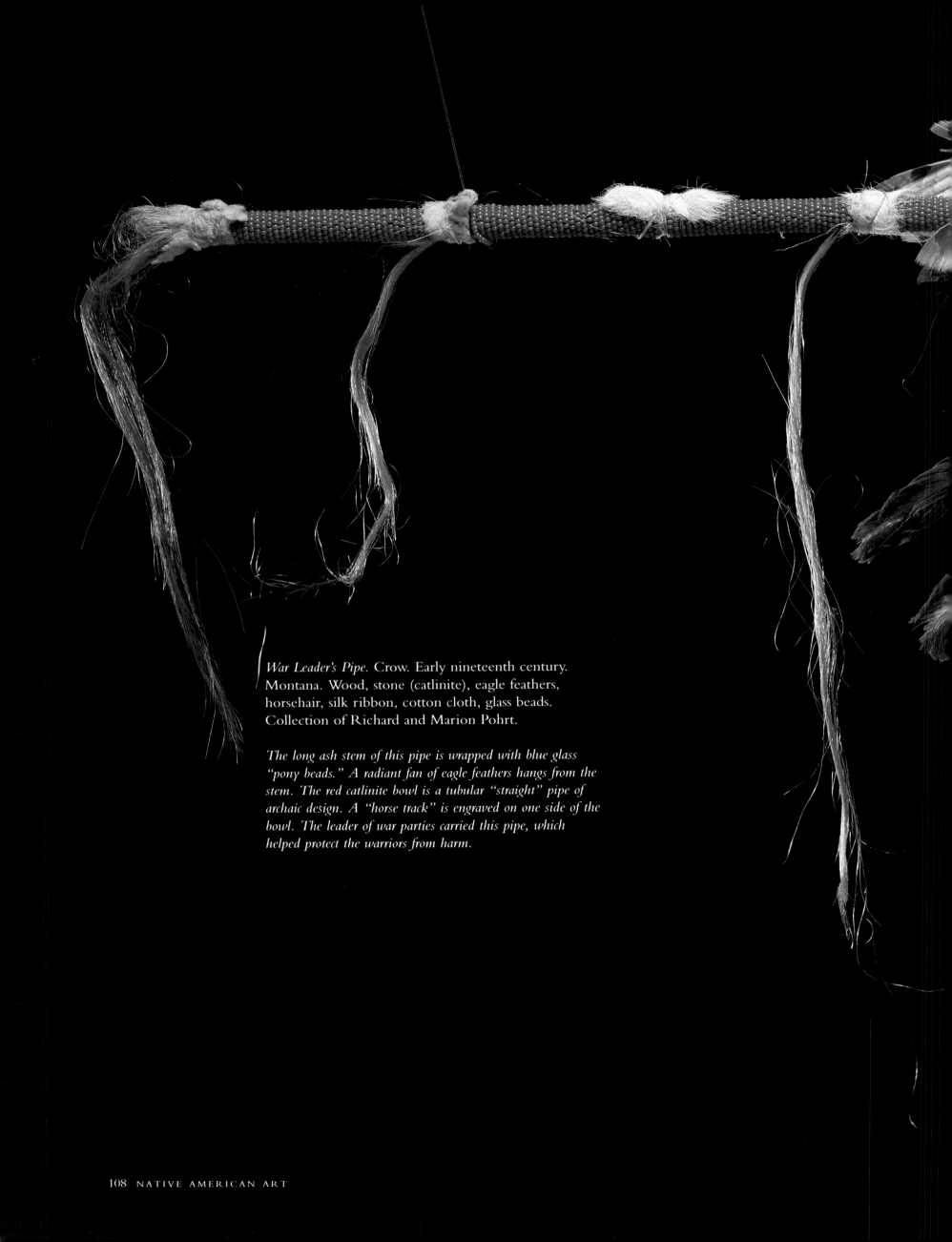

War Leader's Pipe. Crow. Early nineteenth century.
Montana. Wood, stone (catlinite), eagle feathers,
horsehair, silk ribbon, cotton cloth, glass beads.
Collection of Richard and Marion Pohrt.

The long ash stem of this pipe is wrapped with blue glass
"pony beads." A radiant fan of eagle feathers hangs from the
stem. The red catlinite bowl is a tubular "straight" pipe of
archaic design. A "horse track" is engraved on one side of the
bowl. The leader of war parties carried this pipe, which
helped protect the warriors from harm.

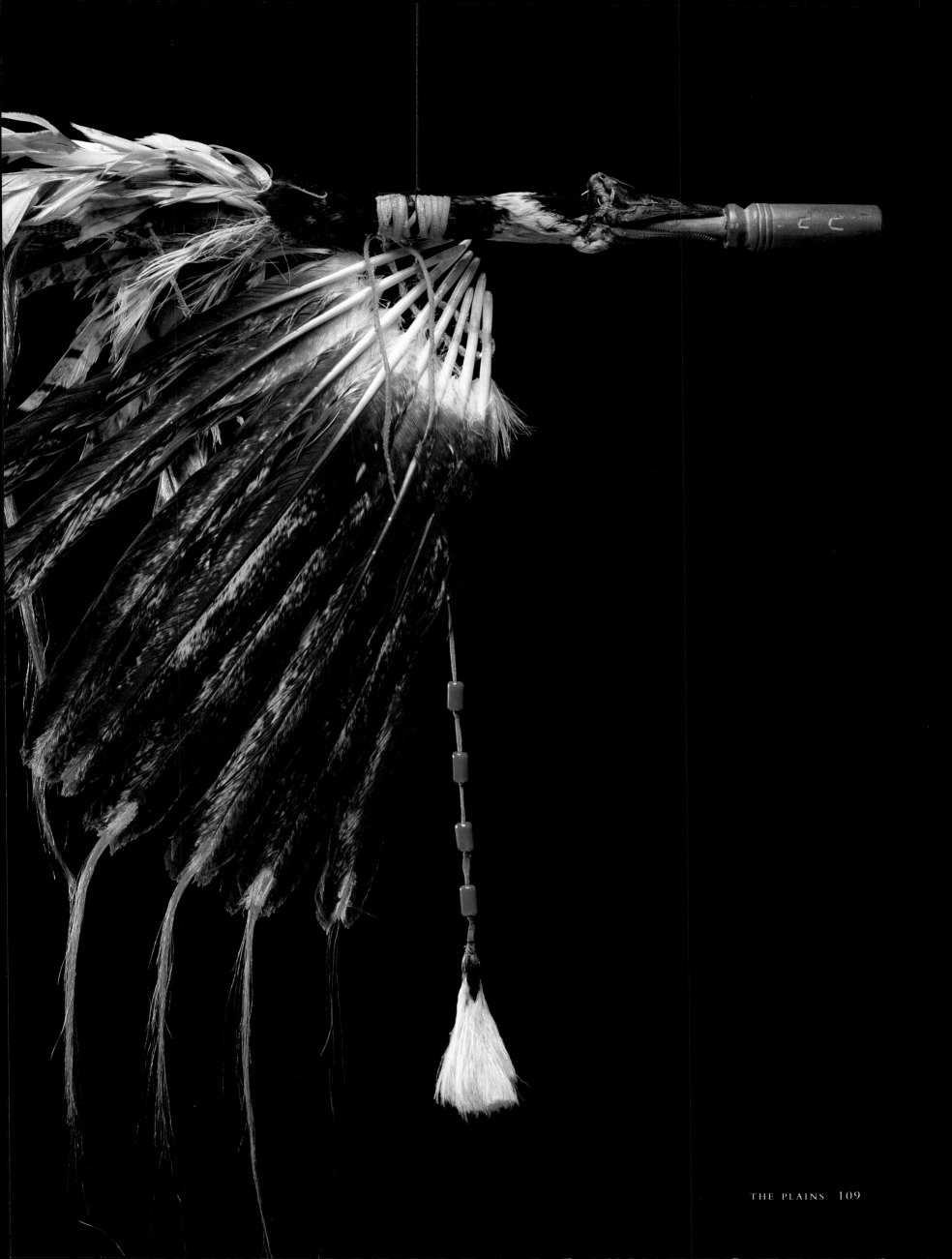

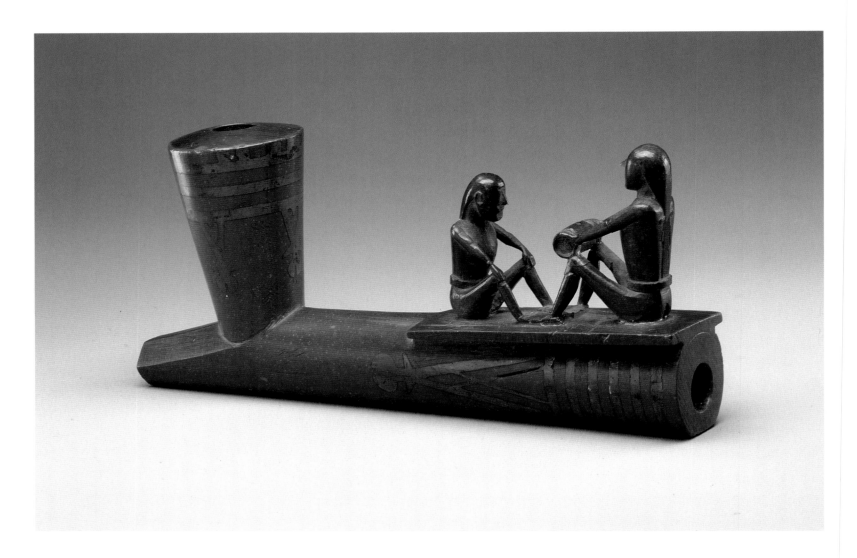

ABOVE: *Pipe Bowl.* Eastern Sioux. Early nineteenth century. Southern Minnesota or eastern South Dakota. Stone (catlinite), lead inlay. Length: 7¼ in. The Masco Art Collection.

This is one of a small number of catlinite pipe bowls produced by an accomplished and yet unknown Eastern Sioux pipe carver during the early decades of the nineteenth century. All known examples of his work include the distinctive buffalo hoof inlay visible on the shank of this pipe. Also, all are carved with finely detailed, barrel-chested figures with spindly limbs, and all his carvings address the theme of alcohol. Here, a larger figure presents a barrel of brandy to a smaller figure who faces him. Fur traders offered barrels of brandy as barter for furs, and Indian leaders of the fur trade distributed brandy to their followers in acknowledgment of their allegiance. The large figure with a barrel on his knees probably represents a fur trade chief through whom fur trade wealth, including brandy, flowed to others.

OPPOSITE TOP: *Pipe Bowl.* Lakota (Western Sioux). Mid-nineteenth century. North or South Dakota. Stone (catlinite), lead, glass bead. Length: 9¾ in. The Detroit Institute of Arts.

The prow of this massive pipe bowl is carved in the form of a horse's head. The laid-back ears, the flared nostrils, and the flying mane convey the forward momentum of a speeding horse in motion. A glass bead inlaid in a lead socket serves as the horse's glittering eye.

OPPOSITE BOTTOM: *Pipe Bowl.* Dakota (Eastern Sioux). c. 1855. Minnesota. Stone (catlinite), lead. Length: 8½ in. The Detroit Institute of Arts.

The lead inlay on this pipe bowl was accomplished by carving out the inlay patterns in shallow relief and then pouring in molten lead. Thin sheets of rawhide wrapped and bound around carved portions of the pipe held the molten lead in place while it cooled. The design on this pipe bowl is one of the most complex and elaborate patterns ever created on pipe bowls using this technique. Eastern Sioux delegates brought this pipe to the Mesquakie in an effort to enlist their support for the Minnesota uprising of 1862. It was later collected at the Mesquakie settlement at Tama, Iowa.

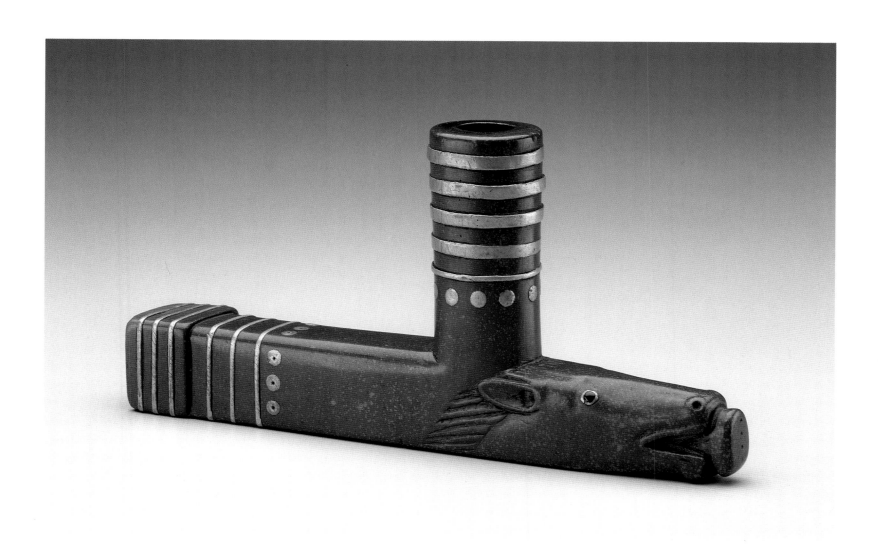

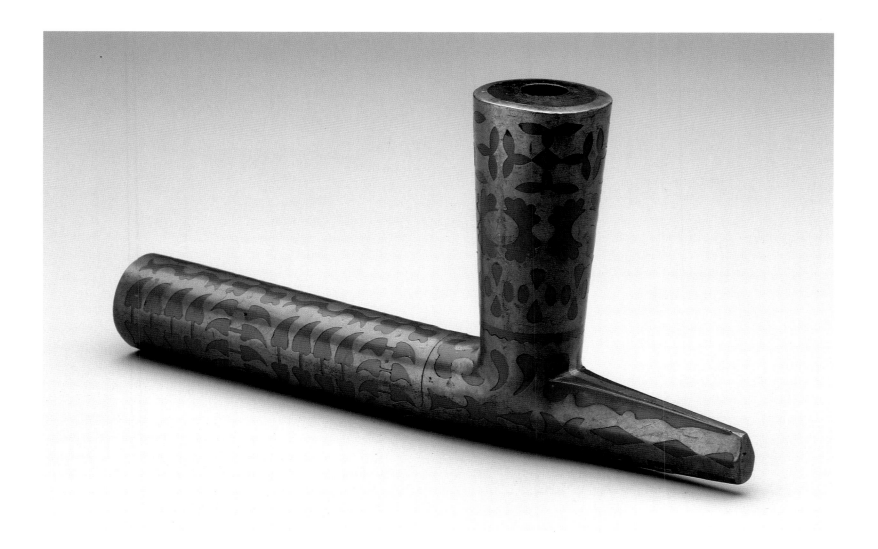

LEFT: *Dance Club.* Lakota (Western Sioux). c. 1890. Standing Rock, North Dakota. Wood, brass tacks, iron spike, glass mirror, porcupine quills. Length: 25 in. The Detroit Institute of Arts.

This elegant dance club was not intended for combat. The head carved on the top of the club represents a Crow warrior with his distinctive "pompadour" coiffure. The Crow were traditional enemies of the Lakota and so the effigy head becomes a kind of trophy, a reference, generally speaking, to Crows bested in battle. Warriors carried clubs like this when celebrating the virtues of male military prowess in the Trophy Dance and the Grass Dance.

BELOW: *Feast Bowl.* Yankton Sioux. Mid–nineteenth century. South Dakota. Wood (maple burl), brass tacks. Length: 17¼ in. The Detroit Institute of Arts.

The quizzical, reductive head carved on the side of this feast bowl represents Eyah, a spirit of gluttony. The broad bowl itself becomes Eyah's extended belly as he exhorts those at a feast to engorge themselves with copious quantities of the host's food. Gluttonous feasting honored the host and addressed a cultural value that advocated consumption of food when it was available in case famine were to follow.

Seated Figurine. Caddo. Late eighteenth or early nineteenth century. Oklahoma. Wood, human hair, cloth. Height: 6¾ in. National Museum of Natural History, Smithsonian Institution, Washington, D.C.

Archaeologists have discovered that the ancestors of the historic Caddo peoples participated in the Mississippian cultural pattern. Although the specific cultural meanings of this sculpture had been lost by the time it was collected, the piece does relate to earlier, prehistoric wood sculptures recovered from the Craig Mound at Spiro. During the Mississippian period, such sculptures represented sacred ancestors or culture heros.

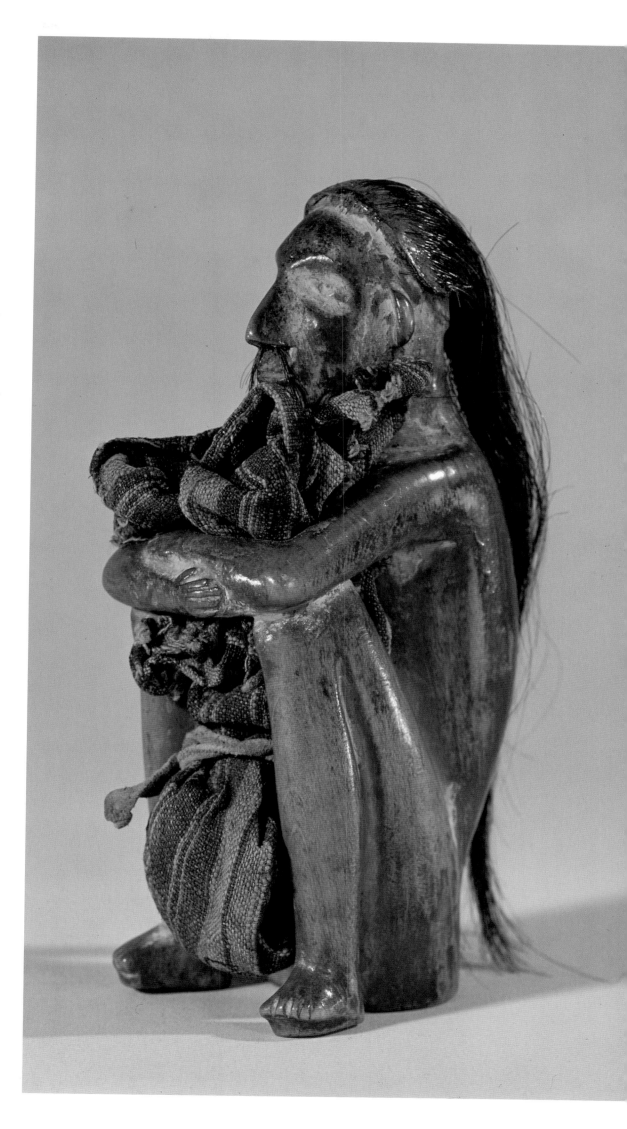

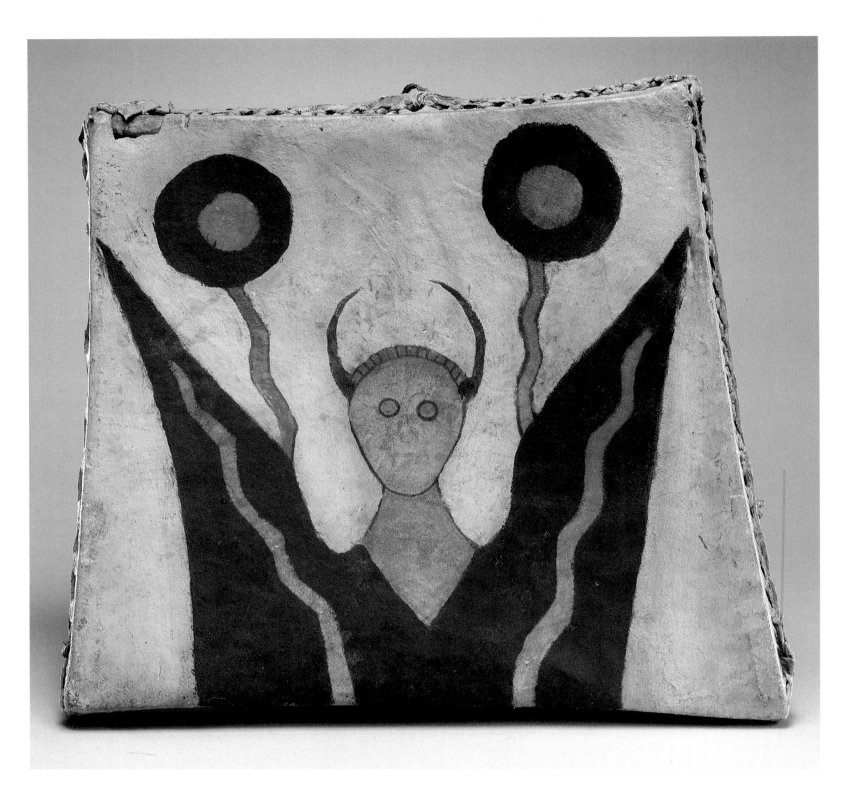

ABOVE: *Square Hand Drum*. Assiniboine or Yanktonai. c. 1860. Fort Peck Reservation, eastern Montana. Deerskin, wood, pigment. Collection of Richard and Marion Pohrt.

A hand drum was played to accompany songs of prayer during the religious ceremonies of many different northern Plains peoples. This one is unusual because of its square shape and its powerful visionary image of a horned spirit being with wings. Colored spheres of spiritual energy float above each wing. A similarly shaped hand drum with buffalo horns attached once belonged to the Hunkpapa Lakota, Sitting Bull.

OPPOSITE TOP: *Page from an Autograph Book: Double Woman Dancers*. Brule (?), Lakota (Western Sioux). c. 1890. Rosebud Reservation, South Dakota. Paper, colored pencil, ink. Length: 9 in. The Detroit Institute of Arts.

This drawing represents the dance of Double Woman, who offered women gifts of either great talent in craftwork, or the power to seduce and control men sexually.

OPPOSITE BOTTOM: *Robe with War Exploits*. 1797–1805. North Dakota. Buffalo hide, dyed porcupine quills, paint. Length: 102 in. National Museum of Natural History, Smithsonian Institution, Washington, D.C.

This robe illustrates its original owner participating in at least ten different battle episodes.

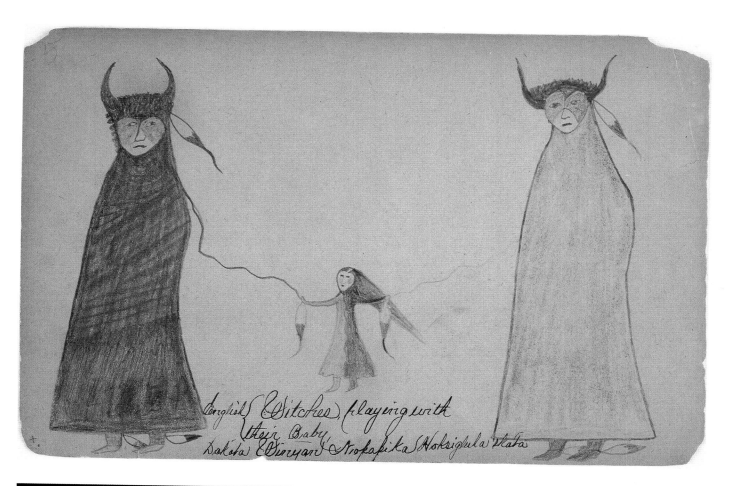

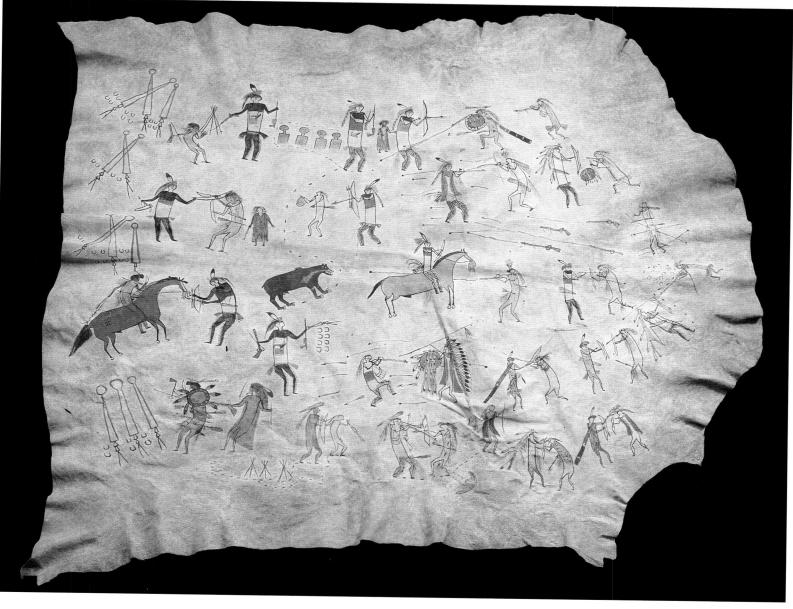

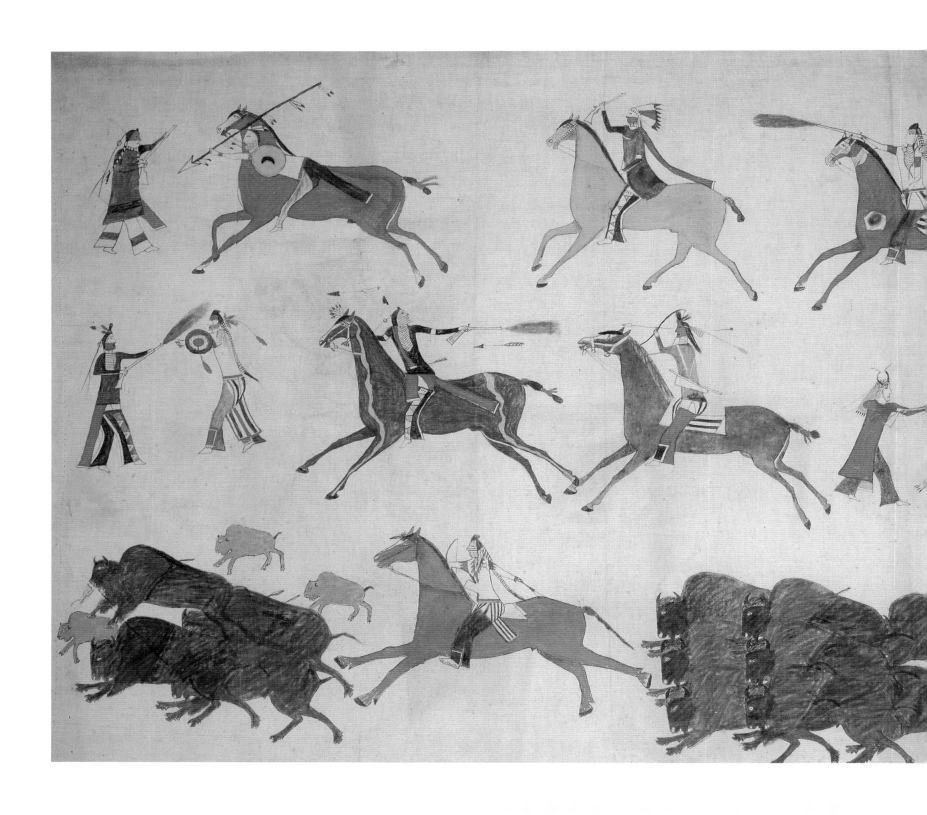

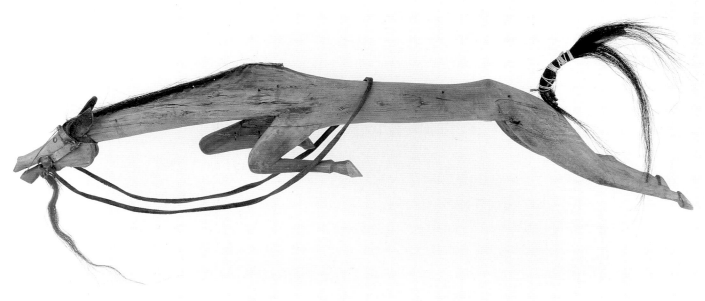

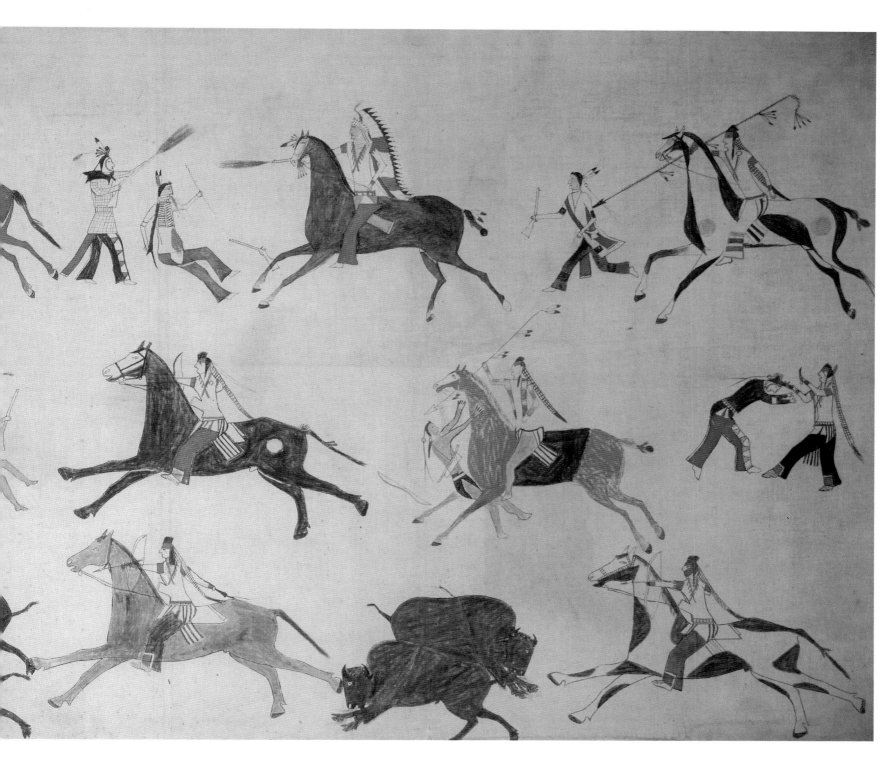

OPPOSITE: *Horse Dance Stick.* Lakota (Western Sioux). Late nineteenth century. Standing Rock, North Dakota. Wood, hide, horsehair, paint. Length: 37½ in. Robinson Museum, Pierre, South Dakota.

This large and impressive carving represents a wounded horse charging into battle. During the reservation period, men danced with "horse sticks" during the Grass Dance to commemorate the bravery and suffering of special horses they had owned who had been wounded in battle. The Hunkpapa warrior No Two Horns, for example, carved several horse sticks to honor his horse that died only after having been shot seven times. This large horse stick may have been carved by No Two Horns or inspired by those carved by him. Blood flows from five bullet wounds visible in the image—in the neck, shoulder, side, and flanks.

ABOVE: *Tipi liner with Battle Pictures.* Crow (?). Montana. Muslin, paint. Length: 86 in. America Hurrah, New York.

A tipi liner, or dewcloth, fits inside the tipi as an inner wall, providing privacy so that firelit shadows of the inhabitants are not projected against the wall, as well as an extra measure of insulation. Tipi liners are frequently decorated with designs—in this case, a male artist painted battle scenes and a buffalo hunt.

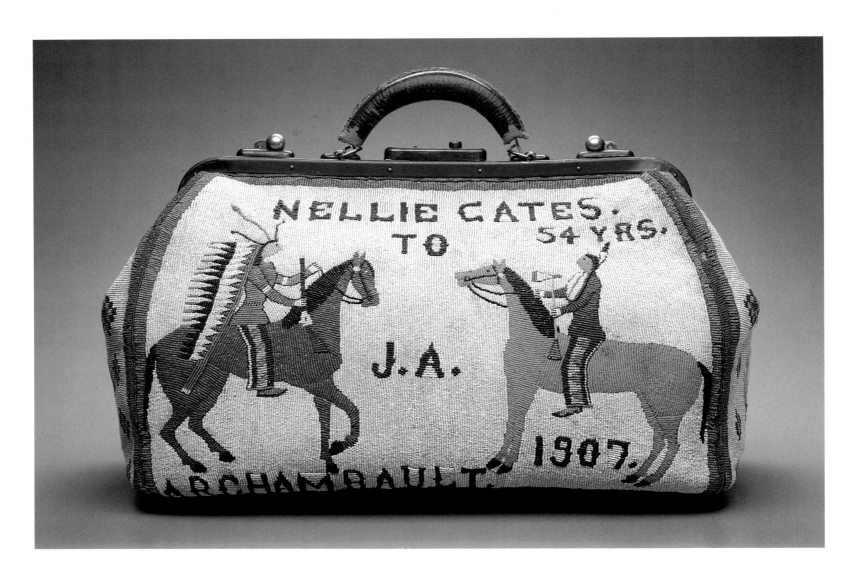

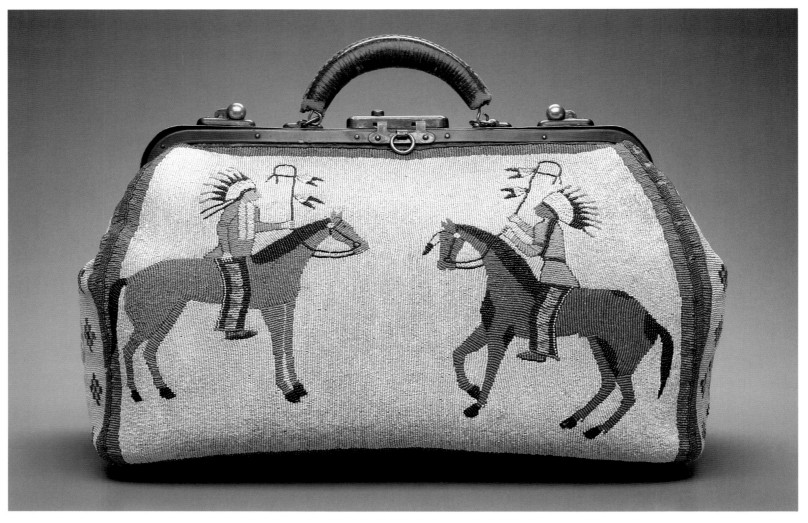

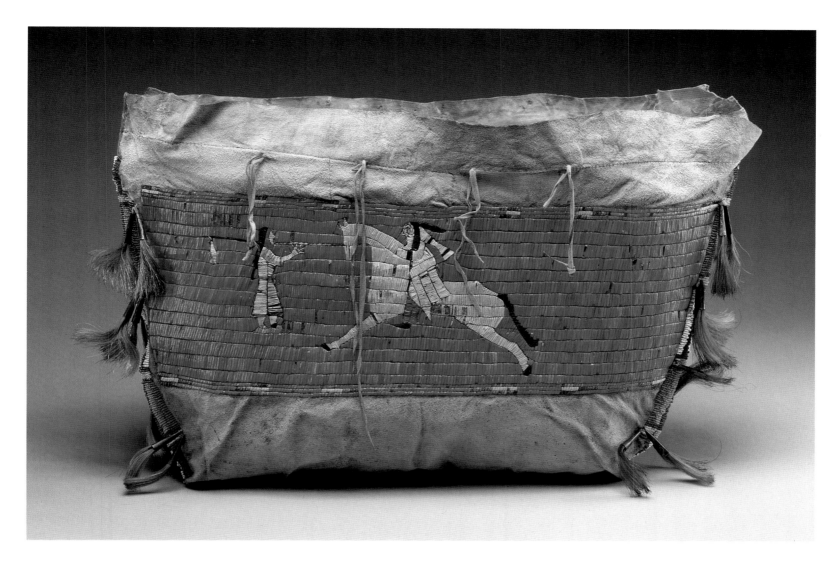

OPPOSITE: Nellie Gates. *Traveling Bag.* Lakota (Western Sioux). 1907. Standing Rock, North Dakota. Commercial traveling bag, glass bead decoration. Length: 18 in. The Masco Art Collection.

Nellie Gates was one of several extraordinary and talented Lakota beadworkers who innovated a distinctive style and genre of glass bead embroidery at Standing Rock during the early twentieth century. This bag was produced for J. A. Archambault and it remained in the Archambault family until very recently. Instead of customary, geometric designs in parallel stitch, Gates experimented with lively, representational images executed with a flat, "spotstitch" technique. Here, mounted warriors on horseback flank the beaded inscription.

ABOVE: *Storage Bag.* Lakota (Western Sioux). c. 1890. Rosebud Reservation (?), South Dakota. Cowhide, porcupine quills, glass beads, tin cones, dyed horsehair. Width: 24¼ in. Buffalo Bill Historical Center, Cody, Wyoming.

Brule Lakota women of the Rosebud Reservation continued to favor porcupine quills for decorative embroidery throughout the late nineteenth and the twentieth centuries. Many Brule women excel in this medium today. Their work is often characterized by the abundant use of bright, vermillion-dyed quills. Here, the quillworker adapted a design derived from men's "ledger book art," presenting a scene in which a warrior dressed in a capote on horseback counts coup with a lance on an enemy woman. Such images captured in pictographic drawings would often recall the event of a specific warrior's accomplishment as a part of his war record. In this design the women celebrate, in a broader sense, Lakota men's bravery in combat.

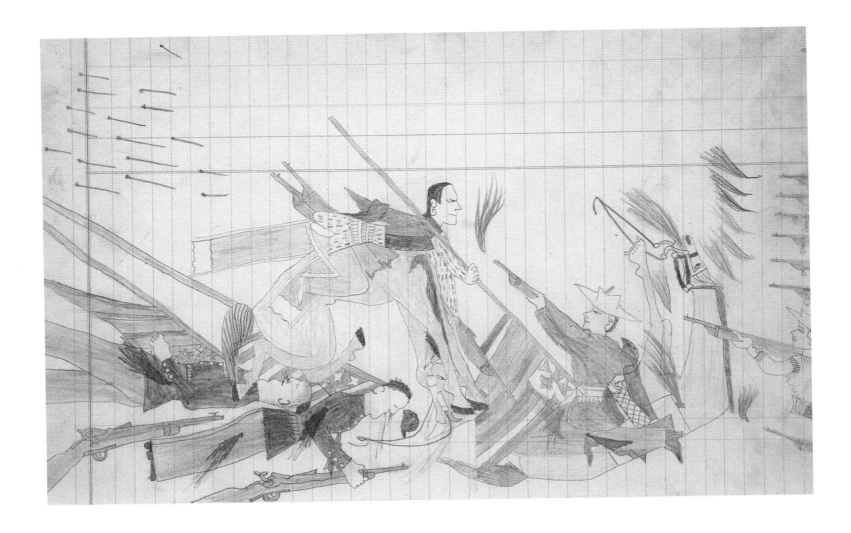

ABOVE: Yellow Nose. *Drawing of the Battle of the Little Bighorn.* Cheyenne. c. 1885. Cheyenne Reservation, Oklahoma. Ruled paper, colored pencil, watercolor, ink. Length: 12½ in. National Museum of Natural History, Smithsonian Institution, Washington, D.C.

Several years after the event, the Cheyenne warrior Yellow Nose drew pictures that illustrated his part in the famous battle of 1876 when George Armstrong Custer lost his life. This particular exploit of Yellow Nose was remembered by many Cheyenne and Lakota who witnessed it. Yellow Nose charged among Custer's men who had dismounted to use their carbines. He grabbed a flag from one of the troopers, and as he rode among the enemy, their bullets flying around him, Yellow Nose struck them with the end of the flag. In this extraordinary drawing, Yellow Nose depicts the wild gyrations of his horse among the panicked and dying enemy as he cooly leans forward with the flag to count coup on the soldiers.

RIGHT: *Quirt.* Osage. c. 1860. Missouri and Oklahoma region. Engraved elk antler. The Detroit Institute of Arts.

A quirt is an item of equestrian equipment like a rider's crop. Quirts belonging to Plains warriors were treasured personal belongings that, like many possessions, were closely tied to the identity and history of their owners. This quirt is engraved with a portion of the owner's war biography: a scene of a horse-stealing raid. Two warriors lead horses away, presumably after capturing them from their enemies.

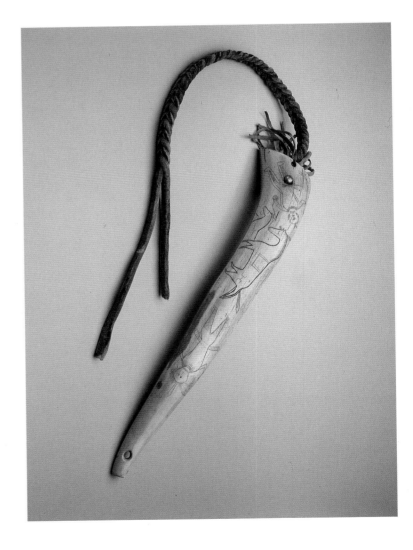

WOHAW

During the winter of 1874, the military organized a great campaign known as the "Red River War" against the Kiowa, Comanche, Cheyenne, and Arapaho tribes of the southern Plains. Camps were burned and the people rounded up and brought into the forts. Seventy-four men, identified as the principle warriors of the tribes, were sentenced to prison, and were sent by railroad to Fort Marion, in St. Augustine, Florida.

Like all men of the Plains, these warriors had been raised in the traditions of pictographic art—the practice of rendering life experiences in drawings, particularly those of battle. The superintendent of the prison at Fort Marion, General Richard H. Pratt, encouraged the young men to produce drawings in the pictographic tradition for sale to visitors to the fort and provided paper, pencils, pens, and ink.

St. Augustine had become a sunny resort town during the 1870s that catered to winter visitors from the North. The Fort Marion prisoners became a local attraction. The entrepreneurial spirit of curio production, General Pratt believed, would help convert the prisoners into productive citizens. The content of the drawings gradually shifted from horse raids and battles to more personal and cultural experiences. Many even recorded life at the fort: standing in ranks in prison uniforms, dancing for visitors, and memories of the train ride from their homeland.

The hundreds of drawings produced by the Fort Marion prisoners, however, represent far more than simple souvenirs. In a sense, they can be considered the beginnings of modern American Indian art. In the media of paper and pen, the men of Fort Marion mediated between their experiences and those of their non-Indian buyers. Their images are often filled with keenly observed detail, thoughtful reflection, and occasionally, a sense of humor that no doubt escaped the attention of most buyers.

In this drawing, the Kiowa warrior Wohaw depicts a group of equestrian warriors elegantly dressed with eagle feather headdresses. The drawing recalls the panoply of a successful war party's return home amidst the praises of their people. Drawings like this helped transform the memory of experience into a legacy of tradition that would nurture the pride of future generations of Plains people.

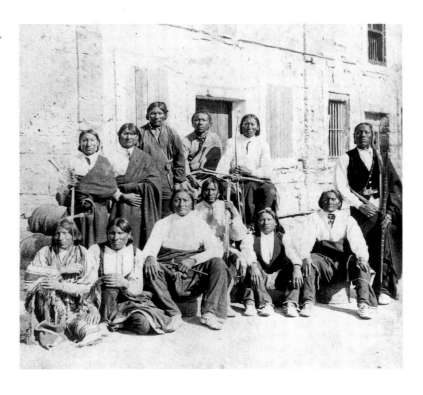

Prisoners at Fort Marion, St. Augustine, Florida, shortly after their arrival in 1875.

Courtesy of William B. Becker.

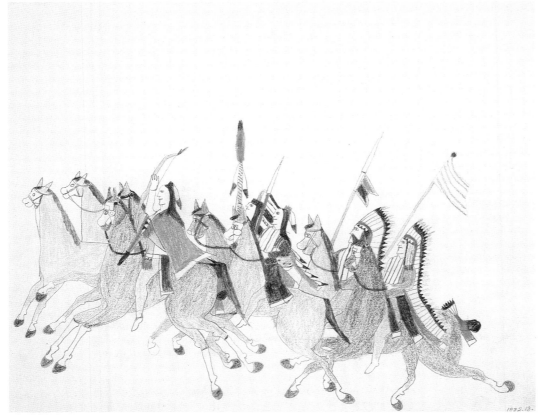

WOHAW (Kiowa). *Drawing.* Late 1870s. Fort Marion, St. Augustine, Florida. Paper, pen, watercolor. 8¾ x 11¼ in. Missouri Historical Society, St. Louis.

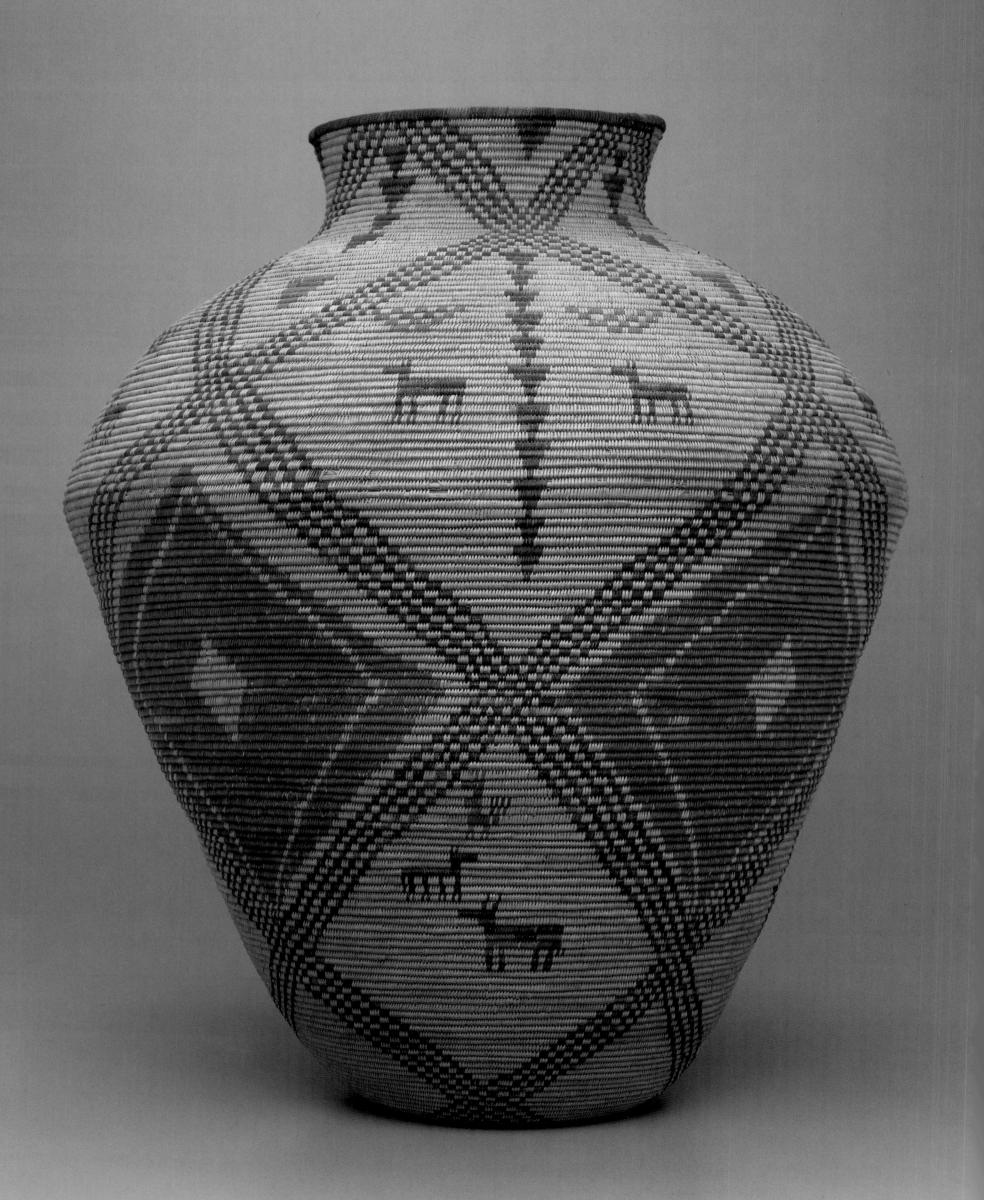

THE SOUTHWEST

The North American Southwest is best characterized by its geographic isolation from the rest of the continent. Far to the south lies the distant, high terrain home to the Mexican cultures that historically maintained only the most tenuous of contacts with the low, arid, and forbiddingly hot region of southern New Mexico and Arizona and the northern Mexican Sonora. To the west and north extends the basin and plateau country of Nevada and Utah, regarded as one of the most difficult terrains in North America. The front range of the Rockies shields the Southwest interior from the southern Plains, pierced only by a small number of passes that eventually became principle routes of trade from the Southwest to the outside world. Communities such as Taos and Pecos, perched at the points where the peoples of the Plains and the Southwest intersected, flourished as locations of great trade fairs. At the heart of the Southwest flow two large river systems: the Rio Grande, which descends east to the Gulf of Mexico, and the Colorado, which drains west to the Gulf of California. The headwaters of both spiral inward toward one another, with innumerable forks and tributaries, to meet in the watersheds of the high Colorado plateau.

ANCIENT PEOPLES

Some stories of origin for many Native American people involve periods of wandering or migration prior to settlement; others relate a more spontaneous arrival. Modern Pueblo people of the Southwest think of themselves as having emerged from the ground at the site of their current homeland. Zuni refer to themselves as the "daylight people" whom Father Sun had summoned out of the Underworld to give him offerings in return for the blessings of sunlight. Archaeologists confirm that many people of the Southwest are, in fact, descended from ancestors that seem to have lived there from the beginning of human life in the region. Over time, other societies migrated from elsewhere.

Originally, the Southwest was host to four major populations, each of which emerged from an earlier hunting and gathering tradition of the Southwest Archaic (5000–100 B.C.). The Pima and Papago of southern Arizona may be the modern descendants of the Hohokam, who established themselves in the area of southern Arizona and the northern Mexican Sonora. The Patayan lived to the west, in the region of the lower Gila and Colorado rivers, surviving today as Yuman-speaking peoples: the Yavapai, Walapai, Havasupai, and Mohave. The Mogollon, who inhabited the northern Sonora of central Arizona and New Mexico, and the Anasazi of the Colorado plateau to the north represent the ancestors of the modern Pueblo. A fifth group, the Athapaskan-speaking Navajo and Apache were relatively recent arrivals, migrating south from Canada sometime during the fifteenth century.

By 300 B.C., the hunting and gathering peoples of the Southwest knew of corn, squash, and beans, and began to incorporate the cultivation of these domestic plants

into their way of life. It was not an abrupt transition; rather, agriculture supplement-ed a diet that also included wild game and food plants. For different communities, at different times, the factors involved in harvesting wild versus domestic foods led peo-ple to favor agriculture and settled village life. Small groupings of pit houses sur-rounded arable spaces for planting, as domestic agriculture in the Southwest emerged and struggled with the delicate balance between the length of the growing season and the amount of available water. In the south, the growing season is long but precipi-tation scarce. To the north, rainfall is more abundant, but higher elevation shortens the growing season. Southwestern agriculturists explored a wide range of techniques and practices to manage water and nurture corn plants to successful maturity. Little wonder, then, that water and corn figured prominently in the cosmologies and ritu-al practices of the Southwest.

The Patayan traditions of the Colorado basin had developed agricultural practices by A.D. 300 based upon the regular inundation of the river bottoms by annual flooding. They farmed the river flats while supplementing their agricultural diet with wild foods. Houses and shelters were small—some ephemeral, some more permanent. This way of life continued from the beginnings of agricultural practice in the region up through the recorded lifeways of the historic Yuman tribes.

The Hohokam (300 B.C.–A.D. 1450) settled one of the most difficult terrains of the Southwest—the arid southern Sonora in the vicinity of the lower Salt and Gila rivers near present-day Phoenix, Arizona. Snaketown, the largest Hohokam city, housing up to one thousand inhabitants, depended upon miles of irrigation canals to water its cornfields. Founded early in the eighth century, Snaketown was organized around a central court surrounded by small, rectangular houses. Platform mounds, a ball court, and imported, small cast-brass bells found at this site indicate close cultural ties to Mexico to the south. Snaketown was the center of a widespread network of Hohokam settlements—large, nucleated communities that remained active until after the thirteenth century. All were sustained by extensive, meticulously engineered irri-gation systems created in response to the parched desert environment. After the four-teenth century, the Hohokam returned to a far more diversified economic system, living in dispersed *rancheras* villages spread out across the landscape, and came to depend upon a proportionately wider range of wild foods.

The Mogollon culture developed in the Southwest heartland, near the present-day central Arizona–New Mexico border. Beginning around A.D. 500, individual villages that became primarily agricultural moved from higher mesa and ridge locations down to sites situated on river terraces where deep alluvial soils retained the ground water necessary to nurture corn. After A.D. 700, agricultural communities abandoned the construction of pit houses and replaced them with rectangular surface dwellings built of stone masonry composed of many residential rooms with shared walls. These "cellular" apartment complexes were often arranged on either side of a central court, the larger structures sometimes including several hundred rooms. The best known Mogollon communities of this kind were located in the Mimbres valley and were known to produce hemispherical ceramic bowls that were placed in graves with the dead and painted with lively representational images of animals and humanlike fig-ures. "Classic" Mimbres pottery of this type presents a rich corpus of symbolic images deeply entrenched in Mogollon mythology.

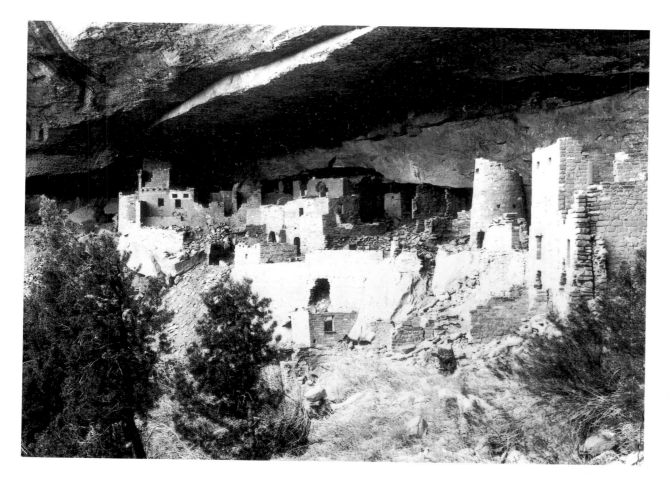

Cliff Palace, Mesa Verde, southern Colorado. This Sumner Matteson photograph of 1900 illustrates the solid masonry construction of this twelfth-century Anasazi town.

The Science Museum of Minnesota.

High in the mesa country of the Colorado plateau, a gradual shift from hunting and gathering wild foods to agriculture characterized Anasazi life over the five centuries from A.D. 400 to 900. Strategies to improve agricultural production included terracing, irrigation, and plotting fields in grids to aid access to run-off water. As was the case with the Mogollon to the south, above-ground "pueblos" replaced pit houses as dependence on agriculture grew. In Chaco Canyon of northwest New Mexico, startling developments in community planning took place during the period known as Pueblo II (A.D. 900–1100). Thirteen major sites and dozens of smaller ones interacted as a massive "macro-community," each location part of a network of ceremonial causeways, watchtowers, and elaborate water management projects. The largest site, Pueblo Bonito, was built as a five-story, semicircular apartment complex of stone masonry with over eight hundred rooms terraced back from a central courtyard.

After A.D. 1100, similarly massive architectural projects were constructed to the north in the Mesa Verde region of southwest Colorado, including the spectacular "Cliff Palace" of over two hundred rooms. By A.D. 1300, however, these locations could no longer support their populations and they were eventually abandoned. Anasazi migrating south to establish new pueblo sites merged with Mogollon populations during Pueblo IV (A.D. 1300–1500). These later communities combined stone masonry techniques of the plateau country with adobe brick construction materials where stone was not plentiful. These were the people, scattered throughout the Rio Grande valley and west between present-day Acoma, Zuni, and the Hopi mesas of Arizona, encountered by Coronado when he journeyed north from Mexico to find the mythic "five cities of Cibola" in 1540.

When the Spanish established their colony in the valley of the Rio Grande, they found not only villages of agriculturalists they called "Pueblos," but also bands of

aggressive hunting and gathering peoples that often preyed upon the villages and the New Mexican *haciendas* for their stores of grain. These were the Navajo and Apache, Athapaskan speakers whose closest linguistic relations are found far to the north in the Canadian Northwest territories. The *Dineh*, as they called themselves, proved exceptionally flexible and adapted readily to the opportunities and examples offered by their new neighbors. Although they never adopted agriculture, the Navajo were profoundly influenced by the symbolic character of Pueblo ritual practice and religious thought, merging them with their own distinctive cosmology. Navajo women learned quickly how to weave textiles from the Pueblo and Mexicans and gathered wool from sheep introduced by the Spanish. The Eastern Apache retained much of the culture derived from their history on the Great Plains, yet the Western Apache appropriated many of the traits and practices of their Pima and Yuman neighbors to the west, including the production of coiled basketry. All in all, the Athapaskans were utterly transformed by their entry into the world of the Southwest after A.D. 1500, and yet enriched its cultural life immeasurably despite a sometimes hostile relationship with their neighbors.

Spanish colonization of New Mexico during the seventeenth century was marked by difficult relations between the Spanish and the indigenous Pueblo, culminating in the Pueblo revolt of 1680 and the eventual reconquest of New Mexico by the Spanish between 1692 and 1694. Although burdened, Pueblo communities retained a large degree of independence under Spanish rule, since traditional structures of community organization and leadership retained real power within the Pueblos.

With the Mexican War of 1846, General Stephen Watts Kearney's "Army of the West" claimed New Mexico and what would eventually become Arizona for the United States. "Anglo" easterners found a curious mixture of Spanish rural culture and Hispanic-influenced Indian communities that were equally foreign to these most recent conquerors.

The Navajo and Apache suffered severely under the new American administration. Hostilities with the Navajo culminated in Kit Carson's invasion of Navajo territory with the intention of permanently removing the Navajo from their homeland. Between 1863 and 1864, hundreds were killed and over nine thousand were captured and sent to endure concentration-camp conditions at the notorious Bosque Redondo reservation in southern New Mexico. In 1868, more enlightened policies allowed the Navajo to return to northern New Mexico and Arizona to the site of the current reservation. The Chiricahua Apache fared even worse. After being forced to move from one unsatisfactory reservation site to another, the Chiricahua under Geronimo fled to Mexico twice in the early 1880s. Deceived by the false promises of General Nelson A. Miles in 1886, Geronimo and his band were imprisoned in Florida after returning across the Rio Grande. The Chiricahua did not experience freedom again until 1913.

The arrival of the railroad to Albuquerque in 1878 opened up a new era for the Southwest. Once distant and inaccessible, it soon became a tourist destination. Fred Harvey, a restaurateur who at first simply intended to make the grueling passage through the Southwest in an 1880s railway car palatable by providing meals, soon recognized that a fortune could be made promoting the arts, crafts, and culture of the

Southwest's Indian people. Harvey was one of many entrepreneurs and traders who began to promote and market Native American art of the Southwest actively as an incentive for tourism. The economy of the Southwest has been, to a large degree, dependent upon the tourist dollar ever since.

VISUAL TRADITIONS

As was the case with many of the cultural traditions in North America, the handwork of the peoples of the Southwest often combined utilitarian purpose with the visual expression of aesthetic ideas. The earliest archaeological record of the region includes tools made of stone and bone, ornaments of imported shell and exotic stone, as well as a variety of other everyday objects that were crafted with attention to purpose and beauty.

The people of the Archaic Southwest were consummate basket makers. As early as 6000 B.C. they were making shallow trays and burden baskets with the technique of twining as well as coiled baskets woven water-tight with a one-rod foundation for cooking with hot stones. Some of the finest baskets produced in the Southwest have been located by archaeologists in caves where they most likely had been placed as offerings. Some of these baskets were filled with clay effigies and various other ceremonial items.

The yucca plant and milkweed yielded fibers which the ancient people of the Southwest used to create bags, sandals, tumplines, and other textile products. Cotton was introduced from Mexico by A.D. 600. The Anasazi wove with looms, making shirts, robes, kilts, sashes, breechclouts, and other garments and accessories, some painted with elaborate geometric patterning resembling that found on pottery. Few of these textiles survive, however, due to their ephemeral nature.

Pottery was introduced to the Southwest from Mexico by approximately A.D. 400 and supplemented the indigenous traditions of basket making. The earliest wares were not decorated, but by A.D. 600 both Hohokam and Mogollon potters adorned their wares with linear patterns painted with red and brown paint against buff or tan slipped surfaces. Hohokam potters favored repetitive patterns of simple, abstracted life forms: birds and figures arranged in swirling compositions across the form of the vessel. White-slip grounds painted with black mineral and carbon paints appeared among Mogollon and Anasazi ceramics by the eighth century A.D., setting the stage for the magnificent black-on-white traditions of the classic Mimbres and Anasazi periods Pueblo II and III, from A.D. 900 to about 1300. Innovative potters expanded upon a basic decorative vocabulary of stepped frets, interlocking spirals, and other geometric motifs made up of solid black, white, and hatched elements, and conceived designs in almost limitless variation that can be seen on millions of pots produced at sites across the central and northern Southwest.

Southwest pottery served three basic purposes: as utilitarian ware, including items such as water jars, storage vessels, dippers, and serving bowls; as ceremonial vessels placed with the dead or given as offerings; and as objects to be traded. Any single vessel might be used for one or more of these purposes, although the more elaborately decorated ceramics were favored as ceremonial and trade ware.

The Mogollon people of the Mimbres valley created startlingly beautiful and symbolically enigmatic black-on-white ceremonial bowls painted with animals and mythical figures. Burials dug into the floors of houses might include several of these bowls inverted over the head of the deceased with holes punched through the bottoms, perhaps to release the spirit of the dead or to ritually "kill" the vessel. For trade, elaborate black-on-red or polychrome pottery known as the White Mountain Red Wares was produced among the western pueblos after A.D. 1100 and proved particularly popular for ceremonial use. Wingate Black-on-Red, Fourmile Polychrome, and Pinedale Polychrome are only some of the variations of this pottery style that were traded throughout the Southwest up through the fifteenth century A.D.

Pottery of the historic Pueblos followed local traditions and techniques. The type of ware was defined by the properties of local clays: the thick, sand-rich clay of the Hopi villages required no additional temper and was "floated" (moistened and polished) without a slip to create its satiny, buff-yellow surfaces; the gray, sedimentary clay of Zuni Pueblo, which required thorough grinding and the abundant temper of ground pottery, was slipped with a white kaolin-like mineral pigment.

Girls learned pottery making from their elder female relations. They were instructed how to prepare the paste with grinding, to temper, and then to knead the result to the proper consistency. The vessel must be carefully built with coils of clay, then smoothed to strengthen the walls of the pot. Thorough polishing and buffing of the surfaces was necessary to prepare the pots for painting. Mothers taught their daughters how to fire their pots outdoors, without a kiln, by piling up fuel around them and carefully controlling the flames. But when it came to decoration, the elder women told their young to seek designs in their dreams. The cultural definition of design was so powerful among the traditional Pueblo that, generally speaking, Zuni girls dreamed of Zuni pots, and Hopi girls dreamed of Hopi pots. But, regardless of the cultural origin of the vision, the emphasis on the pursuit of personally inspired designs as "gifts" from the spirit world through dreams encouraged the ongoing growth and development of design within the framework of tradition.

Pueblo weaving was one of the most important of all the Pueblo craft traditions. Early Spanish colonists remarked on Pueblo weaving ability and collected abundant quantities of cotton *mantas* (wrap-around shawls or dresses) as annual tribute. With the introduction of Spanish domestic animals during the sixteenth century, Pueblo weavers began to employ wool in their textiles along with trade dyes and the unraveled yarns of Spanish cloth. During the following centuries embroidery began to replace paint as a means of decorating textiles and can be seen gracing the long edges of formal *mantas* or the free-hanging ends of sashes worn around the waist as belts. Pueblo people employed the most elaborately decorated textiles as garments or decorative accessories for ritual performance.

Basketry became less important to the historic Pueblo with the advent of pottery and, later, the availability of well-made baskets from Apache neighbors. To the west, however, the Pima, Papago, and Yuman-speaking Havasupai, among other groups, retained a lifestyle and economy dependent upon basket weaving that had changed little from their prehistoric ancestors. Navajo and Apache immigrants to the region

learned to make coiled and twined baskets from their new neighbors. The Western Apache became particularly proficient at the production of fine coiled baskets made with willow or sumac splints and enlivened with patterns sewn with pale willow splints, black "devils claw," and red sumac. Initially, Apache women applied designs only to trays and shallow bowls; covering the baskets with pine-pitch made them water-tight. The tourist market inspired Western Apache women to make large coiled basketry *ollas,* or jars, some over four feet high, decorated with designs previously seen on trays and bowls. These large and ambitious projects, in which graceful form is combined with immaculately controlled surface design, are among the most accomplished baskets ever made.

The Navajo learned the technique of weaving wool with an upright loom from the Pueblo. The earliest Navajo textiles, dating to the seventeenth century, resemble the *manta* dresses of their Pueblo neighbors, but the patterns soon changed. Navajo women used tapestry technique rather than embroidery to create designs. Both early historic Pueblo and Navajo weavers made Spanish-inspired, striped *serapes,* but the Navajo developed this form into the distinctive striped "chief's blanket" by 1800. After the mid-nineteenth century, a substantial part of Navajo economy derived from sheep herding and the production of trade blankets. Navajo wool blankets were among the most celebrated textiles of the Southwest. Plains Indians particularly coveted the striped chief's blankets. Weaving quality reached its height in "classic" *serape*-style blankets that were produced during the 1860s, a period, it might be noted, when the Navajo suffered the privations of the Bosque Redondo reservation experience (1864–1868).

Commercial three-ply yarns and yarns unraveled from American flannels combined with "home-spun" yarn in Navajo blankets of the 1860s, a development very likely spurred by Anglo contact during the Bosque Redondo incarceration. The Navajo, given their long history in production and trade, responded eagerly to the Anglo market. Bright color schemes created with aniline dyes and "Germantown" yarns characterized the inventive patterns and designs in Navajo textiles after 1880, which included heavily serrated diamond motifs influenced by Mexican Saltillo *serapes* and pictorial elements including animals, figures, and even railroad trains. By the turn of the century, traders, in response to their clients' requests for what they perceived to be more "authentic" textiles, asked Navajo weavers to replace the bright color schemes with "natural" browns and grays, while at the same time proposing a shift away from blankets in favor of rugs, which had far more appeal to the tourist buyer. Trader J. B. Moore introduced even more drastic changes when he instructed weavers who sold their work at his Crystal Trading post to emulate the patterns of Turkish and Iranian carpets. Within a period of some three decades, Navajo women had turned their skilled hands from the *manta,* chief's blanket, and *serape* to rugs whose designs were derived from a wide range of new, often exotic, sources.

Navajo creativity and productivity, so apparent in their textile making, were equally evident when it came to the creation of silver and turquoise jewelry. Atsidi Sani, a Navajo trained as a blacksmith, is credited with being the first Navajo to produce silver jewelry, a skill he learned from a Mexican silversmith in 1853. Early Navajo jewelry makers melted down silver coins into ingots which the smith then hammered

and bent into shape, keeping the silver workable by annealing (reheating and rapid cooling). Silver was also cast in simple clay or sandstone molds, cut into shapes or decorated with rudimentary, linear designs using a cold chisel and a file. Silver disks strung on a leather belt, known as "conchas," Spanish-style horse gear, simple bracelets, *ketohs* (archer's wrist guards), buttons, beads, and crescent *naja* pendants for necklaces were among the objects made by early Navajo smiths. After 1880, steel stamps derived from Mexican leatherworking techniques allowed for the application of elaborate surface decoration on Navajo silver, and soldering permitted the addition of appliqué elements. Stone, preferably turquoise, set in a bezel and soldered in place, completed the inventory of techniques that contributed to the astounding growth of Navajo jewelry making between 1880 and 1900.

Silver jewelry production assisted an adjustment within the Navajo community to a cash economy as wealth was converted to jewelry, which, if necessary, could be liquidated as "pawn." Traders, however, worked to direct Navajo jewelry to the outside market. They provided smiths with sheet silver, more effective tools such as blowtorches, and furnished them with precut turquoise to set. As a result, unprecedented quantities of "thin silver" bracelets, concha belts, and *naja* necklaces were produced to satisfy tourist demand after 1900. As with textiles produced by women, male smiths experimented with a wide range of designs and styles, achieving a measure of success that provided a mainstay for the Navajo economy at a time of transition into the modern world.

After 1880, with the advent of tourism, Pueblo pottery also gained wider recognition. Talented and innovative artists responded to the opportunities of the marketplace with skill and creativity. The Tewa-Hopi potter Nampeyo conducted extensive research on sherds and subsequently enjoyed much success reviving designs based

Julian and Maria Martinez, potters of San Ildefonso, New Mexico. Julian and Maria Martinez produced pottery as a team, Maria fabricating the vessels and Julian painting the designs. In this regard they broke away from the traditional manner of making pottery. They found great success, however, and their work was seminal in the development of an international art market for Pueblo ceramics during the twentieth century.

Museum of New Mexico, Santa Fe.

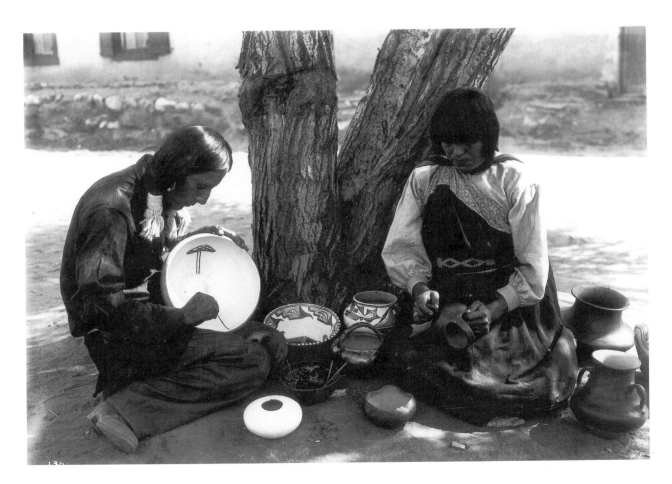

upon prehistoric wares. Others introduced new techniques and designs, such as Julian and Maria Martinez of San Ildefonso, who created coveted "black-on-black" decorated ceramics, where polished black designs contrast with a matte black background. This husband and wife team collaborated—Julian doing the painting—demonstrating how their generation adjusted this traditional women's art to meet the opportunities of the changing world.

The techniques of visual expression in the Southwest are deeply rooted in the past, and yet they have always remained tied to the needs of the present. The Pueblo have always celebrated both tradition and creativity, each generation defining its own identity through subtle shifts in style and form. The Navajo and Apache adapted those traditions that met their needs and expressed their own creative vision. Alien ideas and new market opportunities, supplied first by the Spanish, then the Anglos, impressed their indelible influence upon these craft traditions. And yet, a sense of a continuing relationship with the past endures in even the most innovative creations.

ART AND RELIGION

For the Zuni of the Southwest, religion was, and still is, the relationship between the daylight people of this world and the "raw people": rainstorms, corn plants, animal beings, and kachinas, among others. Life on earth is a gift and entails obligations. The daylight people "feed" the raw people with tobacco, cornmeal, food, clothing, and feather sticks. They honor them with ceremonies, dances, and the creation of beautiful things. The raw people offer, in return, the blessings of health, old age, water, seeds, riches, good fortune—in short, life. Every member of the community is required to contribute toward the community's effort to please the beings of the spirit world, and those individuals who do not fulfill their obligations are considered witches, antisocial, and dangerous. Art serves religion by creating beautiful objects for altars, offerings, and masks for the impersonation of spirit beings. If these objects are removed from the community improperly, their purpose is not fulfilled and the entire community suffers as a result. Understandably, when these works of "art" have been collected as artifacts or circulated in the art market, their improper use has been a continuing source of concern to many Pueblo people.

The kachina dances of the Hopi and Zuni are prime examples of art in the service of religion. Their creation has less to do with the representation of religious ideas, as is true with much Christian art, than with the practice of religious ritual. The kachinas are at once ancestors and clouds. They are beings from the Underworld that humans left behind when they rose up into daylight. It is said that in times past the kachinas would visit, but whoever accompanied the spirits back to the Underworld would die. So now the people impersonate kachinas in dances, thereby insuring the benefit of the blessings of the spirits without the loss of life.

Responsibility for organizing kachina dances has always belonged to the kivas. A kiva is at once a sacred chamber, sometimes excavated below ground, and the group that meets there to fulfill their religious obligations. At Zuni Pueblo, there are six kivas who organize different kachina presentations throughout the year. At Hopi, the kachina dances correspond roughly with the agricultural cycle, beginning at winter solstice and continuing through fall harvest, and are associated with rain necessary to

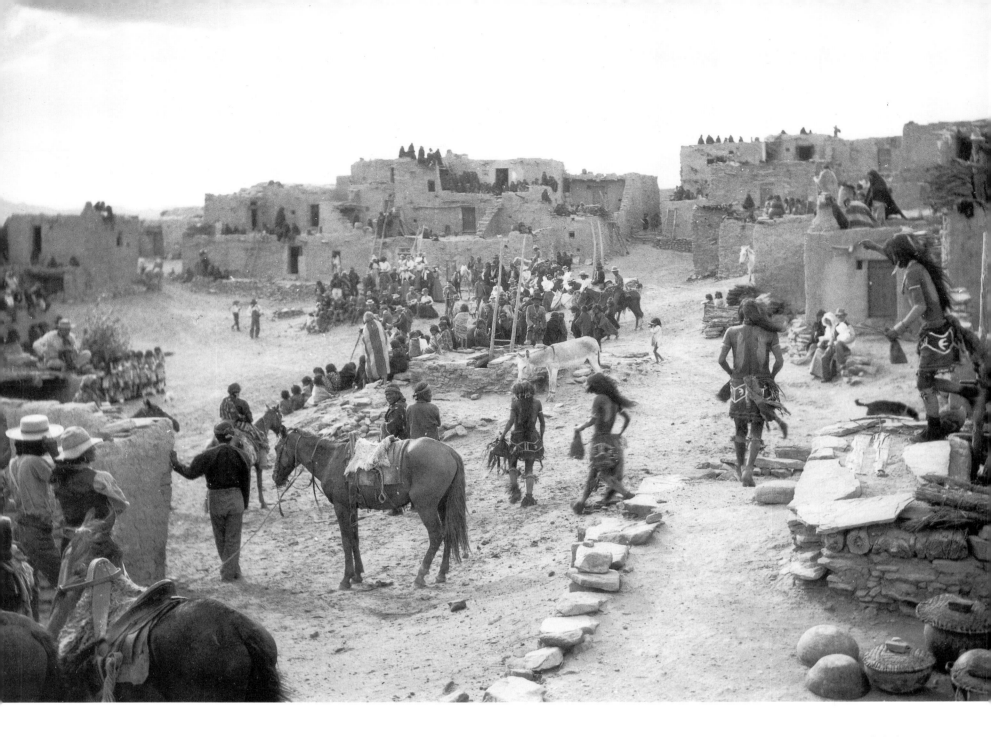

a successful growing season. The Hopi and Zuni together recognize hundreds of different kachina identities, each with their distinctive appearance, significance, and appropriate season during which to appear.

Kachina impersonators dance wearing a leather mask. Although these dancers are individually fitted with masks that they then repaint to represent the different kachinas presented by their kivas, the masks themselves belong to family groups. The masks possess a life force and must be fed cornmeal or corn pollen by a priest. When they are groomed, repainted, and participate in dances that are meticulously and beautifully performed, the kachinas they impersonate are pleased and blessings are bestowed. The kachina masks kept in museums are, in a sense, imprisoned, and the displeasure this causes them is dangerous to everyone.

Kachina dolls carved of cottonwood are distributed to children at the Hopi and Zuni Pueblos. They help prepare children for their adult responsibilities in the future by familiarizing them with the identities of the kachinas. Up until the second decade or so of the twentieth century, kachina dolls were never sold to outsiders. Some felt that even the representation of kachinas in paintings and photographs was inappropriate and potentially harmful. Kachina performances attracted many visitors to the Pueblos during the first decades of this century, but some were eventually closed to outsiders

when it seemed that the spectators might interfere with the intent of the dances. Despite these concerns, however, carved kachina dolls for sale to outsiders soon became widely available, and artists trained at Indian schools produced paintings of kachina and other ritual performances.

The Navajo understanding of the cosmos also acknowledges men's dependence upon spirit beings and the potential for good or harm that this relationship entails. Disease among the Navajo is not simply a medical matter, but an issue of spiritual imbalance that requires resolution through ritual. Failure to observe proper relations with the spiritual forces manifest in the world can cause illness and even death.

The Navajo arts of healing remain ephemeral and secret. When a person falls ill, the nature of the transgressions and the evil unleashed must be identified with the help of a healer, who may then prescribe one or more of many chants that are the privileged possessions of "singers," or holy men. The chant is a mythic, heroic narrative concerning primordial twins who helped bring people into the world with the help of powerful spirit beings. Recitation of the chant is accompanied by the creation of a sandpainting on the floor of a hogan (Navajo house) that illustrates an episode of the narrative. The painting is created with colored sand by the healer and his assistants who "draw" with handfuls of sand that fall in a stream through the thumb and forefinger. When the painting is complete, the patient sits in the center of the painting and the colored sand is rubbed over his or her body. Through this act, the beneficial and healing powers that have been summoned up from the spirit world are absorbed into the patient's body.

When chanter Holsteen Klah began to reproduce sandpaintings as weavings between 1919 and his death in 1936, many Navajo were uneasy about the public display of secret, powerfully charged images. Nevertheless, other weavers began to incorporate images of *yei*, the holy people depicted in sandpaintings, in rugs intended for sale to tourists. They proved popular among buyers.

When people of the Southwest began to make things for sale to outsiders, the new market broadened opportunities for personal creativity and economic security, but it also attacked the fabric of traditional society. Among the traditional Pueblo, the individual is subordinate to the community. Artists who became successful as individuals undermined the strength of the collective. The adaption of religious art to the tourist marketplace also created tensions which have yet to be thoroughly resolved; they may never be. The schism revolves around the reasons for creating things of beauty. Traditional societies of the Southwest often applied this talent collectively to please the spirits. The development of tourism in the Southwest effected a change in the focus of the arts, establishing a system that rewards the talent of the individual by regarding his or her creations as valuable commodities. It is a question of different cultural perspectives that offers no easy answers.

Seated Human Figurine. Hohokam, c. A.D. 1100. Cache 2:9F, Snaketown site, southern Arizona. Ceramic. Arizona State Museum, University of Arizona, Tucson.

This painted figurine was recovered during excavations at the Snaketown site as part of a large cache of some ninety-seven objects that had been broken apart, their fragments thrown into a pit. The cache included a large group of pottery vessels, additional figurines, shell bracelets, stone tools, and objects made of more ephemeral materials, such as coiled baskets, that survived only as fragments or traces. This large, globular bottle conceived as a seated figure with its hooked nose, flat planelike face, and spindly arms and legs is fairly unique in southwestern art and hints at Hohokam ties to the pre-Columbian arts traditions of Mexico to the south.

Frog Effigy. Hohokam, c. A.D. 900–1100. Martinez Hill site, southern Arizona. Marine shell. Length: 1⅜ in.; width: 1⅜ in. Laboratory for Anthropology, Museum of Indian Art and Culture, Santa Fe, New Mexico.

The Hohokam extended networks of trade south into Mexico, north to the turquoise mines of the Colorado plateau, and west to the Gulf of California where they procured marine shell for ornaments. This frog effigy is carved from half of a bivalve clam shell. Shells and frogs may have been understood as metaphors for water among the Hohokam; both elements are combined for double symbolic potency in this ornament.

RIGHT: *Eight Stone Images.* Mimbres (?). A.D. 1000–1100. Found near Sanders, New Mexico. Stone, paint. Heights: 2¼–4¾ in. The Brooklyn Museum, Museum Expedition 1903, Museum Collection Fund.

The function of this group of figures is uncertain, but stylistically they correspond to other, reductive figures conceived in broad, blocky forms found elsewhere in the Mogollon and Anasazi territories. Despite their simplistic detail, they create a lively and diverse group. The fact that they were deposited together as a cache suggests that they were intended as a kind of offering during a ritual of prayer.

BELOW: *Cache of Ritual Figures.* Mimbres. A.D. 1150–1400. Cliff Valley area, New Mexico. Wood, stone, cotton, feathers, fiber, paint. Largest height: 25 in. The Art Institute of Chicago.

This unusually well-preserved cache of wooden and stone effigies was probably intended as a shrine or offering. Few collections of figurines like this have survived and perhaps were not meant to; as with offerings of the historic Pueblos, their function was served when they eroded away to dust.

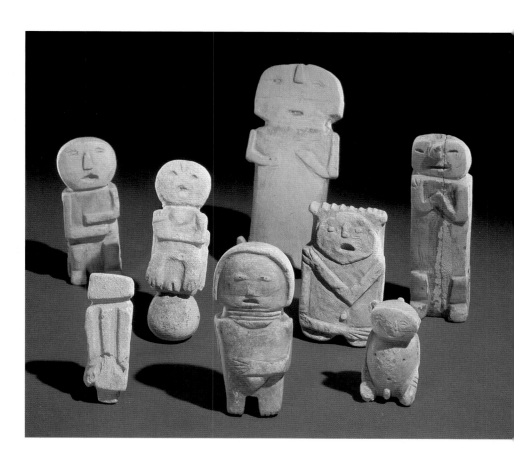

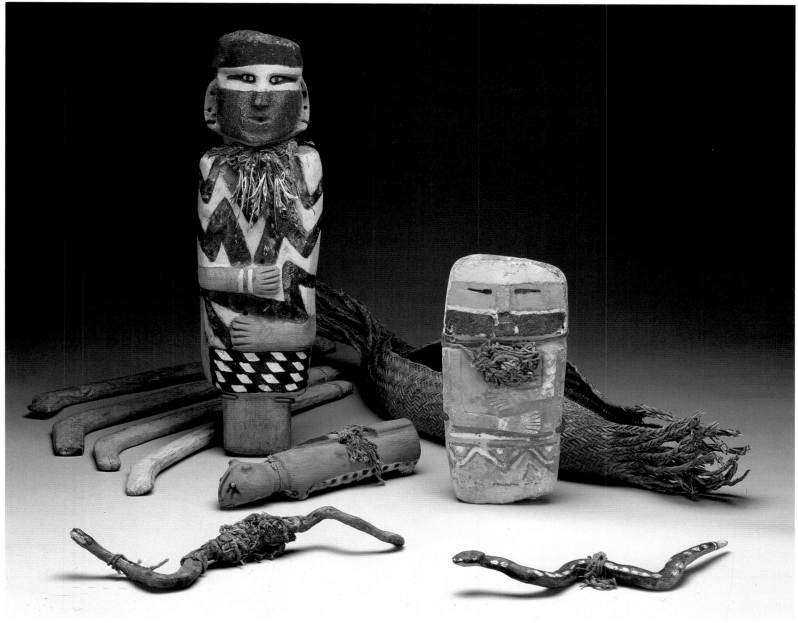

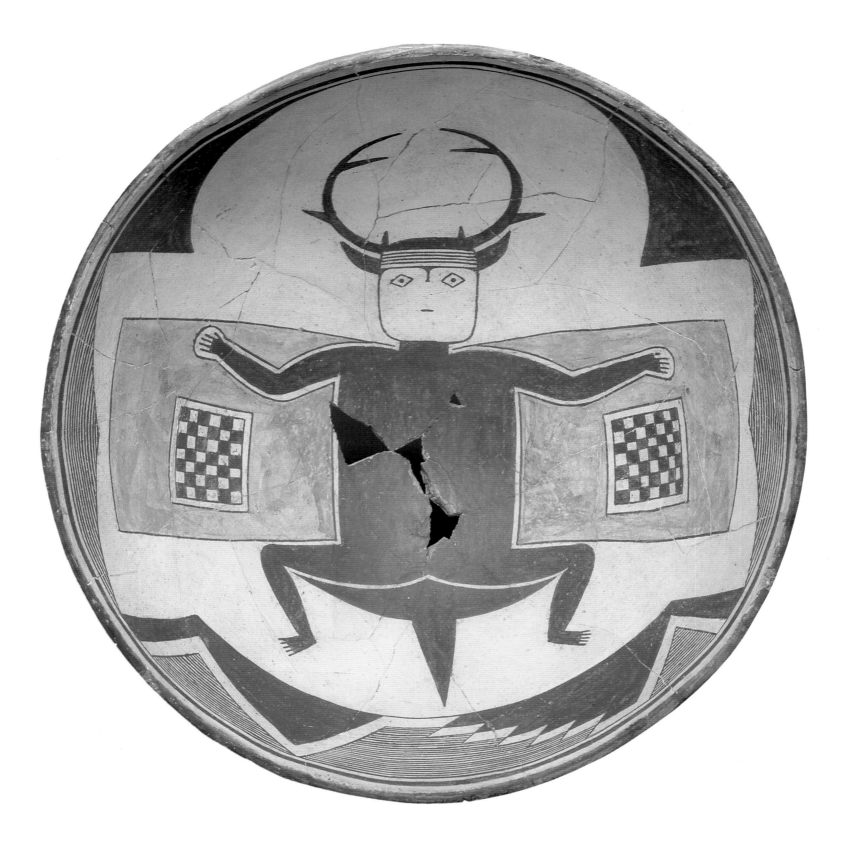

Black-on-White Bowl. Mimbres culture, Mogollon tradition,
A.D. 1000–1200. Mimbres valley, New Mexico. Ceramic. Height: 5 in.;
diameter 11¾ in. Tony Berlant Collection.

*Mimbres bowls are nearly hemispherical in shape, the interiors painted with images
of many different kinds of creatures that often combine the attributes of humans and
animals, as seen here. This humanlike figure flies with wings like a bat and has
horns on its head. Bowls like these were stacked face down, often in piles of four,
sometimes placed over the head of the deceased. Each bowl was pierced with a "kill-
hole" in the bottom. Some scholars have interpreted that this kind of configuration
of stacked bowls represents the dome of the sky and its four layers, through which
the soul of the deceased must ascend.*

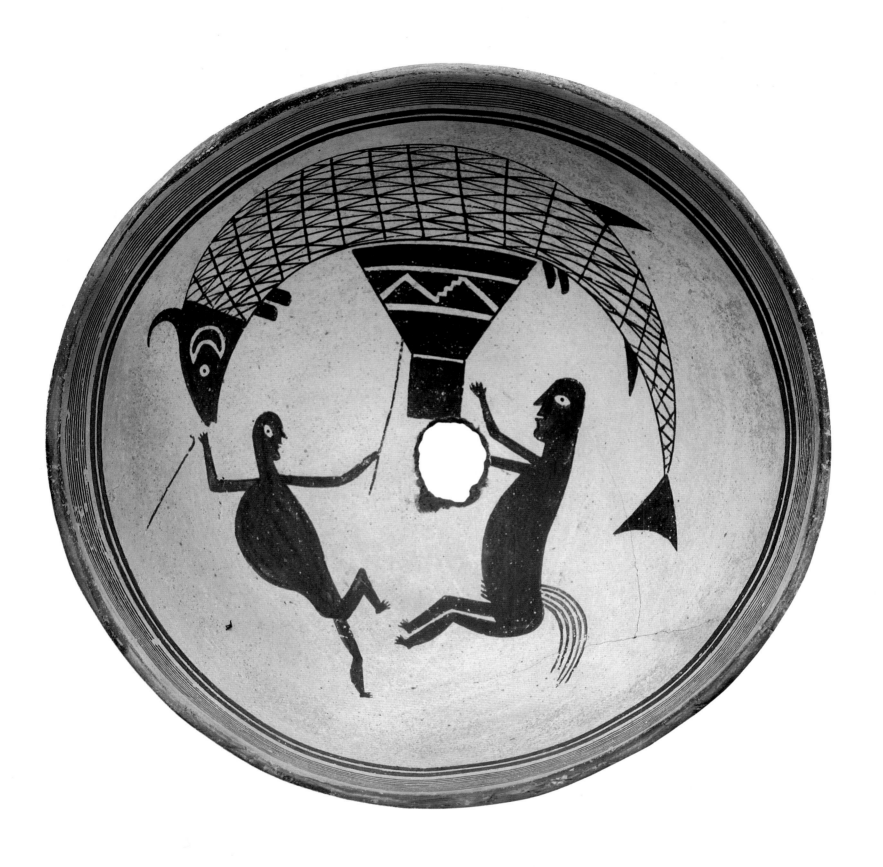

Black-on-White Bowl. Mimbres culture, Mogollon tradition,
A.D. 1000–1200. Mimbres valley, New Mexico. Ceramic.
The Detroit Institute of Arts.

*In this Mimbres design two figures, a hunchback and a human who has the
hind-quarters of a hoofed animal, seem to be enacting an episode of a mythic
narrative. In the center is a large, bell-shaped basket which contains a giant fish.
Many Mimbres designs include references to water animals, water being of great
concern to the lives of Mogollon farmers.*

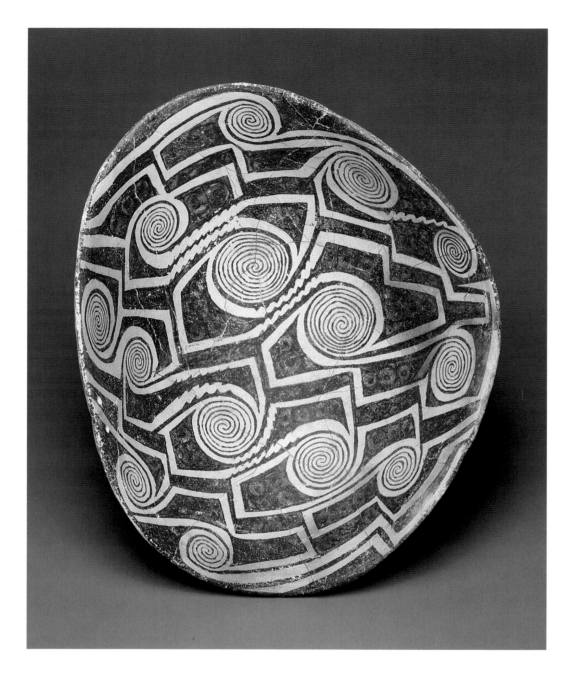

OPPOSITE TOP: *Seed Jar.* Anasazi. A.D. 1200–1300. Northern Arizona. Ceramic. Diameter: 14½ in. The St. Louis Art Museum.

The low, rounded vessel with an incurvate rim is known generally as a "seed jar," used presumably for the storage of grain. The design on this jar was developed with a broad cross-hatched pattern that formed a grid. Individual squares were then filled in with black paint, or alternately left open with central black dots. These kinds of designs are characteristic of the so-called Kayenta styles of the western Anasazi late in the Classic Pueblo III period.

Black-on-White Bowl. Mimbres culture, Mogollon tradition, A.D. 900–1100. Mimbres valley, New Mexico. Ceramic. Height: 5½ in.; diameter: 14¾ in. Tony Berlant Collection.

This bowl is painted with a bold design of spiral motifs arranged in broad, zig-zag bands. The pattern of smudged circles is made up of finger prints, where the painter dipped his or her finger in paint to apply the design.

OPPOSITE BOTTOM: *Storage Jar.* Anasazi. A.D. 1100–1300. Northern Arizona. Ceramic. Diameter: 14⅜ in. The St. Louis Art Museum.

The Anasazi mineral paint tradition is characterized by its sharp black mineral paint designs applied to a snowy-white slip. The geometric patterning includes interlocking spirals and "stepped frets" which often seem to intimate the movement of water. The generalized tradition was interpreted in dozens of regional styles throughout the greater region of the Colorado plateau in what is called the "four corners" region of Arizona, New Mexico, Colorado, and Utah. Their myriad differences and similarities continue to perplex archaeologists who have attempted to classify them. This large water jar represents the mineral paint tradition at its most highly developed period, the Classic Pueblo period, or Pueblo III.

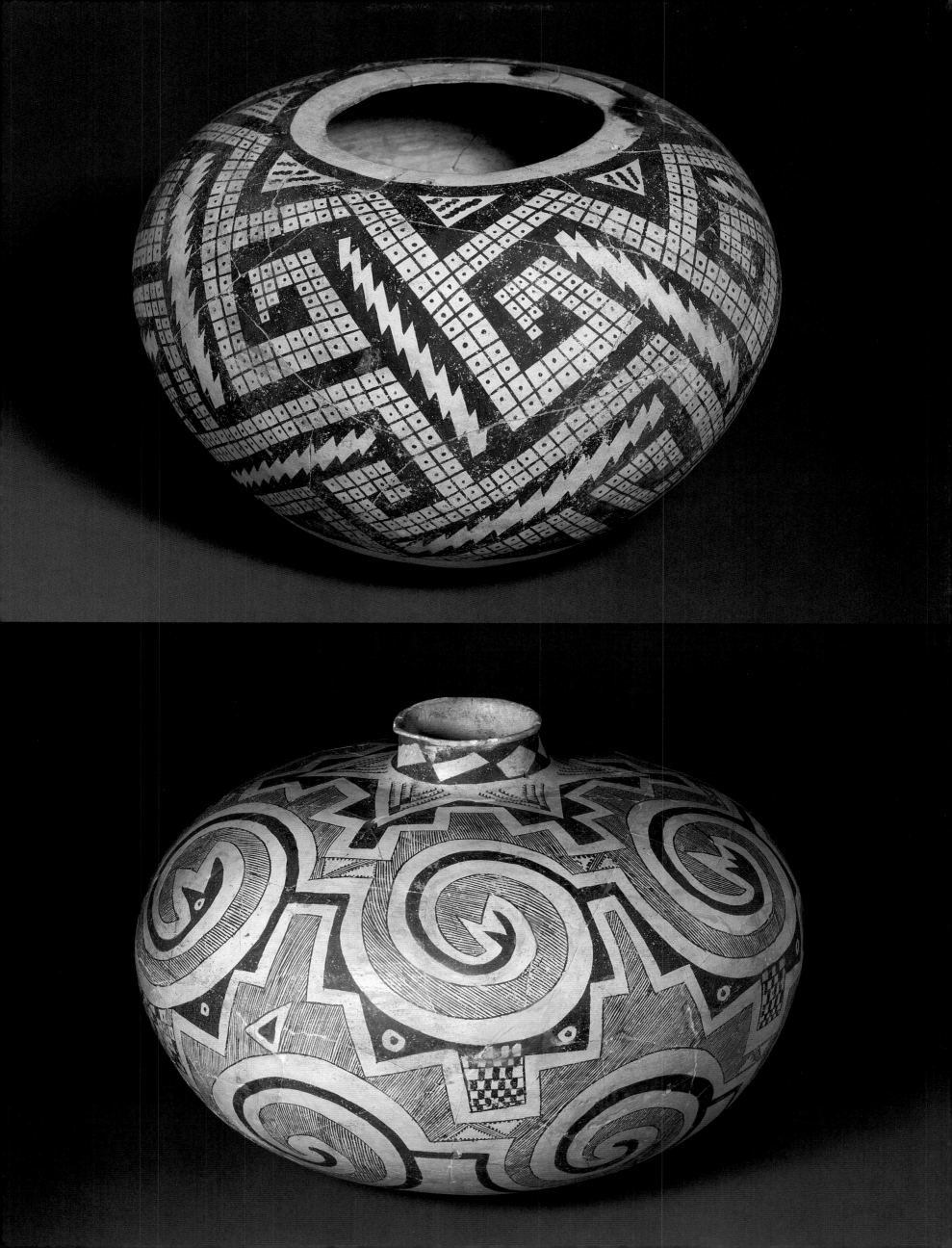

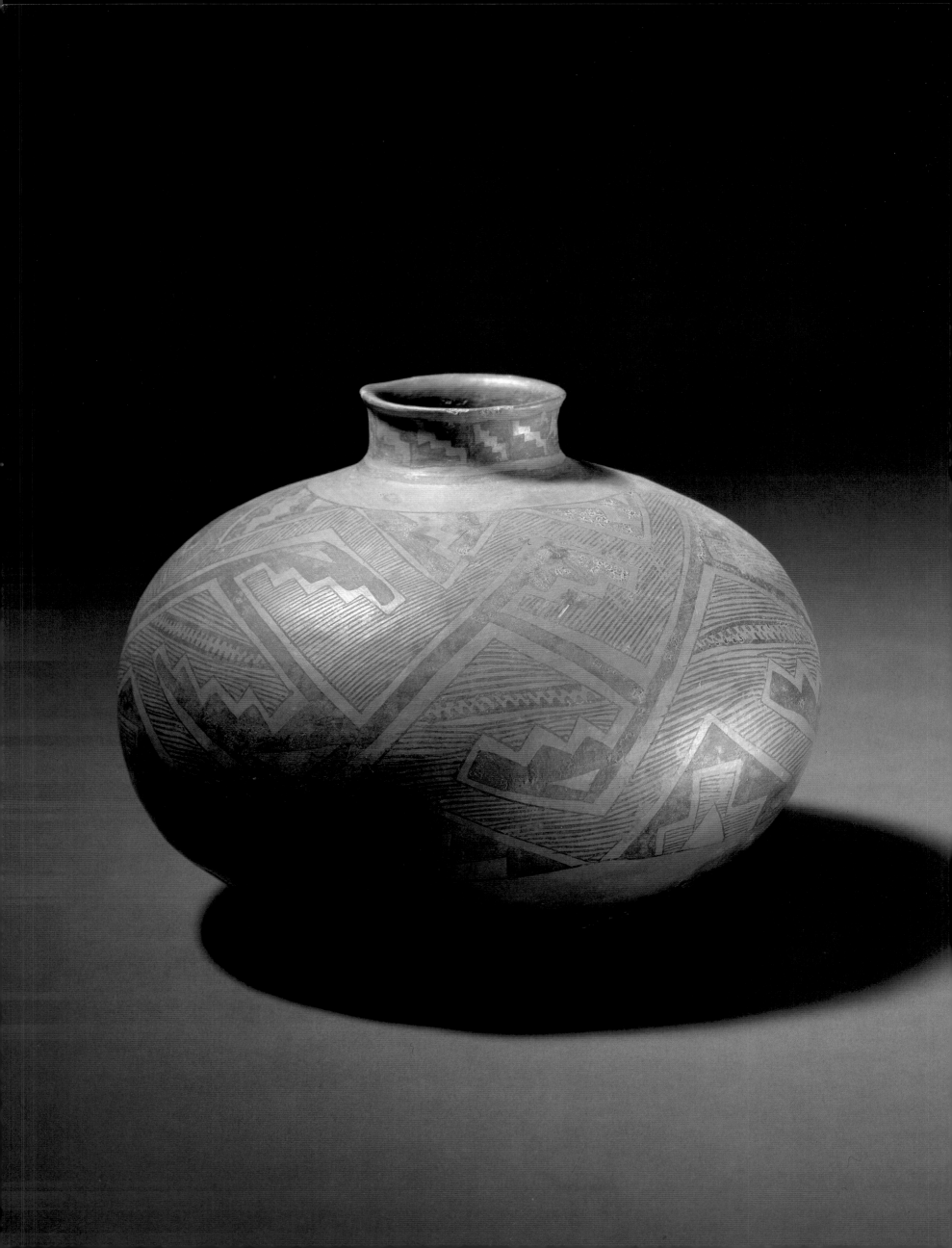

OPPOSITE: *St. Johns Black-on-Red Storage Jar.* Anasazi. A.D. 1000–1200. Upper Salt River region, northern Arizona or New Mexico. Ceramic. The Heard Museum, Phoenix, Arizona.

St. Johns Black-on-Red is one of several varieties of White Mountain Red Wares made in the high plateau country of the northern Arizona and New Mexico border. This variety is distinguished by its dramatic red slip that serves as the underpainting for black mineral paint designs. In the Wingate series, of which St. Johns Black-on-Red is a variant, the geometric design is developed with a repeating pattern of solid and hatched stepped frets, with the hatched elements slightly larger and filled with delicately painted diagonal lines.

TOP: *Fourmile Polychrome Bowl.* Anasazi. A.D. 1350–1400. Upper Salt River region, northern Arizona or New Mexico. Ceramic. Diameter: 12 in. From the collection of Robert S. Colman.

Fourmile Polychrome, which represents the latest of the White Mountain Redwares series, is characterized by bold, asymmetrical designs in black, delicately outlined with a chalky white mineral paint against the deep-red slip. In this design, the interior of the bowl is divided in two with paired parrots on one half and a broad spiral form flanked by stepped frets on the other.

BOTTOM: *Wingate Black-on-Red Jar.* Anasazi. A.D. 1000–1200. Upper Salt River region, northern Arizona or New Mexico. Ceramic. Diameter: 13 in. Dallas Museum of Art.

Wingate series bowls and jars are early White Mountain Red Wares and were immensely popular trade ware among the Anasazi. Examples of this kind of pottery have been recovered by archaeologists at sites throughout the greater Anasazi region. They were often used as offerings in outdoor shrines and have been found grouped in caches in caves or other remote locations.

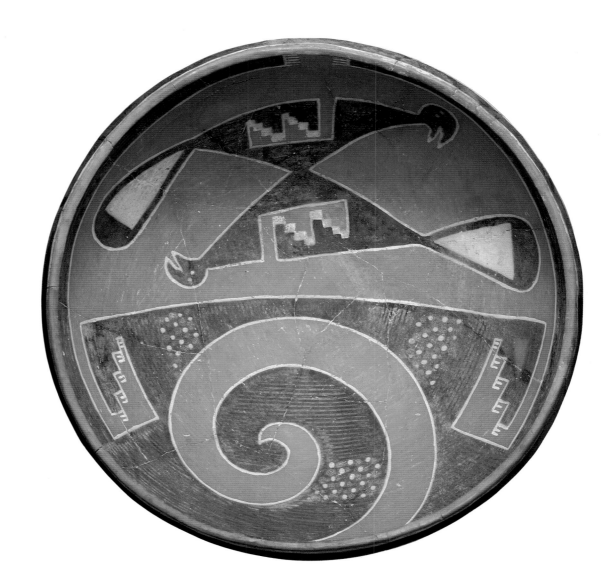

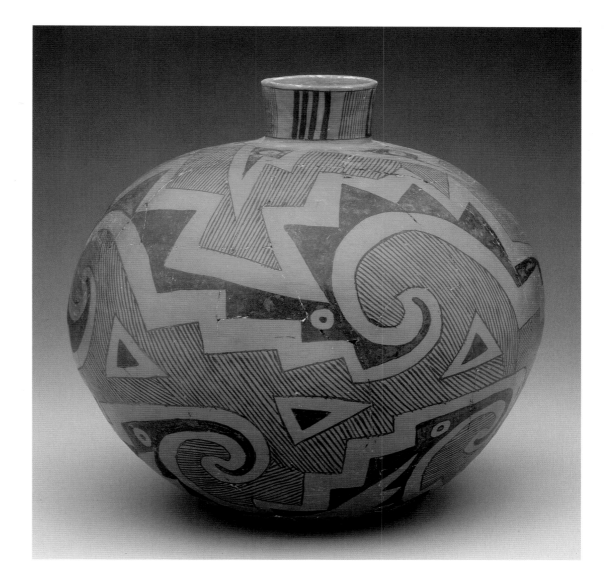

Fourmile Polychrome Bowl.
Anasazi. A.D. 1300–1400. Fourmile site, Arizona. Ceramic. Diameter: 10 in. Dallas Museum of Art, Foundation for the Arts Collection, 1988.

Two hummingbirds are combined with a stylized flower in this Fourmile Polychrome design. The life forms are subtly integrated into the bold patterning.

Pinedale Polychrome Parrot Effigy Bottle. Anasazi. A.D. 1250–1325. Upper Salt River region, northern Arizona or New Mexico. Ceramic. Length: 9 in. From the collection of Robert S. Colman.

The Anasazi and the Pueblo people who were their descendants used parrot feathers as offerings to accompany prayers. Trade in parrot feathers originated in Mexico well to the south. This effigy bottle seems to honor the parrot. The bottle itself might have been an offering intended for a shrine or some other such location.

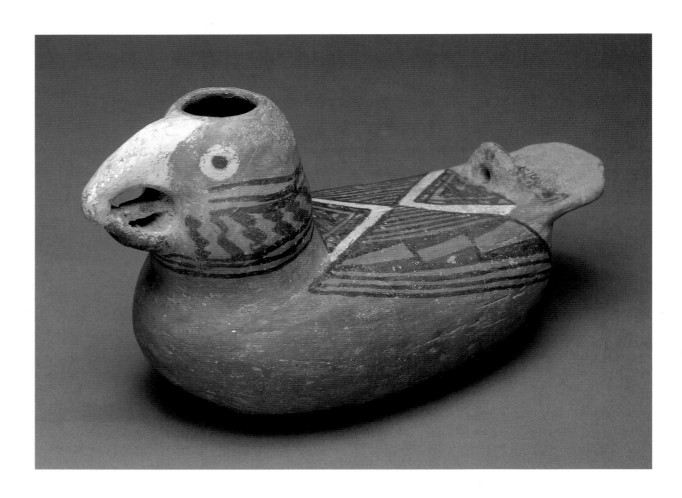

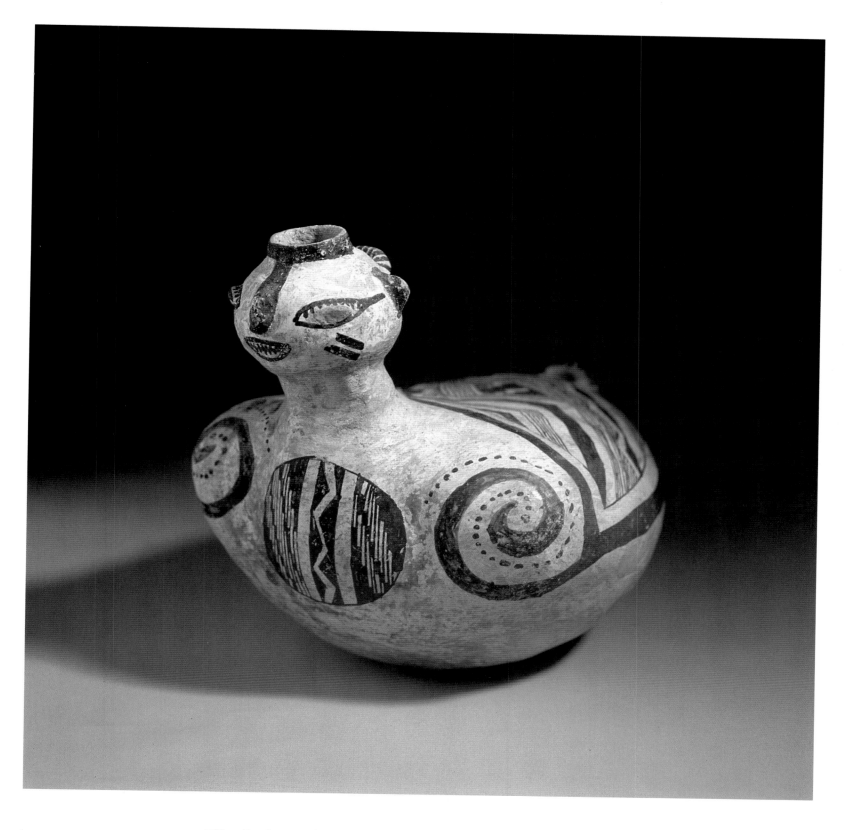

Effigy Bottle. Mimbres, Mogollon tradition, A.D. 1000–1200.
Mimbres valley, New Mexico. Ceramic. Height: 7⅞ in. Arizona
State Museum, University of Arizona, Tucson.

*This bottle in the form of a duck with a grinning, humanlike face is one of
only a few Mimbres effigy bottles known. The circular medallion on the
breast and the geometric patterning on the back are typical of the Mimbres
geometric style.*

Sityatki Polychrome Jar. Hopi. A.D. 1400–1625. Northern Arizona.
Ceramic. Length: 9 in.; height: 5 in.; width: 4 in. Tony Berlant
Collection.

*During the two centuries prior to the penetration of New Mexico by Spanish
colonists, the populations of the Southwest shifted gradually southward, forming
the enclaves of Pueblos along the Rio Grande valley that exist today. The Hopi,
however, remained stable in the region of northern Arizona, and the occupation
of the area can be traced back many centuries through the distinctive varieties of
Hopi pottery. Sityatki Polychrome was a highly decorated ware of the early his-
toric period, made just prior to the arrival of the Spanish. This vessel illustrates
the characteristic rounded shoulder form of Sityatki Polychrome jars, but the
painted images of an arm and hand are unique and exceptional.*

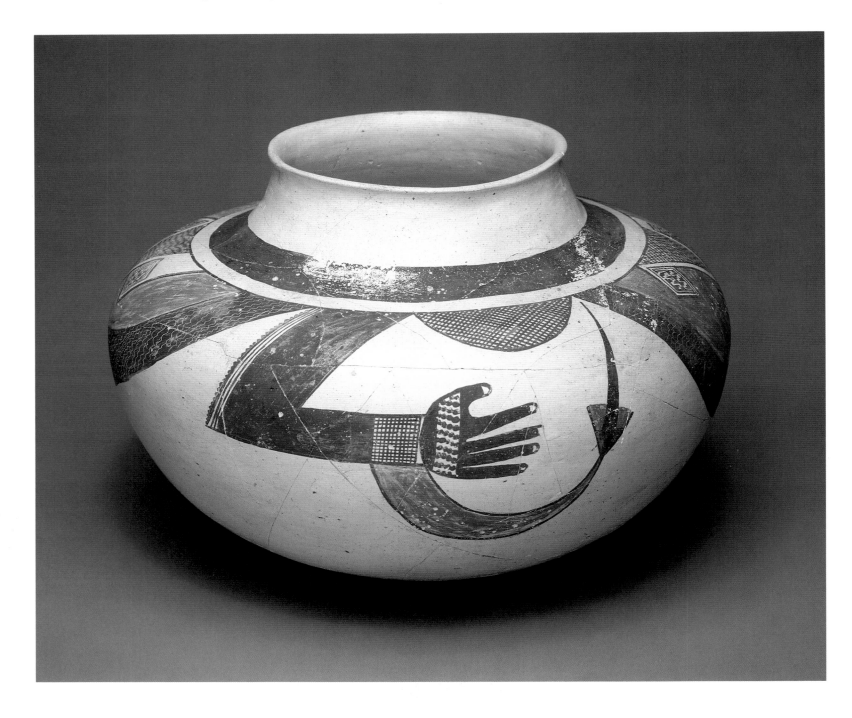

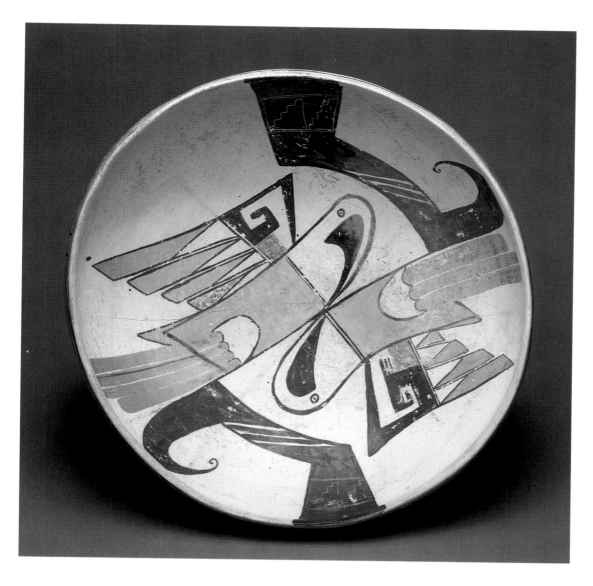

TOP LEFT: *Sityatki Polychrome Bowl.* Hopi. A.D. 1400–1625. Northern Arizona. Ceramic. Height: 5¾ in.; diameter: 12 in. Tony Berlant Collection.

The interior of this early Hopi bowl is painted with the images of paired parrots, but rendered in an abstract, almost rectilinear form. Parrot feathers were used for prayer sticks and to decorate kachina masks.

BOTTOM LEFT: *Sityatki Polychrome Bowl.* Hopi. A.D. 1400–1625. Northern Arizona. Ceramic. Diameter: 11½ in. Janis and William Wetsman Collection.

The interior of this Sityatki Polychrome bowl is stippled with red and green paint creating a shimmering texture of color. This technique was unique to the Hopi.

OVERLEAF LEFT: *Water Jar.* Zuni Pueblo. 1825–1850. New Mexico. Ceramic. Height: 12¾ in. The Brooklyn Museum.

The squared body of this vessel, with its sharp junctures between the body and the base and the shoulder and the neck, characterizes Zuni water jars of the early nineteenth century. A broad stepped band filled with fine-line hatching meanders across the surface of the jar, isolating stepped triangles as perches for butterflies. The stepped elements, reminiscent of the form of a rising thunderhead, and the migratory butterfly signify the importance of rain in the lives of the peoples of the Southwest.

OVERLEAF RIGHT: *Water Jar.* Zia Pueblo. Nineteenth century. New Mexico. Ceramic. Height: 15¼ in. The Detroit Institute of Arts.

Water jars of the nineteenth century gathered from several pueblos feature images of domestic chickens or roosters who strut amidst flowers and plants. This representational style may have been inspired by European-American folk art seen by Pueblo potters in embroidery and crewelwork.

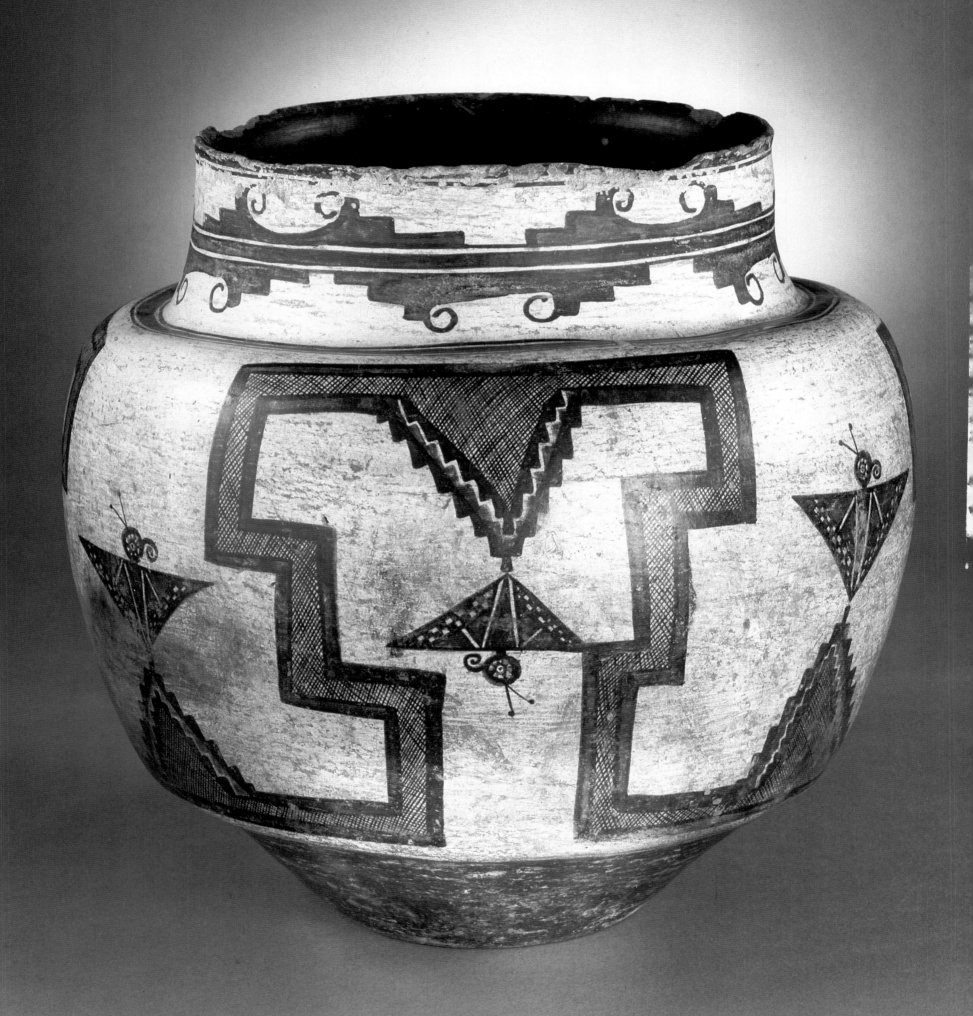

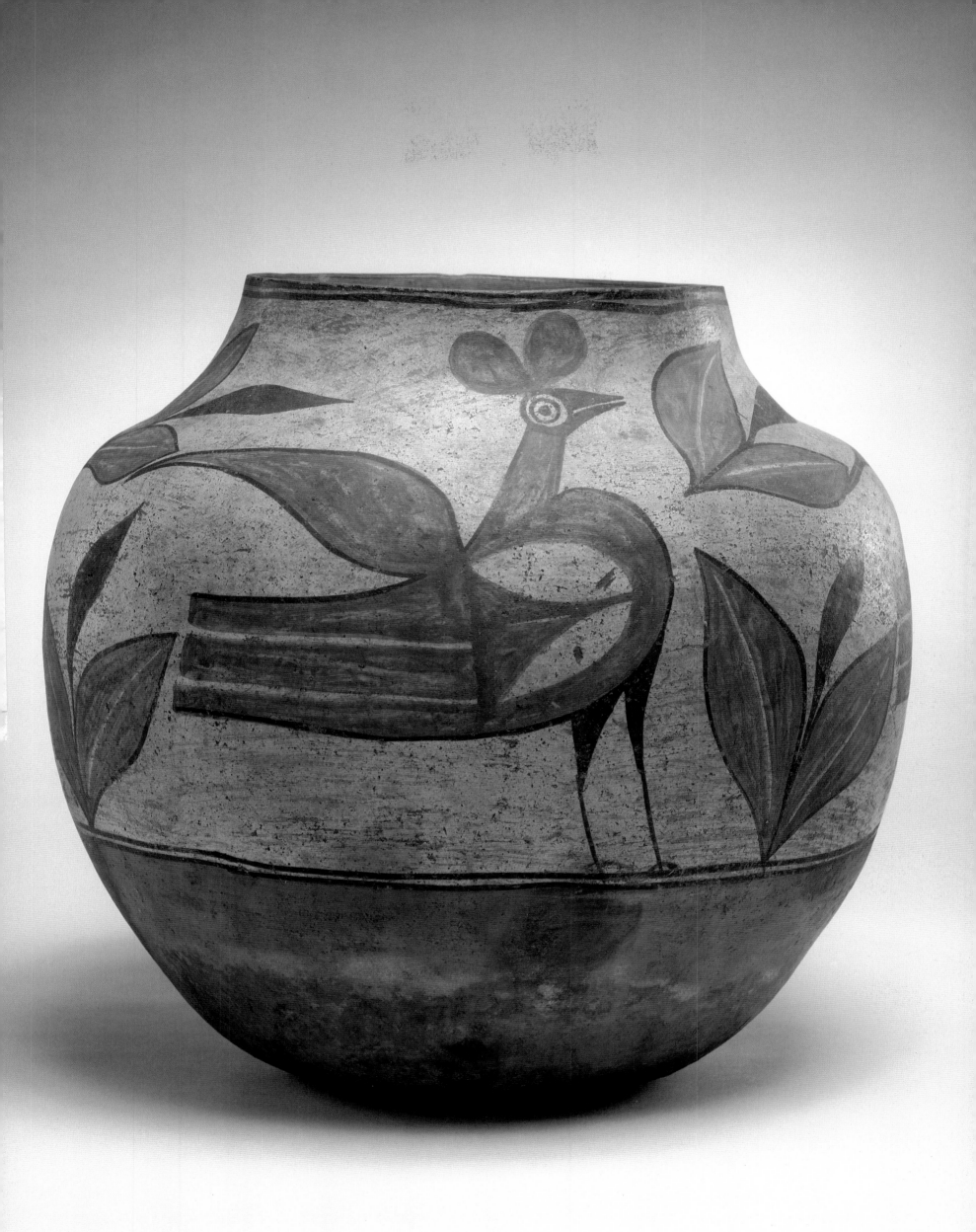

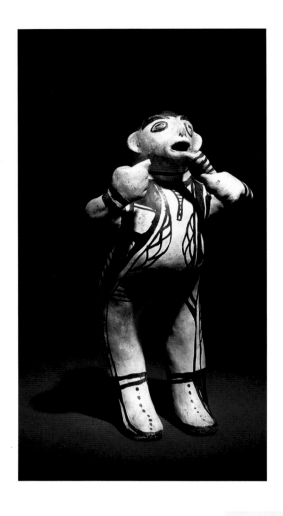

LEFT: *Figurine.* Cochiti Pueblo. Early twentieth century. New Mexico. Ceramic. American Museum of Natural History, New York.

Large, hollow figurines innovated by Cochiti potters responded to the development of a tourist economy in the Southwest late in the nineteenth century. Slipped with white and painted with black and red, Cochiti figurines often feature animated poses and expressive faces.

BELOW: *Aco Polychrome Jar.* Acoma or Laguna Pueblo. 1710–1720. New Mexico. Ceramic. Height: 11½ in. School for American Research, Santa Fe, New Mexico.

The conical base and the abruptly bulging body that narrows to a gently rounded shoulder characterizes early historic water jars of the Keres-speaking Acoma and Laguna Pueblos. The painted designs feature featherlike elements and stepped patterns, reminiscent of clouds, arranged in rectilinear panels.

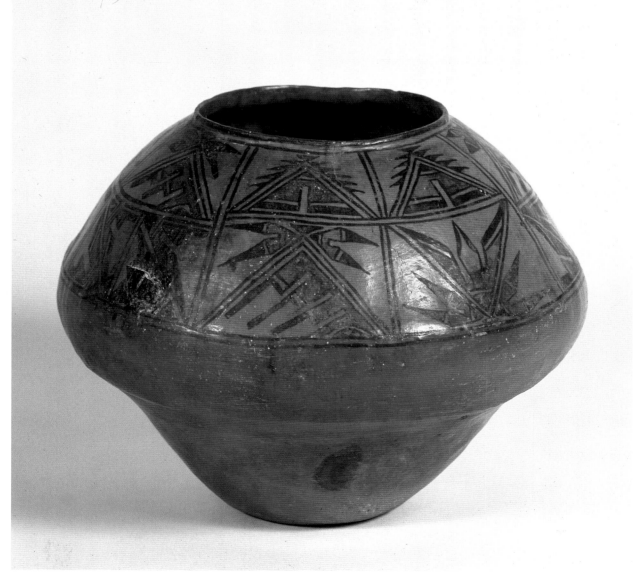

NAMPEYO

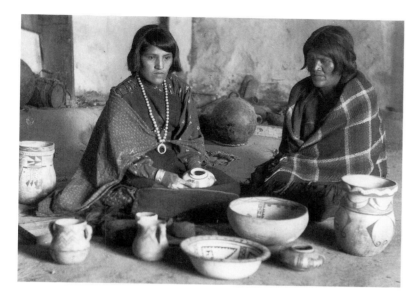

Nampeyo (right) and her daughter, Annie Nampeyo Healing, 1901. Nampeyo's traditions of pottery-making were inherited by her daughters, Annie being the eldest and one of the most accomplished among them. Whenever Nampeyo traveled to give demonstrations, whether to "Hopi House" at Grand Canyon, or to Chicago in 1910, she was always accompanied by her family.

Milwaukee Public Museum.

Nampeyo was born around 1860 in the Tewa village of Hano on First Mesa of the Hopi mesas. She was educated in the traditions of Hopi pottery-making by her elder female relations, like most other Hopi potters. Unlike other potters of her generation, however, she began to study the designs she found on ancient shards and fragments around the mesas of her home. With this knowledge, she revived the traditions of ancient Sityatki polychrome wares and other ancient styles by making large and impressive jars and bowls.

Her abilities caught the attention of photographers and ethnographers who visited the Hopi villages late in the nineteenth century. Fred Harvey, a restaurant and crafts entrepreneur, hired her to demonstrate pottery-making at his "Hopi House" Lodge at the Grand Canyon. She was also featured at the United States Land and Irrigation Exposition of Chicago in 1910, where she was promoted as "the greatest maker of Indian pottery alive."

Nampeyo was one of several Native American artists of the early twentieth century whose abilities and talent had a great impact on outsiders' perceptions of American Indian art and traditions. As an artist identified by name, she transcended the "anonymous" character of the crafts tradition and raised her creations to be considered as "art." Her work also emphasized the value of Native American cultural traditions as part of a uniquely American heritage, an idea that contributed in no small way to the great reforms of federal American Indian policies and the formation of the Indian Arts and Crafts Board during the 1930s. Although Nampeyo herself never worked for such sweeping social developments in the early twentieth-century Indian world—she never learned to speak English and lived quietly at her home in Hano until her death in 1942—her work certainly inspired them.

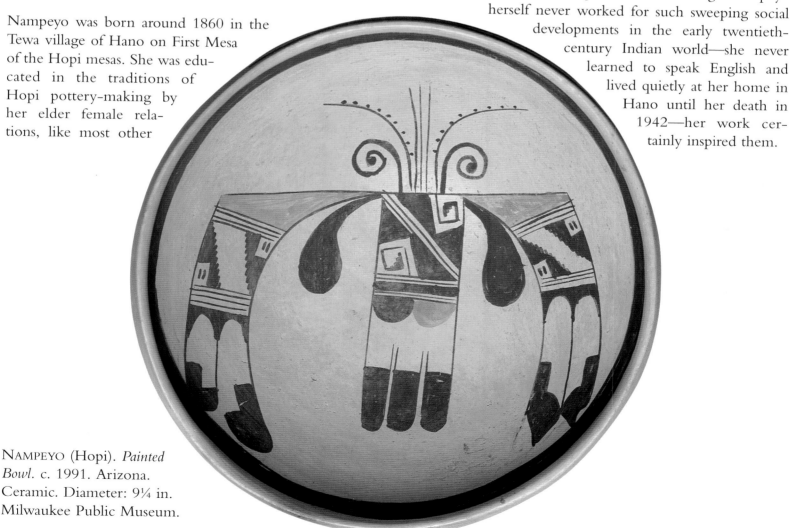

NAMPEYO (Hopi). Painted Bowl. c. 1991. Arizona. Ceramic. Diameter: 9¼ in. Milwaukee Public Museum.

BELOW: Lillian Salvadore (Acoma Pueblo). *Olla (jar).* 1984. New Mexico. Fired clay, slip paint. Height: 9 in.; width: 11¼ in. Museum of Fine Arts, Boston. Gift of a Friend of the Department of American Decorative Arts and Sculpture.

Lillian Salvadore is the daughter of well-known Acoma potter Frances Torivio, who has been producing pots since the 1920s. The work of Salvadore and her sisters range from innovative, contemporary designs to delicately rendered miniatures of turn-of-the-century Acoma water jars, like this olla, and continues an Acoma pottery tradition that began perhaps as early as A.D. 1100.

OPPOSITE: *Water Jar.* Acoma Pueblo. c. 1900. New Mexico. Earthenware. Height: 12 in.; maximum diameter: 13 in. California Academy of the Sciences, Elkus Collection, San Francisco.

Beginning in approximately 1860, several Acoma potters began to decorate jars with heavy black bars and other geometric shapes. The designs ran up over the body, shoulder, and neck of the vessel without articulating the shoulder break. These kinds of designs are still popular among the potters of Acoma.

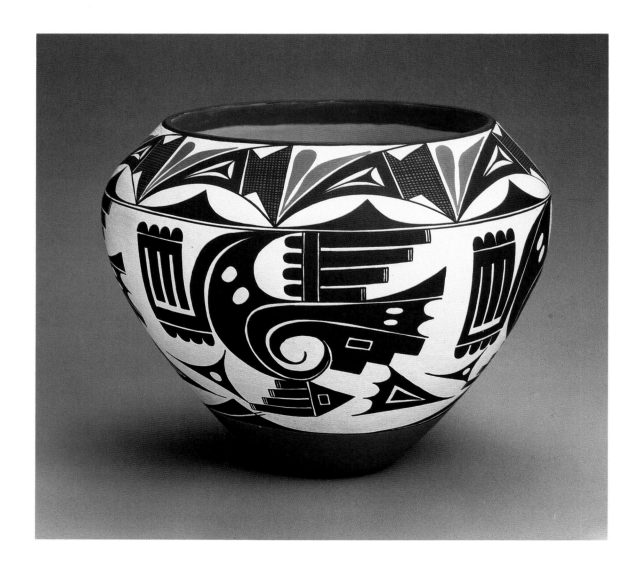

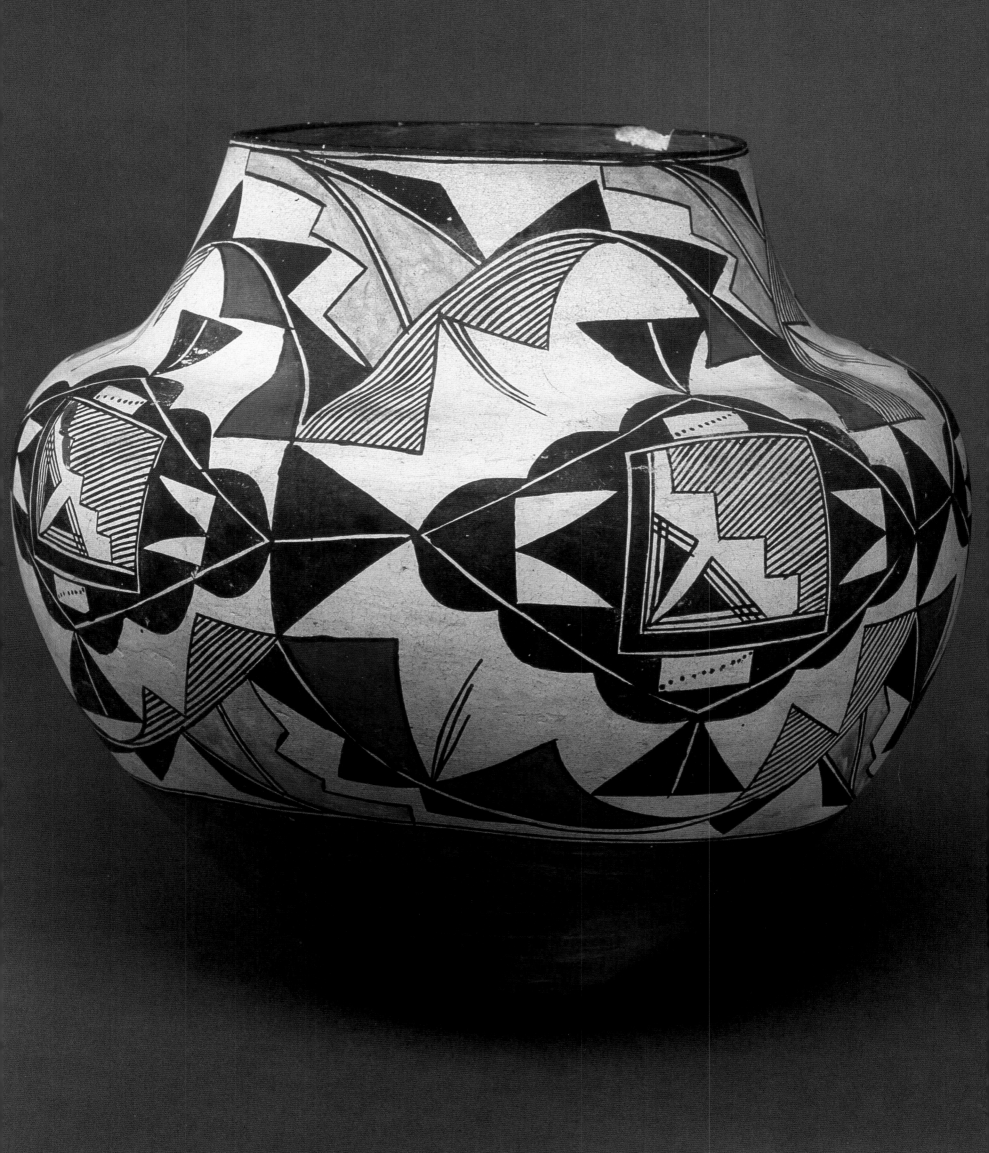

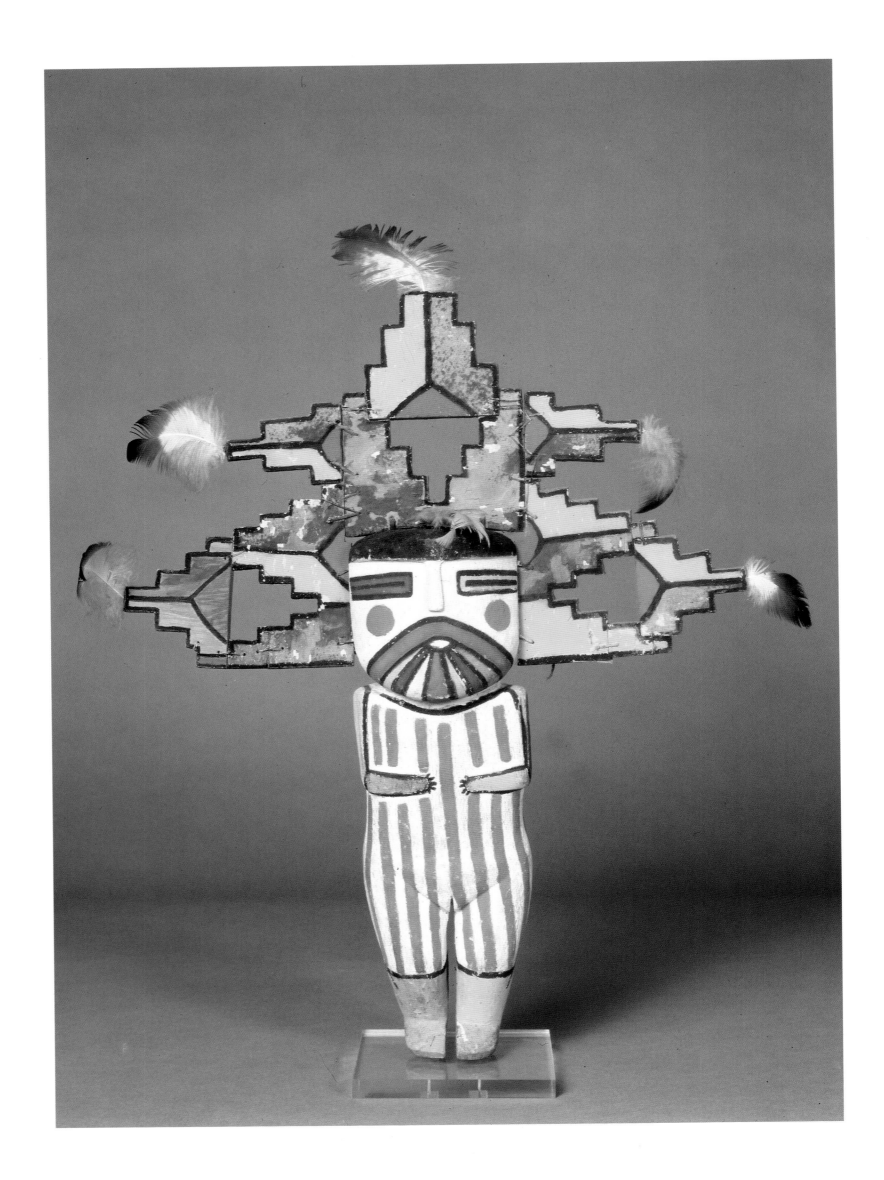

OPPOSITE: *Butterfly Maiden Kachina.* Hopi. c. 1877. Arizona. Cottonwood, feathers, paint. Height: 19¾ in. The Denver Art Museum.

The earliest kachina dolls collected from the Hopi are carved with simple, reductive torsos in static poses resembling altar figures. The striped, nude form of this Butterfly Maiden Kachina is surmounted by an enormous "tablita" headdress. The brightly painted stepped triangles of the headdress are based on cloud forms, the great thunderheads that bring rain to the pueblos.

RIGHT: *Shalako Kachina.* Zuni Pueblo. Early twentieth century. New Mexico. Wood, nails, muslin, wool yarn, fur, horsehair, feathers, leather, paint. Height: 45 in. Southwest Museum, Los Angeles.

Every year, in late November or early December, the six Shalako Kachinas cross Zuni river and enter into the ceremonial plaza on the south side of Zuni pueblo. The Shalako are couriers for the priests of the kachina village whose arrival announces the renewal of the annual cycle of kachina performances. There is one Shalako for each of the six kivas, or ceremonial groups, at Zuni. The Shalako impersonators hidden beneath Shalako's garments support the head of Shalako atop a hand-held pole so that the masked figure towers over eight feet tall. This kachina doll represents one of the Shalako, wrapped in a decorative manta, *or embroidered shawl.*

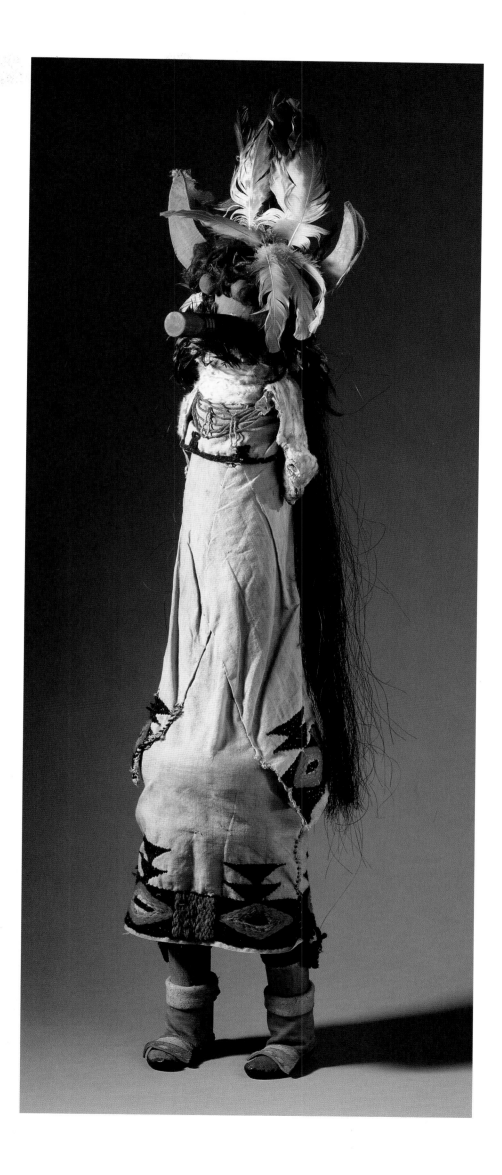

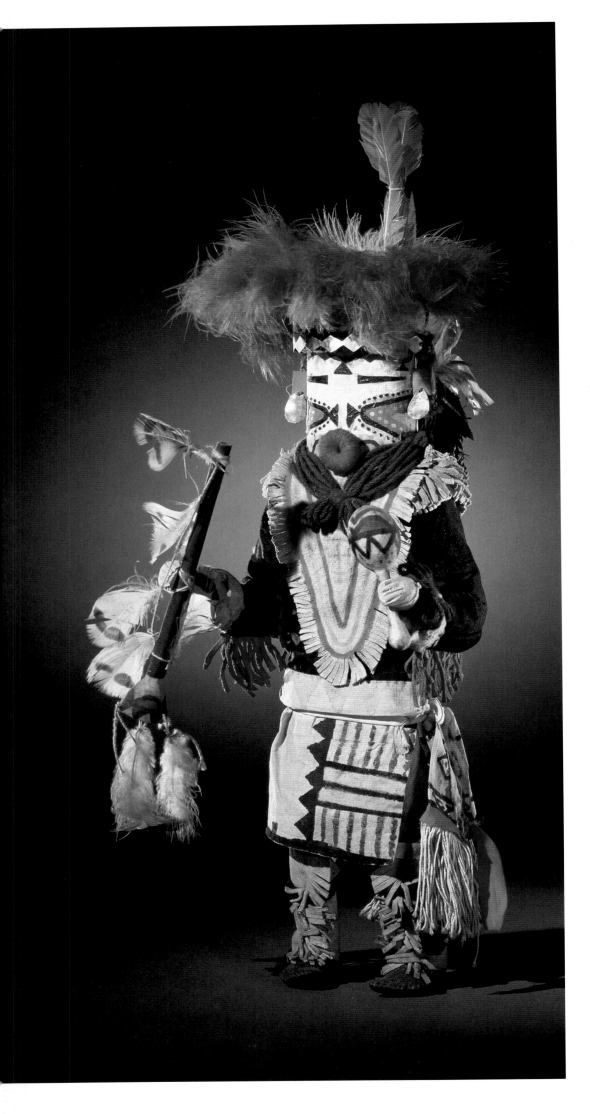

LEFT: *Kachina Doll*. Zuni. 1902–1903. New Mexico. Wood, wool, cotton, deerskin, feathers, paint, tin. Height: 22½ in. The Brooklyn Museum, Museum Expedition 1903, Museum Collection Fund.

This kachina holds a rattle and a dance flute. It is one of seventy-three produced by Zuni carvers in 1902 and 1903 to be sold in secret to the Brooklyn Museum: Zuni governance did not permit the sale of kachina dolls to outsiders at that time.

OPPOSITE: Hilili *Kachina Doll*. Zuni. Collected in 1905. Cottonwood, feathers, cotton and wool fabric, hair, fur, yucca, paint. Height: 14¾ in. Peabody Museum of Archaeology and Ethnology, Harvard University, Cambridge, Massachusetts.

Zuni traditionally distribute kachina dolls to children to familiarize them with the complex round of dances sponsored by kivas during the ritual year. The dolls represent the kachinas, beings that visit Zuni every year from their home beyond Corn Mountain to the west. This kachina has a large mouth, a long black beard, a collar of wildcat skin around his neck, and above his head stand the valuable feathers of the eagle, bluebird, and red hawk. Red paint from the sacred lake colors his body, and his arms and legs are painted yellow. He holds yucca fronds in both hands with more tied around his wrists. He represents Hilili, one of the winter dances performed at Zuni.

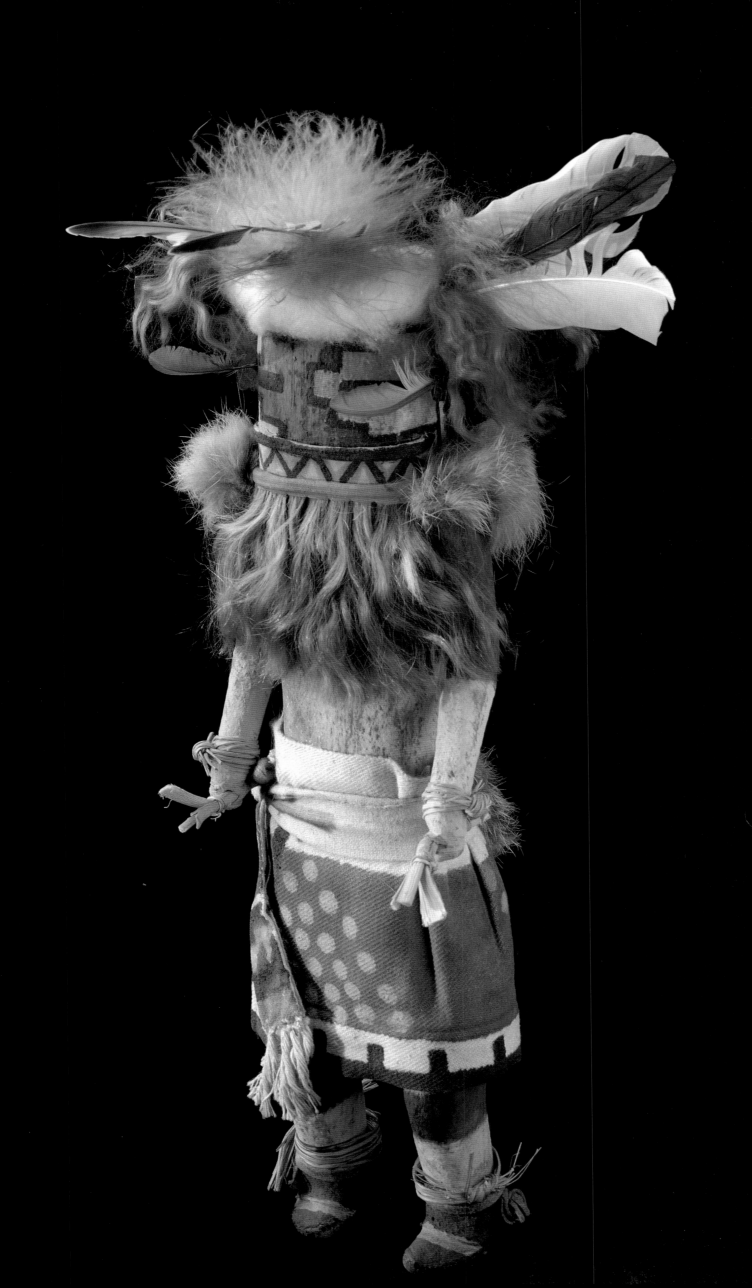

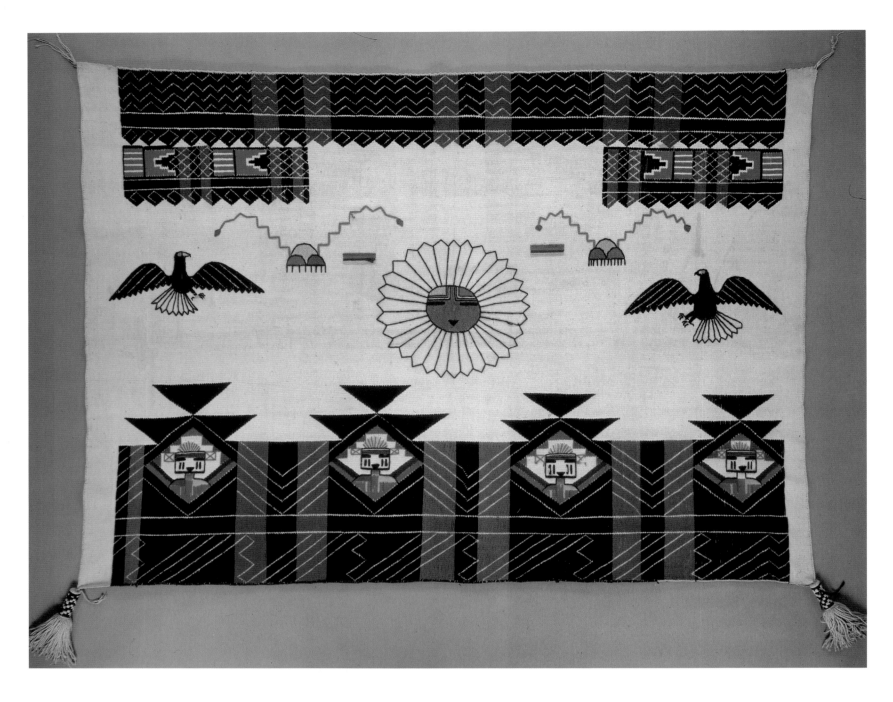

"Kachina" Manta. Probably woven by Fred Shumia (Hopi). c. 1905.
Northern Arizona. Embroidered cotton. Length: 64 in. American
Museum of Natural History, New York.

*This embroidered manta was worn across the shoulders by a kachina dancer. It
features the face of Tawa, the Hopi sun kachina, embroidered in the center of
its white field, flanked by thunderclouds and eagles. Blocks of embroidery above
the eagles include terraced triangles, representations of clouds, and blocks of hor-
izontal, parallel lines, all symbols for rain. Additional kachina faces with black
warrior marks on their cheeks fill the diamond-shaped spaces arranged on the
lower border of the manta.*

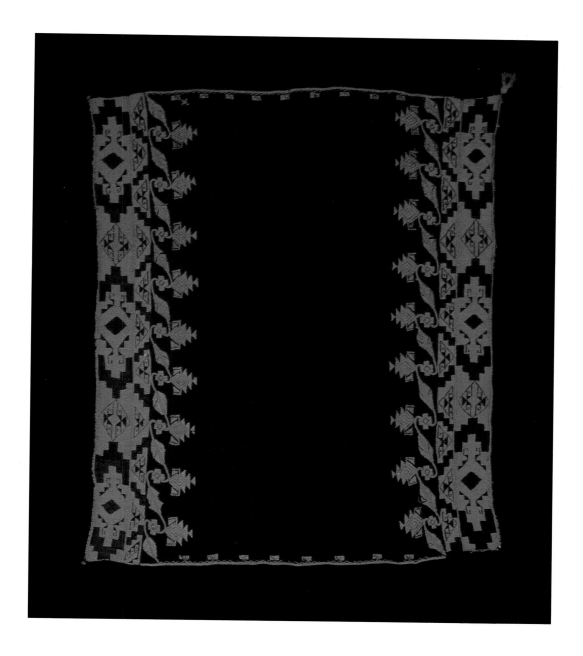

Manta, or Wearing Blanket. Acoma. 1850–1860. New Mexico. Wool. Length: 55 in. School for American Research, Santa Fe, New Mexico.

This manta is woven with black wool with indigo borders using the "diamond twill" technique, meaning that the wefts range across alternating numbers of warps to create a kind of diamond patterning in the weave. Red yarn unraveled from commercial cloth was used to create the elaborate embroidered patterns over the indigo borders. The unusual curing leaf forms visible in the embroidery indicate an interest in European-American decorative arts.

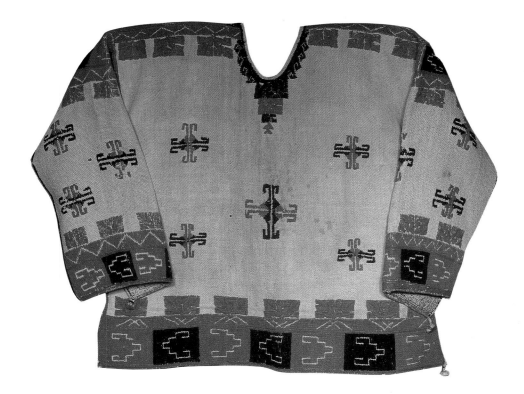

Shirt. Jemez Pueblo. Nineteenth century. New Mexico. Hand-spun cotton and wool, indigo dye. Height: 23 in. The Denver Art Museum.

The production of cotton textiles is an ancient tradition in the Southwest, although the shirt tailored from home-spun cotton cloth is a nineteenth-century innovation. Early cotton textiles were painted. Later cotton garments like this one were decorated with embroidery—in this example, red and indigo-dyed wool yarn. The borders of the lower edge, shoulders, and cuffs on the sleeves are reminiscent of the decorative treatment of mantas, or wearing blankets. Shirts like this were worn for ritual events and by governors and chiefs during formal occasions.

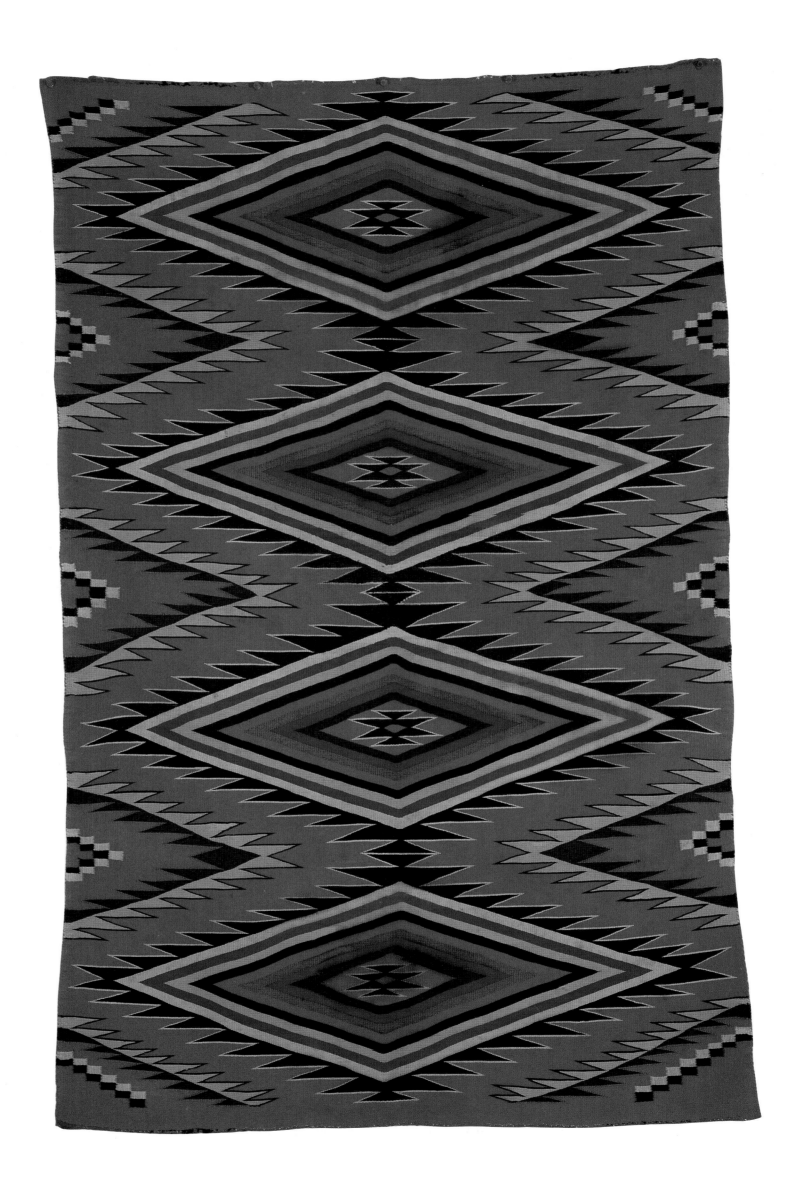

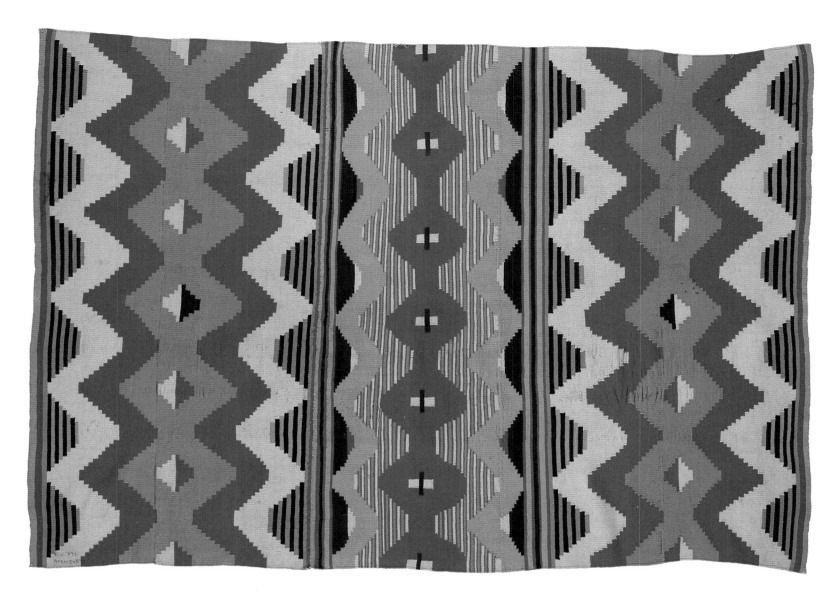

OPPOSITE: *Germantown "Eye Dazzler" Blanket.* Navajo. 1880s. Northern Arizona. Wool, cotton. 53 x 34 in. Joshua Baer & Company, Santa Fe, New Mexico.

Navajo blankets woven with commercially produced yarns after the return from the Bosque Redondo incarceration are often referred to as "Germantown" blankets. They were made during an episode of great experimentation and, generally speaking, the workmanship is very high. The "eye dazzler" style, combining hot color combinations in busy, geometric patterns, was a spontaneous and popular variation that developed around 1880. Buyers of blankets included increasing numbers of Anglos, and weavers tested the market with inventive and innovative designs.

ABOVE: *Serape-Style Wearing Blanket.* Navajo. 1870s. Arizona. Cotton warps, wool yarn. Length: 76 in. The Detroit Institute of Arts.

This wearing blanket was purchased from the Navajo by Captain Harrison Weeks of the Eighth Calvary in 1876. The weaving combines homespun and commercial yarns, some unraveled from wool fabrics. The blanket was worn so that the central panel fell down the back and the symmetrical sides met in the front. Stepped zig-zag bands over narrow stripes characterize serape-style blankets of this period.

ABOVE: *First-Phase Chief's Blanket*. Navajo. 1800–1860. Arizona. Wool. Length: 7⅝ in. Los Angeles County Museum.

This is the earliest style of Navajo striped wearing blanket. These austere, striped blankets were made by Navajo weavers for sale to their Ute neighbors to the north, who preferred blue, white, and brown stripes. When the blanket is wrapped around the shoulders, the broad central band is seen as a belt around the waist. The term "chief's blanket" is something of a misnomer for this style of striped blanket, since the Navajo themselves do not recognize chiefs. Many of these blankets were traded to distant tribes where their beauty and value were highly appreciated, and where only wealthy and prestigious "chiefs" could afford to buy them.

OPPOSITE: *Serape-Style Blanket*. Navajo. c. 1860. Northern Arizona. Cotton cord and wool yarn. Length: 76 in. School for American Research, Santa Fe, New Mexico.

This most beautiful of the Navajo classic serape-style blankets has a tragic history. It was worn by the Cheyenne Chief White Antelope at the moment of his death during the notorious Sand Creek Massacre in Colorado in 1864. It was woven from a broad array of commercial and hand-spun yarns, some undoubtedly unraveled from machine-woven wool fabrics. The soft, commercial dyes temper the boldly conceived design. Broad zig-zag serrated stripes in red, black, and orange range across the sides of the blanket, interrupting an inventive series of vertical bands of repeating geometric elements that march outward symmetrically, in ascending scale, from the large green diamond that dominates the center of the design.

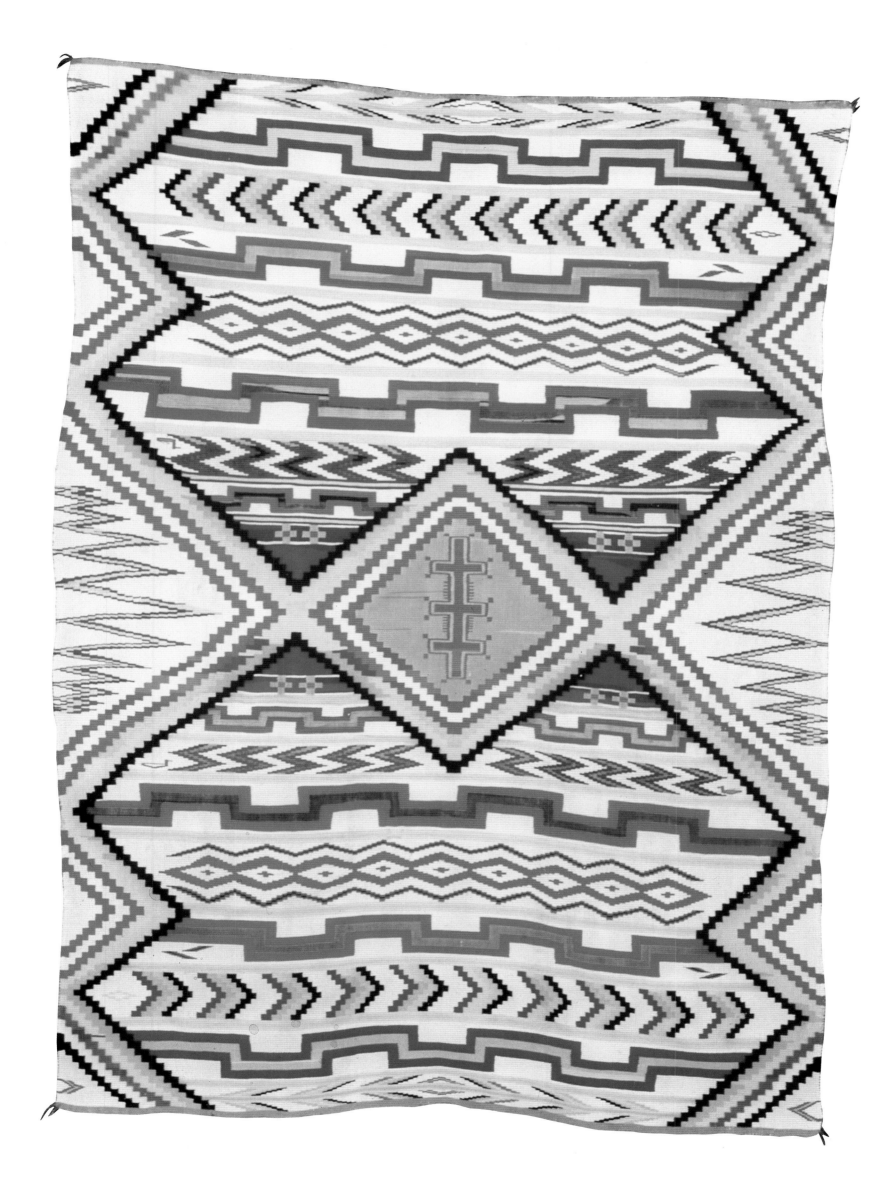

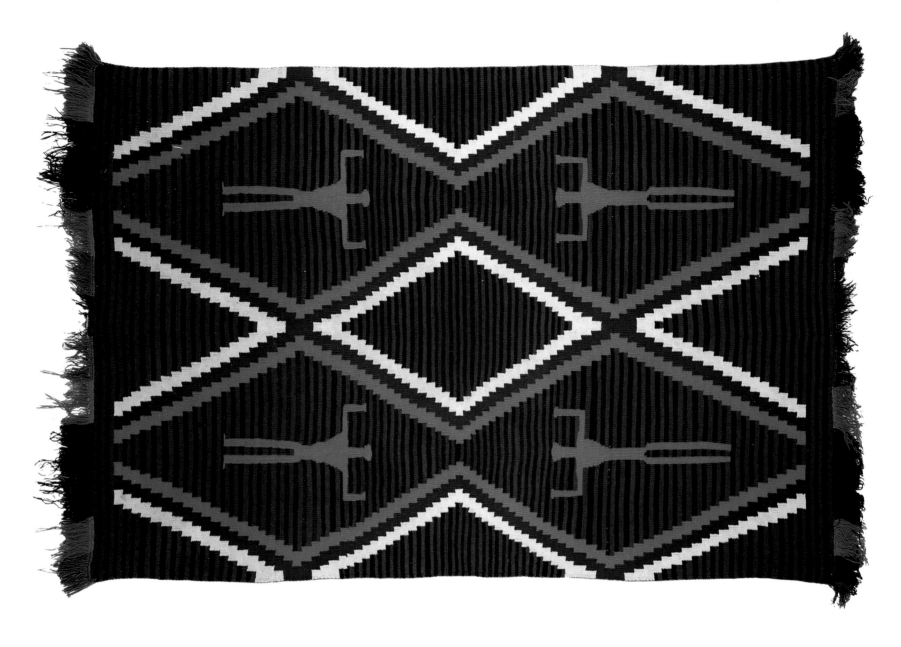

Early Pictorial Germantown Blanket. Navajo. 1880s. Northern Arizona. Wool. James and Kris Rutkowski Collection.

Pictorial elements worked into designs is another feature of Navajo "Germantown" weaving that employed commercially manufactured yarns. This type of weaving features the fine parallel banding of earlier "classic"-style serapes with elongated standing figures in red.

OPPOSITE: *Pictorial Weaving with Locomotive.* Navajo. 1890s. Northern Arizona. Wool, cotton. 22½ x 18¾ in. America Hurrah, New York.

Trains with passenger cars became popular motifs for Navajo pictorial weaving of the 1890s in response to the increasing number of tourists who journeyed to the Southwest by train and who wished to take home a memento of their trip. This weaving is notable for its closely observed detail.

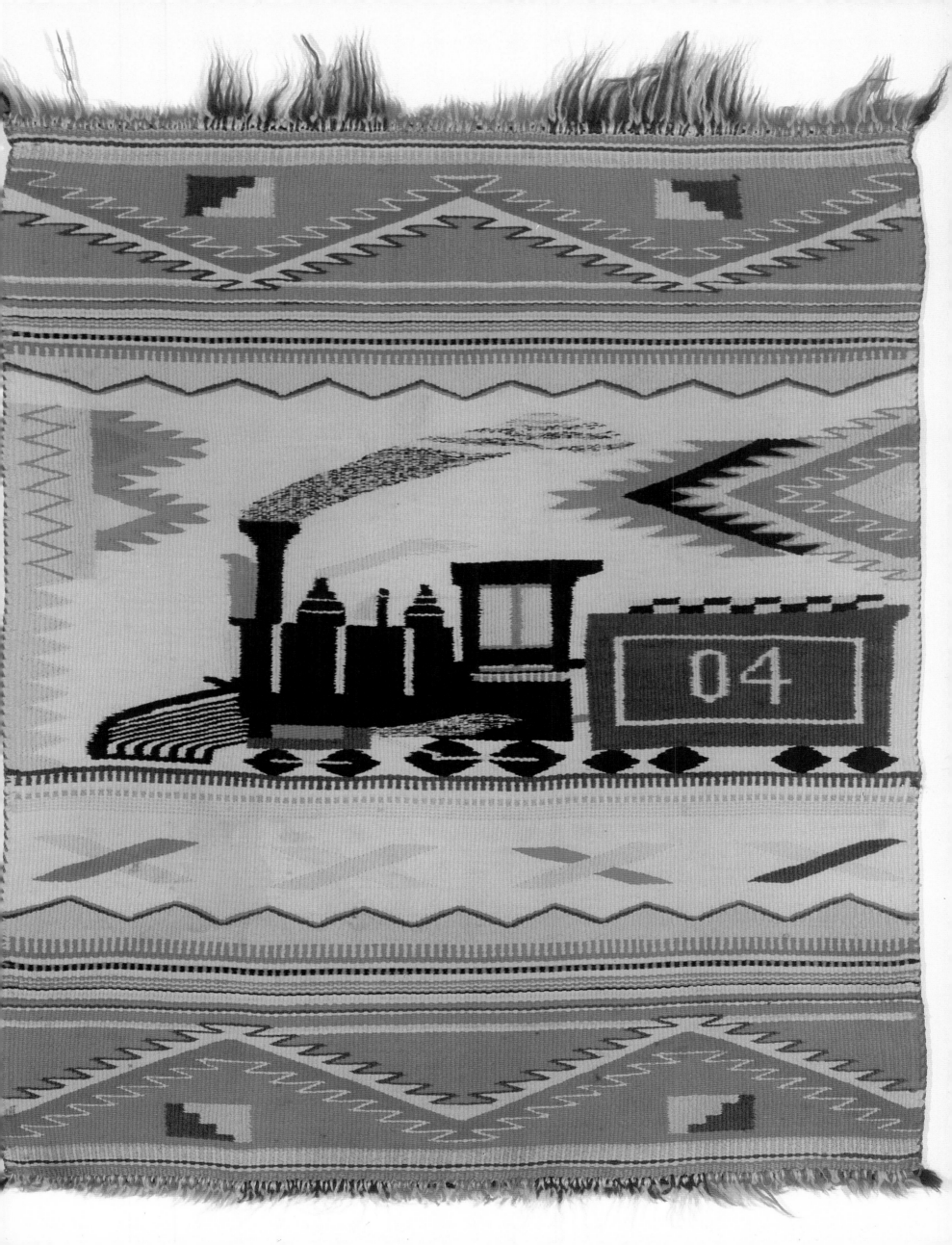

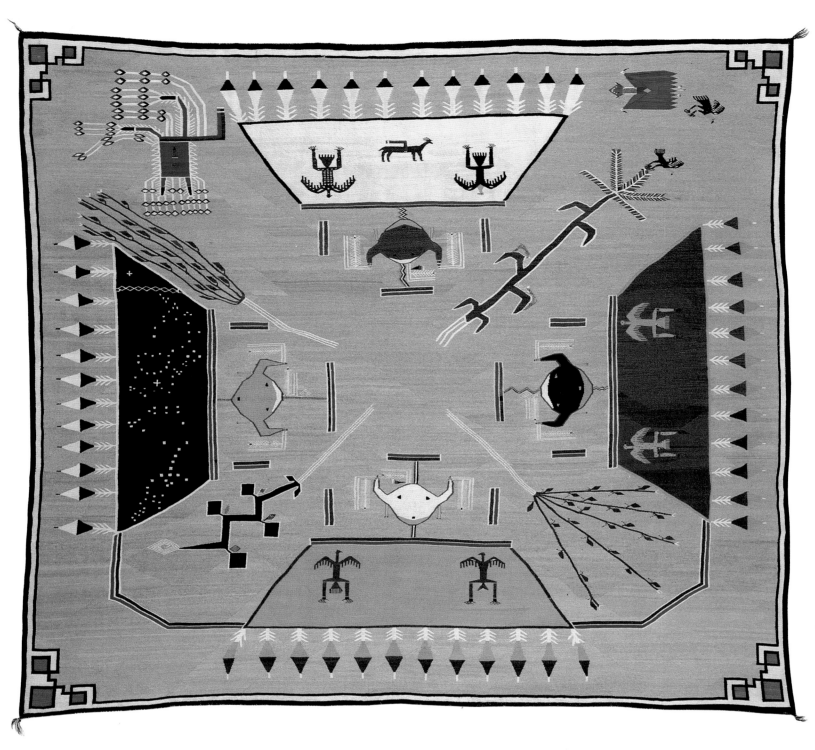

Sandpainting Weaving. Navajo. Early twentieth century. Northern Arizona. Wool yarn. Length: 123½ in. Tony Berlant Collection.

This Navajo weaving illustrates "the Skies" sandpainting from the "Shooting Chant." It shows the episode of the Navajo creation story when the Sun gave the four skies of the daily cycle to his children, the Hero Twins. In the center are the horned faces of blue sun, black wind, white moon, and yellow wind. They hover above the four skies: white dawn, blue day, yellow twilight, and black night. The four sacred plants recognized by the Navajo—corn, squash, bean, and tobacco—are located in the spaces between the skies.

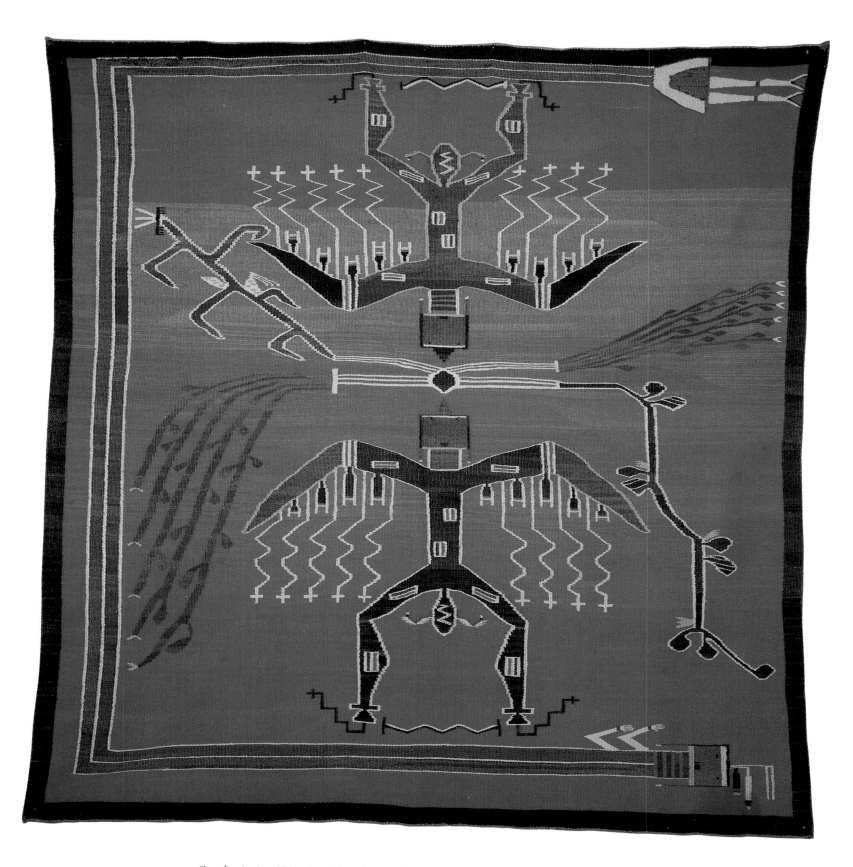

Sandpainting Weaving. Navajo. Early twentieth century. Northern Arizona. 75 x 79 in. America Hurrah, New York.

Holsteen Klah, the famous Navajo holy man, or "singer," is generally credited with being the first to supervise the production of Navajo weaving that replicated the images of sandpaintings. Others apparently duplicated Klah's idea, as is the case with this blanket.

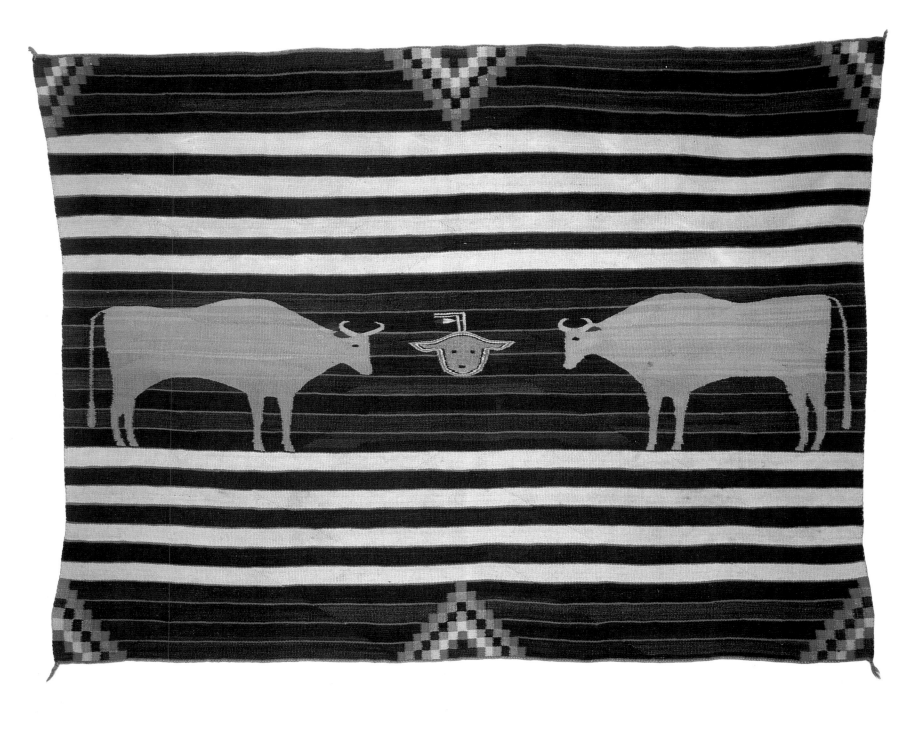

ABOVE: *Pictorial Chief's Blanket.* Navajo. 1890–1910. Northern Arizona. 63 x 79 in. America Hurrah, New York.

This weaving combines the striped format of a late (third-phase) chief's blanket with a floating horned face that customarily would represent the moon or the sun in a Navajo sandpainting. Early in the twentieth century, some weavers began to incorporate pictorial elements from sandpaintings in their designs. Sandpaintings were the sacred prerogative of healers who made them as part of a cure to heal the sick. In weavings like this one, the image is intended to be purely decorative.

OPPOSITE: Irene Clark. *Standard Rug.* 1990. Arizona. Wool yarn. Length: 63½ in. The Denver Art Museum.

This piece follows the A/B/A pattern conceived by Clark's ancestors more than a century ago. A bold central panel containing two rows of red serrated diamonds in stepped crosses falls down the back when the blanket is worn horizontally across the shoulders.

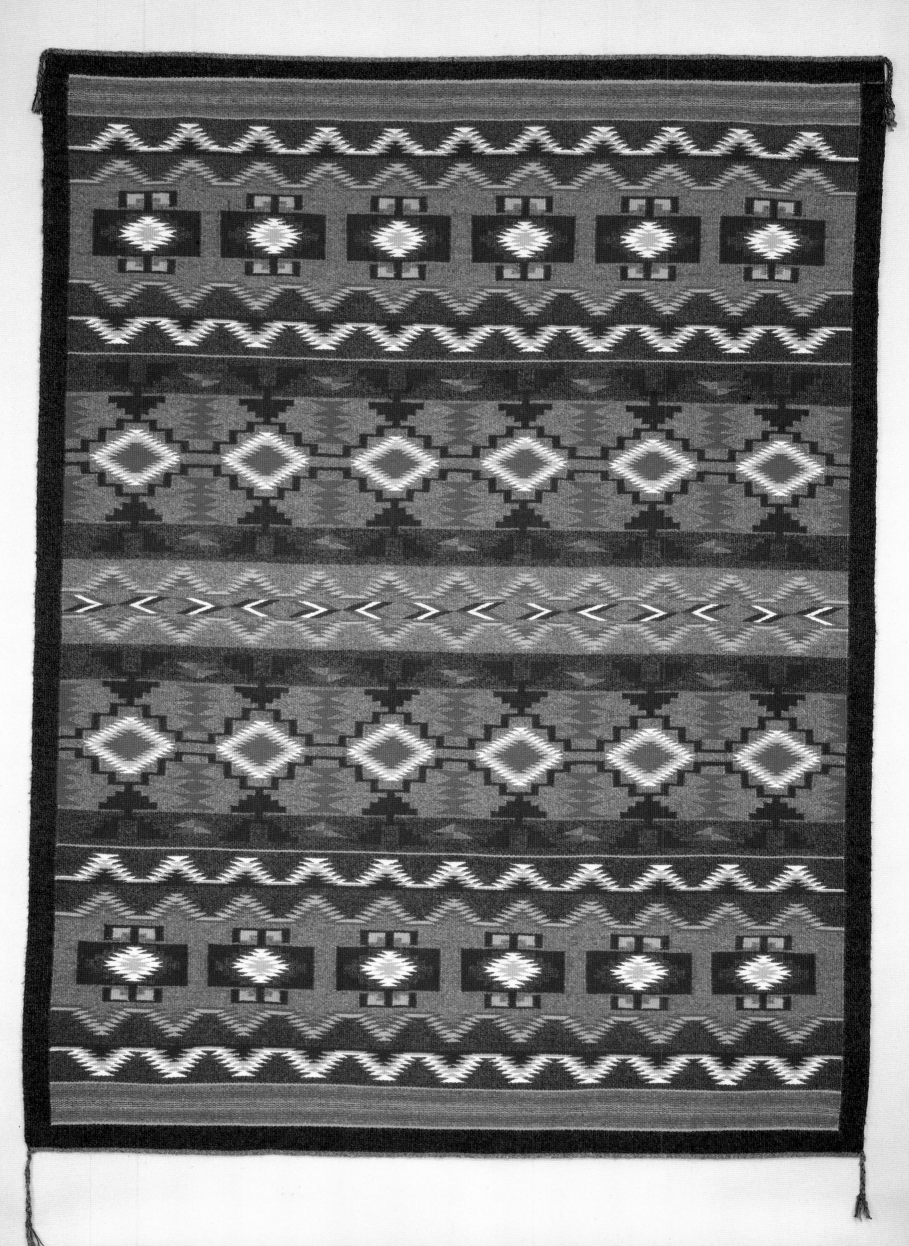

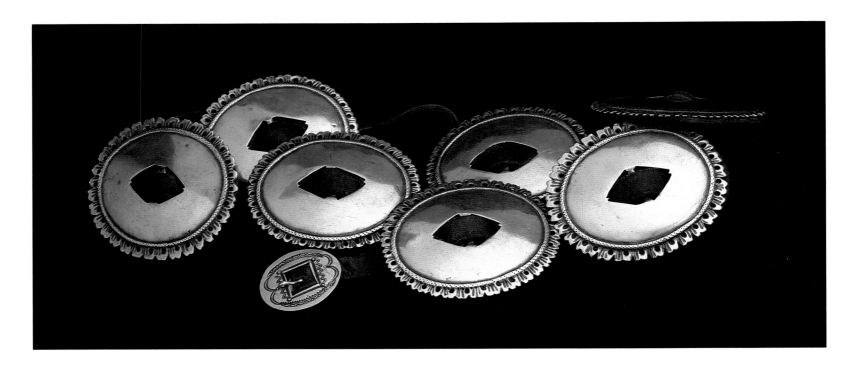

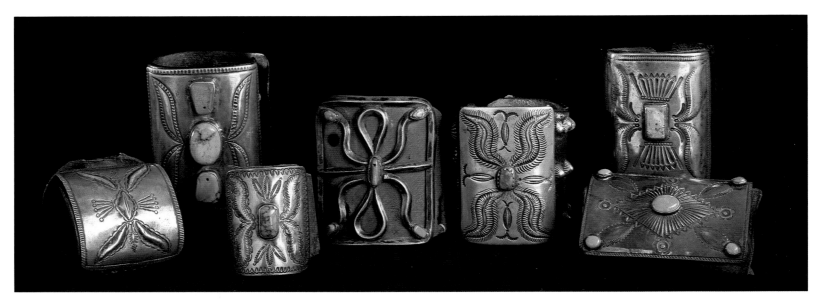

TOP: *Concha Belt.* Navajo. 1870s or 1880s. Northern Arizona. Silver, saddle leather. Length of single concha: 3½ in. Herbst Collection.

Silver "conchas" for belts were among the earliest categories of silver ornament made by Navajo smiths. The oval shapes were made from ingot silver and decorated without stamps using only files, a cold chisel, and a nail to punch out the holes around the edges. The saddle-leather belt is strung through diamond-shaped slots with a little filed "tongue" in the center. These elegant early forms were relatively easy to make since they required no soldering. The stamped buckle is a later addition to the belt made sometime between 1890 and 1910.

ABOVE: *Seven Ketohs.* Navajo. 1890–1920. Northern Arizona. Silver, turquoise, saddle leather. Average length: 3½ in. Herbst Collection.

Navajo archers when at war or hunting wore a leather band called a ketoh to protect their wrists from the bowstring. Silversmiths began to decorate ketohs with cut or cast silver plaques late in the nineteenth century, when they became more decorative than functional. The earliest style of bow guard in this group, dating to the 1890s, is visible on the far right.

OPPOSITE: *Squash-Blossom Necklace.* Navajo. 1920s. Northern Arizona. Silver, turquoise, strung on original fiber. Length: 16 in. Herbst Collection.

The "squash-blossom necklace" is made of spherical beads, "squash-blossom" beads, and the central pendant called a naja. *A "trumpet" was simply soldered to a spherical bead and then a square shank added for stringing.*

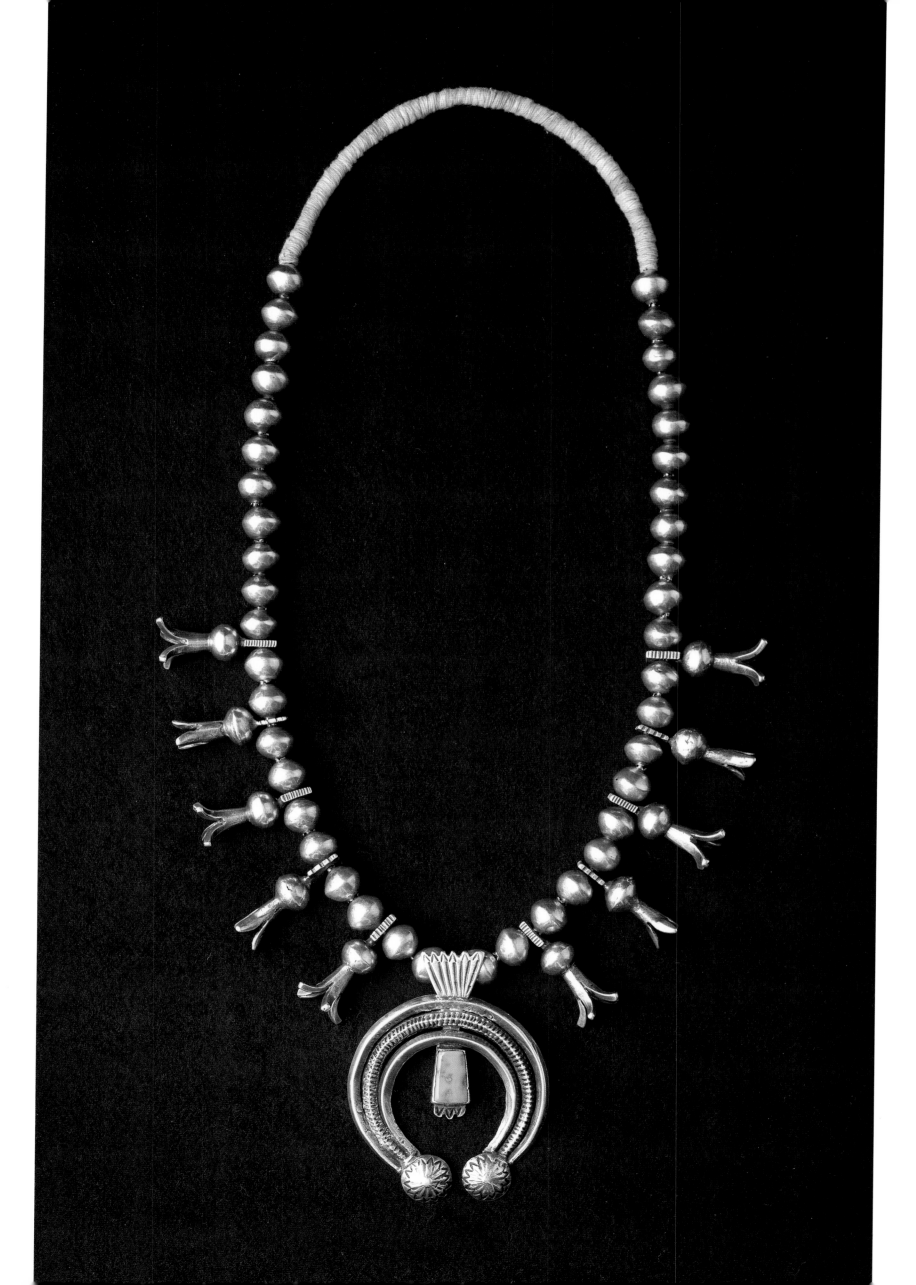

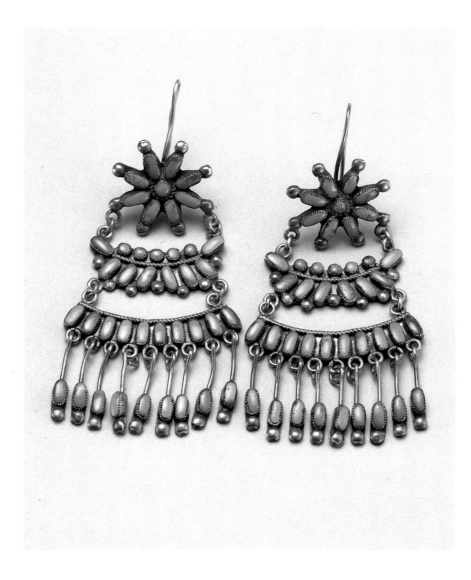

Pair of Earrings. Zuni. Early twentieth century. New Mexico. Silver, turquoise. Length: 3 in. Jeanne Penney Collection.

Zuni silversmiths preferred to work with small stones that were set in patterned arrangements. These Zuni "drops" are composed of upper rosettes linked by short chains to two bars of twisted wire with rows of inset stones, and "fringe" pendants that hang free from the bottom. The result is kinetic sculpture that responds to every movement.

BELOW: *Sixteen Bracelets.* Navajo. 1880–1930. Northern Arizona. Silver, turquoise. Average length: 2½ in. Herbst Collection.

This group of early Navajo bracelets represents a number of different styles and techniques. Bracelets of the late nineteenth century, like those visible on the right, bottom center, and lower left, were decorated with simple file and chisel markings. Turquoise settings and elaborate stamps drawn from Mexican leather-working techniques characterize most of the remaining bracelets, which date to the first decades of the twentieth century. Bracelets of this period are known for their beautiful stone, ranging in color from a pale blue-green to a deep azure, depending on the mine of origin.

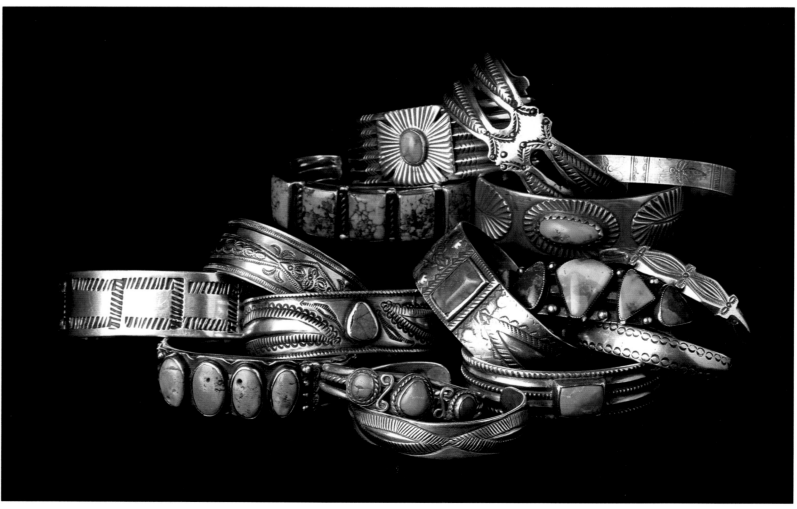

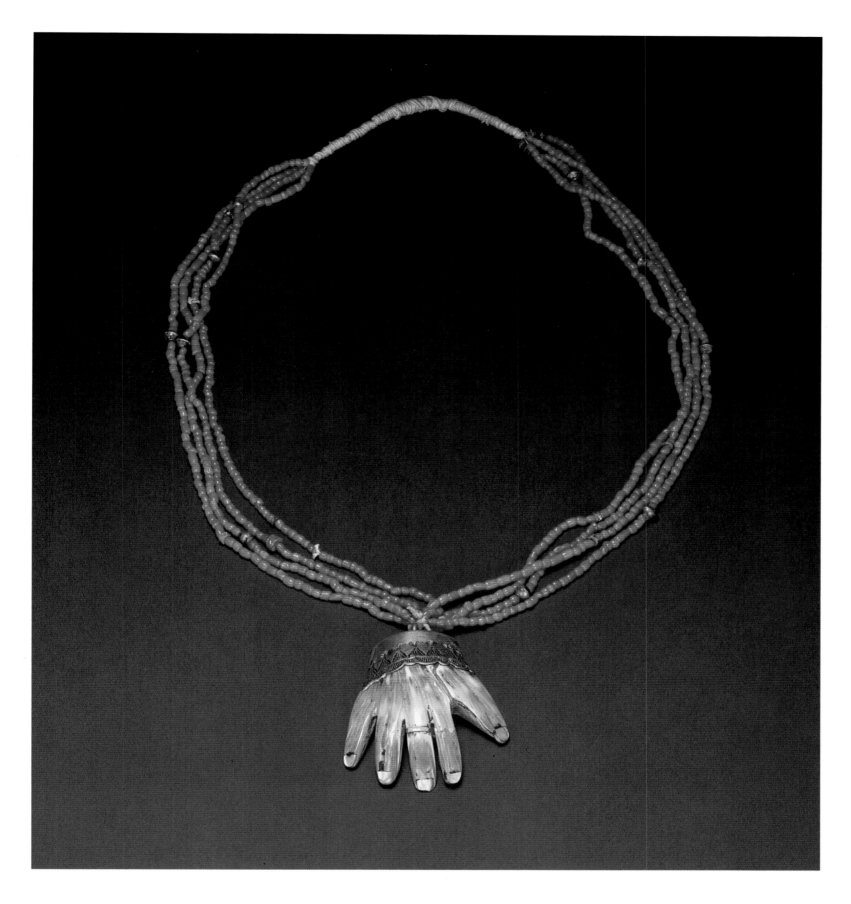

Necklace with Hand Effigy Pendant. Pueblo. 1920s. New Mexico. Red coral, shell, silver, turquoise. Laboratory of Anthropology, Museum of Indian Art and Culture, Santa Fe, New Mexico.

This necklace is composed of four strands of red coral beads interspersed with turquoise and silver. The pendant shaped like a human hand is made of cut marine shell set in silver. Shell "fingernails" in a contrasting color were set separately, as was the turquoise ring.

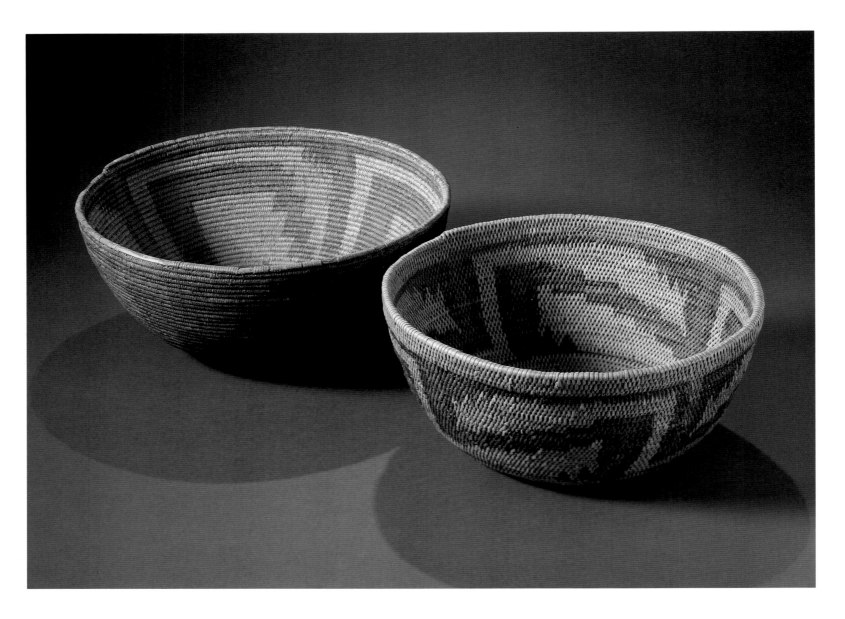

ABOVE: *Two Coiled Baskets.* Anasazi. A.D. 1100–1300. Southern Utah. Natural and dyed sumac. Largest diameter: 11½ in. Southwest Museum, Los Angeles.

These are two of nine baskets found nested together in southern Utah, where they were probably left as an offering in an outdoor shrine, perhaps in a cave or rock shelter. Basket weaving had always been important to the ancestors of the modern Pueblo; the pre-pottery traditions are called "Basket Maker culture" by archaeologists. The Anasazi perfected the art of coiled basket weaving with tight, compact stitches and geometric patterning, as can be seen on this pair.

OPPOSITE: *Three Basket Trays.* Pima. 1920s. Southern Arizona. Willow, martynia, beargrass. The Philbrook Museum of Art, Tulsa, Oklahoma.

These three basket trays display the striking radial patterning for which Pima baskets are famous. Unlike the neighboring Apache, Pima basket weavers use bunched beargrass instead of willow rods for a foundation, and sew the baskets with blond willow splints or contrasting black "devils claw" (martynia).

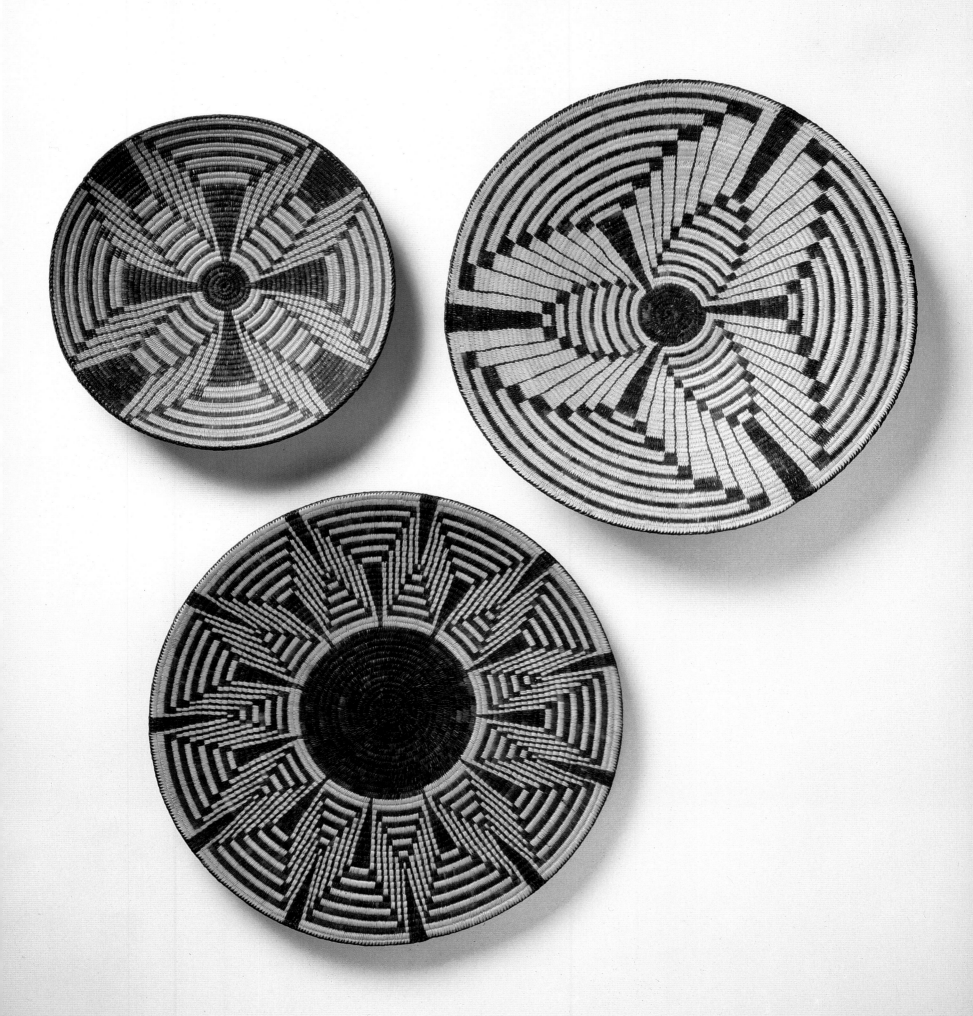

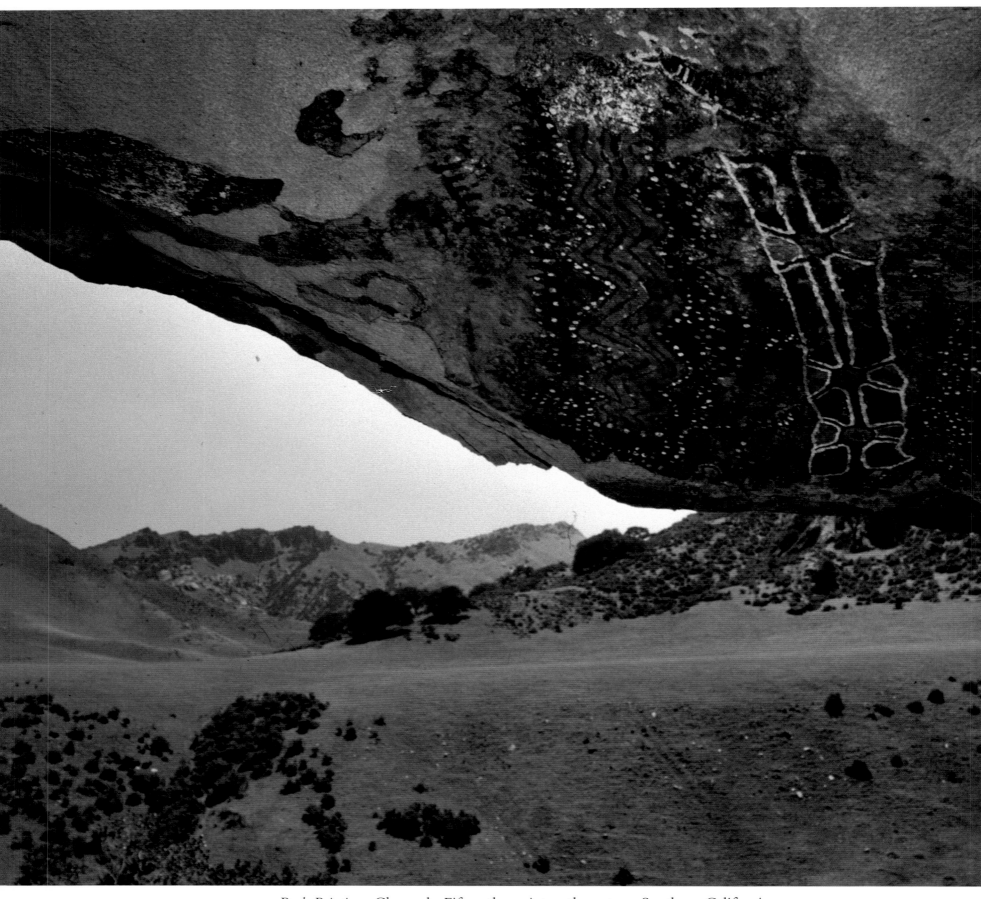

Rock Paintings. Chumash. Fifteenth or sixteenth century. Southern California.
Photograph by Campbell Grant, courtesy of the Santa Barbara Museum of Natural History.

The colorful and hallucinatory paintings produced by Chumash shamans that depict their
experiences with the spirit world are found in caves and rock shelters in southern California. Because
of vandalism and thoughtlessness, few survive today undamaged; many have been destroyed altogether.

THE FAR WEST

A WORLD APART

The Great Basin, stretching between the front range of the Rockies and the Sierras that parallel the Pacific Coast, separates California from the rest of the continent to the east. This, the driest region in North America, proved a formidable barrier to nineteenth-century European-American immigrants who sought the promised land of California. It had, in fact, isolated California from the rest of North America throughout most of the region's history of human habitation. Archaeologists estimate that after 2000 B.C., relatively few groups joined the populations of the California Archaic, leaving most of the resident cultures to develop without significant influence from or involvement with the outside world. As a result, the Indian people of California developed an unprecedented number of local languages and traditions. At least sixty-four, and perhaps as many as eighty, different languages are known to have existed; today, less than two dozen survive, some of which will assuredly be lost when the few elders who speak them join their ancestors.

The Great Central Valley dominates the topography of northern and central California, flanked by the Sierras to the east and the coastal ranges to the west. The varied ecozones of hardwood and pine forest, chaparral, and grasslands proved a most hospitable environment to support human life. Deer and elk was always plentiful, and agriculture never proved necessary. By 6000 B.C., however, the hunting populations of California came to depend more on collecting and processing wild plant foods than hunting wild game. Communities close to the shore harvested abundant resources from the sea. Those in the interior valleys collected acorns which were converted into a nutritious mush by leaching out the tannic acid and boiling the pulverized meat with water. Major inland rivers offered large salmon runs in the fall. The people of the eastern ranges depended on edible roots such as amass and epos as staples in their diet. The northwest coastal range was the most densely inhabited region, with the population thinning to the south due to less rainfall and drier conditions. There, people tended to live in small, dispersed communities, numbering from fifty to no more than five hundred individuals. All in all, it is estimated that when the Spanish arrived on the southern coast, more than 300,000 native people lived in the California culture area.

Despite the linguistic diversity of California, several factors account for the fact that many common traits existed among California's early native population. One was the dependence of most of the cultures upon natural resources, particularly plant foods, to sustain them. Another was the development of extensive networks of exchange for raw materials. Black obsidian, or volcanic glass, was favored among many prehistoric groups for the production of blades, knives, and projectile points. Archaeologists have traced the distribution of obsidian from several quarry sites throughout California via an extensive series of ancient trails. Shell beads and cut abalone shell, resembling mother-of-pearl, were also coveted for use in fashioning ornaments and were traded extensively from people on the coast to inland groups.

The Spanish explored the coast of California during the seventeenth century to determine if there were ports suitable to receive the fleets of galleons that plied their way across the Pacific between Manilla and Mexico. Russian and English interests in the northern Pacific coast provoked Spain to consolidate the California coastal territories with the Mexican provinces of Sonora, Sinaloa, and Chihuahua. Early in the summer of 1769, a Spanish colonizing expedition under joint secular and religious leadership established itself at San Diego, and by 1800, more than twenty additional missions stretched along the southern and central coasts with *presidio* (military forts) at San Diego, Santa Barbara, Monterey, and San Francisco. The Franciscan missions recruited neophytes aggressively among the coastal Indian communities and exploited them as slave labor. Thousands died from misuse, corporal punishment, malnutrition, and disease. By 1836, only 15,000 of the 53,600 Indians baptized since 1769 had survived. Under the independent Mexican government, the missions were dismantled. The land was then appropriated by *haciendas*, large plantations whose Mexican owners continued to depend on Indian slavery and accumulated new slaves by raiding native communities farther and farther to the north. Native resistance plunged the region into guerilla warfare.

With the Treaty of Guadalupe Hidalgo of 1848, California became a possession of the United States. The flood of American immigration after the gold rush of 1849 and the hunger for land perpetuated the ongoing hostilities between the indigenous residents and the newcomers. Use of slave labor, including the kidnapping of children, continued through 1867, when slavery was abolished with the Fourteenth Amendment to the Constitution. Conflicting federal and state policies concerning Indians in California, exacerbated by blatant corruption, undermined any kind of systematic attempts to develop reservations. White communities often took it upon themselves to simply exterminate the local Indians. Even when relations stabilized near the end of the nineteenth century, after Indian people had been forced from the most desirable locations, land problems and conflicting claims clogged the courts. By 1900, the Indian population of California had dropped to scarcely twenty thousand. Today, dozens of small reservations and communities dot the California landscape. Significant obstacles still exist, but Indian people continue to look for solutions to the problem of self-determination.

CEREMONY AND THE COMMUNITY

Most of the native California communities traditionally were modest in size, prompting some anthropologists to call them "tribelets" instead of tribes. The tribelet corresponded to the community or village inhabited by a number of related families and numbered, for the most part, between fifty and one hundred people, occasionally reaching several hundred, but never more than a thousand. The political leader was the "chief," usually a hereditary position that carried great wealth and functioned principally to manage the community's economy. Village society was individualistic and competitive rather than communal and cooperative. Individuals worked to improve their own living conditions and to elevate the status of themselves and their family group. Ambitious people strived to control wealth in the form of shell money, baskets, feather ornaments, obsidian blades, and other valuables, gathering these objects as family treasure, displaying them during ceremonies, distributing them to sponsor prestigious rituals, or literally consuming them by cremation at the funerals of important family members. Techniques used to produce these valuable crafted

items were, in many cases, privileged information and remained closely guarded secrets. Barter, exchange, and trade in these "treasures" offered one avenue for economic advancement. It is not surprising, in such a social structure, that wealthy families exerted great influence over community affairs.

A large ceremonial structure dominated most California communities: plank "dance houses" to the north and subterranean or semisubterranean dance houses that doubled as sweat lodges to the south. The wooden dance houses of central Californians were the scenes of Kuksu ceremonies, celebrations during which ghosts and spirit beings, impersonated by painted dancers decorated with feather and shell ornaments, descended from the surrounding forests and hills. In some communities, Kuksu honored the first fruit, but throughout the region the appearance of these spirit dancers benefitted the health and well-being of the entire group.

In the northern interior, the Big Head performance was a similar set of ceremonies featuring a dancer representing a powerful spirit being, wearing a costume that included numerous wands capped with flowers or feathers arranged around the performer's head. Farther to the north, the Hupa, Karok, and Yurok staged "World Renewal" ceremonies in late summer and early fall. Two prominent dances of this type, the Deer Dance and Jumping Dance, featured the display of treasured regalia owned by wealthy families. Deer Dancers carried the flayed skins of Albino deer upright on long bowls; Jumping Dancers wore elaborate headdresses made of red-tail flicker feathers and carried specially woven basket "purses" filled with straw to call attention to their shape. The ceremonies of the California tribelets varied from one community to another, but the Kuksu and Big Head "cults," which were practiced over a large geographic area, shared many common features. Knowledge of these ceremonies spread from one community to another through trade and intermarriage.

THE ART OF BASKETRY

Baskets played a central role in the life of California Indians. Although some of the southern California tribes produced pottery, baskets were by far the most widely used form of vessel and utensil. Their popularity may have been tied to the predominance of acorns in the California diet and the kinds of processing equipment required for the preparation of acorns for consumption. Baskets served a multitude of purposes: acorns were collected and stored in baskets; acorn meat was ground in basket mortars and leached in basketry sieves; and acorn gruel was cooked in baskets, served in baskets,

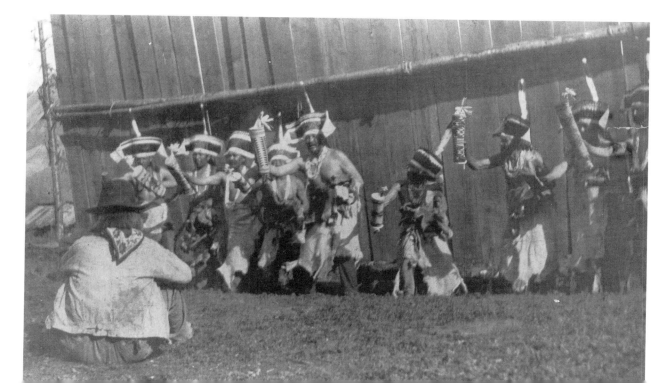

These Hupa Jump Dancers wear headdresses of red flicker feathers and flourish "wallets" in their hands. These treasured objects represent the wealth and power of these esteemed family elders.

Riverside Municipal Museum, Riverside, California.

and eaten from basket vessels. Californians also used baskets to collect wild seed foods stripped from plants and bushes with basket "seed beaters," the seeds then winnowed and parched on basketry trays. And basket traps were used to catch fish and animals.

The importance of baskets in the lives of the Indians of California extended beyond the collection, processing, and storage of food. Mothers carried their babies in basket cradles. Miniature baskets that hung from baby carriers captured the infant's interest, and later, toddlers played with these miniature baskets. Pubescent Pomo girls received a special set of beautifully made basketry vessels with which to eat and drink while isolated during their menses. Women kept these cherished baskets for life and used them for no other purpose. Especially fine baskets were exchanged between families during marriages, and baskets were burned as an expression of mourning after the death of a family member. Shamans possessed specially made baskets for the storage of their religious paraphernalia, and baskets were held as part of the regalia for ceremonial dances. Wealthy families hoarded "treasures" of fine basket collections: sets of large cooking and serving baskets for hosting feasts, and quantities of small jewel-like baskets for gifts and distribution during funerals and commemorative ceremonies. These societies, within which personal status was highly valued, judged an individual or family by the quality and quantity of their baskets.

Baskets were made from many different plant materials that provided both structural and decorative elements. Californians practiced two basic basketry techniques: weaving, including simple wicker and many varieties of twining; and coiling or sewing. Twining was practiced exclusively by some northern groups, while coiling was more common in the south. The central Pomo used both techniques equally. Several groups incorporated additional materials into special "fancy" or "treasure" baskets. Iridescent *haliotis* shell pendants and white *marginella* shell beads added a lustrous quality, and the colorful feathers of small song birds, the red crests of woodpeckers, green mallard duck feathers, pale yellow feathers from the breasts of meadowlarks, or the topknots of the California valley quail added brilliant color and imaginative flair to already beautifully crafted pieces. The bottoms of small, shallow Pomo "treasure baskets" were covered with designs composed of vibrant feathers since they were intended to be displayed hung from the ceiling.

While both men and women built utilitarian baskets, decorated and fine baskets were woven by women. Most baskets were decorated with some kind of design, most often a pattern generated from a series of simple geometric shapes. Women assigned names to these designs and terms for how to combine the design elements. Animals or animal parts, so much a part of these peoples' everyday lives, were represented on their finest baskets. Some of the most popular designs among the Pomo, for example, included "deer teeth," "crow foot," "killdeer eyebrow," and "bat wing." When describing a basket pattern, a woman would combine the design name with a kind of qualifier that described how the design or multiple designs were arranged and repeated on the basket, such as "deer-back arrow head crossing" or "design empty in the middle ants close in a row." These conventions for design description possessed no narrative or personal meaning. Like women's nonrepresentational designs found elsewhere in North America, the designs on California baskets reflected a broad philosophical view of the relationship between human culture and the natural world.

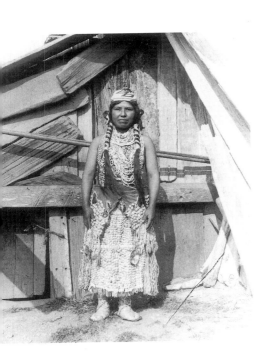

This 1901 photograph shows Elsie Frank, a Yurok woman, dressed in lavish regalia. She wears a twined basketry hat with a skirt and apron decorated with dentalium and abalone shell, and an abundant number of shell necklaces. She is outfitted appropriately for a ceremonial display of wealth.

Phoebe Hearst Museum of Anthropology, University of California, Berkeley.

With the exception of the Spanish colonialists who received presentation baskets from the eighteenth-century Chumash and other "Mission" Indians of the southern coast, outsiders took little interest in California basketry arts before 1880. After California became a state of the union, its dramatic landscape, its deeply rooted Indian heritage, and the remarkable history of native handworks began to be considered by some as part of California's charm. In 1864, Abraham Lincoln was petitioned to turn over the Valley of Yosemite to California as a nature reserve. After 1890, Miwok and Paiute residents of the Yosemite valley began to make an increasing number of their baskets for sale to visitors to the newly established national park. Curio stores opened to cater to tourists. By the turn of the century, tourist demand for native baskets increased. In 1916, Yosemite initiated an annual event known as Indian Field Days, which included basket competitions and abundant opportunities for sales. Basket makers of Yosemite responded to the burgeoning market by developing new styles of baskets, adding beaded decoration, innovating new forms such as jars and pedestal baskets, and incorporating designs drawn from commercial illustrations such as flowers, figures, and even the patriotic union shield.

The transformation of the California Indian basket from everyday container to desirable collectible was aided by the efforts of traders, entrepreneurs, and promoters of basketry art. Grace Nicholson became a widely known dealer as she traveled extensively throughout California during the first decade of the twentieth century scouring villages for old baskets to sell to American museums and their ethnographers, while at the same time striving to develop exclusive patronage relationships with talented basket makers. She was particularly successful among the Pomo and the northern Karok, Hupa, and Yurok. She, along with other dealers and promoters, created a demand for Indian baskets among tourists and collectors.

Vendors of California Indian baskets promoted basketry artists as well as their wares, aggressively guarding access to an artist's work. Grace Nicholson retained exclusive rights to the baskets of Pomo weaver Mary Benson and Karok weaver Lizzie Hickox, the latter making exceptionally fine, twined lidded baskets with a distinctive, innovative shape that was her own invention. The most famous basket maker of this period was Washoe artist Louisa Keyser, who made baskets exclusively for Carson City dry goods vendor Abe Cohn. Cohn supported and sponsored Keyser, providing her with living quarters and livelihood in return for all of her basketry production.

As the lifestyles and economies of California Indian people changed to adapt to the realities of the modern world, basket making became a means of entering into the cash economy. Talented basket makers produced baskets for the new market of collectors and tourists with energy and creativity. Promoters of western Indian baskets recognized, however, that buyers desired something traditional—something that spoke of the past, not the present. The art of basketry recalled a proud past—one that had been destroyed by the modern world but which collectors hoped to rediscover. Modern basketry artists drew upon this heritage and gave new expression to deeply rooted traditional concepts through innovative techniques and designs. The individual creativity of many Indian artists was compromised, however, as promoters and vendors sought to "authenticate" their work by obscuring the realities of the present and creating in its place a myth of the past. Many Indian artists continue to struggle with this issue today.

DATSOLALEE

The famous Washoe basket weaver known as "Datsolalee" was born to the Washoe name Dabuda but preferred her Anglo name, Louisa Keyser (c. 1850–1925). She was one of the most accomplished and innovative Native American basket makers of her generation, a period when native people throughout North America were trying to adjust to the realities of modern society and a changing economy. Like many basket makers throughout the Great Basin and California region, Louisa Keyser sold many of her traditional baskets to the European-American settlers, visitors, and tourists who went west during the expansion. The location of her Washoe homeland, close to Lake Tahoe and Carson City, was commercially advantageous, but her success was primarily due to her promotional relationship with Abe and Amy Cohn, owners of a clothing and curio shop in Carson City called The Cohn Emporium. Encouraged by the Cohns to emulate the styles of the successful Pomo "fancy-basket" makers of central California, Keyser created a novel category of basket, an exceptionally large and finely woven, nearly spherical basket bowl they called the *degikup,* a basket type without precedent in the Washoe tradition, or, in fact, anywhere in the world.

The Cohns promoted Keyser and her *degikup* by creating a fictive "authenticity" that would correspond better to their clients' perceptions of Native American art. Louisa Keyser became "Datsolalee," meaning "big hips," due to her large size, and was presented as a "Washoe Princess," although the Washoe themselves had never recognized that title. Her innovative *degikup* became a traditional burial basket that only the "princess" was allowed to produce. This fictive persona captured the imaginations of Louisa's clients, and was featured in many articles and books, but always as "Datsolalee," a name that condescendingly ridiculed her weight. Contemporary enthusiasm

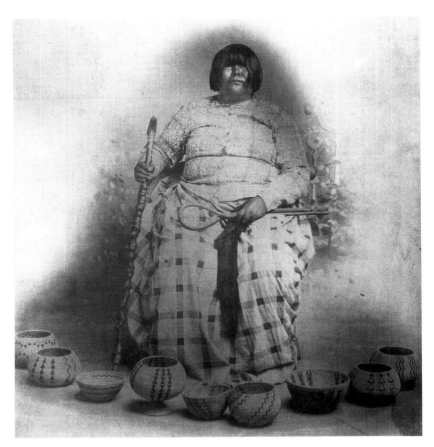

Louisa Keyser, "Datsolalee," with her baskets.
Nevada State Museum.

for her work never recognized her accomplishment as an innovator and a true artist.

Keyser's remarkable artistry is fully appreciated today, and is clearly evident in the Philbrook *degikup.* The tightly controlled pattern of triangular motifs stacked in vertical columns visually emphasizes the exaggerated curve of the basket shape; rarely has basket art so successfully fused volume with surface design.

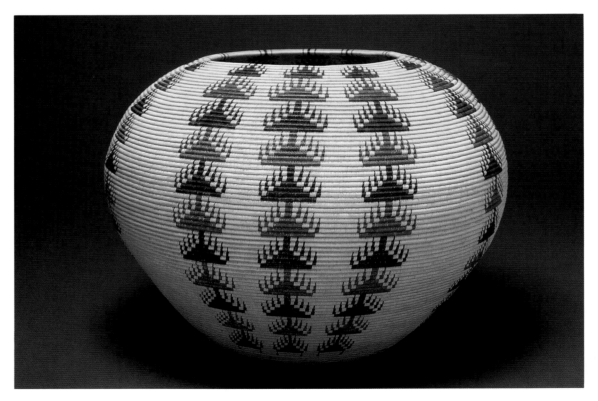

LOUISA KEYSER. *Degikup.* 1917–1918. Oklahoma. Willow twigs, broken fern stems, redbud bark.
Height: 12 in.; maximum diameter: 16¼ in. The Philbrook Museum of Art, Tulsa, Oklahoma.

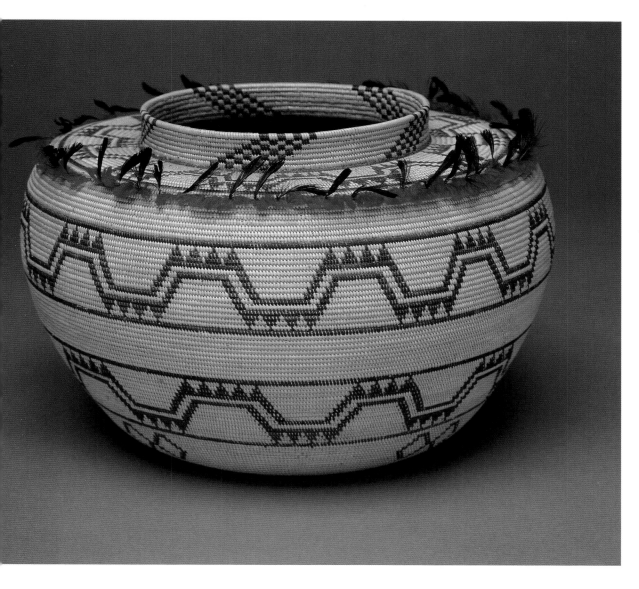

Basket Jar. Chumash. Eighteenth century. Southern California. Juncus stem and sumac root. Height: 15¾ in. Peabody Museum of Archaeology and Ethnology, Harvard University, Cambridge, Massachusetts.

Coiled baskets made by the Chumash people of the southern California coast are among the rarest and most finely made baskets in California. The Chumash, ruthlessly exploited as slave labor by the eighteenth- and early nineteenth-century Spanish missions, saw their population decline from an estimated 20,000 people to less than 3,000 by 1834. Only approximately 225 Chumash baskets have survived to the present day.

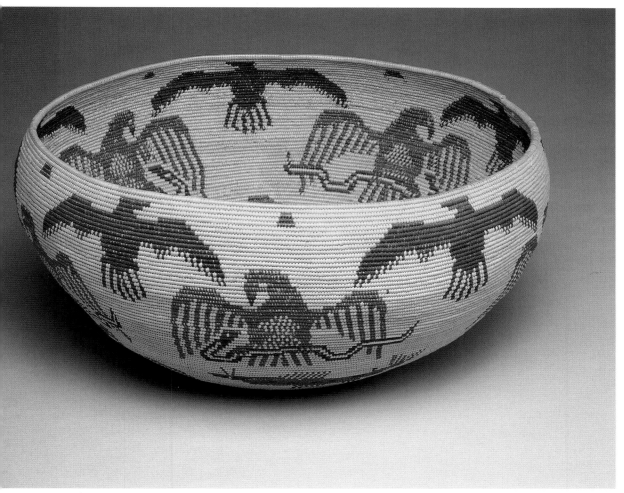

Kate McKinney (Maidu). *Basket Bowl.* c. 1890. Sierra Nevada, central California. Redbud, bracken fern root, willow. Diameter: 13½ in. Courtesy of Janis and William Wetsman Collection.

In this unusual basket, Kate McKinney introduced the "rainbird" design borrowed from basket weavers of southern California, but adapted it to the graceful, Maidu basket bowl shape. The weave on this basket is exceptionally fine and uniform. In her design, black birds rise gracefully to the rim, flanking larger birds in red below.

BELOW: *Conical Burden Basket.* Pomo. Nineteenth century. Central California. Willow, sedge root, redbud. Height: 20½ in. The Heard Museum, Phoenix, Arizona.

The people called Pomo actually represent seven distinct groups that speak languages unintelligible to each other. The notion of a Pomo people stems from their regional proximity close to an ancient quarry for red ochre, used for dye, called pho ("red earth") mo ("hole"). This large, conical basket is made with twining technique. The design develops in the wefts, with redbud spirals around the conical form from the base to rim, each element of the design expanding in size as the shape of the basket opens.

OPPOSITE TOP: *Gift Basket.* Pomo. Nineteenth century. Central California. Conifer root, willow, shell. Southwest Museum, Los Angeles.

Pomo "boat"-shaped baskets are a form of special gift basket intended for presentation; they represent a form of wealth. Pomo baskets are made with both coiling and twining technique. This twined basket is decorated with cut shell beads and pendants of mother-of-pearl.

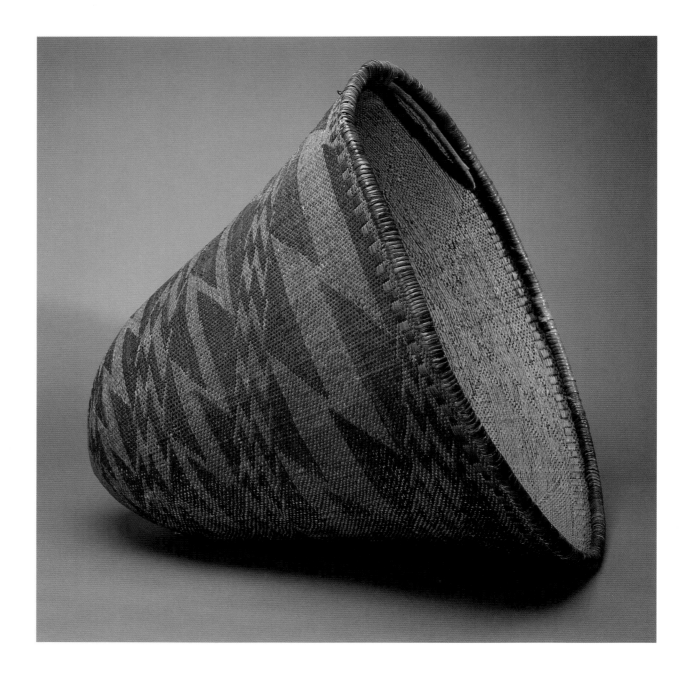

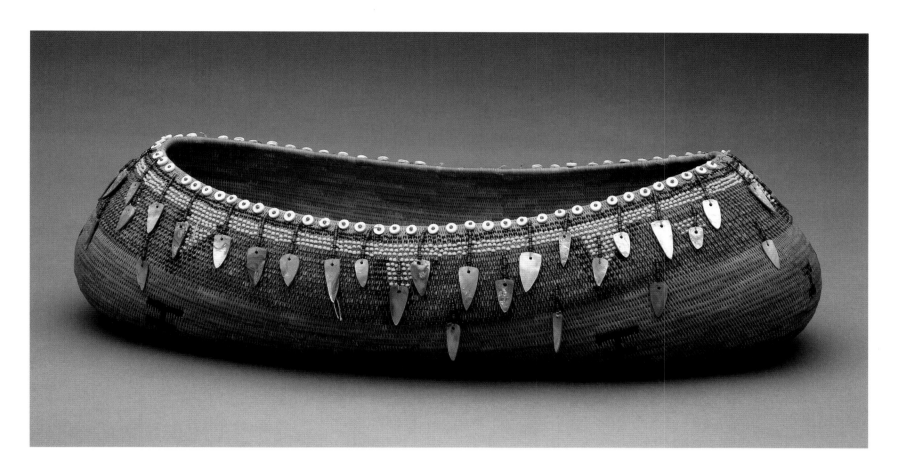

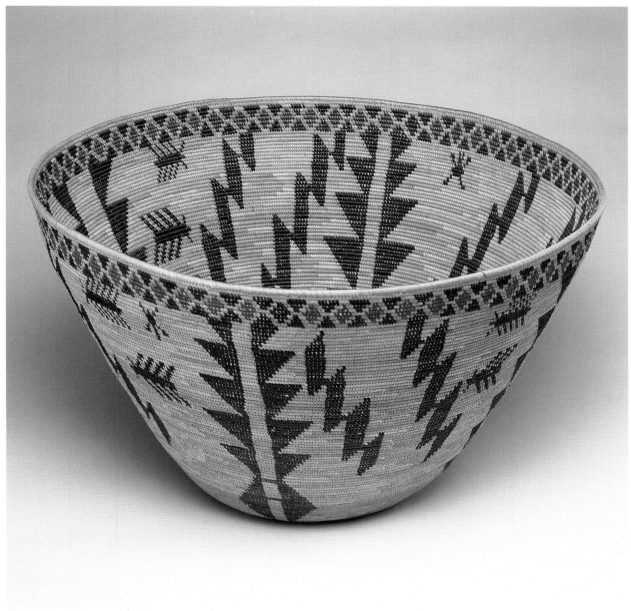

LEFT: *Coiled Basket.* Yokuts. Early twentieth century. Central Valley, California. Redbud, sedge root, bracken fern root, grass. Diameter: 20 in. Courtesy of Janis and William Wetsman Collection.

This large basket features the customary Yokuts "rattlesnake" pattern of a diamond band beneath the rim, but the lower portion of the design includes more dynamic and inventive elements: bolts of lightning and flying insects. The first decades of the twentieth century represent an episode of great experimentation and creativity among California basket weavers, as they sought innovative designs that would appeal to the newly expanded market among non-Indian collectors.

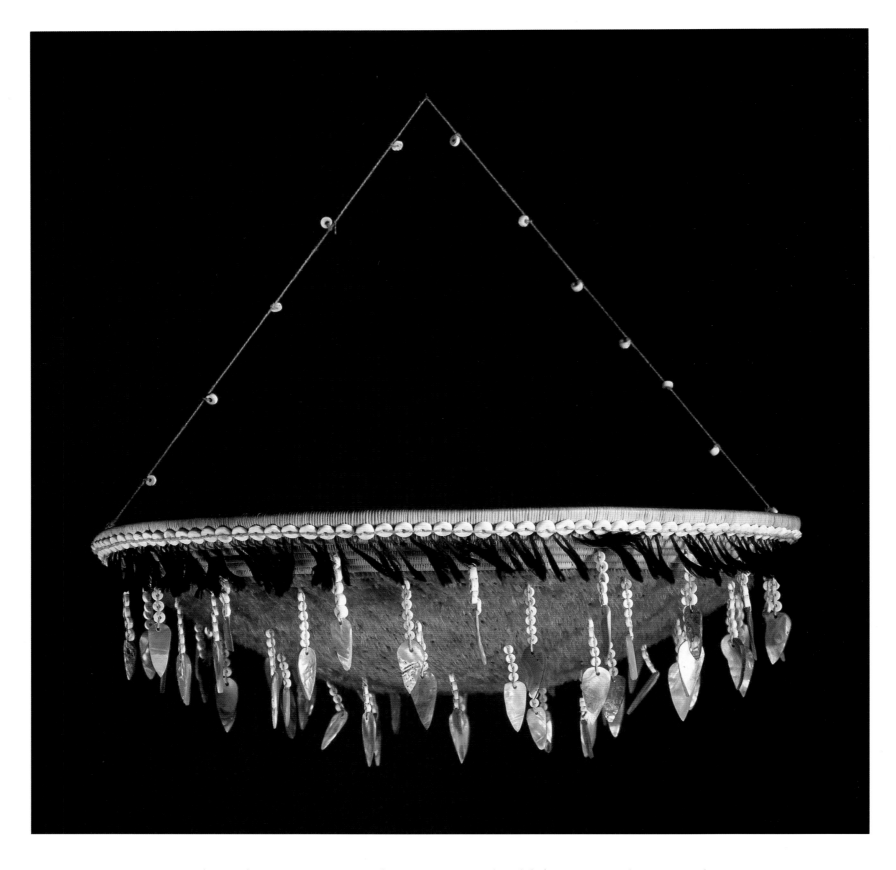

Feather Basket. Pomo. Nineteenth century. Central California coast. Sedge root, willow, feathers, shell. Southwest Museum, Los Angeles.

Finely made and highly ornamented baskets functioned as honored gifts or offerings for funerary cremations among the Pomo. This earliest type of feather basket, called tapica *or "red basket," used red woodpecker feathers exclusively for the feather mosaic with the addition of quail topknots beneath the rim. The underlying basket was made with coiling technique using willow splints without a pattern. Individual feathers plucked from a birdskin were secured beneath each coil as the basket was made. Pendants of cut shell beads and mother-of-pearl hang from the sides. The basket is intended to be hung by a cord strung with beads.*

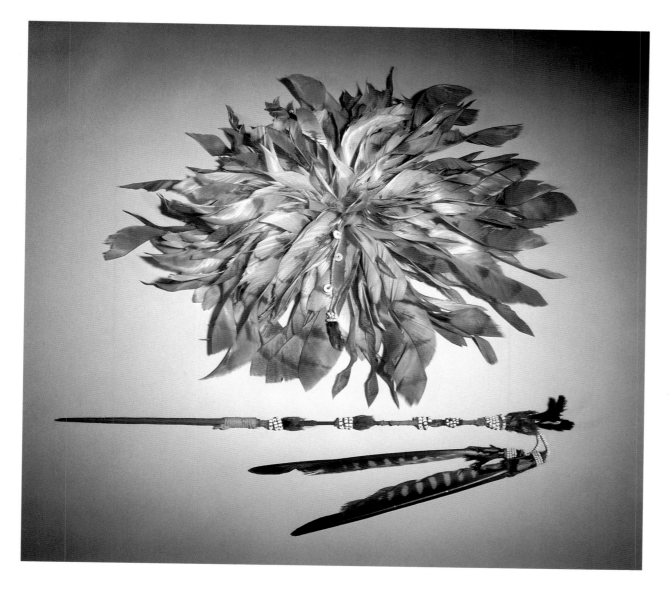

George Barber (Maidu). *Ceremonial Hair Ornament.* Early twentieth century. Sierra Nevada, central California. Barn-owl feathers, prairie-falcon feathers, quail topknot feathers, acorn-woodpecker scalps, hide, glass beads, cotton string, wool, dye, iron wand, wood. The Brooklyn Museum, Museum Expedition 1908, Museum Collection Fund.

This hair ornament worn for Maidu ritual dances consists of a spherical bunch of owl feathers mounted on an oak pin. The triple-pronged hair pin includes flicker feathers, feathers from the red scalp of the acorn woodpecker, quail topknots, and pendants made of cut abalone shell with white glass beads.

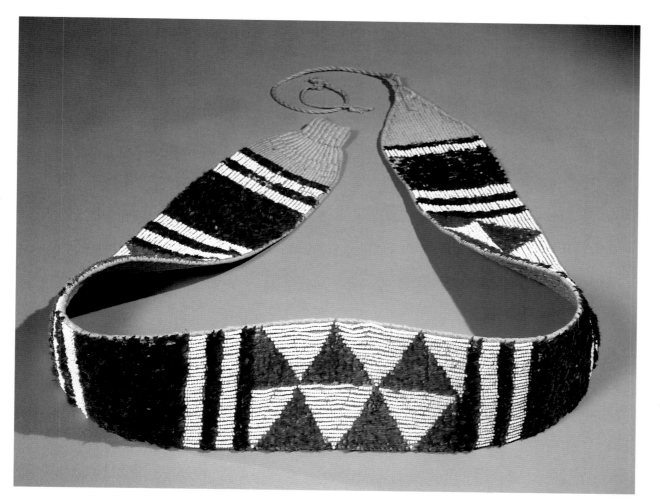

Feather Belt. Maidu. 1855–1870. Sierra Nevada, central California. Feathers, glass beads, hemp, jute or cotton cordage. Length: 67 in. The Brooklyn Museum, Museum Expedition 1908, Museum Collection Fund.

Wealthy Maidu wrapped belts like these around their waists when performing ritual dances. They were treasured possessions. A man might present one to a woman whom he intended to marry. Customarily, these belts were cremated with their owners at the time of their death. The cordage was woven with a simple loom with green mallard duck feathers and the scalp feathers of at least twenty-five woodpeckers secured beneath the wefts.

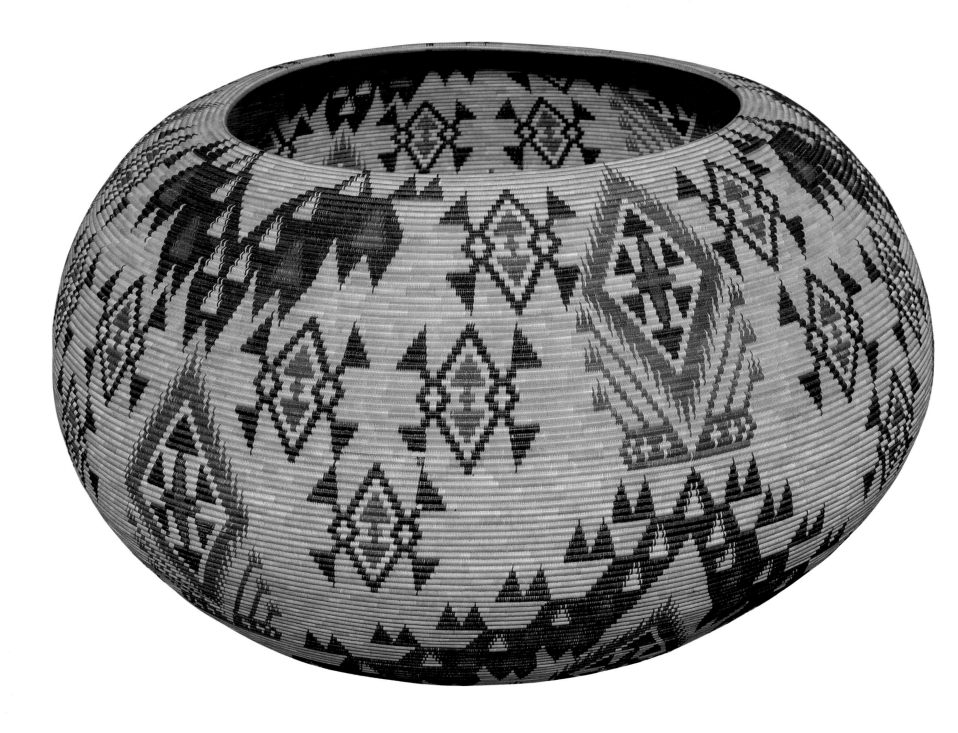

ABOVE: Carrie Bethel (Mono Lake Paiute). *Coiled Basket.* 1930s. Yosemite Valley, central California. Sedge root, redbud, bracken fern root, willow. Diameter: 32½ in. Yosemite National Park Collection.

Carrie Bethel was one of several accomplished basket weavers who worked in Yosemite National Park during the first decades of this century making baskets for sale to park visitors and for commercial vendors of Indian basketry throughout the country. She traveled to San Francisco in 1939 to participate in an exhibit organized by the American Indian Arts and Crafts Board for the Golden Gate International Exposition. This, the largest basket ever produced by the artist, took her four winters to complete.

OPPOSITE: *Coiled Basket.* Maidu. Late nineteenth century. Sierra Nevada, central California. Natural and peeled redbud. Height: 16⅛ in. The Heard Museum, Phoenix, Arizona.

The northern or mountain Maidu live on the western foothills of the northern Sierra Nevada, their settlements ranging in location from the Sacramento basin to the high mountain valleys. This basket was an ambitious project that enlarged the standard, smaller, short Maidu basketry bowl shape into a more elegant, tall, swelling form. The delicate bands of redbud designs draw on an old, traditional Maidu vocabulary of geometric motifs.

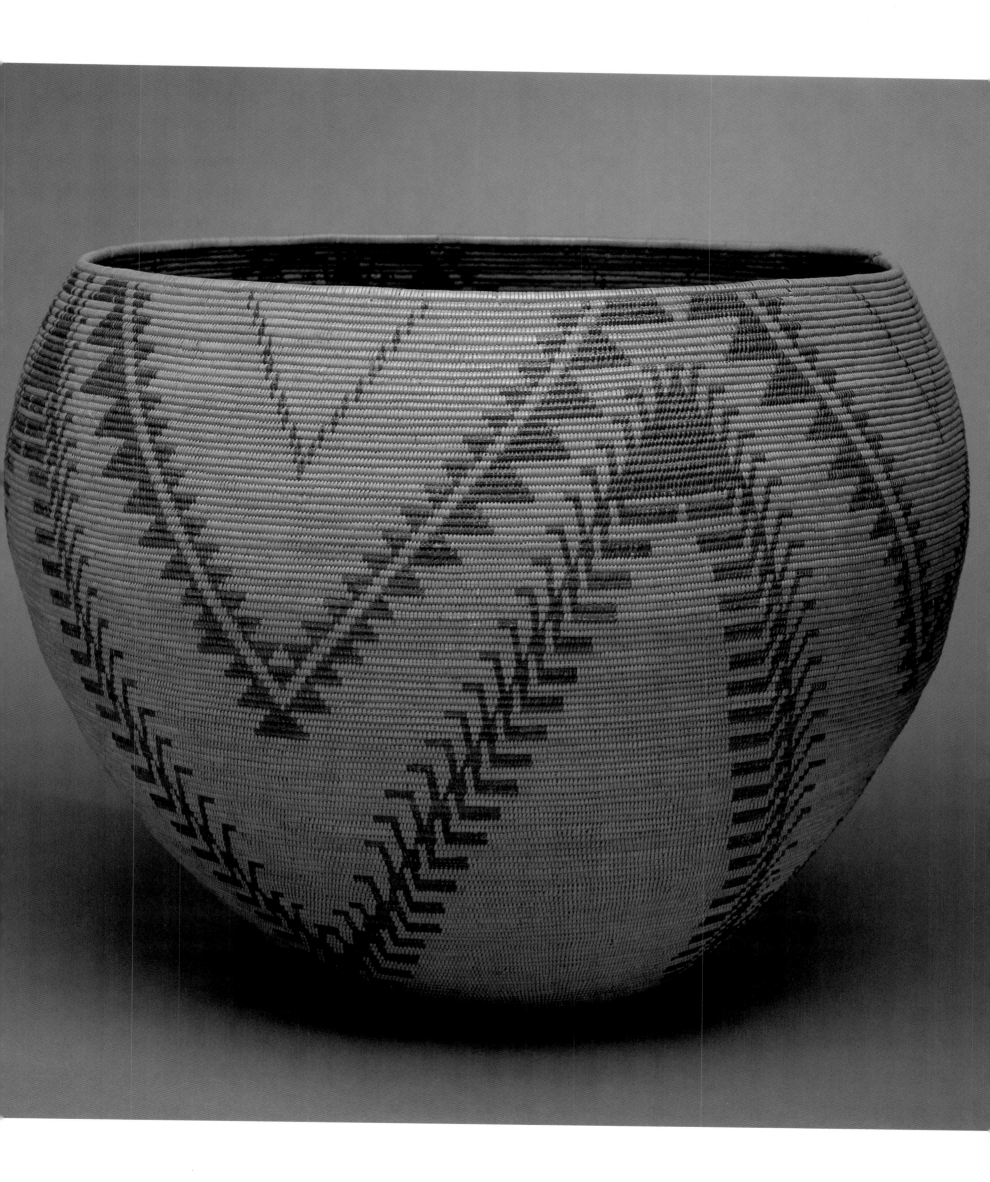

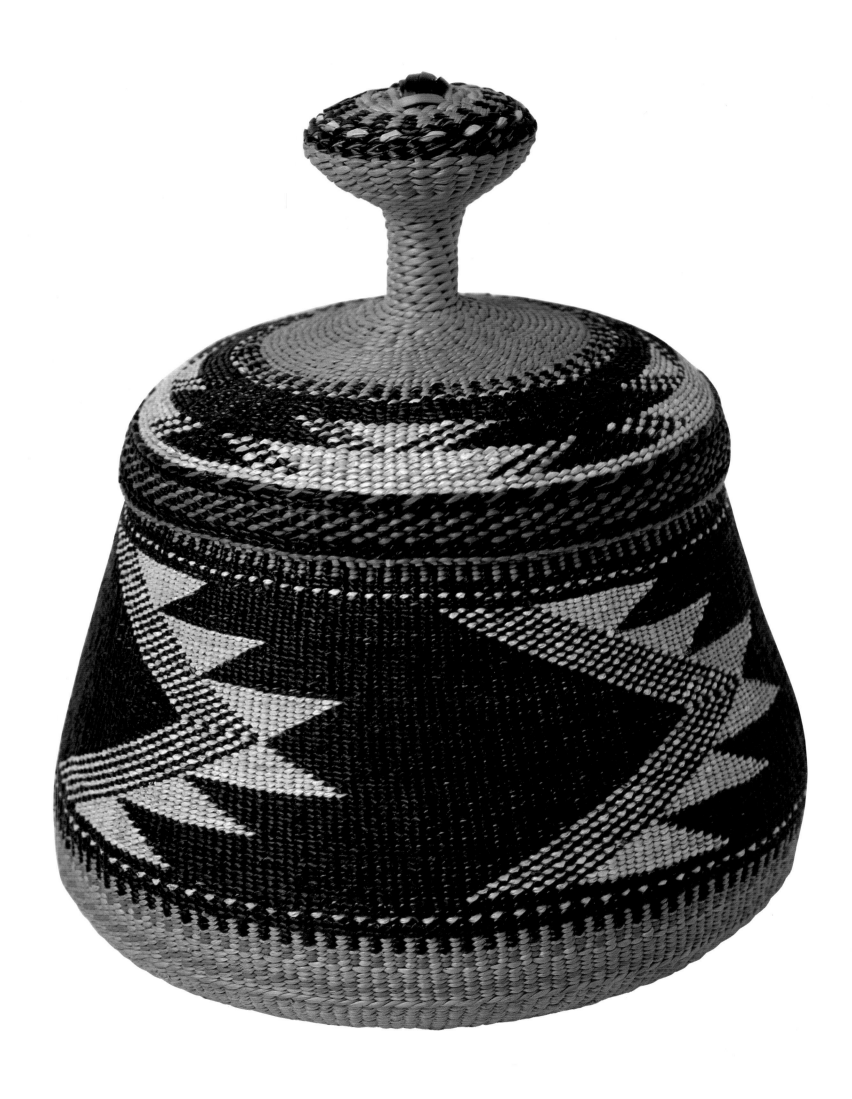

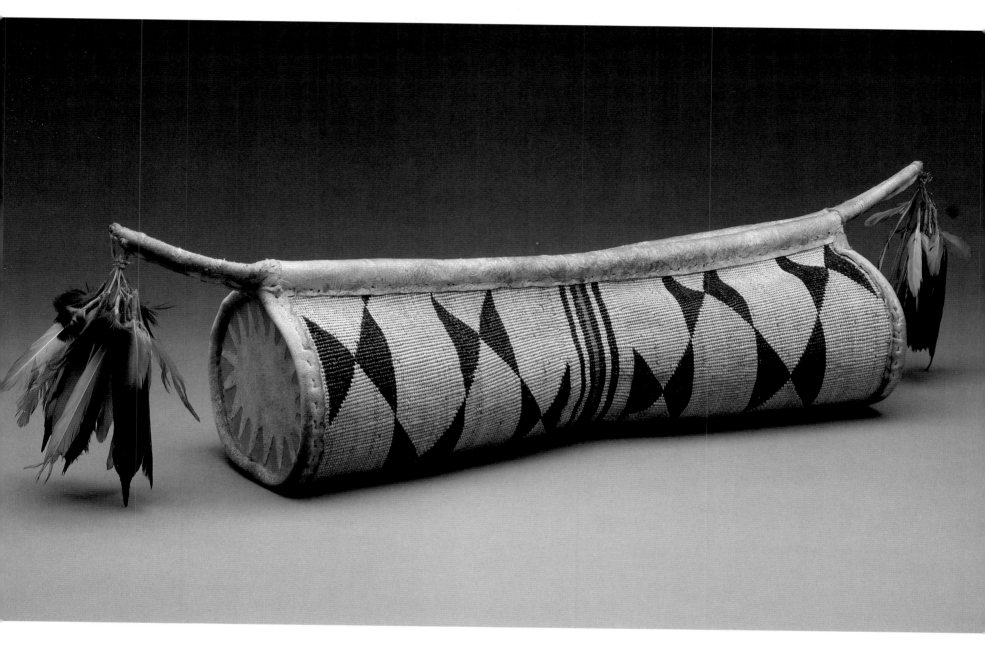

OPPOSITE: Elizabeth Conrad Hickox (Hupa). *Twined Basket with Lid*. c. 1920–1934. Northern California. Beargrass, maidenhair fern, porcupine quills, willow and spruce root, hazel sticks, staghorn lichen. Height: 5 in.; diameter: 4¾ in. The Thaw Collection, Fenimore House Museum, Cooperstown, New York.

Elizabeth Hickox was an extremely talented Hupa basket weaver who innovated this unique form, a kind of basket jar with a handled lid. The form may be based loosely on styles of china teapots or sugar jars with their graceful handles. This is reputed to be the smallest basket of this kind made by Mrs. Hickox, and is crafted with the finest stitching.

ABOVE: *Jumping Dance Basket*. Hupa. Nineteenth century. Northern California. Willow, conifer root, beargrass, maidenhair fern, feathers, deerskin. Southwest Museum, Los Angeles.

Hupa Jumping Dance performers wore wide headbands of woodpecker scalps and carried tubular baskets like this one, stuffed with grass to preserve their shape. They are intended to resemble oversized elk horn purses whose engraved designs are emulated in the overlay patterns of the basket. The purses functioned as receptacles for shell money; the large, purse-shaped baskets, therefore, symbolized great wealth.

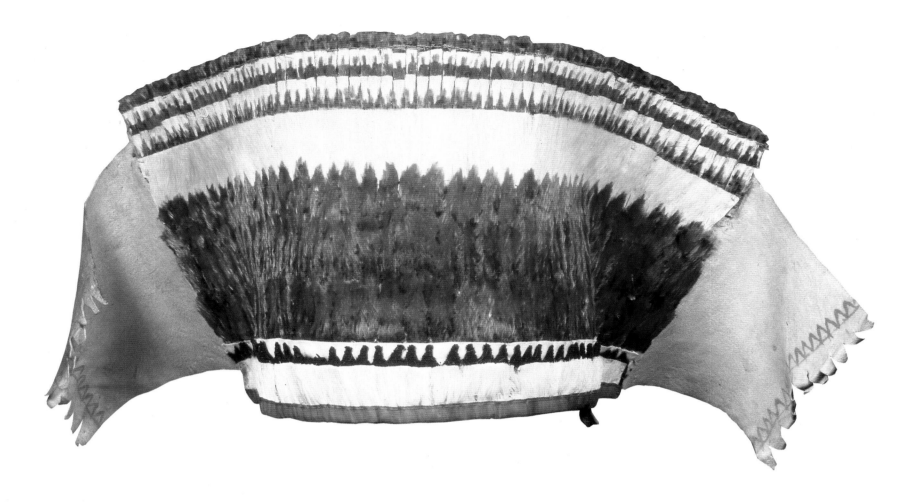

ABOVE: *Jumping Dance Headdress.* Yurok. Nineteenth century. Klamath River region, northern California. Albino deerskin, feathers, cotton cloth. Width: 29 in. The Denver Art Museum.

The Jumping Dance is a "World Renewal" or "first fruits" ceremony in which the performance is conceived as part of a cycle of life that maintains humankind's blessed relationship with the cosmos. It usually takes place in September or October to coincide with the acorn harvest and salmon runs. Part of the ceremony involves the private recitation of esoteric prayers within the dance house, but the public portion of the ceremony follows for five to ten days, during which wealthy men stage the presentation of treasured and famous valuables by distributing them to dancers. As the days pass, more and more valuables and regalia are revealed by the dancers, and increasing numbers of spectators attend to witness and enjoy the spectacle. This Jumping Dance headdress is made with red woodpecker skins and blue bird feathers mounted on the pristine white hide of an albino deer.

OPPOSITE: *Dance Hat.* Karok. Nineteenth century. Northern California. Feathers, deerskin. Height: 7½ in. Peabody Museum of Archaeology and Ethnology, Harvard University, Cambridge, Massachusetts.

This headdress made of deerskin and feathers was worn during the brush dance, one of several secular celebrations staged by the Karok in which wealthy community leaders displayed expensive and very prestigious regalia. The crown of red-shafted flicker feathers is tipped with yellow breast feathers of the goldfinch.

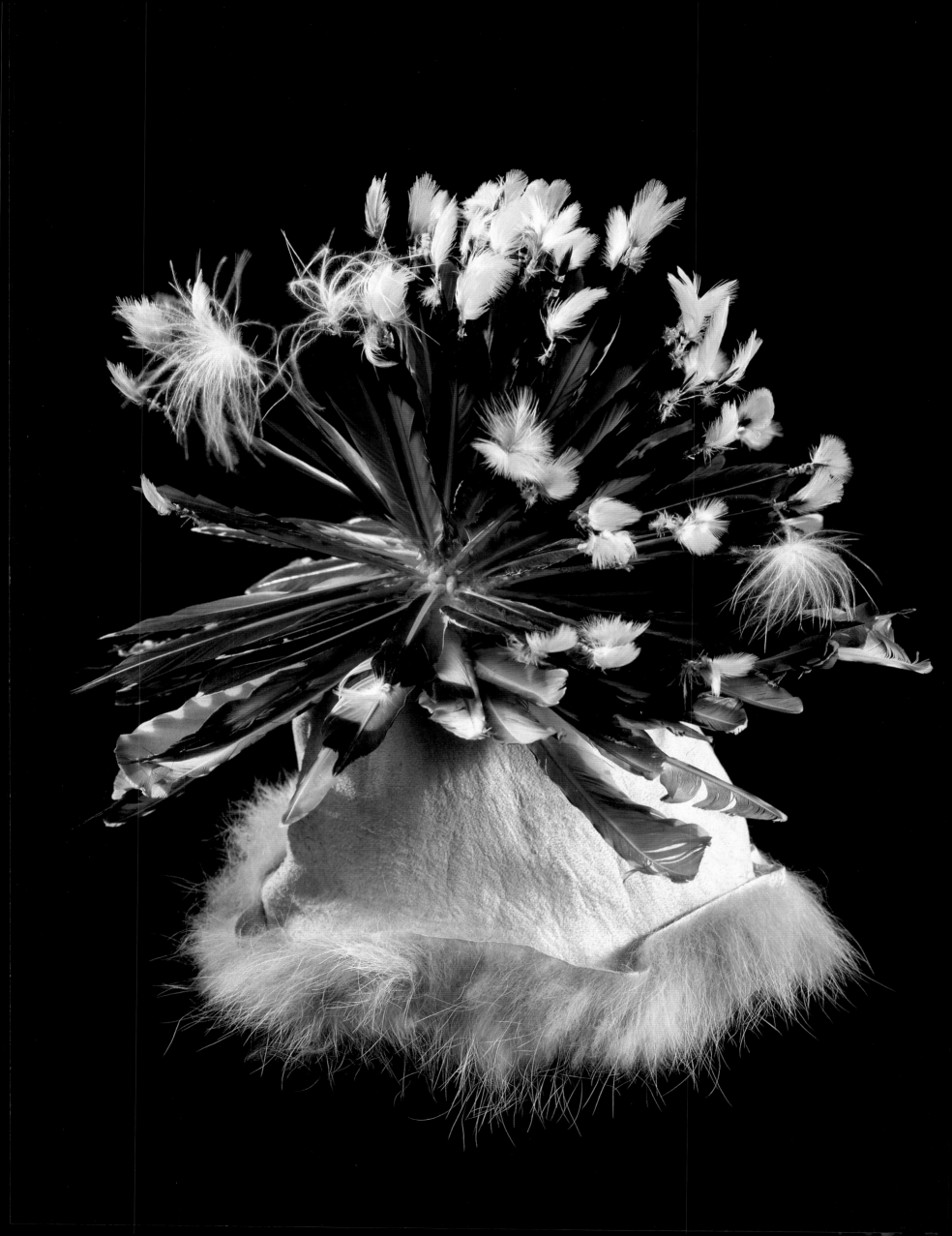

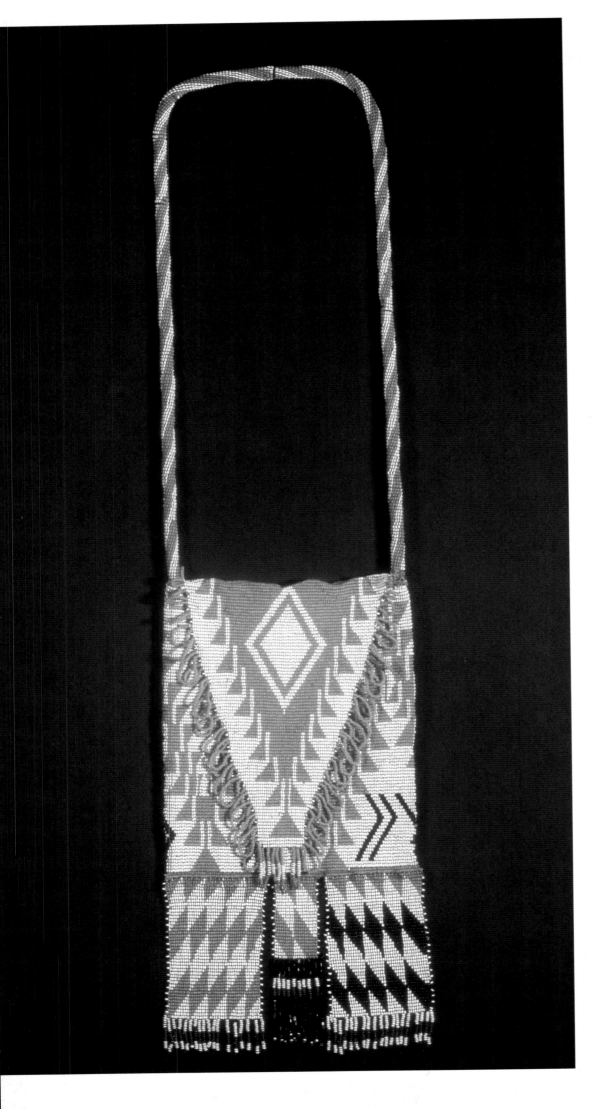

LEFT: *Beaded Bag.* Achumawi. Nineteenth century. Pitt River region, northern California. Glass beads, cotton thread. Length: 7⅝ in. The Denver Art Museum.

The Achumawi live in the highland regions of northeastern California in an environment that combines forested uplands with valley marshlands and lakes. They made twined baskets like their northern California neighbors, but here, characteristic Achumawi basket patterns have been adapted to woven beadwork in this rare shoulder pouch.

OPPOSITE: *Woman's Skirt.* Hupa(?). Late nineteenth century. Northern California. Deerskin, abalone shells, clam shells, beargrass, maidenhair fern, iris fiber, copper. Length: 36 in. The Brooklyn Museum, Museum Expedition 1903, Museum Collection Fund.

This formal skirt, worn for special social and ritual occasions, wrapped around the sides and back, with a separate fringed apron worn over the open front. Thick necklaces of shell beads and a hemispherical, twined basket hat completed the regalia. The shell and abalone pendants represent considerable wealth.

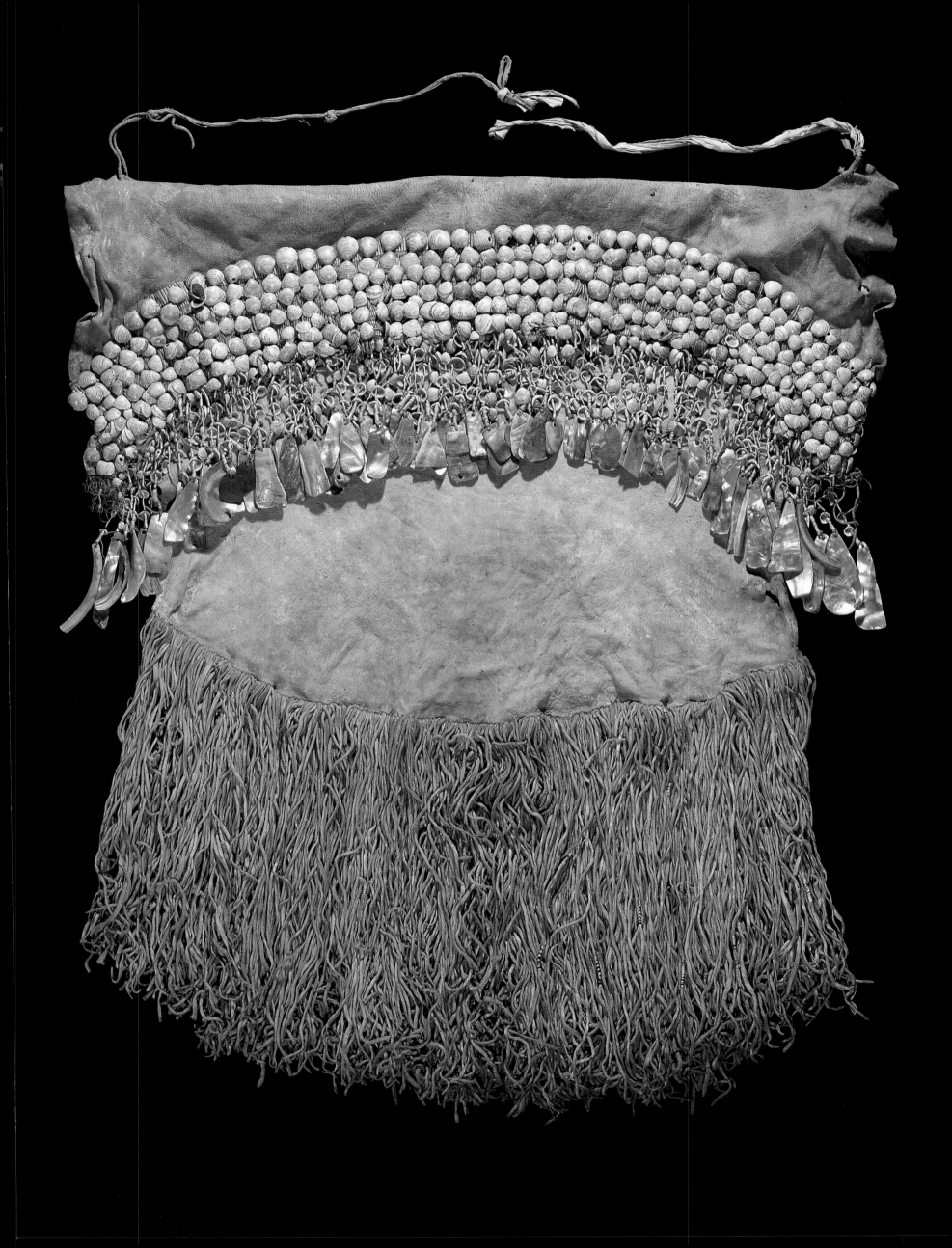

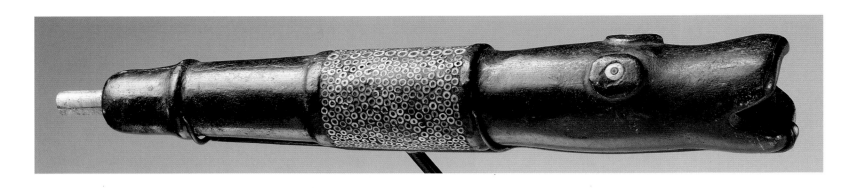

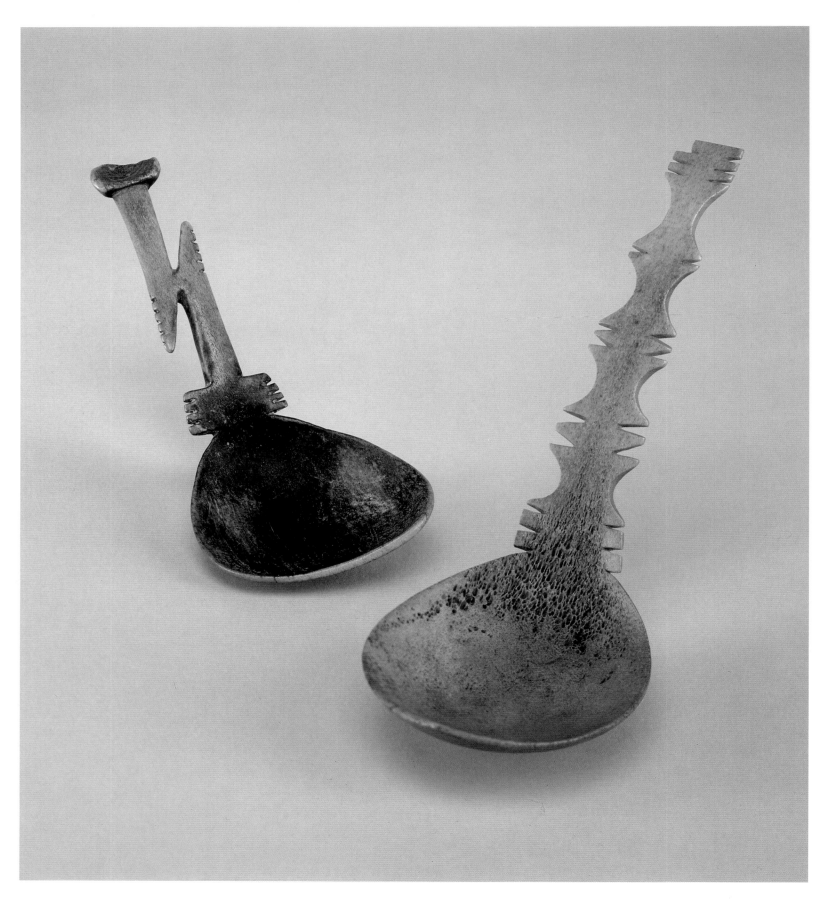

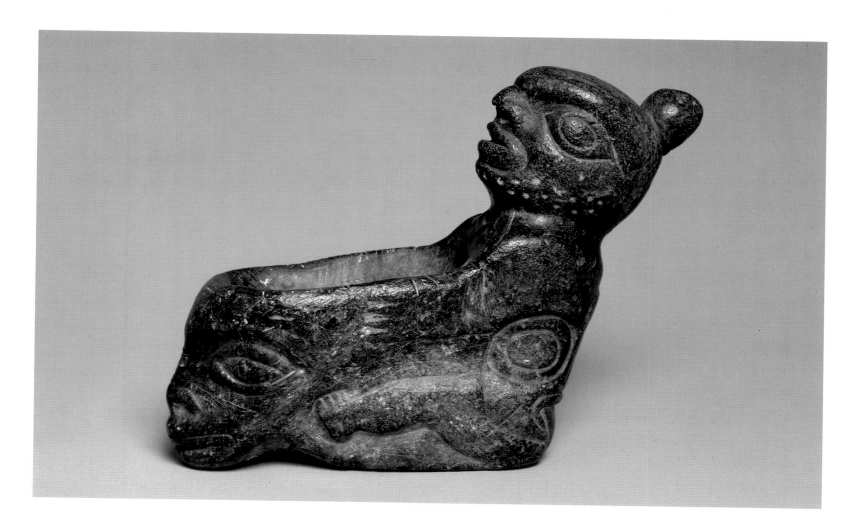

OPPOSITE TOP: *Tubular Effigy Pipe.* Gabrielino. A.D. 1400–1600. San Nicholas Island, southern California coast. Stone (steatite), shell, wood. Length: 10½ in. The Gordon Hart Collection, Bluffton, Indiana.

The large steatite quarries on Santa Catalina Island, just east of San Nicholas, provided the raw material for an important steatite crafts industry among the Gabrielino Indians, who inhabited the islands and the adjacent mainland, and their neighbors, the Chumash, to the north. Steatite was used for cooking bowls, utensils, animal carvings, and pipes, like this one. The wide-eyed animal with its open jaws and a collar of inlaid shell beads defies any identification, but its warm, rounded forms are characteristic of southern California steatite sculpture.

OPPOSITE BOTTOM: *Two Spoons.* Karok, Yurok, or Hupa. Nineteenth century. Northern California. Elk antler. Longest length: 6¼ in. The Denver Art Museum.

Spoons made of elk antler were used by well-to-do Karok, Yurok, and Hupa men to eat acorn mush; women used mussel shell utensils. The spoons were highly prestigious items that symbolized wealth and status. The handles were often carved in fanciful, geometric shapes.

ABOVE: *Seated Human-Figure Bowl.* Marpole culture, 350 B.C.–A.D. 200. Washington State. Stone (steatite). Length: 8⅝ in. National Museum of the American Indian, Smithsonian Institution, New York.

Over fifty stone seated figurines carved with a bowl held on the lap have been found in southern British Columbia and northern Washington State. This carving is unusually detailed. The seated figure with its slightly beaked nose, bulging eyes, and parted mouth, leans backward while it grasps with both its arms and legs the bowl that becomes the massive head of some kind of creature.

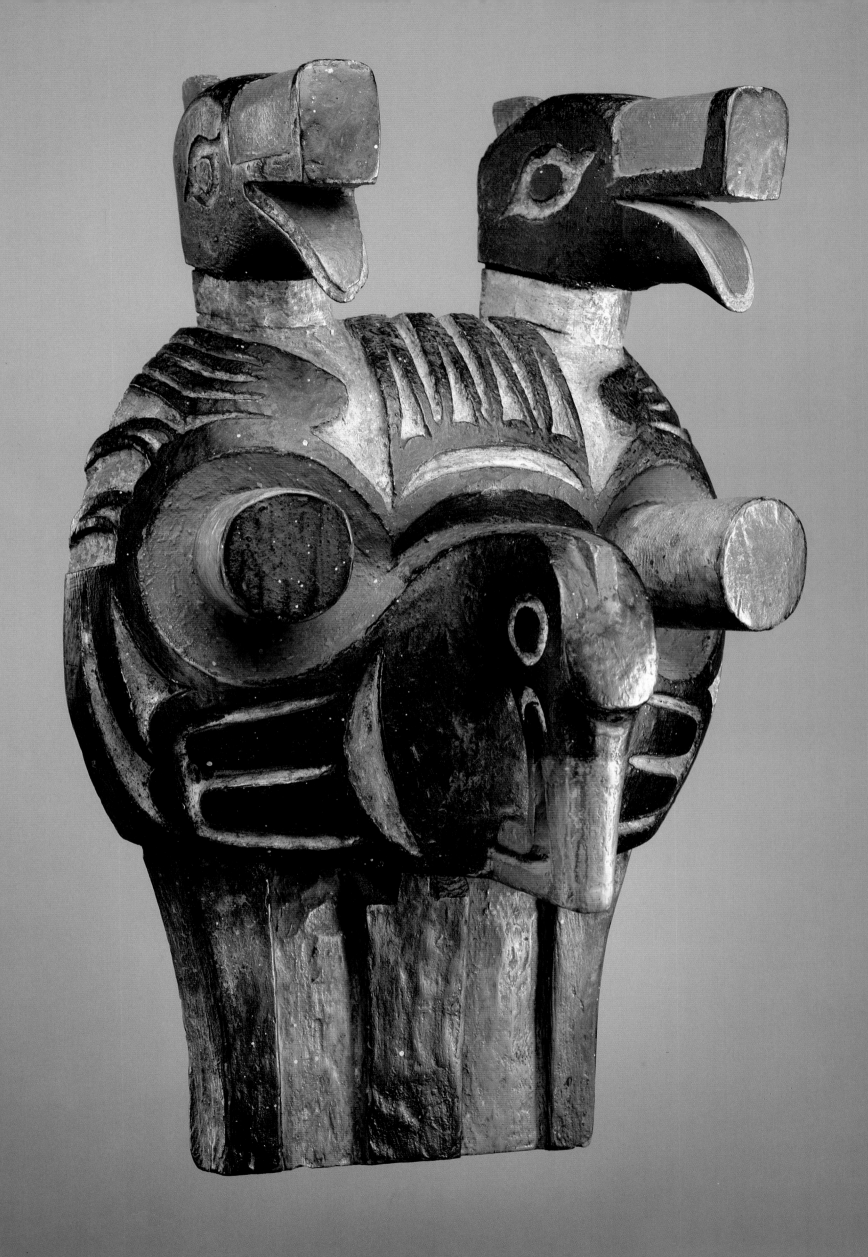

THE NORTHWEST COAST

The Pacific cordillera of British Columbia isolates a rugged coast of innumerable bays, inlets, fjords, and islands. On shore, dense old-growth forests of cedar, spruce, and pine rise abruptly to meet the rugged mountain country of the coastal range. The narrow coastal shelf, between the upland forests and the open ocean, where summers are cool and winters relatively mild, provides a generous habitat for the support of human life.

ANCIENT BEGINNINGS

Early peoples lived in coastal villages and looked to the sea for their sustenance and livelihood. The bountiful resources of the Pacific Northwest Coast nurtured cultural life without the need for agriculture. Salmon and eulachon (candle fish or smelt) clogged the coastline's many streams and rivers during spring and fall spawning runs; herring, halibut, and cod were harvested offshore. In addition, the people hunted deer, bear, and other animals in the inland forests. Berries, greens, roots, nuts, marine algae, and many other varieties of plants added variety to the Northwest Coast diet.

The sites of man's earliest presence on the coast are now very likely underwater, covered by the oceans swelled by the thawing of the Ice Age polar caps. By 7000 B.C., the shorelines of British Columbia had conformed roughly to their present levels, and archaeologists have found that early residents camped near salmon streams to harvest annual salmon runs. After 3000 B.C., the people of the Northwest Coast moved seasonally between relatively large winter villages and smaller summer hunting and fishing camps, establishing a basic pattern of life that has persisted among succeeding generations to the present day. Enormous middens—garbage heaps of mussel shells and other refuse—that accumulated over hundreds, if not thousands, of years mark early village sites. Tools of polished stone, such as adzes, hammers, and mallets, recovered archaeologically, testify to an elaborate prehistoric woodcarving tradition, although little woodwork has survived from prehistory. Carvings of human figures fashioned in antler, bone, and stone confirm that Northwest Coast traditions of figural sculpture are rooted deeply in the past.

The earliest European visitors to the region encountered a way of life that had developed over thousands of years. The people of the Northwest Coast, like their southern neighbors in California, had only minimal contact with European Americans until the late eighteenth century. The Russian emperor Peter the Great ordered the exploration of the Siberian coast early in the 1700s to determine whether Asia and America were joined. The task fell to Vitus Bering, who launched two expeditions to the strait that now bears his name in 1725 and 1733. Bering's accomplishments opened the way for Russian development of trade in sea otter pelts headquartered in southeast Alaska. Concerned about Russia's presence on the American west coast, Spain initiated its own program of exploration and established colonies in California.

The English also claimed interests in the area based upon the brief visit of Sir Francis Drake to the Oregon coast in the 1580s. As a result, James Cook included the Northwest Coast on the itinerary of his first Pacific voyage, touching ground on Vancouver Island in 1778. Multinational recognition of the abundant potential for fur trade development on the Northwest Coast resulted in increasing numbers of maritime traders and administrative outposts after 1790. Spanish, American, English, and French competed aggressively for access to Northwest Coast Indian trade.

The tribes of the Northwest Coast welcomed trade for the most part. Wealth in fur trade goods enriched powerful families and helped promote increasingly elaborate ceremonial displays of wealth and power in feasts, distributions of wealth and gifts, commissions of massive art projects, and sponsorship of elaborate masquerade rituals and dances. Iron and steel tools, received in trade from the Europeans, made possible increased production of wood carving with further technical and aesthetic refinement. Sustained contact with the outside world, however, also brought devastating epidemics to the native peoples. An estimated precontact population of over 200,000 dwindled to less than 40,000 living descendants by the mid-nineteenth century.

While today the Northwest Coast is linguistically complex, including among its population some forty-five distinct languages, frequent cultural interaction between neighboring groups throughout history resulted in the development of many common cultural characteristics. The three major language families of the north, for example, share many beliefs, values, and practices. The Tlingit live on the coast of the southeastern Alaska panhandle, northern neighbors to the Haida, who also inhabit the Queen Charlotte Islands, some thirty to eighty miles offshore. The Tsimshian, including the Nishga and Gitskan, settled on the adjacent coast of British Columbia and well inland along the Skeena and Nass rivers.

For all three groups the winter village is the central organizational factor of social life, as it has been for many thousands of years. Every village is home to a number of large, extended, matrilineal families, each owning one or more houses made of massive cedar timbers. In the traditional communities, in addition to houses, lineages own hunting territories, sites for gathering edible plants, and fishing stations, as well as more intangible property such as titles, names, dances, songs, and designs known as crests. All inherited property descends through the female line. Hereditary chiefs control access to lineage resources, including names, titles, and crests, which can be claimed by family members only through ceremonies of confirmation and distributions of wealth known as potlatches. Lineages belong to one of two social divisions anthropologists call moieties, which derive from the stories of their origin. Tlingit lineages consider themselves either Raven or Wolf; the Haida, Raven and Eagle; and the Tsimshian recognize four divisions—Wolf, Grizzly, Raven, and Eagle. The northern groups are also linked by almost identical art styles which are tied closely to the expression of their various lineage crests.

Wakashan language speakers originally settled and continue to live to the south in central and southern British Columbia: the northern Kwakiutl, consisting of the Haisla, Haihais, Bella Bella, and Oowekeeno inhabit the central coast; the southern Kwakiutl or Kwakwaku'wakw, the northern Georgia Straits; the Nootka, or Nuu'chal'nuth, live on Vancouver Island's rugged west coast; and the Makah, on the

Olympic peninsula of Washington State. Lineage structures and notions about lineage property among the Wakashan speakers recall traditions similar to those of the north, except that the lineages are patrilineal in descent and do not manifest in formal crests. There is also no clan or moiety structure linking lineages together. Instead, members of lineages claim rights to ceremonial prerogatives and privileges through ties to both parents' lineages and those of one's marriage partner. Chiefly demonstrations of power are expressed through masquerades and other forms of dramatic performance which are presented at potlatches, where wealth is distributed as confirmation of status and rank.

The Coast Salish consist of sixteen different language groups of the southern Northwest Coast linked linguistically to seven additional Interior Salish groups of the northwest plateau region of Washington and Oregon. Of the coast peoples, the Bella Coola are something of an anomaly, having settled well north of other Salish speakers on the Bella Coola river amidst the northern Kwakiutl. Culturally, they resemble their Kwakiutl neighbors more than their Salish relatives. The Salish-speaking Coxmox who live adjacent to the southern Kwakiutl on Vancouver Island also acquired many southern Kwakiutl traits. Traditional Coast Salish communities were characterized by smaller family units rather than large extended lineages, a number of related families living together in a single, plank winter house. Families owned resource territories, but, unlike the Kwakiutl, each family recognized a wide range of different kin relations scattered throughout different communities who could be counted on for cooperation and aid. Wealthy families hosted potlatches and some presented masquerade performances, but these were much less elaborate than those among the Kwakiutl to the north.

Historically, among all the peoples of the Northwest Coast, wood sculpture has dominated the visual arts. Masks, totem poles, feast dishes, and clan hats, plus a wide variety of other kinds of objects expressed the intricacies of family heritage, origin, and sources of power. The objects and the ideas they conveyed represented wealth—not simply material wealth, but wealth in the form of status and distinction among peers. Underlying all displays of visual art was the notion of ownership and privilege. Objects, designs, ideas, stories, songs, and ritual acts were the exclusive possessions of those who had the right to claim them. The visual arts therefore played a fundamental role in communicating the identity and character of family privileges and possessions. As a result, the Northwest Coast hosts one of the richest traditions of visual arts in the world.

THE SOUTHERN TRADITIONS

According to the oral traditions of his family, when one young and ambitious southern Kwakiutl man named Maxwa was sent by his father to claim a bride from the chiefly lineage of a neighboring village, he was given an amazing and powerful gift by his future father-in-law. He received the right to perform the *Hamatsa*, or Cannibal Dance.

The host chief invited the young man and his family members into his house to feast. When they were seated, all heard strange and ominous whistles coming from behind a screened enclosure at the rear of the house. The chief said, "Now, listen to the

supernatural power of your wife, son-in-law Maxwa. Now you have obtained in marriage the cannibal dancer whom you have heard." The notables of the chief's clan then took up batons and beat out the rhythm of the Cannibal Dance. "Now, watch us, son-in-law, and you, tribe," the chief instructed his guests, "to see our ways." The eerie cry of the cannibal dancer came from behind the screen and then the dancer himself emerged, restrained by attendants, crazed and frightening in appearance, possessed by cannibal power. He was led four times around the central fire pit of the house and retired behind the screen. Then the visitors heard the snapping sound of monstrous jaws, and four horrifying creatures appeared from behind the screen to dance around the fire. The first was *hoxhoxu*, a giant crane with a long, pointed beak, followed by the crooked beak, with his ravenous mouth and arching nose, then the cannibal raven, and finally a creature called *Galukwadzawis*, "the Crooked Beak of Heaven." When these figures had left, the cannibal dancer returned, this time carrying a corpse which he laid down on the floor and devoured in front of the horrified guests. More dances and songs followed, with rituals of purification to cure the cannibal dancer of his craving for flesh. When Maxwa returned to his village, after his visit was over, he brought with him abundant gifts from his father-in-law, including a box which contained the regalia necessary for the performance of the Cannibal Dance that had been given to him. Many years later, Maxwa would sponsor a similar performance to welcome his son-in-law, but this time it would be his own son who would appear as the cannibal dancer.

The Cannibal Dance is just one of many performances, albeit the most prestigious, that might be owned by a chiefly Kwakiutl family and presented at feasts as part of the family's wealth. The power and prestige of these performances derived from their narrative of danger and its resolution. According to oral tradition, the cannibal birds represented in the masquerade live with the most fearsome cannibal, *Baxwbakwalenuksiwie*, "the cannibal-at-the-north-end-of-the-world." During the months of the winter ceremonial season when all the lineages are at their winter houses, these monsters travel south and kidnap the children of the chiefs. Family elders rescue the young men, who are crazed with spirit power by their experience and crave human flesh. The senior men of the lineage then cure the victim through songs and rites of purification, demonstrating their power over the supernatural. This narrative of the masquerade reenacts the dance's story of origin: how these rituals were acquired by ancestors through dangerous and yet successful encounters with beings from the supernatural world.

Of course, these dances are staged events. The young man is trained how to behave as a cannibal dancer and the entire performance is carefully choreographed, from the masked dancers who impersonate the monstrous birds to the careful preparation of the prop that represents the eaten corpse. The chief commissions expert carvers to make the masks and pays them well. He also pays the dancers who wear the masks, the attendants, the singers, and everyone else who participates in the performance. The elaborate nature of the entire masquerade and its expense is a measure of the chief's greatness. The cannibal dancer himself is sponsored by the chief—he is often a son or nephew. When the dancer has successfully completed the performance, it is his, and he in turn may eventually give it to his son-in-law as partial repayment for the gifts he has received from his wife's father.

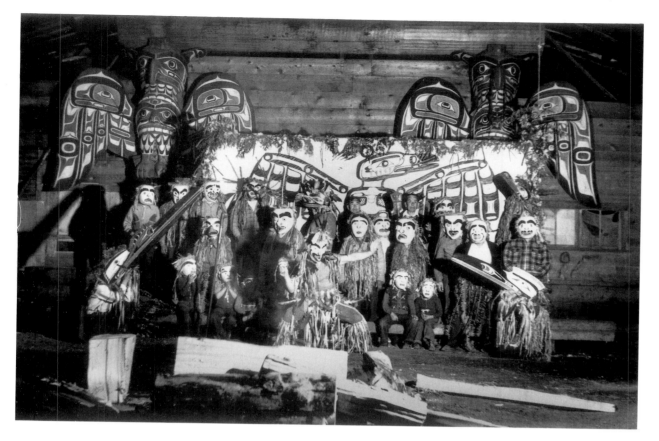

This photograph of a Kwakiutl pot-latch at Gilford Island, British Columbia, in 1946 shows the masks of the Atlakam dance. Atlakam masks represent spirit beings of the forest. A Quail Dancer struts expansively in the lower center of the photograph. This Atlakam set was carved by Willie Seaweed, Joe Seaweed, and Charles Nowell. Willie Seaweed is visible in the rear row near the center, without a mask.

Royal British Columbia Museum.

The Cannibal Dance is one of many performances that might be enacted at the winter ceremonial, each masquerade depicting encounters with supernatural beings and featuring masks of many different types. During one type of winter ceremonial masquerade known as the Tla'sala performance a chief wears a special "frontlet" headdress and dances so that the loose plumes of eagle down placed in the crown of seal whiskers scatter freely in the air as he moves. The dance represents the energy of the chief's power as he calls into the dance house a host of different supernatural creatures for everyone to see. One after another, a series of elaborately masked dancers enter the house before the assembled guests and dance before the whirling chief. After four days of dancing, the dancing chief is transformed into a supernatural creature and is impersonated with a mask.

Masquerades of the winter ceremonial are always staged during the events of a potlach, when rival lineages are invited to feast while witnessing the host's expressions of power and wealth. The host serves food in special and elaborately carved dishes, each one acquired by claims to family traditions. The potlatch culminates in the distribution of wealth, when the host gives away enormous numbers of blankets and other goods to all those present. The most valuable gift is the gift of a "copper," a large copper plaque that has its own individual identity, history, and value, which, over time, may amount to many thousands of blankets. By participating in the potlach and accepting the host's gifts, the guest lineages are obligated to reciprocate with even more extravagant feasts and potlatches, or be shamed and lose prestige. Families and villages of the southern Kwakiutl, for instance, compete with one another as generous hosts, each lineage ranked by the success of its potlach.

The potlatch is apparently an ancient tradition of the Northwest Coast. The fur trade of the nineteenth century brought increased wealth to the people of the Northwest Coast and reduced inter-village warfare. The importance of the potlach grew as a

result of this prosperity among all the Northwest Coast tribes. Like the Kwakiutl, some groups accompanied potlatches with the presentation of masquerades. Wealthy Nootka chiefs sponsored *Kukwala*, or the Wolf Ceremony. Spirit wolves, impersonators wearing helmet masks, captured high-ranking children who were then liberated and cured by elders with hereditary privileges of the chief's family. After the children's return, the chief would often stage additional masquerade performances in which he presented mysterious and sometimes dangerous supernatural beings. Tsimshian chiefs presented masquerades during potlatches as expressions of their supernatural power or *halait*. Some Haida chiefs also procured rights to winter ceremonial masquerades directly from the northern Kwakiutl. Tsimshian and Haida masquerades of this kind were, for the most part, derivations of the far more elaborate masquerade ceremonials of the Kwakiutl and were sometimes acquired through intermarriage.

Kwakiutl masks for the winter ceremonial are often large, brightly painted, impressively carved, and exaggerated in form. Many include moving parts: eyes that open and close; mouths that speak or beaks that open and snap shut; or faces that change expression or split open to reveal another face beneath. The dancers control these animated actions with strings and levers. Some performances include marionettes or other forms of puppets that might represent corpses that walk or lifelike human figures that substitute for the chief when he is decapitated during a Houdini-like trick that resolves when the chief is magically resurrected. During a Kwakiutl potlatch, late at night, in a darkened house lit only from the fire pit, the images can be fabulous, amazing, terrifying, and unbelievable—all of them carefully and elaborately conceived by the host to convince the audience of his almost limitless power.

THE NORTHERN TRADITIONS

In the north, among the Tlingit, Haida, and Tsimshian, potlatches celebrated the presentation and display of crests. A crest is at once a design, often of an animal or other kind of creature; the object on which the crest is displayed, such as a hat or a house post; and the story that tells how the lineage acquired the crest. The story usually relates to the origins of the family—how their ancestors, during their migration to their current homeland, were assisted by the animal or being identified in the crest who then gave them the right to present its image as a family possession. Crests were guarded jealously, their use forbidden by others without permission of the owning family. They might be lent, but they were rarely given to others, and practically never offered to in-laws, unlike the willing exchange of winter ceremonial dances by the Kwakiutl. A crest captured in warfare could not be displayed by the former owners until they had purchased it back from the enemy. Crests belonged to moieties—the broad divisions of the Tlingit, Haida, and Tsimshian—and also to clans and lineages. The potlatch provided an occasion for displaying crests that identified an individual as a member of a lineage, clan, and a moiety. Objects with crest designs were never worn on everyday clothing: a crest was highly revered and respected and could be displayed only if validated through payment or distribution of wealth.

The crests of a lineage were controlled by its ranking chief and distributed at potlatches to family members. Each time a crest was conferred upon someone, payments had to be made to everyone who witnessed, and thereby sanctioned the event. The

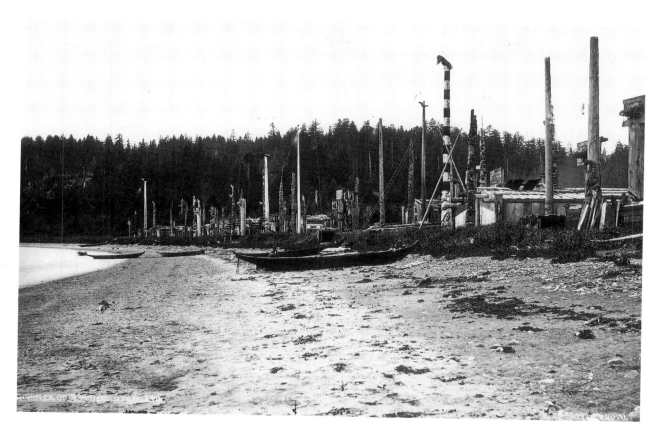

Haida village of Skidegate, 1881, a winter village whose large cedar houses with their memorial poles and crest carvings are owned by prominent families.

American Museum of Natural History, New York.

most elaborate potlatches accompanied naming ceremonies during which a ranking young member of the lineage was given the name or title of a deceased elder. The naming ceremony was at the same time a commemorative ritual for the dead. The continuity of names and crests as they descended through the generations assured the integrity and social ranking of the lineage.

The most elaborate crest carvings decorated the architectural elements of great houses. Among the Tlingit, interior house posts were carved with massive images of crest animals. The most impressive crest display, however, adorned the enormous interior screen that separated the chief's quarters at the rear of the house from the rest of the structure. This rear room also served as the treasure house where the household's valuable crest objects were stored. Crests also decorated the towering totem poles of the Haida and Tsimshian. Sequences of crests, often relating to a mythic origin narrative of the lineage, were arranged in vertical succession—fantastic bears, ravens, eagles, and other creatures carved directly into an entire log of red cedar. Exterior house posts, sometimes pierced through the center with an entrance hole, also displayed crests, while free-standing "memorial poles" were erected during commemorative potlatches. The construction of a house or the raising of a memorial pole required a public validation through potlatch.

Crests were found on the elaborately decorated clothing worn during potlatches, often appearing on woolen robes decorated with colorful appliqué. The most impressive statements of lineage were, however, the great Tlingit clan hats—large, conical helmets of wood carved with the sculptural forms of crest animals. Other crest-bearing objects—feast dishes, serving bowls, ladles, and spoons, among others—did not belong to individuals, but, rather, belonged collectively to the lineage. They were stored and cared for by the lineage chief who also supervised their distribution and use among clan members.

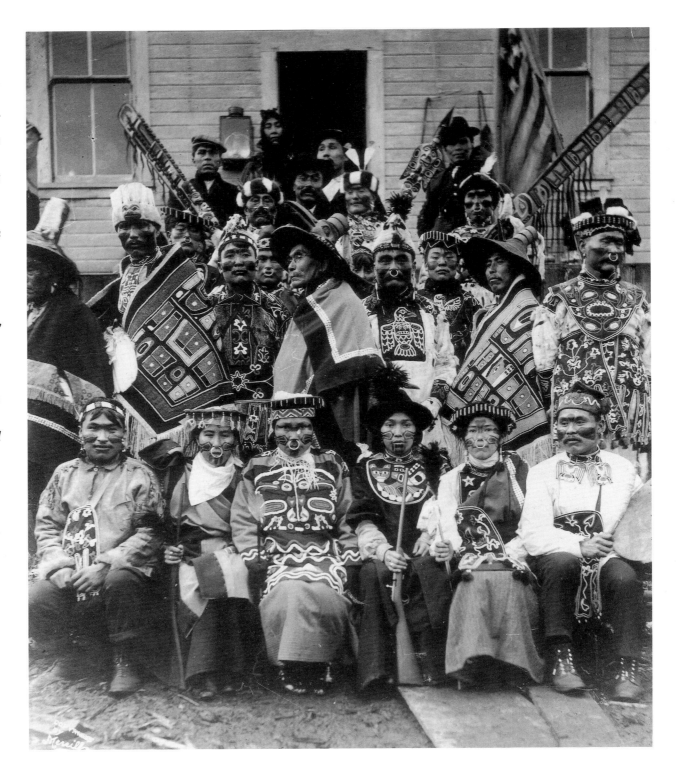

Tlingit Potlatch at Sitka, December 9, 1904. The members of the Silver Salmon clan of the Sea Lion House at Sitka are wearing regalia displaying the clan crests. Particularly important are the "clan hats," the broad-rimmed, conical hats with "potlatch rings" stacked on top, worn by the senior men standing in the second row. The man in the center wears the "Raven Traveling," or "Raven Barbecuing," hat that recalls how Raven tricked all the animals and birds who wanted to share in the king salmon he had killed. He sent them all away to search for special leaves to cook the salmon and then he ate it all himself. During the nineteenth century, the raven clans of Sitka and Yakutat fought each other for five years over who possessed the proper right to wear this hat.

American Museum of Natural History, New York.

Many other kinds of objects were decorated with more generalized animal images, crest-like designs and patterns that were considered more simply as expressions of power possessed by the clan. These designs, which often adorned painted boxes, rattles, frontlet headdresses, and the elaborately woven blankets made of cedar bark and mountain sheep wool made by the Tlingit of Chilkat village, employed strict principles of organization and form. Broad "formlines" define the overall structure of the image, often an animal presented frontally with strict bilateral symmetry, divided into zones that correspond to body parts spread out over the decorative field of the box or blanket. These broad contours contain highly conventionalized and repetitive elements that resemble feathers or fins, limbs, claws, and hands. Ovoid elements resembling small profile faces articulate the joints of the shoulders and hips; narrow frontal faces stand in for the eyes. The result is highly abstract and yet meticulously organized and coherent. The principles of formline design were also applied to sculpture, where the formline carved in shallow relief wraps around sculptural forms of animal

images, defining detail. The three northern language groups—the Tlingit, Haida, and Tsimshian—shared the formline art style to the extent that it is often difficult to determine the exact origins of individual carvings or painted designs.

THE ARTS OF THE SHAMAN

Although the shaman played an important role in the ongoing well-being of each of the Northwest Coast cultures, nowhere was he more revered than among the Tlingit. The Tlingit shaman cured the sick, assured success in warfare, discovered and destroyed harmful witches, identified thieves, predicted the future, and maintained good relations with the animal world upon which the community depended.

Most often the role of shaman was hereditary, passing from the shaman to a young descendant. A young person called to become a shaman would hear a buzzing in his ears and then collapse into a deep, lifeless trance as the spirit of the deceased shaman entered into his body. Later, he would fast in a secluded spot where *yek* animals, who would become his spirit helpers, would come to him, offering their assistance by falling dead at his feet, tongues protruding. The shaman would then collect the tongues or other body parts of these spirit helpers—the land otter primary among them, but also the mink, weasel, squirrel, hawk, owl, bluejay, loon, kingfisher, cormorant, and crane, among others—and put them in a sack called his *shutch*, which became the source of his powers and abilities. The animals recognized by Tlingit shamans as potential *yek* shared, for the most part, the ability to transcend natural boundaries just as the shaman could transcend supernatural boundaries. The land otter, for example, moves effortlessly from land to water in the same way the shaman must travel from this world to the spirit world and back again.

Each Tlingit shaman possessed a collection of objects to assist him in his responsibilities: among them, masks, rattles, ivory charms, and a special headdress with a grizzly claw crown. Masks were used in sets of four or eight and depict various animal *yek* and also a range of humanlike *yek*—angry men, chiefs, old men, and young women. *Yek*, both human and animal, are ghosts of the dead whom the shaman called forth into this world to serve his purposes. They might take either human or animal form, and their transformation from one state to another was an attribute of their spirit identity. Most Tlingit shaman's masks reflect this dual identity by representing beings with both human and animal characteristics. Often the face is primarily human in form, with human eyes, eyebrows, cheeks, and mouth, but with a bird's beak or bear's ears. The shaman performed often at public festivals, displaying his powers by dancing with his *yek* while wearing masks.

The shaman employed the entire set of masks when curing the sick, wearing each one in turn as his *yek* arrived to assist with the cure. A shaman's cure was a public spectacle. The sick person's family assembled as an audience, and clansmen of the shaman assisted with singing and drumming. The shaman circled his patient, trembling with convulsions as his *yek* took control of him, gesturing toward the infected part of the patient's body with charms carved of bone and ivory worn around his neck, and shaking a rattle held in his hand. At last the shaman might fall exhausted by his efforts. When the shaman left, a charm inhabited by one of the shaman's *yek* protected the patient. But if the patient died from his illness, the shaman returned the payment he had received.

Tlingit art representing *yek* or a shaman's spiritual powers touched many other areas of Tlingit life. The shaman was instrumental in warfare, his headdresses sometimes resembling the massive war helmets of lineage leaders. His *yek* helped him to foresee enemy plans and numbers and to predict the outcome of the coming battle. Combat was not simply an issue of personal prowess among the Tlingit, but required great spiritual risk and preparedness as well. The war regalia and weapons of the Tlingit often included images of *yek* that apparently were intended to assist warriors in battle. The shaman's spirit figures also were carved as charms or lures on halibut fishing hooks and sticks used to trigger dead-fall traps to improve their efficacy. Unlike crests, which functioned to identify and celebrate lineage within the framework of the community, shamanistic imagery of the Tlingit helped bring spiritual powers to bear on situations of life that entailed risk or uncertainty when dealing with the world outside the community—a world fraught with contending spiritual energies.

ART AND THE OUTSIDE WORLD

Early visitors to the Northwest Coast were attracted by the unique artistry of the region and naturally sought mementos of their journeys. Small objects carved in the distinctive Northwest Coast style proved particularly popular as souvenirs. Haida carvers of the Queen Charlotte Islands, a frequent port of call for whalers up through the 1830s, expanded upon the traditions of pipe carving to produce trinkets made of a black slate material called argillite for sale to visitors. They adapted crest designs for their fanciful pipes, but combined and confused the crest elements in such a way that exclusive lineage rights would be protected. Later artists of the mid-nineteenth century incorporated elements of the white culture that they observed: parts of ships, images of captains and sailors, men on horseback, and domesticated animals. Souvenirs in argillite continued to be produced by Haida carvers into the twentieth century. The content and style shifted over time to include illustrations of traditional Haida culture and mythology in the 1870s and to focus primarily on the creation of miniature totem poles, boxes, and dishes during the early twentieth century.

The height of trade in sea otter pelts on the Northwest Coast lasted only through the last quarter of the eighteenth century. Thereafter, the sea otter population declined and traders from the outside world began to diversify their interests. Conflicts with traders were common, but the principle danger from sustained contact with the outside world came from imported diseases. Whalers frequently put in at Northwest Coast communities, collected supplies and left infectious diseases. During the nineteenth century, fatal epidemics swept up and down the Northwest Coast killing thousands. When the Hudson's Bay trading company established the colony of Victoria on Vancouver Island in 1899 by British Imperial land grant, a new era of more permanent settlement by outsiders commenced.

Precontact societies were rigidly structured with chiefs and nobles inheriting rank and privilege. Declining populations, combined with new sources of wealth from the outside world, acted to democratize Northwest Coast societies and ultimately threatened their existence. Commoners or those with only tenuous claims to titles who became wealthy challenged the traditional leadership, while, concurrently, dwindling numbers of notables left many titles open for claim. During the late nineteenth century, as greater wealth and access to privilege became concentrated in the fewer, and

newer, rich, families competing for rank within the looser social structure held more frequent, increasingly extravagant potlaches. Government officials and missionaries responded by condemning potlatches and winter ceremonials, claiming that these gatherings encouraged the squandering of wealth and the spread of infectious disease. Consequently, the Canadian government outlawed potlatches in 1885.

Northwest Coast cultures were scrutinized increasingly by the fledgling fields of anthropology and museology. Between 1875 and 1925, American and European museums competed vigorously for the most thorough and complete collections. Museum professionals believed that American Indian culture was fading quickly, and therefore the time for collecting material for North American Indian displays was short. This perception sparked massive collecting programs on the Northwest Coast. Many of the relatively few surviving members of once powerful families agreed to sell traditional regalia, masks, and crest objects, especially after the potlatch ban. Intensive field collecting disbursed hundreds of thousands of objects, many of them lineage treasures, to distant museums. Museum collecting was slowed by the Great Depression, but by that time most Northwest Coast art had already been removed. As one historian put it, there was more Northwest Coast art in New York City museums than in all of British Columbia.

The potlatch ban was repealed in 1951, and this tradition now survives as an integral part of the lives of today's Northwest Coast native people. Some potlatch objects, confiscated while enforcing the ban, have been returned and the arts are being revived. Certainly, many of the cultural traditions were lost and cannot be regained, but the recent efforts of Northwest Coast Indian artists, chiefs, and families toward restoring a sense of community identity is an ongoing testimony to cultural survival.

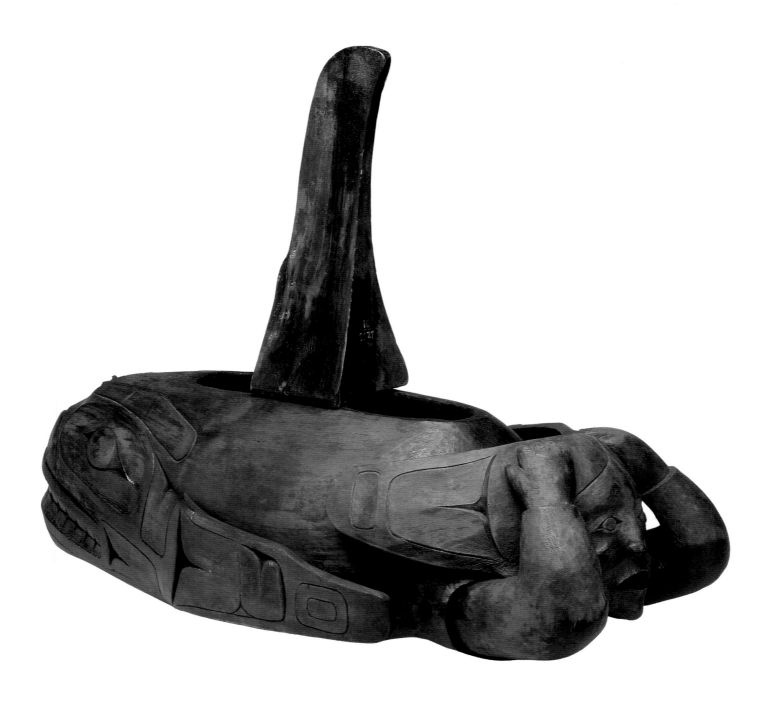

ABOVE: *Killer Whale Feast Dish*. Kwakiutl (kwak-waku'wakw). Late nineteenth century. Hopetown, British Columbia. Wood, paint. Height: 24 in. American Museum of Natural History, New York.

This feast dish, used for serving copious amounts of fish oil to guests during a potlatch, is part of an ensemble of masks and other objects that were used to perform the mythic narrative, the adventures of Siwidi. *Siwidi was the son of a chief who was kidnapped by* Kumugwe, *the master of the undersea world, and brought to his fantastic house on the bottom of the ocean. Kumugwe then directed* Siwidi *to embark on an undersea voyage to find supernatural treasures. To do so* Siwidi *was transformed into a killer whale. The feast dish shows* Siwidi *speeding through the water in the midst of his transformation from human being to sea mammal.*

OPPOSITE TOP: *Spoon*. Chinook (?). Nineteenth century. Columbia River region, Washington or Oregon. Mountain sheep horn. The Thaw Collection, Fenimore House Museum, Cooperstown, New York.

This spoon is made from a section of mountain sheep horn. The horn was softened by being boiled in water and cut so that the end formed the handle of the spoon and its length opened outward to create the bowl. An animal figure with its ribs exposed is carved on the handle. The animal probably does not represent the owner's guardian spirit, but rather refers more generally to the potency of the owner's spirit power. Elaborately carved ladles owned by wealthy and accomplished individuals testified to their success and well-being. They became treasured family heirlooms.

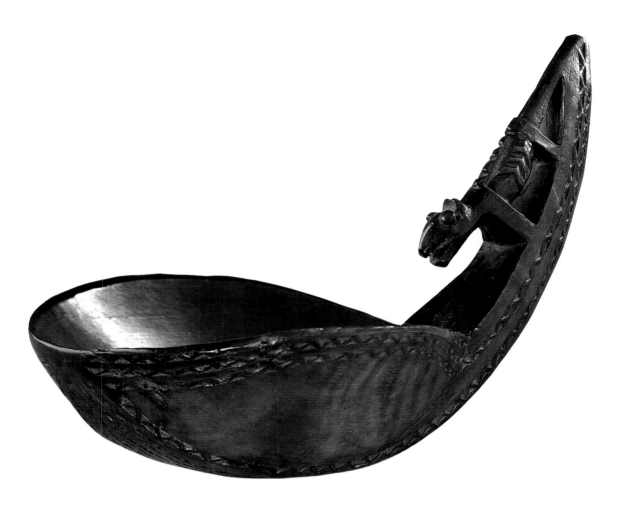

BELOW: *Oil Dish.* Quinault. Nineteenth century. Western Washington State. Wood (alder?), glass beads. Length: 12 in. Whitman College Collection.

This oil dish was sculpted into the form of an other-worldly creature, perhaps a spirit being of the sea. White glass beads inlaid for the eyes and running down the neck and around the rim enliven the wood surfaces of the carving. Wealthy and powerful families owned collections of beautiful ladles and spoons and treasured them as heirlooms. During feasts, dried fish was consumed by dipping morsels into the bowl filled with oil rendered from seal blubber.

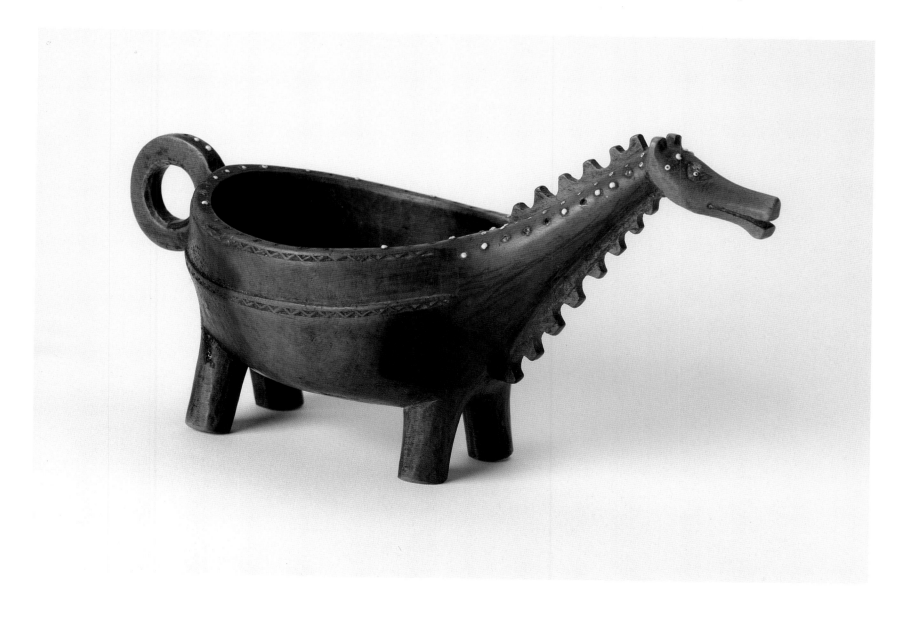

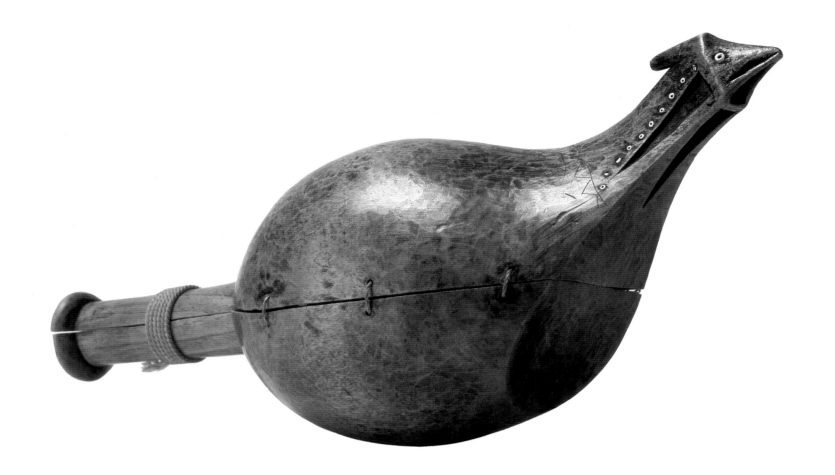

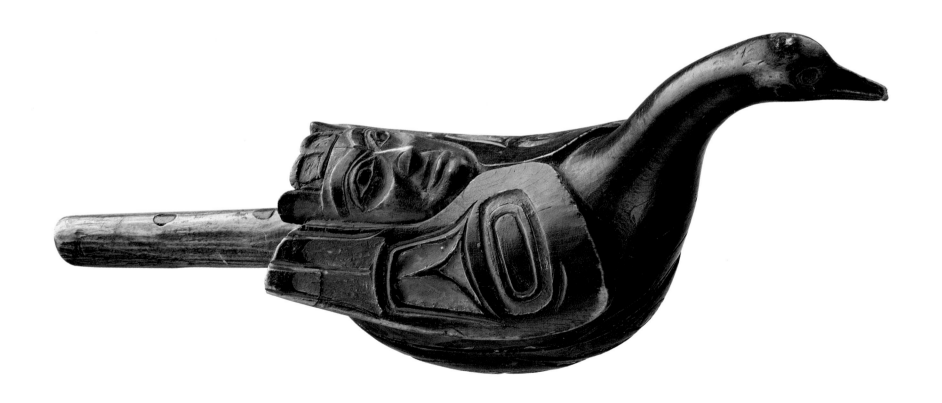

OPPOSITE TOP: *Grouse Rattle.* Makah. Nineteenth century. Southern Vancouver Island or Cape Mudge, Washington State. Wood (alder?), glass beads, pebbles, cord. Length: 12½ in. Courtesy of the Thomas Burke Memorial Washington State Museum, Seattle.

This rattle is carved from two pieces of wood joined together with cord lashings. It represents a ruffled grouse, with its crest, long neck, and round body. The reductive form of the carving eliminates unnecessary detail while enlivening the form with linear facets and edges, emphasized with inlaid glass beads. The grouse rattle was used to accompany the performances of the Makah Winter Ceremonial, or Klookwalli.

OPPOSITE BOTTOM: *Bird Rattle.* Haida. Nineteenth century. Queen Charlotte Islands, British Columbia. Wood, fiber. Length: 10½ in. The Masco Art Collection.

This early and rare bird-shaped rattle with a human face carved on the back is intended to convey the transport of a shaman into the spiritual realm. Chances are, however, that a Haida chief, not a shaman, used the rattle to accompany his displays of power during Winter Ceremonial masquerades which he sponsored.

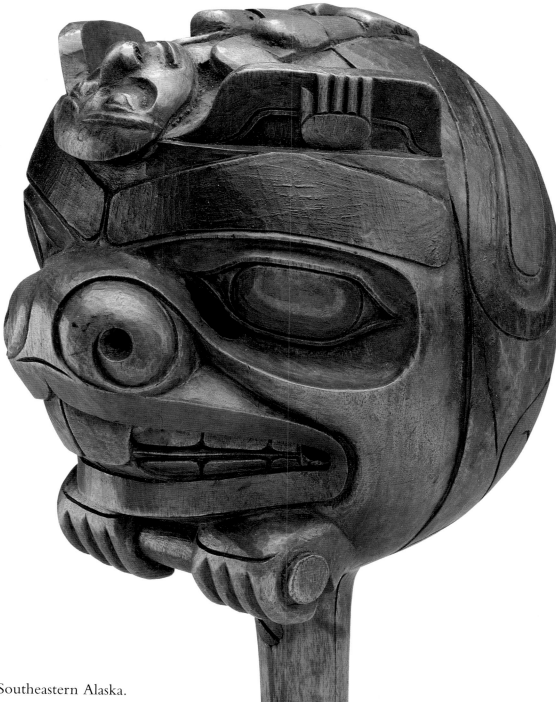

RIGHT: *Beaver Rattle.* Tlingit. Nineteenth century. Southeastern Alaska. Wood. Length: 10½ in. The Masco Art Collection.

The large incisors identify this beaver who grasps a stick beneath its chin with its forepaws. A humanlike figure reclining on his back above the beaver's brow may represent a shaman during an experience of spiritual transport. The carver portrayed the figure's hands on the beaver's upright ears.

LEFT: *Comb.* Nootka (Nuu'chal'nuth). Late eighteenth century. West Coast, Vancouver Island, British Columbia. Wood (cedar), shell. Height: 9½ in. The Thaw Collection, Fenimore House Museum, Cooperstown, New York.

This is one of the small number of Northwest Coast objects that illustrate sculptural styles of the eighteenth century. This comb comes from Vancouver Island, perhaps Nootka Sound, where early explorers sought shelter from the heavy seas of Vancouver's west coast. The Spanish based in California established a post at Nootka Sound late in the eighteenth century. The broad and impassive volumes of the face's cheeks and brow swell outward from the squared frame of the comb, which is inlaid with cut shell.

OPPOSITE LEFT: *Ceremonial Club.* Makah. c. 1550. Wood (yew). Length: 17¾ in. Makah Cultural and Research Center, Neah Bay, Washington. Photograph courtesy of Ruth Kirk.

Ozette was a large village of some one hundred and fifty houses that extended some three-quarters of a mile along a narrow beach of the northern Washington coast. A tragic mud slide buried at least four houses, possibly more, nearly five hundred years ago, sealing the contents beneath two to four meters of clay. When excavated in the 1970s, many well-preserved objects were recovered, including this ceremonial club with its end carved to resemble the head of an owl. Since owls were associated with "doctors" or healers among the Makah, this object may have been part of a shaman's paraphernalia.

OPPOSITE RIGHT: *Figurine Pendant.* A.D. 200–1200. Sucia Island, San Juan Islands, Washington State. Antler. Height: 8⅞ in. Courtesy of the Thomas Burke Memorial Washington State Museum, Seattle.

This small figurine was probably worn on the chest as a pendant. This piece and others like it found elsewhere in the region resemble Siberian shaman's pendants, which has led some to believe that they represent evidence of ancient shamanistic practice on the Northwest Coast. The simple, reductive form of a standing figure wearing a skirt does not resemble nineteenth-century Northwest Coast carving styles to any great degree, save for the squared mouth and the "eye-joints" visible on the backs of the hands. The production and use of this type of pendant did not survive into the historic period.

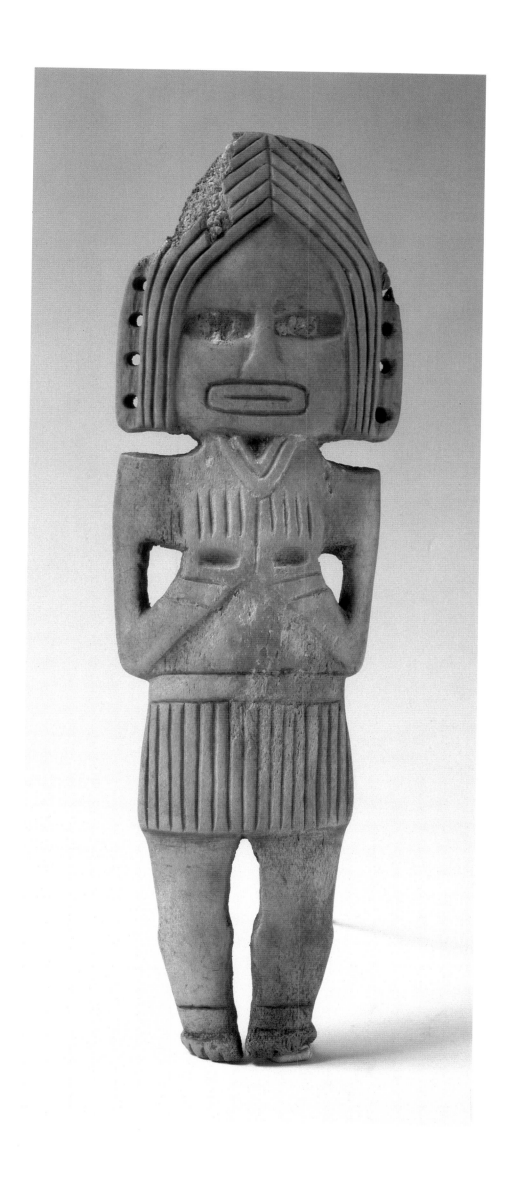

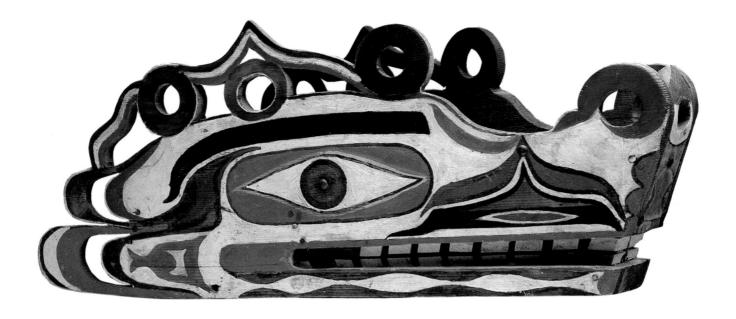

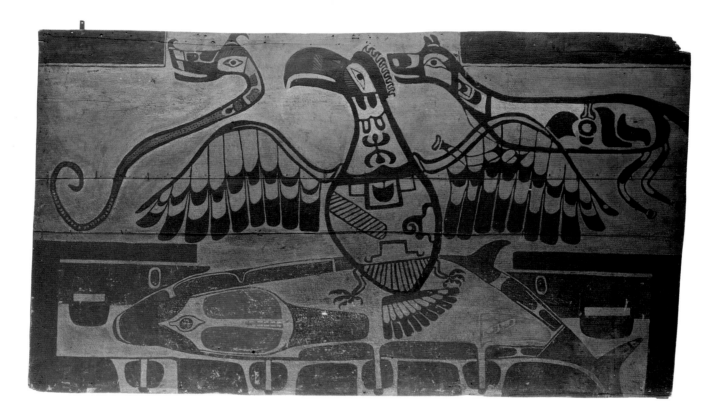

TOP: *Mask of Hinkeets*. Nootka (Nuu'chal'nuth). 1910. West Coast, Vancouver Island, British Columbia. Wood (red cedar), brass tacks, paint. Length: 25 in. Seattle Art Museum. Gift of John Hauberg.

This distinctive style of mask, worn horizontally on the head like a helmet, is distinctive to the Nootka. It is composed principally of two flat sides, painted with an animal's face, and is joined by cross struts and a panel in front to represent the snout. When paired with another, identical mask, it represents one of the two heads of the "double-headed serpent," a powerful, supernatural being.

ABOVE: *Interior House Board*. Nootka (Nuu'chal'nuth). Nineteenth century. West Coast, Vancouver Island. Wood (cedar), paint. Length: 117½ in. American Museum of Natural History, New York.

This famous painting illustrates the Thunderbird lifting a killer whale out of the sea. People of the Northwest Coast believed that Thunderbirds and killer whales fought in perpetual conflict.

OPPOSITE: *Mask Representing a* Dzunukwa. Kwakiutl (kwakwaku'wakw). Nineteenth century. British Columbia. Wood, human hair, copper. Height: 11½ in. The Detroit Institute of Arts.

A dzunukwa is a monster of the forest, a shaggy cannibal that preys upon small children. A chief may wear a dzunukwa mask called gikaml *when giving away "coppers" during a potlatch.*

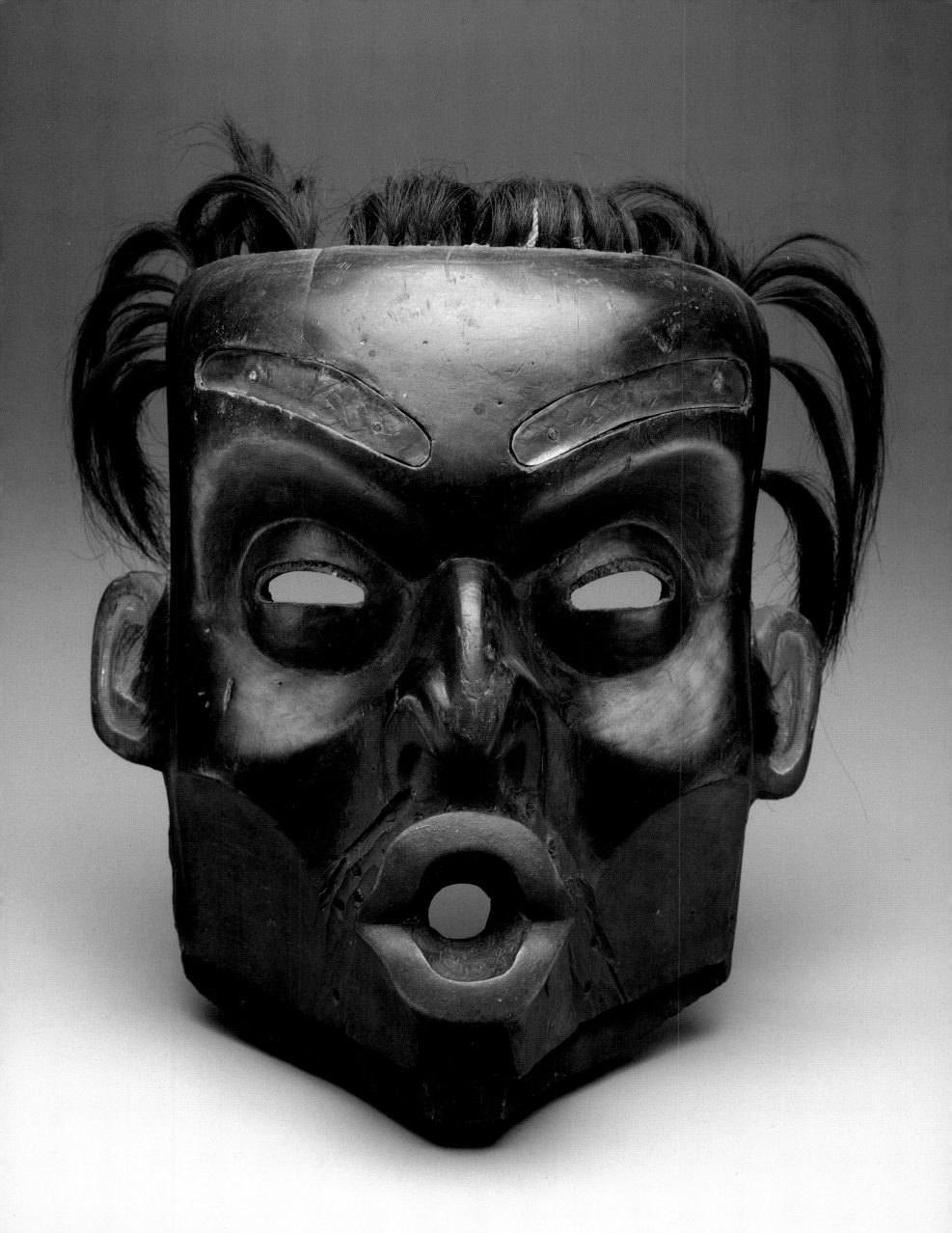

WILLIE SEAWEED

Willie Seaweed was born the son of the chief and inherited his father's titles: "Hilamas" meaning "right maker," and "Siwid," the foremost title of the Nakwaxda'xw tribe of Ba'a's village at Blunden Harbor. The modern surname "Seaweed" is derived from the latter title. His privileged birth required from him great responsibilities for upholding the ceremonial traditions of his tribe: conducting feasts, distributing wealth, and staging dances and ceremonies for display of his family's prerogatives. The isolated location of Ba'a's village protected it against enforcement of the "potlatch law," which forbade ceremonial dances and masquerades. Over the years, the conservative community and its chief continued to preserve the knowledge necessary to perform dances.

Willie Seaweed inherited rights to be initiated as a *Hamatsa*, a cannibal dancer, a ceremony he performed four times. He also sponsored *Hamatsa* performances for his own child, Joe Seaweed. By the age of thirty, Willie Seaweed had become a skilled carver and he received commissions for carvings and masks from many different villages. He also continued to acquire prerogatives for ceremonial performances for his family through his subsequent marriages and the marriages of his children, which are documented in his masks and ceremonial carvings. Willie Seaweed grew to be a venerable chief in his own right who, like his father, was widely recognized as an authority on tradition and ceremonial protocol. His knowledge and artistic skill brought Kwakiutl arts traditions into the twentieth century where they continue strong today.

The mask pictured here was carved by Willie Seaweed, and represents the Crooked Beak, a monstrous cannibal bird, part of one of the most powerful supernatural performances of a Kwakiutl potlatch. The dancer wears the mask tilted upward and dances around the center fireplace, pausing when the rhythm of the song halts to squat and snap its beak as a sign of its voraciousness. The arching crest of the beak and the scroll beneath the lower jaw spiral inward toward the gaping jaws of the monster. This exaggerated, flamboyant carving represents a high point of Seaweed's creativity and skill.

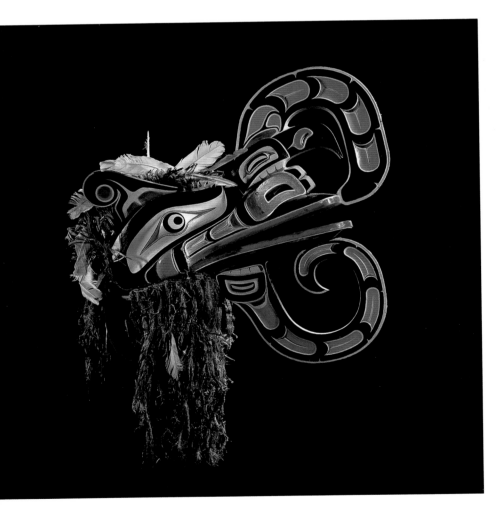

WILLIE SEAWEED
(Kwakiutl, Nakwaxda'xw). Hamatsa *Crooked Beak Mask*.
1940s. Kingcome Inlet, British Columbia.
Wood, cedar bark, paint. Length: 37 in.
Royal British Columbia Museum.

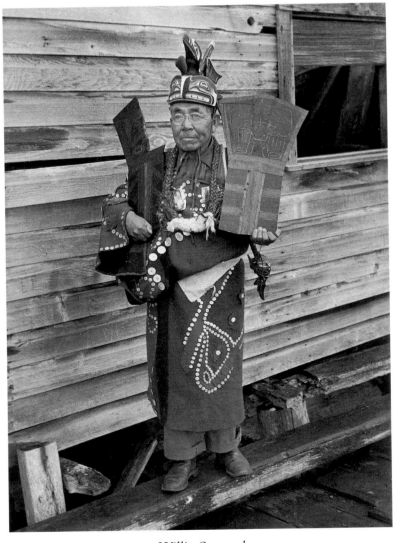

Willie Seaweed
Royal British Columbia Museum.

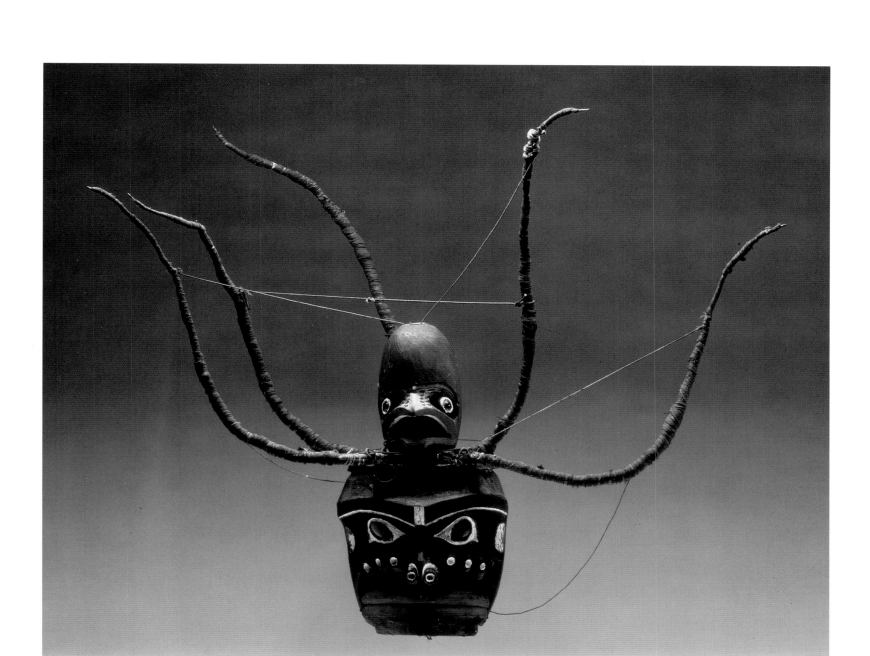

Octopus Mask. Kwakiutl (kwakwaku'wakw). Late nineteenth century. Gilford Island, British Columbia. Wood, bark, cord. Height: 12 in. American Museum of Natural History, New York.

This mask representing an octopus was part of a masquerade performance that illustrated the treasures owned by Stone-Body, the son of a legendary chief. Masks of a fisherman and his attendant performed at the same time to enact a narrative. Kwakiutl artists were masters of illusion. Cords allowed the dancer to move the legs of the octopus in a lifelike manner.

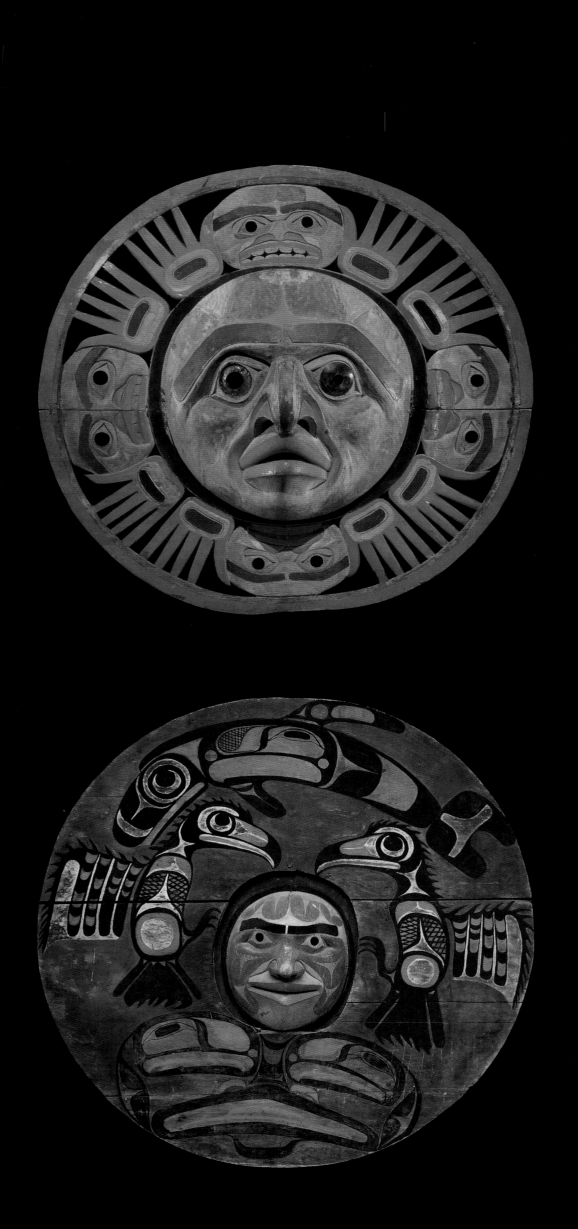

TOP LEFT: *Sun Mask*. Bella Coola. Nineteenth century. Central British Columbia. Wood, paint. Diameter: 24¾ in. American Museum of Natural History, New York.

Ahlquntam *is considered the most powerful super-natural recognized by the Bella Coola. During the Bella Coola Winter Ceremonial,* Ahlquntam *is invoked through a masquerade in which he demon-strates his supernatural powers. This mask represents the sun, which* Ahlquntam *guides and uses as his canoe. In the performance, the sun (this mask) appears against the back interior wall of the dance house and travels across the house beneath the roof until it sinks and disappears on the opposite side.*

BOTTOM LEFT: *Sun Mask*. Bella Coola. Nineteenth century. Central British Columbia. Wood, paint. Diameter: 42¾ in. The Seattle Art Museum. Gift of John Hauberg.

The center of this sun mask is inhabited by Ahlquntam, *a powerful supernatural being who guides the sun across the sky. Two ravenlike birds and a killer whale painted on the sun disk frame the more three-dimensional face of the mask. The carving exhibits the exaggerated style and bulging features so characteristic of Bella Coola masks.*

OPPOSITE: *Frontlet*. Bella Coola. Nineteenth century. British Columbia. Wood, paint. Height: 11¼ in. The Masco Art Collection.

This is the central panel of a "dancing headdress," worn on the head with this carving set against the dancer's brow, his face framed by long pendants of ermine skin. The large size of the frontlet, with the supplemental figures above and below the central bird's head, are customary Bella Coola design ele-ments for this form of headdress and were used as well by several other Northwest Coast groups.

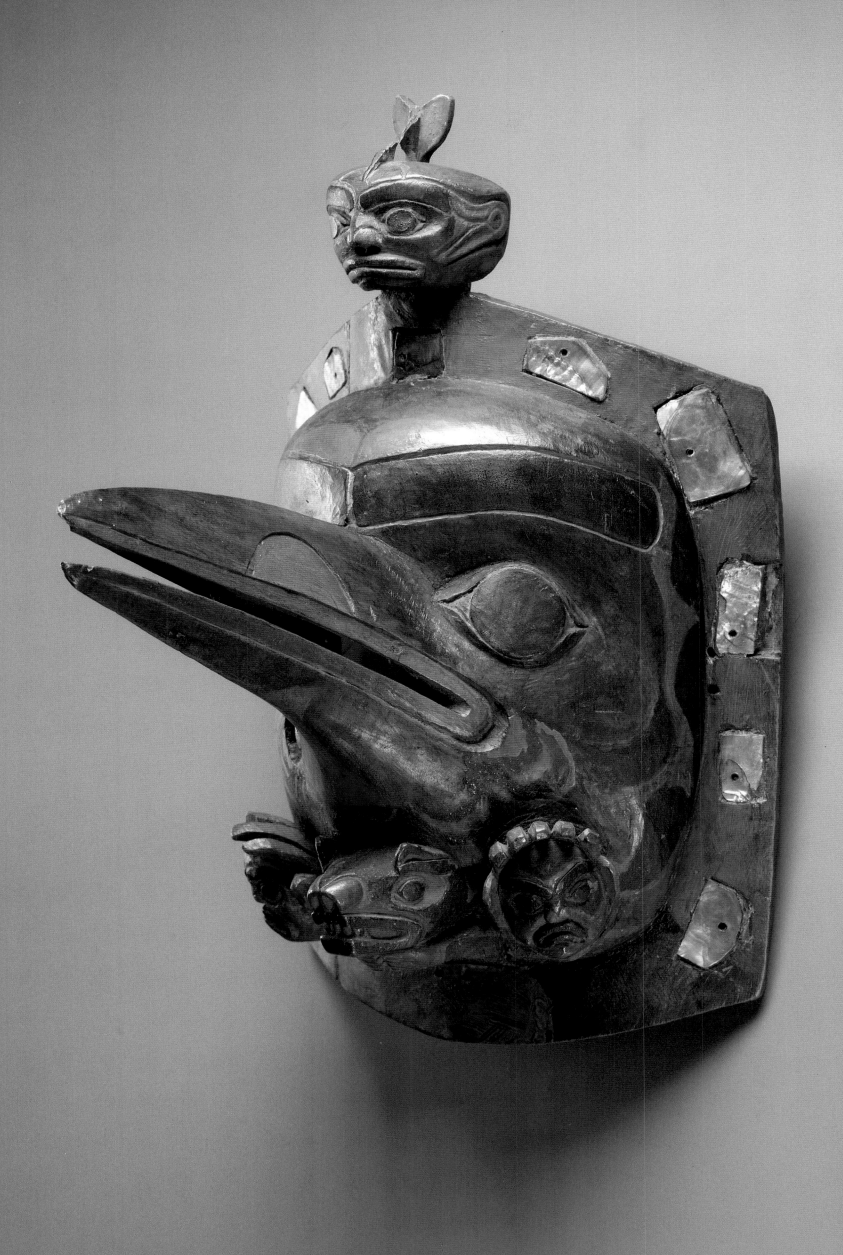

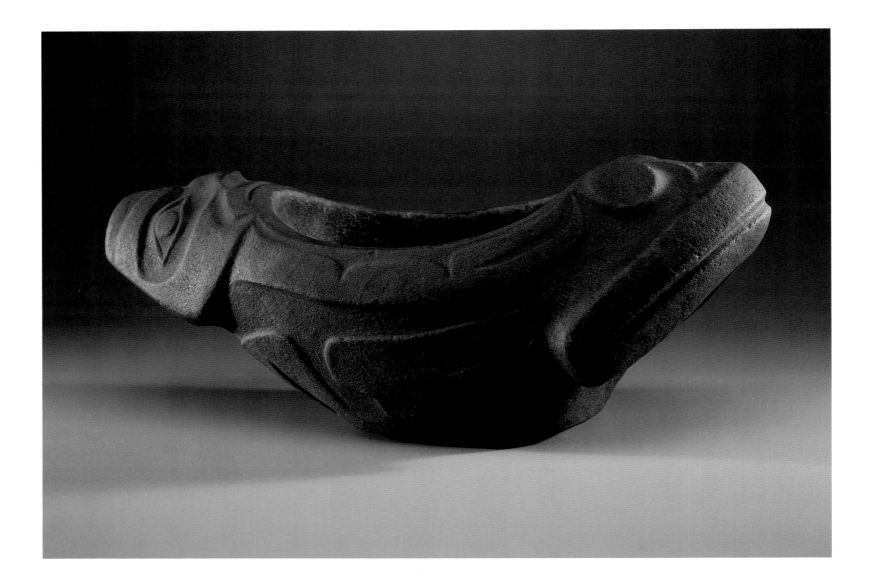

ABOVE: *Bowl*. Haida. Eighteenth century or earlier. Kiutsa, Queen Charlotte Islands, British Columbia. Stone, ocher. Length: 17⅜ in. McCord Museum of Canadian History, Montreal.

The exact age of this stone carving is unknown, but most agree that it was made long before whites came into contact with the Queen Charlotte Islanders. It was collected by George Mercer Dawson in 1878. The carving combines the head of a fish on one side and the upper torso of a wealthy old woman on the other. The circular opening of the bowl becomes her large labret, or lip plug, a symbol of age and prestige. The bowl was probably used to grind tobacco, the only plant cultivated by the precontact Haida.

OPPOSITE TOP: *Bowl*. Haida. Eighteenth century. Queen Charlotte Islands, British Columbia. Wood. Length: 10¼ in. The British Museum, London.

This wooden bowl was collected by Captain George Dixon when he visited the Queen Charlotte Islands during his voyage of 1785–1788. This type of bowl was no longer being made by the late nineteenth century. A creature with humanlike features lays on its belly with legs bent upward at the knees so that the heels of the flexed feet touch the rear rim. The arms sweep back along the base of the bowl, the hands curving upward to the hips with long, extended fingers. Thick, archaic-style "formline" elements fill in the sides of the bowl above the arms.

OPPOSITE BOTTOM: *Oil Dish*. Haida. Nineteenth century. British Columbia. Wood. The Thaw Collection, Fenimore House Museum, Cooperstown, New York.

This unusually lively oil dish is carved in the form of an otter who has just captured a salmon. Small serving dishes like this one for fish oil are part of the panoply of a potlatch. The host's wealth and power are represented by the treasures he displays and distributes to his many guests.

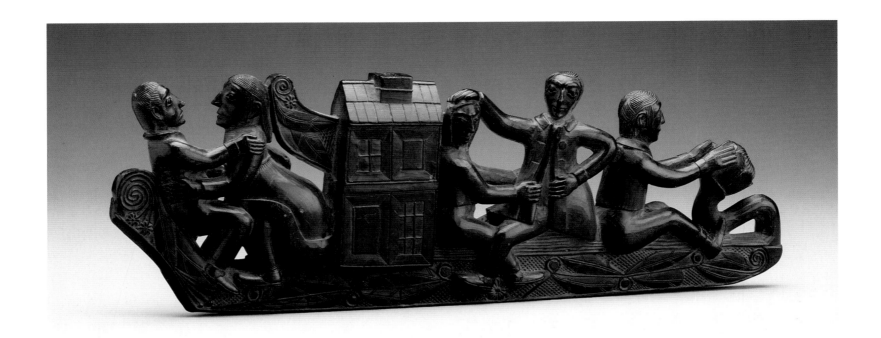

ABOVE: *Pipe Bowl*. Haida. Mid-nineteenth century. Queen Charlotte Islands, British Columbia. Stone (argillite). Length: 10 in. The Masco Art Collection.

Haida carvers quarried this distinctive coal black slate known as argillite for pipe bowls. By the middle of the nineteenth century, most objects made of this material were intended for sale to visitors, like this extremely stylized and unsmokable pipe bowl. The figures in European clothes, the elements of architecture, the nautical details, and the designs drawn from other sources are the carver's reflections of his changing world. Carvers developed this distinctive style to be separate from the "formline" style used to depict crests so they would not violate crest prerogatives when selling curios to visitors.

RIGHT: *Dagger*. Tlingit. Nineteenth century. Southeastern Alaska. Bone, steel, twine, hide. Length: 15¼ in. The Masco Art Collection.

This fighting knife is a lethal weapon. Its association with danger and risk is symbolized by the elaborate carvings visible above the grip of the bone handle. A frog emerges from a bear's head, with a small humanlike figure crouched on its brow. These kinds of carvings are generally associated with shamans' charms and their representations of yek, or powerful spiritual guardians drawn from the realm of the dead.

OPPOSITE: *Female Figure*. Haida. Mid-nineteenth century. Queen Charlotte Islands, British Columbia. Wood. The Thaw Collection, Fenimore House Museum, Cooperstown, New York.

The Haida villages of the Queen Charlotte Islands became a frequent stop for nineteenth-century whalers and fur traders to gather provisions. Men were eager to buy curios made by Haida carvers in a variety of materials as souvenirs of their visits. Haida carvers are known for their fastidious technique and attention to detail, although the naturalistic style of this carving was calculated to appeal to non-Indian buyers. This small figurine of a Haida women dressed in European-style clothing probably represents a prostitute.

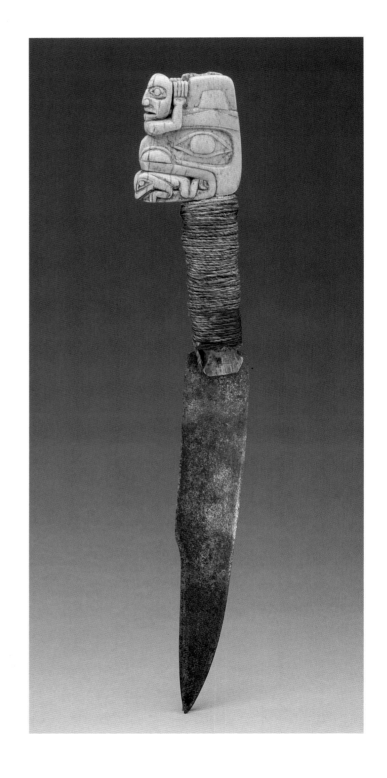

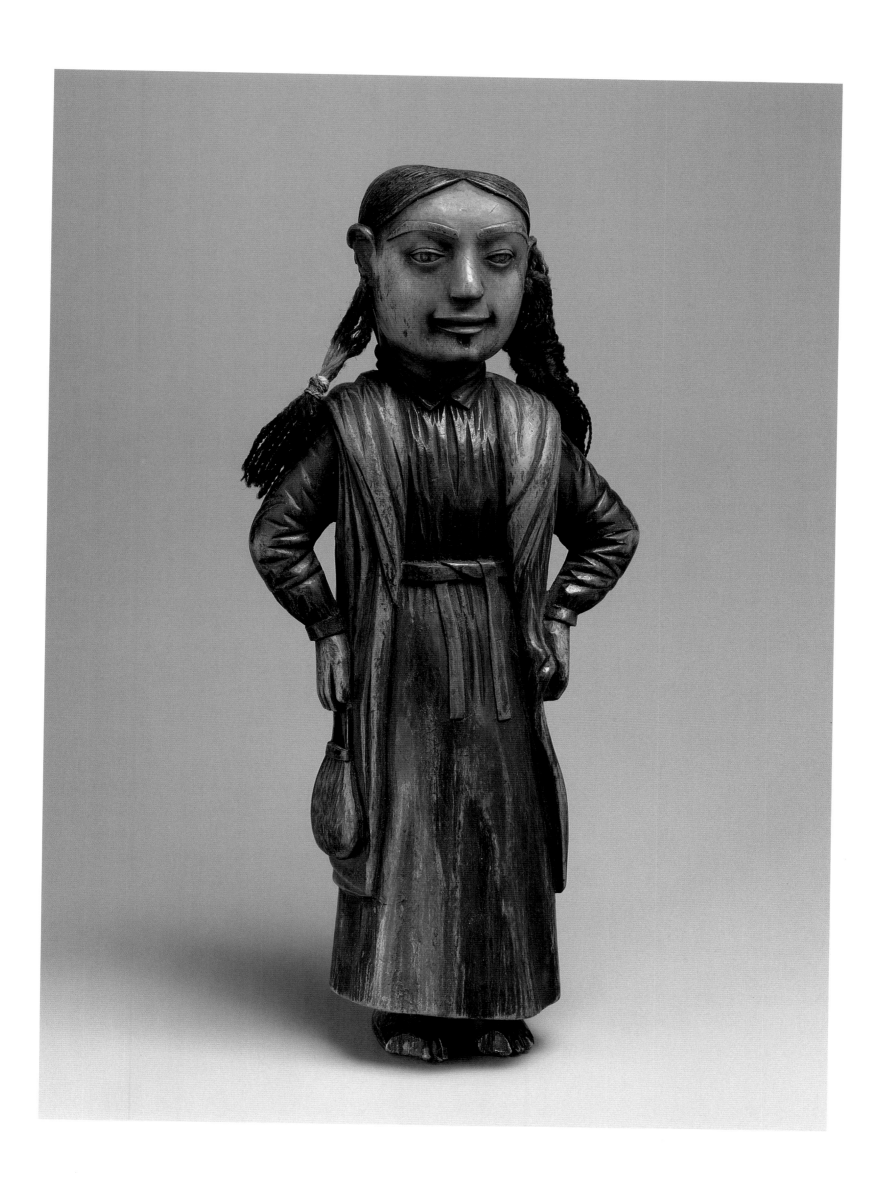

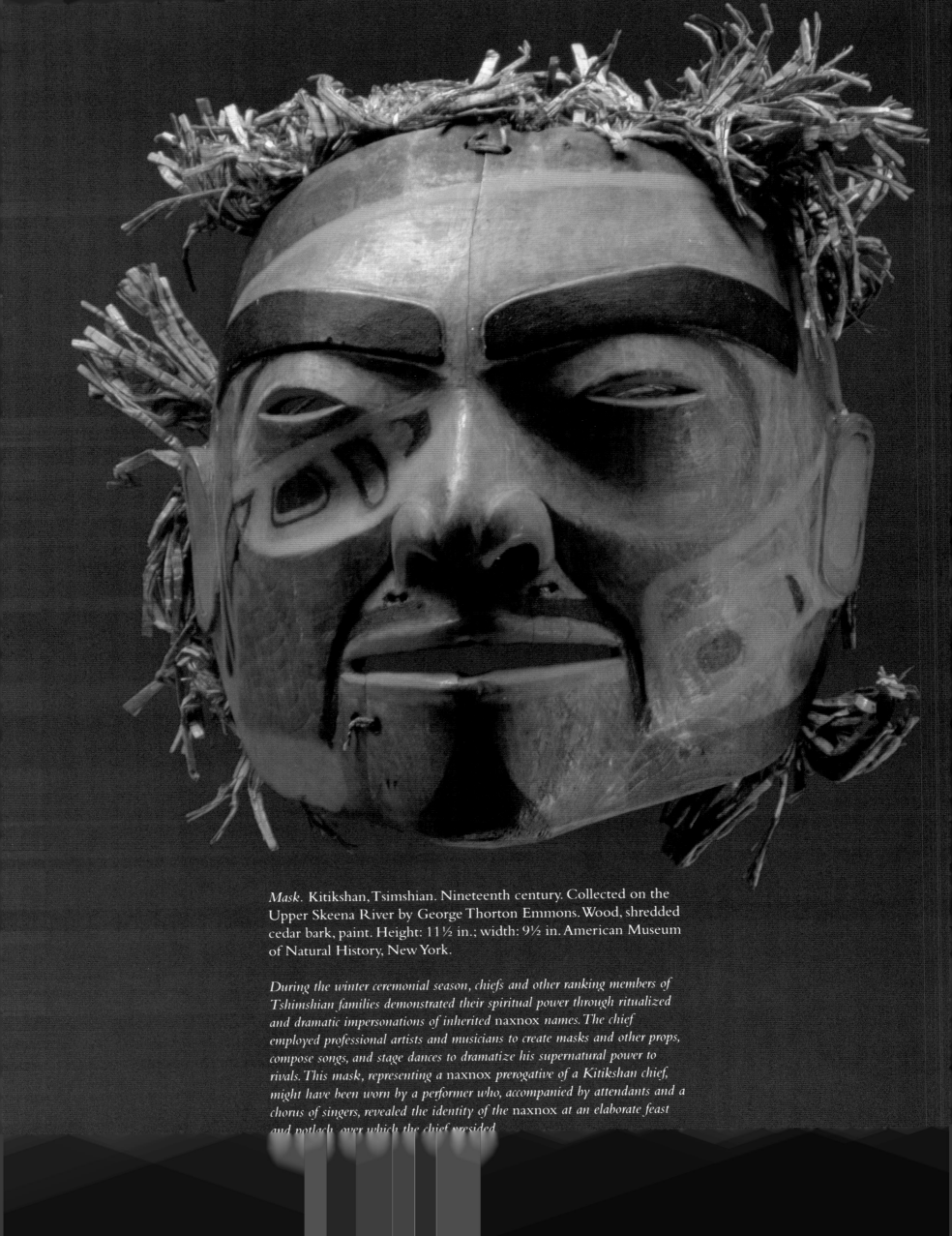

Mask. Kitikshan, Tsimshian. Nineteenth century. Collected on the Upper Skeena River by George Thorton Emmons. Wood, shredded cedar bark, paint. Height: 11½ in.; width: 9½ in. American Museum of Natural History, New York.

During the winter ceremonial season, chiefs and other ranking members of Tshimshian families demonstrated their spiritual power through ritualized and dramatic impersonations of inherited naxnox names. The chief employed professional artists and musicians to create masks and other props, compose songs, and stage dances to dramatize his supernatural power to rivals. This mask, representing a naxnox prerogative of a Kitikshan chief, might have been worn by a performer who, accompanied by attendants and a chorus of singers, revealed the identity of the naxnox at an elaborate feast and potlach, over which the chief presided.

Frontlet Dancing Headdress.
Tsimshian. Nineteenth century.
British Columbia. Wood, shell,
ermine skins, hide, seal
whiskers. Length: 7¼ in. The
Masco Art Collection.

*The dancing headdress was the pre-
rogative of chiefs, and crowned the
ensemble of chiefly regalia which
often included a Chilkat blanket
wrapped around the shoulders and a
bird rattle held in one hand. Loose
eagle or swan's down piled into the
"cage" formed by the upright sea
lion whiskers on top of the frontlet
shook loose and floated around the
chief while he danced, welcoming
guests as a symbol of peace. The
plaque that is carved of hardwood
represents a mythical creature linked
to the chief's lineage—in this case,
a beaver.*

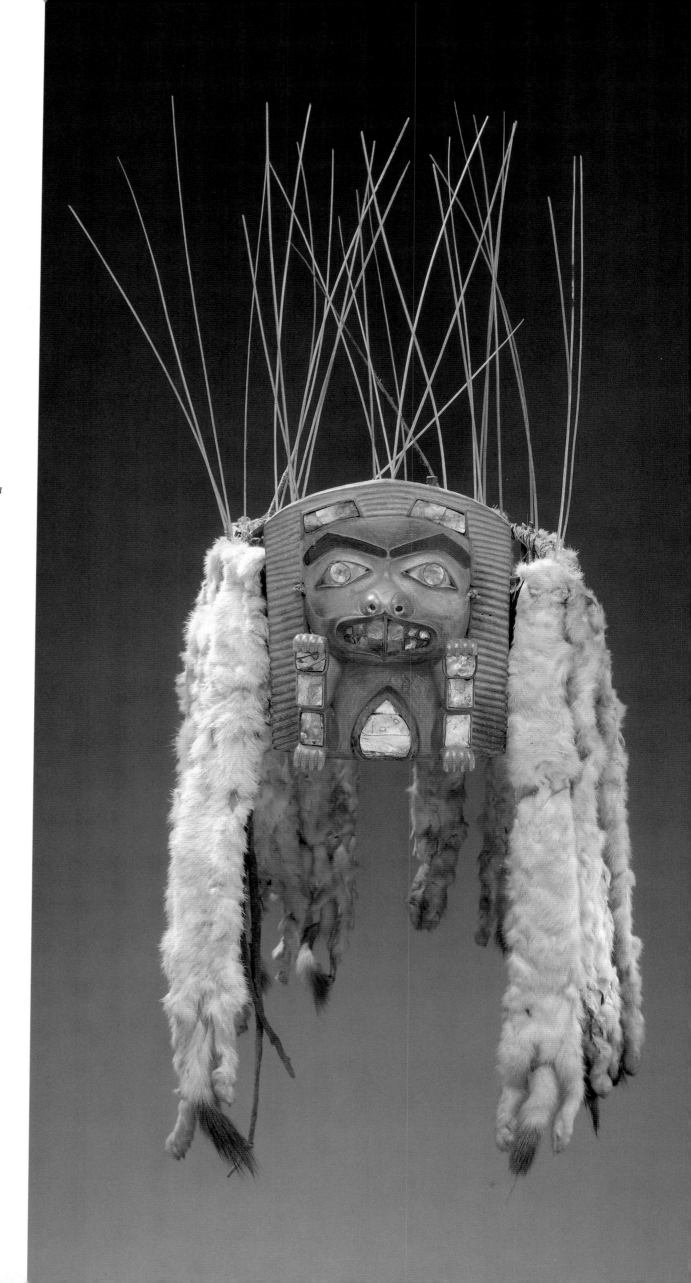

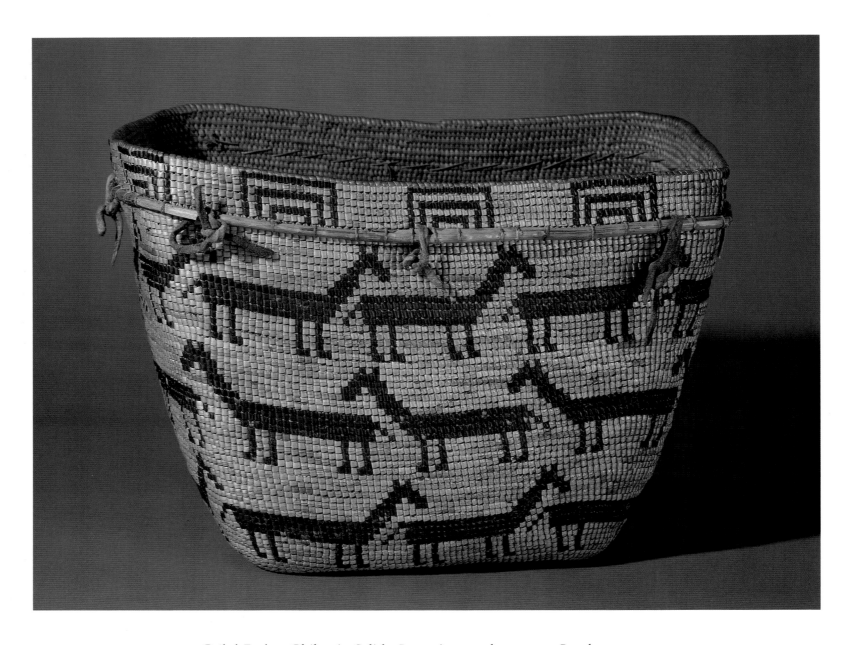

Coiled Basket. Chilcotin Salish. Late nineteenth century. Southern British Columbia. Cedar root, beargrass, red cherry bark. Height: 12¼ in. The Heard Museum, Phoenix, Arizona.

The Salish tribes of southern British Columbia made sturdy baskets of red cedar root. The coiled technique for construction is identical to that of coiled California baskets made well to the south, but the means of decoration is very different. Delicate grasses of blonde and deep maroon are folded beneath and over individual coils in a technique called "imbrication," which covers the entire exterior of this Chilcotin basket. Chilcotin basket weavers incorporated pictorial elements into their designs late in the nineteenth century, like the horses which are visible here.

Bent-Corner Chest. Bella Bella (Northern Kwakiutl). Nineteenth century. Milbanke Sound, British Columbia. Wood (cedar), paint. Length: 35¾ in. The Seattle Art Museum. Gift of John Hauberg and John and Grace Putnam.

Important families stored heirlooms, regalia, and crest objects in massive, lidded chests like this one. The form of a generalized animal, outlined by the narrow and attenuated "form-lines" in black, is spread across the surface of the broad side of the chest. The head occupies the upper center with two narrow faces for eyes. The large, eyelike "ovoids" in the four corners actually represent the shoulder and hip joints of the creature. Delicate hands in red flank the "body" of the creature in the lower center. A similar creature is painted more simply in black and red on the sides of the chest.

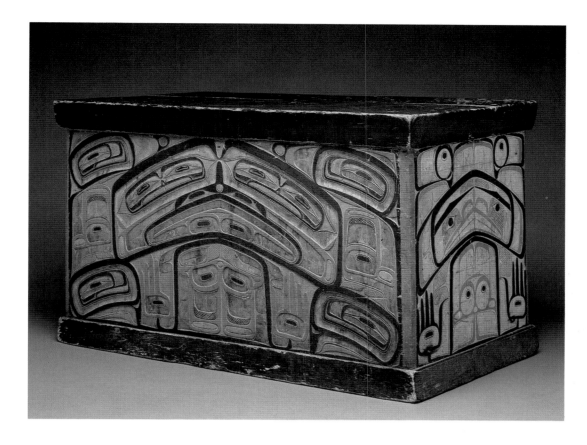

Bent-Wood Box. Tlingit. Nineteenth century. Chilkat, southern Alaska. Wood (cedar), paint. Height: 18 in. American Museum of Natural History, New York.

The sides of this box are made from a single length of wood, bent to form three corners and sewn closed at the fourth. The sides are lashed to a square base. Most remarkable about the box, however, is the complex painted design produced by some unknown artist known only as "the master of the black field." The "black field" refers to the quadrants of the box design that are painted entirely black with designs in red. Northwest Coast painting is a highly organized and conservative tradition that employs a relatively narrow range of formal elements, but often combines them in very imaginative ways. The eyes, fragments of body parts, and standardized "fillers" such as "split-U's" and "ovoids" represent the disarticulated form of an animal, perhaps an eagle. Each side of the box is different and divided into four parts. The elements of the animal form, often split in half or turned on their sides, have been scattered throughout these sixteen spaces. The design on this famous box is an intellectual puzzle as well as an example of the maker's masterful control over the idioms of Northwest Coast painting.

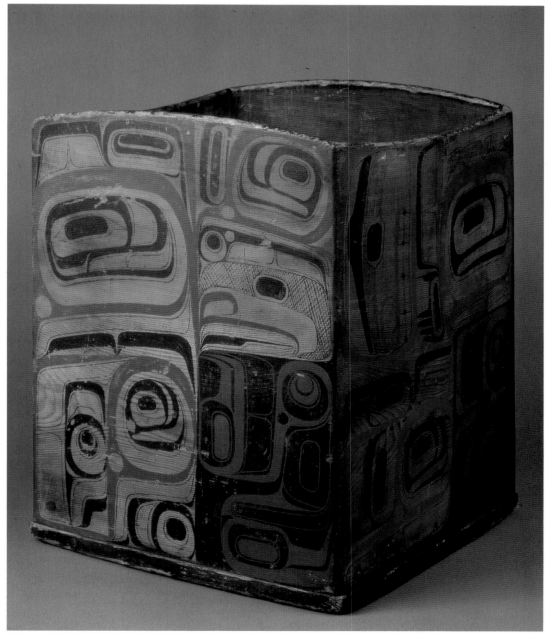

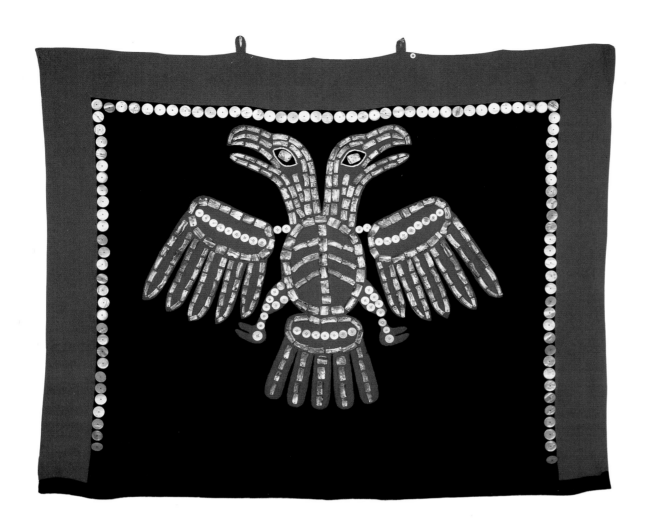

Button Blanket. Tlingit. c. 1900. Wrangel (?), Alaska. Wool cloth, abalone buttons. Height: 4 ft.; width: 5 ft. The Denver Art Museum.

This elaborate robe displays a Tlingit clan crest. Crests are prized possessions of the lineage, displayed on public occasions during potlatches, funerary feasts, and naming ceremonies. Family crests embody the spiritual relationship linking a particular animal to the family through some incident or interaction recounted as family myth. The design of this impressive double-headed bird may have been influenced by the Russian Romanoff coat-of arms. The Russians had attempted to colonize Tlingit territory in southeastern Alaska, remaining an active presence from 1799 until the sale of Alaska to the United States in 1867.

Robe. Coast Salish. Early nineteenth century. Southern British Columbia. Mountain goat wool. Length: 59⅞ in. National Museum of Natural History, Smithsonian Institution, Washington, D.C.

This rare example of Salish weaving was made with a twining technique. The robe is pieced together from several independently made pieces including the large, floating panel in the center. The textile was collected in 1841 during the Wilkes Exploring Expedition.

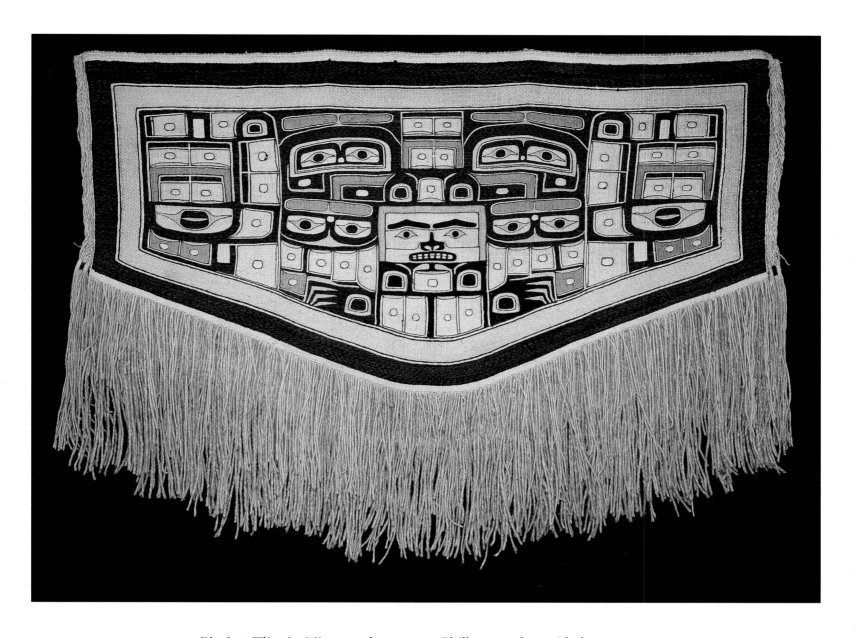

Blanket. Tlingit. Nineteenth century. Chilkat, southern Alaska. Mountain-goat wool, yellow cedar bark, commercial yarn, dye pigments, spruce boards, native paint. Height: 51 9/16 in. The Seattle Art Museum. Gift of John Hauberg.

The Tlingit women of Chilkat village, Alaska, wove beautiful and highly coveted blankets with warps of cedar bark and wefts of goat wool. The blankets from Chilkat were highly regarded as chiefly regalia and were traded to villages up and down the coast. The designs were adapted from paintings produced by male artists on "pattern boards," which functioned as design templates for the weaving. The designs do not represent crests, but more generalized animals in conventional "formline" design. Here, a bearlike creature resides in the center panel, his massive head filling the entire upper half. Far more generalized patterns flank the bear on either side.

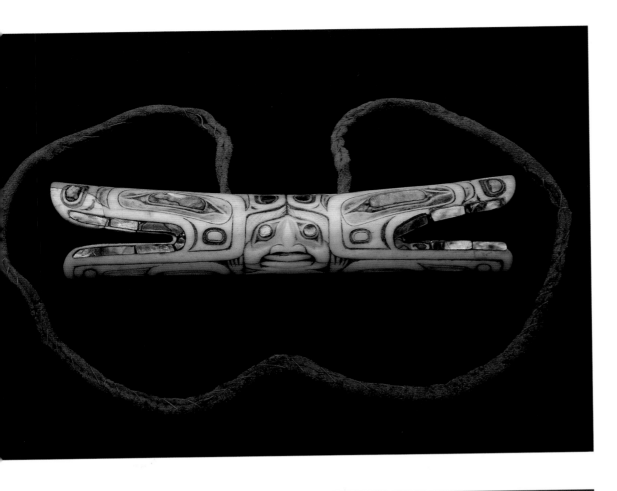

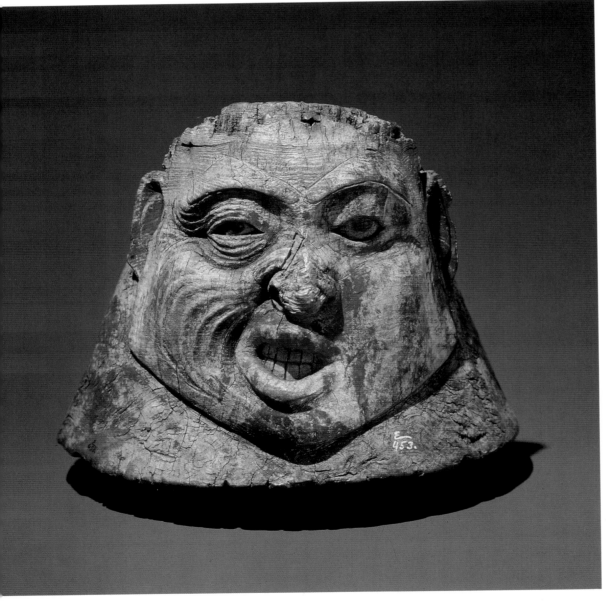

TOP: *Soul Catcher.* Tsimshian. c. 1840–1860. Nass River, British Columbia. Bone, abalone shell, hide. Length: 7¾ in. The Seattle Art Museum. Gift of John Hauberg.

The "soul catcher," as it is called in English, is a category of charm employed by Tsimshian shamans. With it, they retrieve the distressed "soul" that has left the body of the sick and has begun its journey to the land of the dead.

BOTTOM: *War Helmet.* Tlingit. Nineteenth century. Dry Bay, southeastern Alaska. Wood. Height: 9⅞ in. American Museum of Natural History, New York.

A Tlingit war helmet was often worn with other protective armor, including a collar and slat or hide armor. The grimacing face carved on this helmet adds to the intimidating appearance of the warrior as he goes into battle. Furthermore, the image may represent a yek, or spirit being from the dead who has contributed his power to the warrior's prowess.

OPPOSITE: *Crest Hat.* Tlingit. Early nineteenth century. Southern Alaska. Wood (alder), spruce root, abalone shell, human hair, copper, hide. Height: 15 in. Thomas Burke Memorial Washington State Museum, Seattle.

The sculpted form of this flaring, conical hat represents the crest of the killer whale. Its eyes and teeth are faced with iridescent abalone shell; its pectoral fins and flukes are painted behind the head in classic "formline" style. The dorsal fin rises up above four disk-shaped "potlatch rings" woven of spruce root. The fin is inhabited by a seated figure, whose eyes, teeth, palms of the hands, and soles of the feet are also inlaid with shell. Human hair hangs as pendants behind the hat. Crests are the exclusive property of noble families; they combine an object like this hat with an image — in this case, the killer whale—and the story of how the family acquired the crest. The display of crests takes place only at potlatches when accompanied by distributions of wealth to all who witness the event.

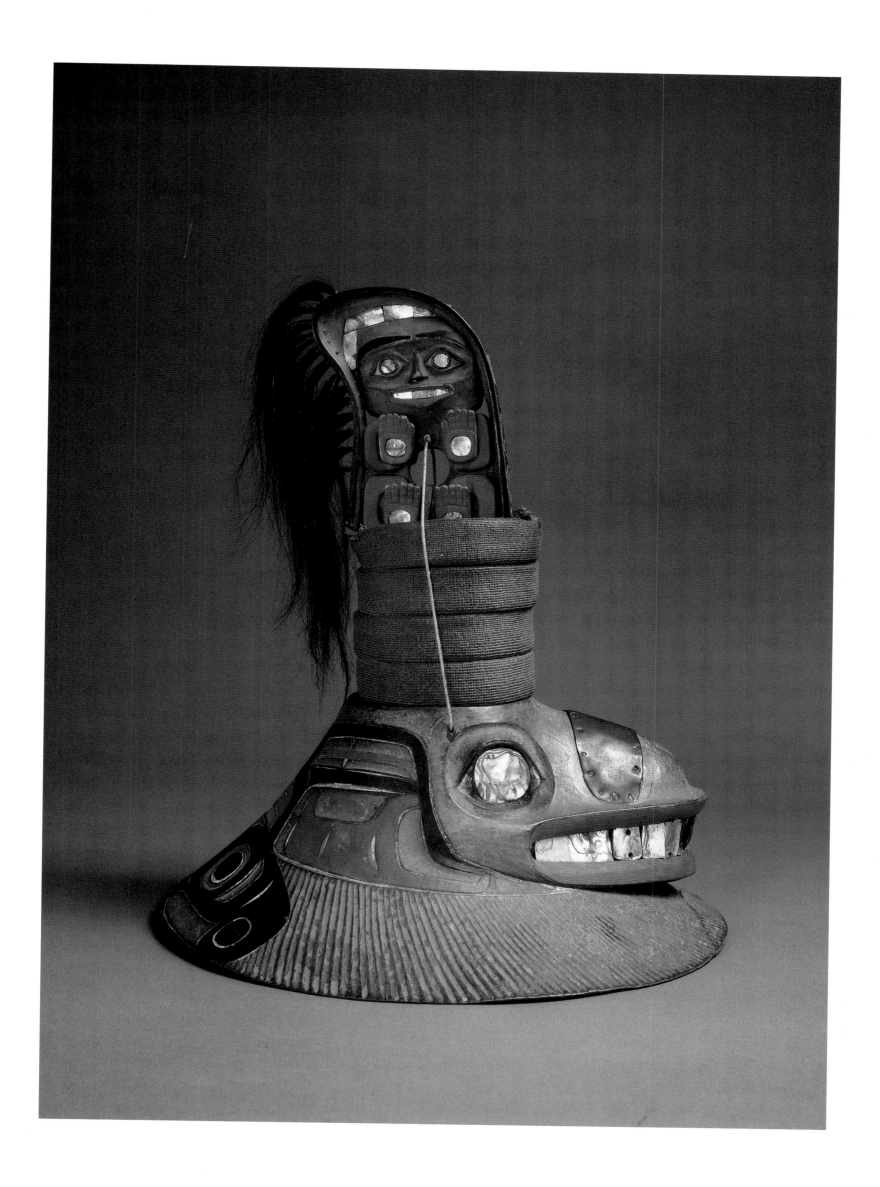

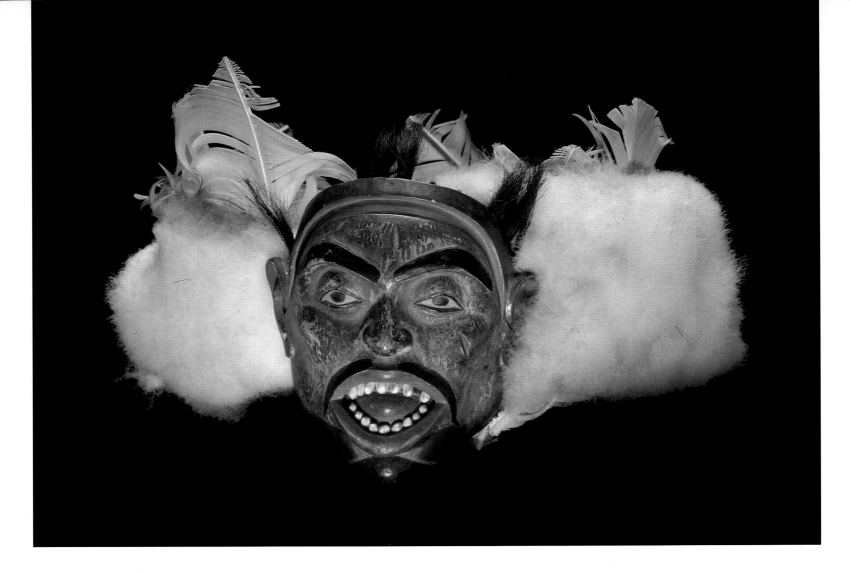

ABOVE: *Shaman's Headdress.* Tlingit. Nineteenth century. Southeastern Alaska. Height: 8¼ in. American Museum of Natural History, New York.

This headdress was worn with the miniature face that is carved in the center perched on the shaman's brow. The face represents a yek, *one of the shaman's guardian spirits.*

OPPOSITE: *Face Mask.* Haida. Nineteenth century. Queen Charlotte Islands, British Columbia. Wood. Height: 11¼ in. The Masco Art Collection.

This expressive mask is notable for its facial painting that perhaps displays the identifying features of a particular characterization for a Haida masquerade performance.

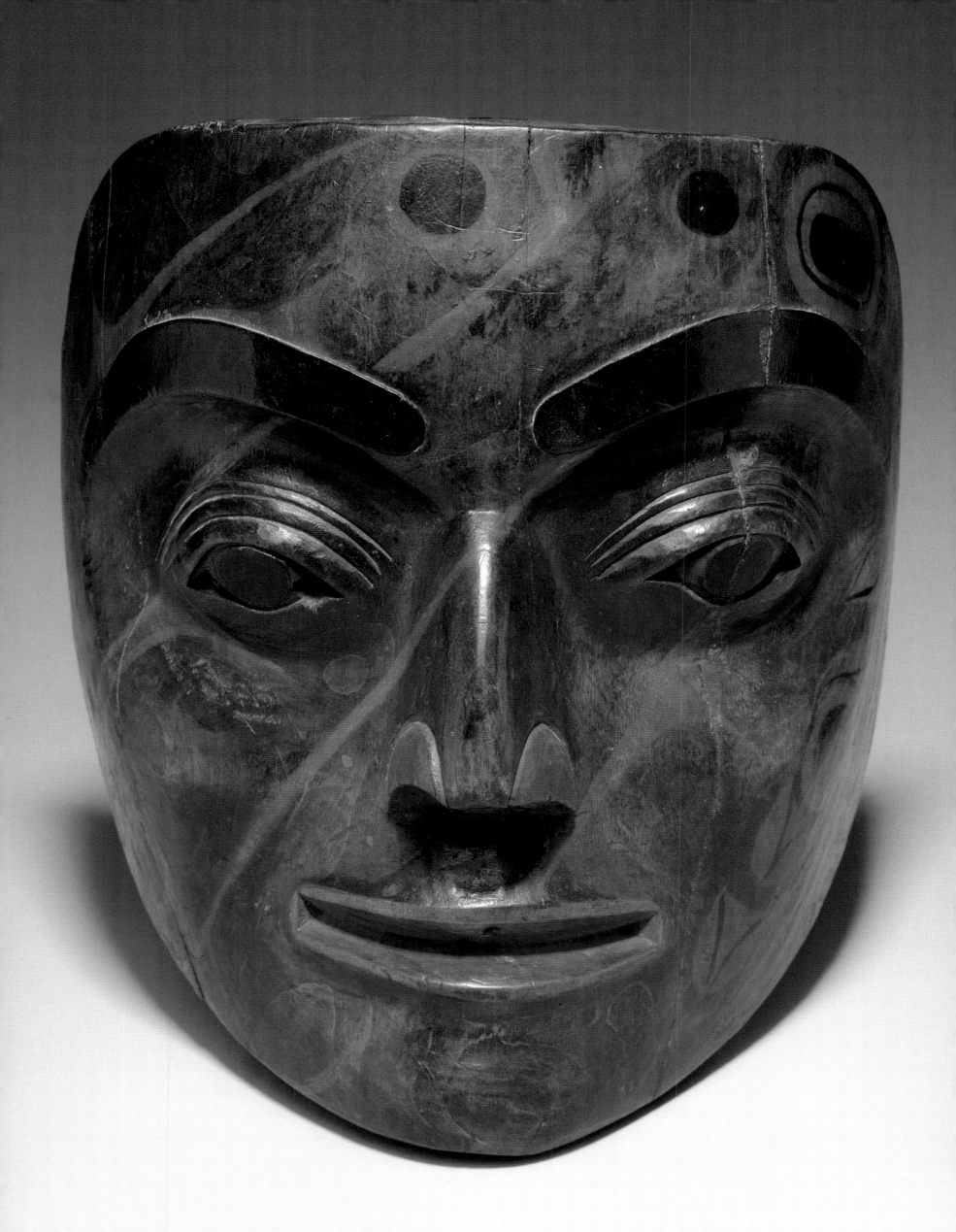

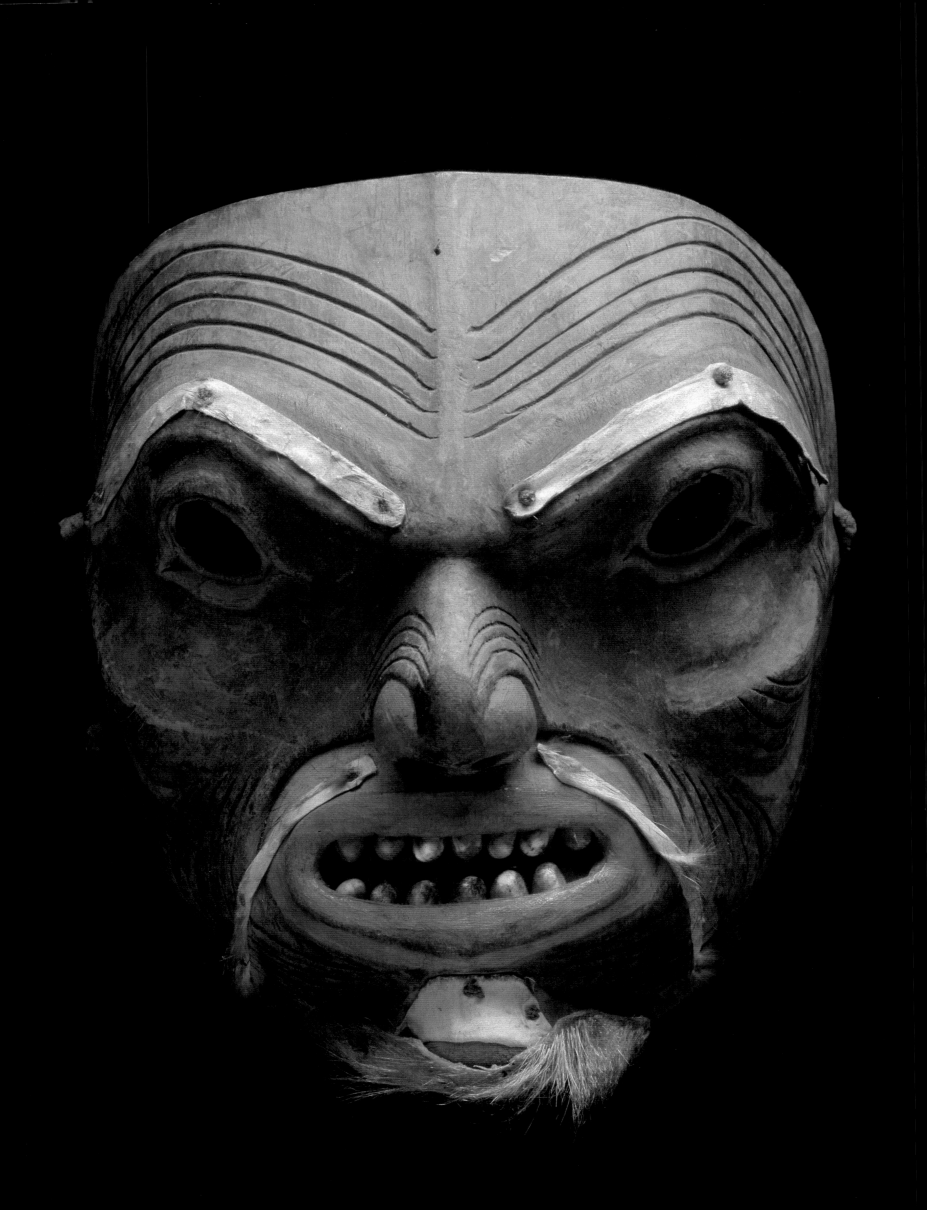

OPPOSITE:. *Shaman's Mask.* Tlingit. Chilkat, southern Alaska. Wood, animal skin, operculum, ivory, human hair. Height: 8¼ in. American Museum of Natural History, New York.

This is one of a set of several masks used by a Tlingit shaman to perform cures. The masks represent yek, or spirit helpers, who are actually souls of the dead in the forms of animals or different categories of human beings. This mask, with its furrowed brow, wrinkled face, heavy eyebrows, mustache, and beard (the hair has worn away from most of the applied hide), represents an old man.

RIGHT: *Bear Mask.* Tlingit. c. 1820–1840. Southeastern Alaska. Wood, rawhide, paint. Height: 10⅛ in. Private collection.

This old and exquisitely carved mask represents a shaman's spirit that combines the features of a bear with that of a human face. The broad, grinning mouth is framed with the flat, ribbon-like lips of classic Tlingit-style carving. The eyes tilt forward contributing a sinister expression to its leering stare. Miniature faces inhabit the creature's ears. The carving effectively communicates a frightening and powerful manifestation of a shaman's yek.

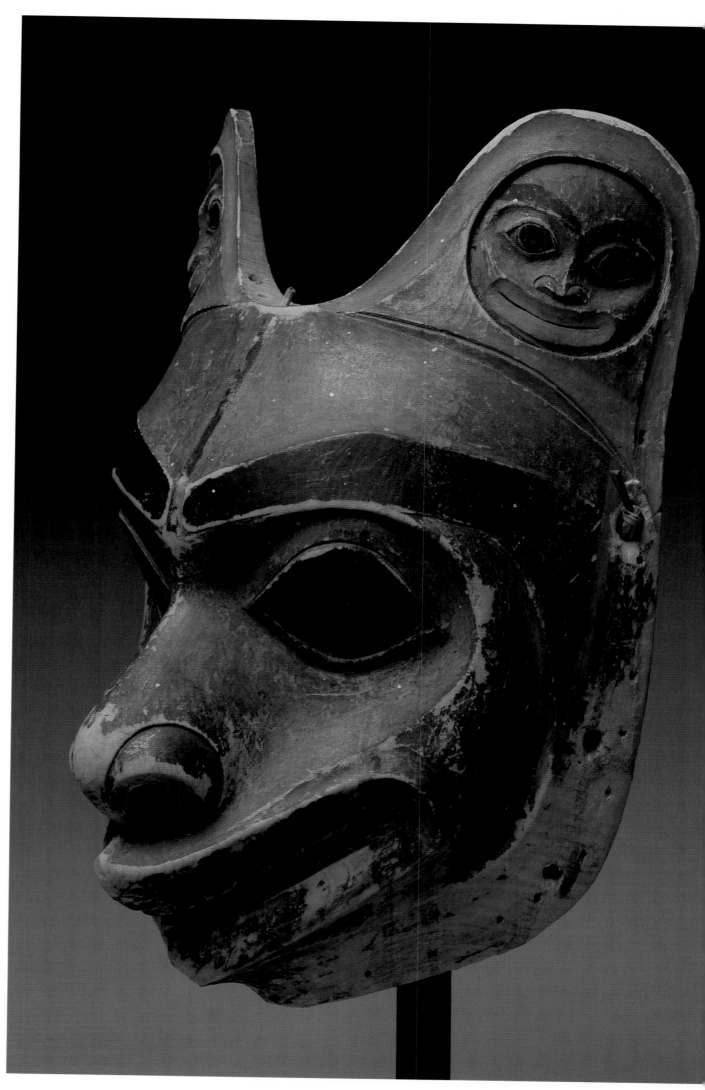

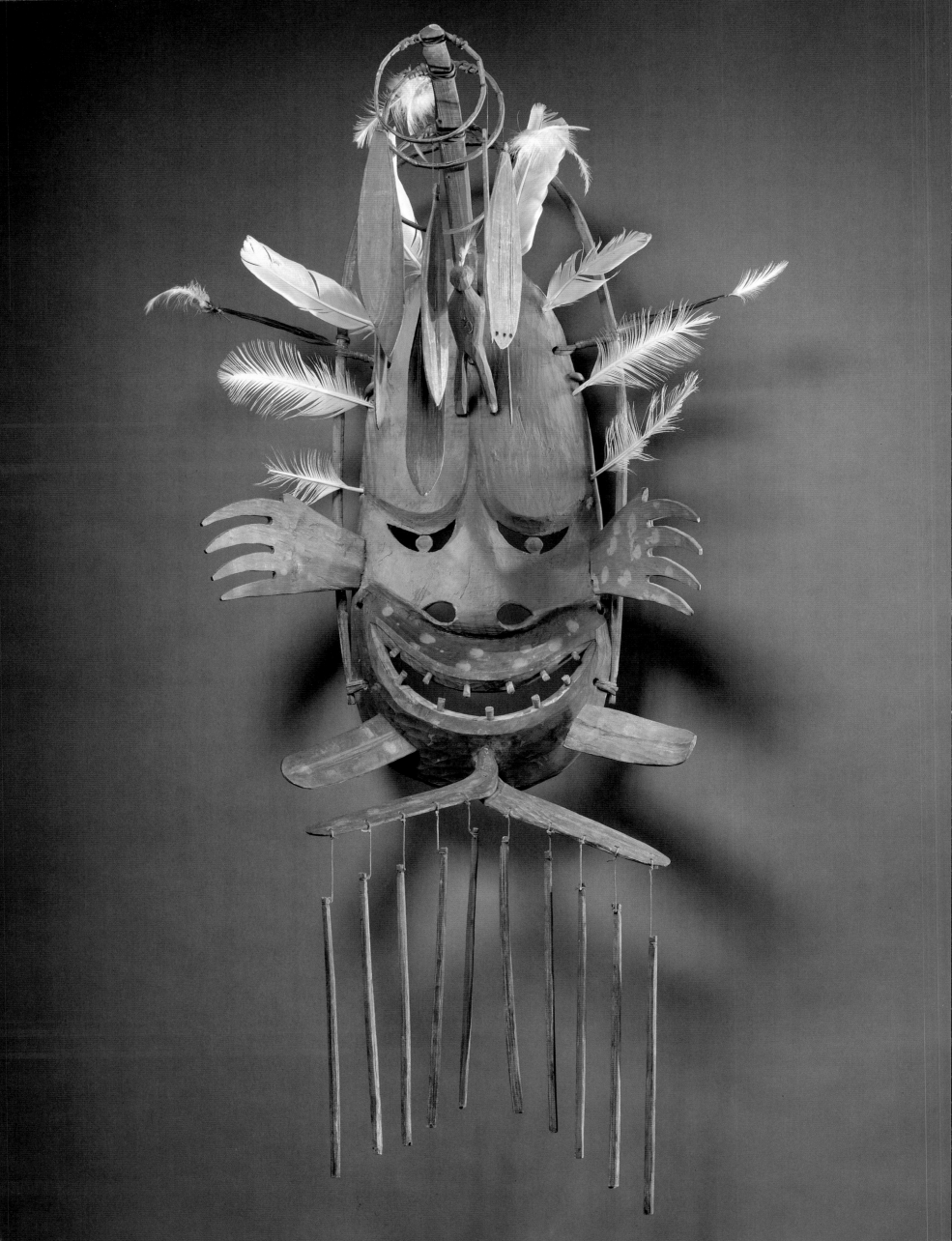

THE ARCTIC

The Arctic region and some areas of the adjacent Subarctic are home to a unique people known as Eskimo. With the exception of the Subarctic Eskimo of Alaska and Greenland and the Aleut, who inhabit the Aleutian Islands, most Eskimo dwell in those areas where the shores freeze in winter, in close proximity to their primary quarry, the walrus. Although life in the Subarctic resulted in certain differences in lifestyle, traditional Eskimo economies were characterized by almost complete dependence upon hunting. Unlike most other areas of the world where hunting and gathering peoples lived, the cold environment and short growing seasons of the north precluded the availability of any appreciable food plants to support human life. The difficult environment supplied only a narrow range of food resources: primarily fish, sea mammals, caribou, and musk ox hunted in summer, and some birds and small game. Meat gathered during the summer was stockpiled to insure the people's survival over the dark winter months.

SIBERIAN MIGRATIONS

The Arctic region, requiring from its earliest inhabitants thorough mastery over knowledge of the environment and its resources, offered only the most tenuous and fragile opportunities for cultural life. By 2000 B.C. small family groups were settled sparsely in locations from Alaska to Greenland. This early episode of Arctic settlement is known as the Arctic Small Tool Tradition, named for its assemblage of microblades, burins, scrapers, and projectile points delicately chipped in chert. The small, isolated communities, often only a single household, must have been inhabited by the most courageous and hardy of individuals to have braved the harsh Arctic environment with such a limited technology. During the first millennium B.C., the patterns of Eskimo cultures were more firmly established by the people of the Norton tradition, who brought with them from Siberia a far more complex material culture, including oil lamps, skin boats, pottery, and a wide range of more specialized weapons for hunting. These people lived in relatively large, sunken homes constructed of rocks, whalebone, and driftwood, often covered with sod. The Point Hope site of Ipiutak culture located on the northern Alaska coast and dated during the first few centuries B.C. is the largest known village of this early period; it included some six hundred houses. Ipiutak is known particularly for its highly developed art in walrus ivory: burial sites have revealed delicately engraved harpoon parts, animal effigies, and masks made of composite pieces.

Ipiutak in northwest Alaska, Old Bering Sea on the central Coast, and Okvik culture in the southwest Alaskan archipelago established the foundations for the development of Thule culture, the precursors of the modern Eskimo. Each of these cultures practiced related yet distinctive styles of ivory engraving and design. These early Eskimo fashioned many different kinds of tools, implements, weapons, and ornaments from the carved tusks of walrus: boat parts and toggles, bucket handles, knife

OPPOSITE:
Shaman's Mask. Eskimo (Yupik). Nineteenth century. Lower Kuskokwim River region, Alaska. Wood, feathers. Height: 44½ in. Metropolitan Museum of Art, New York.

Eskimo shamans employed masks during festivals to demonstrate their spiritual powers. They hired dancers and carvers to portray spirit beings and staged presentations with song, dance, and narrative to describe their supernatural experiences. This mask, with its broad, toothy grin, may represent Tunghat, a supernatural carnivore honored by the Eskimo for its hunting ability.

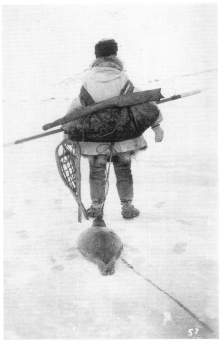

Seal hunters, Wales, Alaska, Seward Peninsula, winter 1920. These men hunted seals on the pack ice by waiting patiently at their breathing holes with a toggle-point harpoon.

David Penney Collection.

grips, and human figurines, among others. The hard, creamy-white ivory was adapted to many uses, some of the most ingeniously designed objects being elements of harpoons used for hunting sea mammals. A toggle-point carved of ivory, slotted at the tip to receive a thin blade of ground slate, was designed to turn sideways beneath the blubber layer of a walrus or seal after being detached from the harpoon. A heavy foreshaft and socket held the toggle-point in place for throwing, while adding heft for impact. An ivory counterweight at the base of the harpoon balanced the heavy toggle-point, foreshaft, and socket for more accurate throwing. Once the toggle-point was embedded in the quarry, floats and drags attached by a line slowed the flight of the wounded animal and tired it for the kill. All the ivory components of the harpoon were decorated with a gossamer web-work of engraved designs, artistic entreaties to the spirits for a successful hunt.

The engraving styles and artifact designs on walrus ivory objects identify various cultural episodes of the ancient Arctic traditions. The more stolid, spurred-line patterns of Okvik contrast with the exuberant, curvilinear designs of Old Bering Sea, whose objects were stylistically characterized by increasingly open, free-flowing designs. The Punuk style of the Bering Strait followed Old Bering Sea by approximately A.D. 600 with heavier, more deeply incised linear elements arranged more mechanically. The Thule cultural pattern followed at about A.D. 1200, representing the full development of Eskimo economies in its modern form. Thereafter, the archaeological record traces increasing regional diversification.

The modern Eskimo can be divided into two large linguistic groups: the Inuit of the Arctic northern slope, from Alaska across Canada to Greenland; and the Yupik of the Alaskan west coast, the Bering Strait, and Siberia. The Aleut, who are linguistically independent of the Inuit and Yupik, also straddle the Bering Strait along the Aleutian archipelago to the south of the Yupik. The most familiar, traditional Eskimo way of life was practiced by the Inuit. People settled inland to hunt land mammals such as musk ox and caribou during the summer, then moved out onto the pack ice and built igloos, or ice houses, to hunt seal during the winter, returning to their coastal villages to hunt sea mammal and fish in open water during the spring. The northern Alaska Inuit lived in semisubterranean houses grouped in relatively large coastal villages where men conducted whaling expeditions from the edge of the float ice or in skin boats. Yupik lived in many different locations, including the inland delta region of the Kuskokwim and Yukon rivers and the islands of the Bering Strait. Yupik communities were larger and more populous than those of other Eskimo, this relatively broad-based culture producing the most elaborate traditions of visual art in the region. The Aleut were consummate seafarers who hunted the open waters off the Aleutian Islands in kayaks.

THE ART OF THE HUNTER

The Eskimo were entirely dependent upon game animals for survival and believed that animals give up their bodies for human beings only if they are respected and treated well. According to tradition, each member of an animal species is linked together by a common *inua*, or inner spirit. If, for some reason, the *inua* of game animals are displeased with their treatment by hunters, they will not permit themselves to be hunted and the community will starve. Art, then, became, for the Eskimo, part

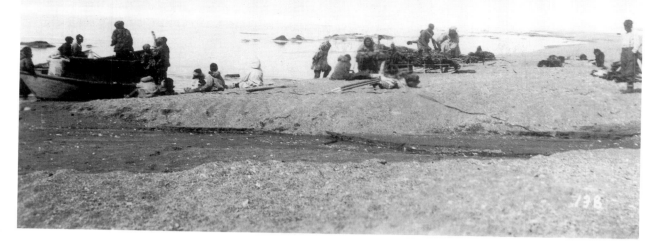

Shore of the Bering Strait in summer, Wales, Alaska, 1920. Dog sleds have brought cached caribou meat to the shoreline to load into umiaks (skin-covered boats), perhaps for a trading expedition. The Eskimo usually moved inland during the summer to hunt caribou, and used the opportunity of open water to travel extensively for visiting and trading.

David Penney Collection.

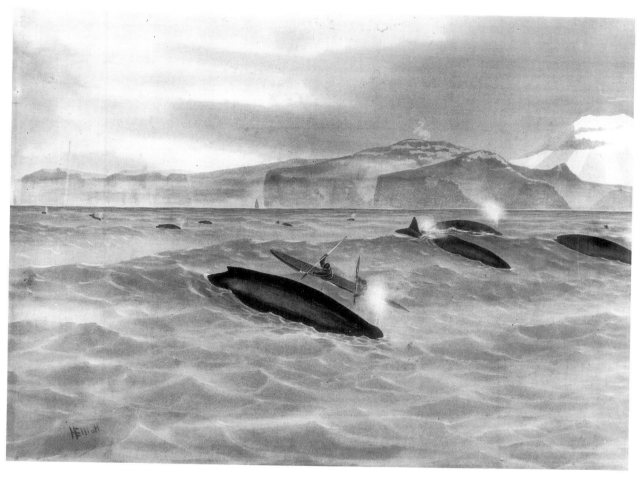

Aleut men hunted whales in the open ocean from small, two-man kayaks. Darts killed the whales, but they had to float ashore on their own to be harvested. Whalers waited on shore and sang sacred whaling songs to draw the carcass near. This watercolor illustration by Henry W. Elliot, who visited the Aleutians in 1864–1866, conveys the danger and drama of Aleut whale hunting.

National Museum of Natural History, Smithsonian Institution, Washington, D.C.

of the technology of hunting as weapons and hunters' tools were decorated with engravings to honor and please the spirits of game animals. Some early engraved designs include faces and other animal elements that resemble the monstrous and ravenous *Tunghat*, a master hunter who is emulated and feared by modern Eskimo. Engraved animal forms may also represent the *inua* of the game the hunter sought.

The relationship between human beings and animals is, ideally, one of mutual respect and purpose. The hunter, mindful of the animals' perceptions and judgment of him, carefully observed his attitude, demeanor, and behavior while hunting as well as in daily life. A successful hunt depended as much on the quarry's willingness to be hunted as it did on the hunter's skill and prowess. Ritual observances, moral behavior, and clear and positive thought were as important to the success of an Eskimo hunter's campaign as was his harpoon.

The seals that had given themselves to the Yupik community throughout the year were honored in an annual ceremony called the "bladder festival," which paid

respects to the seals' *inua* thought to reside in their bladders and helped insure their rebirth. The festival began as hunters took the bladders of the captured seals to the community *qasgiq*, a communal ceremonial structure or dance house. A four-day festival followed, filled with songs, dances, masquerade performances, and feasting intended to please the *inua* of the seals represented by their bladders, which were inflated like balloons and hung from the rafters. At the end of the festival, the hunters burst the bladders with harpoons and sank them in the sea, a ritual that signified the return of the spirits of the hunted seals to their source in hopes that they would once again nourish the community.

The Yupik shaman presided over the ceremonies of the bladder festival as part of his responsibility for the entire community's relationship with the animal world. Should game disappear, the shaman could travel to the moon to speak with the master of animals, seeking the reason animals had been prevented from coming into the world. The shaman could also travel beneath the sea to visit the spirits of seals and other sea animals. The shaman's body would fall lifeless in its spirit's absence, and upon the spirit's return the shaman's body would come back to life. Many of the shaman's public performances during the bladder festival and other public gatherings included demonstrations of his mastery over life and death. He might be lowered under the ice, harpooned like a seal, or consumed in flame, but he always revived unscathed from the experience as proof of his powers.

During the bladder festival and other, related kinds of hunting ceremonies, the Yupik shaman organized masked performances that included dance, song, and narrative. The shaman orchestrated the event, employing the best dancers and singers. Sometimes he made his own masks, but often he commissioned them from an accomplished carver with detailed instructions. The masks and the performances they enhanced carried many different meanings. Some masks represented the *inua* of desirable game animals that the shaman sought to honor and control, and many accompanying masquerades mimicked the appearance and behavior of animals. Other masks might represent the shaman's spiritual helpers, like the dreaded and monstrous *Tunghat*. A masquerade using masks might convey the narrative of the shaman's predecessors—perhaps the adventures of an ancient shaman whose spirit came to inhabit the living shaman's body. The carefully choreographed masquerades were presented in the *qasgiq* before a large audience, and might be accompanied by a chorus of women dressed in their finest regalia and dancing with finger masks and singing. These performances were conceived to display beauty, skill, humor, and drama with the intention of pleasing the spirit world with whom the community lived in close communion.

EVERYDAY ART

Every member of the Eskimo community made things that were necessary for everyday life. Women prepared hides and tailored garments. Men carved implements and utensils from driftwood and walrus ivory. All the materials used by Eskimos to make things possess their own spiritual essences that act together with the maker to fulfill a purpose. The spirit of driftwood desires to be carved, for example, just as the man desires to carve it. Once these materials have been transformed into objects, their spiritual purpose is linked closely to the owner. Men must incorporate the pieces of

old kayaks, for instance, when they build new ones. And fragments of ancient kayaks and other implements are preserved for generations in the *qasgiq* as part of the community's spiritual legacy. When brought out and displayed during the opening rituals of the bladder festival, they inspire songs and stories recalling ancient heros and their accomplishments.

An individual's personal possessions included a large variety of carefully made tools, weapons, charms, and implements, as well as boxes and cases to keep them in. Many of these were carved with designs relating to the spiritual relationships between human beings and animals, or those between men and women. Because the survival of early Eskimo communities depended to a large degree on the ability of every member to make these necessary items, a particularly talented and capable number of artists emerged toward the end of the nineteenth century, well poised to participate in the growing tourist market for traditional crafts.

Early visitors to the Arctic, beginning with the whalers of the nineteenth century, were charmed by the diminutive but finely crafted objects made by Eskimo carvers. Travelers in the Arctic also sought out warm and durable Eskimo parkas and boots. Eskimo visited whale ships with hides, fur garments, fresh meat, walrus ivory, and carvings for trade. Sculptural images of animals sold well among the outsiders, as did ivory objects engraved with linear pictographic scenes of hunting and everyday life. Contacts remained sporadic and incidental between the Alaska Eskimo and the outside world until the Klondike gold rush of 1890. Visitors desiring souvenirs of their Alaskan journeys fueled the market for Eskimo carvings in ivory, which expanded to include models of sailing ships, cribbage boards, and more fanciful renditions of animal and human figures. The engraving style developed from simple linear figures to intricate and detailed compositions inspired by printed engravings seen in illustrated papers and magazines.

As the twentieth century progressed, Eskimo economies became increasingly dependent on sales of crafts items and carvings. As a result, men and women experimented with media and form to please outside buyers. Women started producing innovative baskets woven from whale baleen by 1915, and the people of the Yukon and Kuskokwim delta fashioned coiled baskets from native grasses. By the 1920s, an inventory of fairly standardized craft items were being made for outside sale including ivory bracelets, dolls, miniature bird and animal figurines, and even napkin rings.

Because of their remote and difficult environment, Eskimo people avoided many of the problems and conflict that befell American Indians who lived in more desirable regions. The Yupik, Inuit, and Aleut remained virtually isolated from the outside world until well into the twentieth century. But eventually, missionaries, traders, and educators convinced the people to abandon their nomadic way of life in favor of more permanent settlements in large villages. Eskimo economy, for so long dependent upon hunting, was also transformed as modern technology and consumerism hastened a new lifestyle. Arctic people are still contending with the implications of these changes today. But, as with many other native peoples of North America, the economic rewards received and traditional values preserved by the production of arts and crafts helped a proud people with a deeply rooted heritage to make the difficult transition into the modern world.

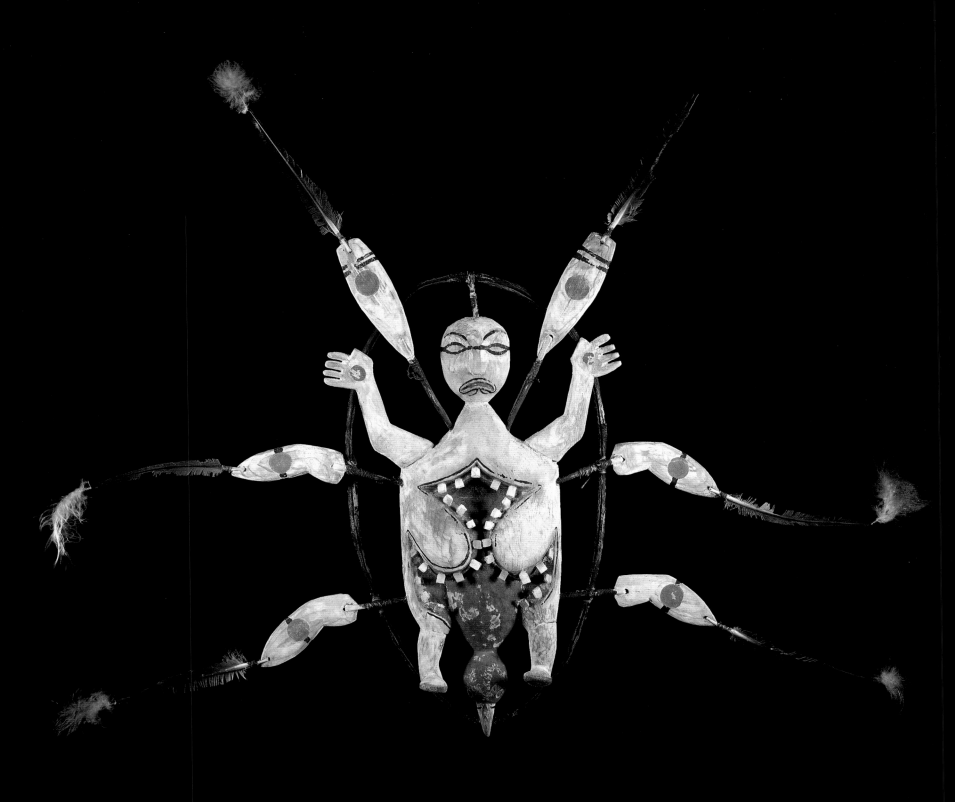

Mask. Eskimo (Yupik). Nineteenth century. Lower Kuskokwim River region, Alaska. Wood, feathers. Length: 30 in. The Detroit Institute of Arts.

This mask employs several symbolic and metaphorical elements to describe the shaman's mastery over the spirit world. The dots on the palms of the figure with his hands upraised identify Tunghat, a voracious, supernatural carnivore. The holes in the creature's hands permit some game animals to escape, leaving some for humans. The body of the central figure splits open, exposing ribs and inner organs, symbolizing the spiritual transformation of the shaman as he enters the spirit world. The water bird that emerges from the body of the figure is associated with finding game, since hunters look for birds to signal the location of walrus or whales. The kayak paddles and seal fins that are arranged around the figure are symbols of transport through water, the way to the spirit world which the shaman must travel to find the spirits, or inua, of game animals.

Mask. Eskimo (Yupik). Nineteenth century. Western Alaska. Wood. Height: 7⅞ in. The Detroit Institute of Arts.

Tunghat is a supernatural hunter with the combined features of a polar bear and a sea lion. The sculptor here has captured the menacing expression of Tunghat's eyes, its broad, voracious mouth, and the sea mammal's nostrils.

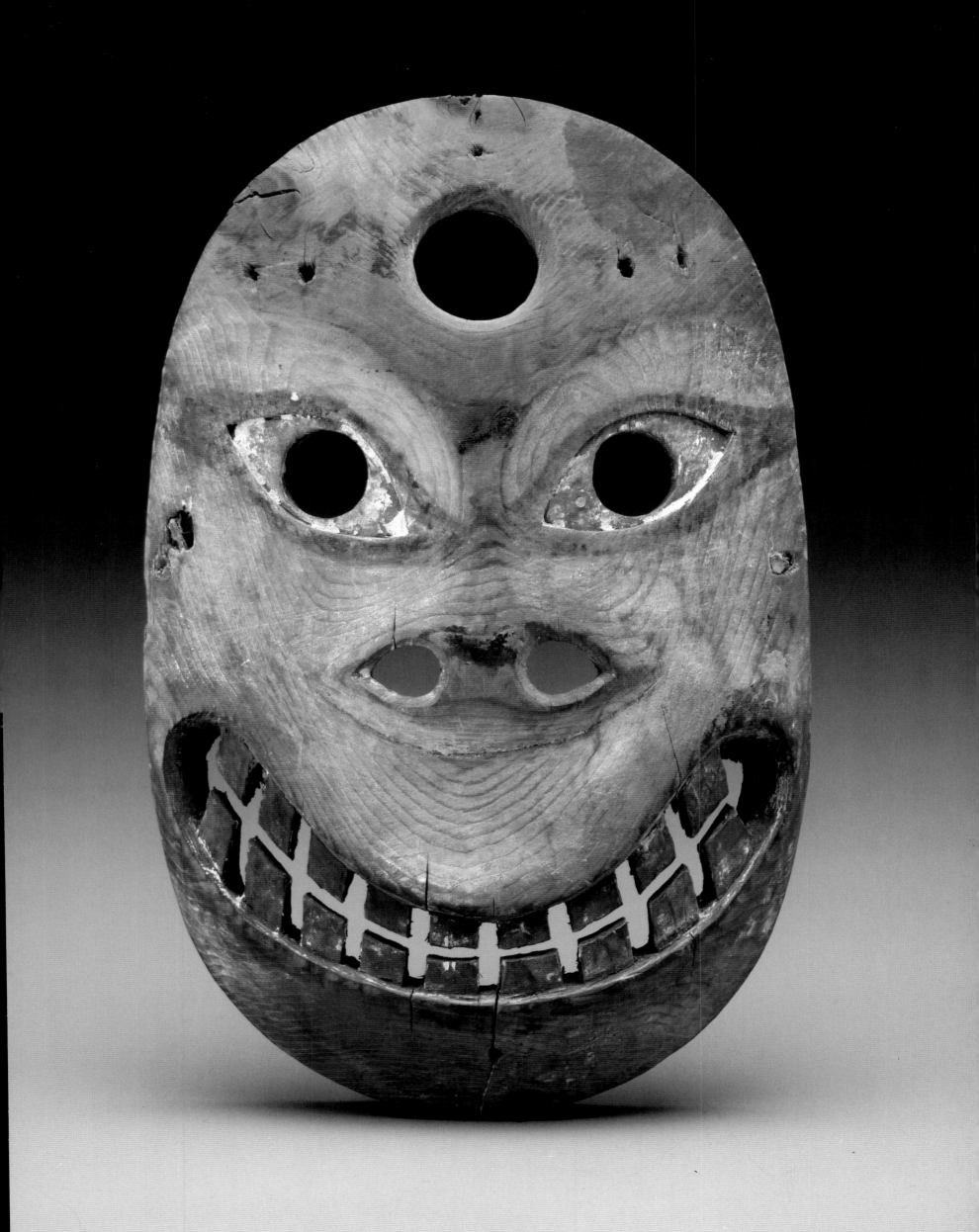

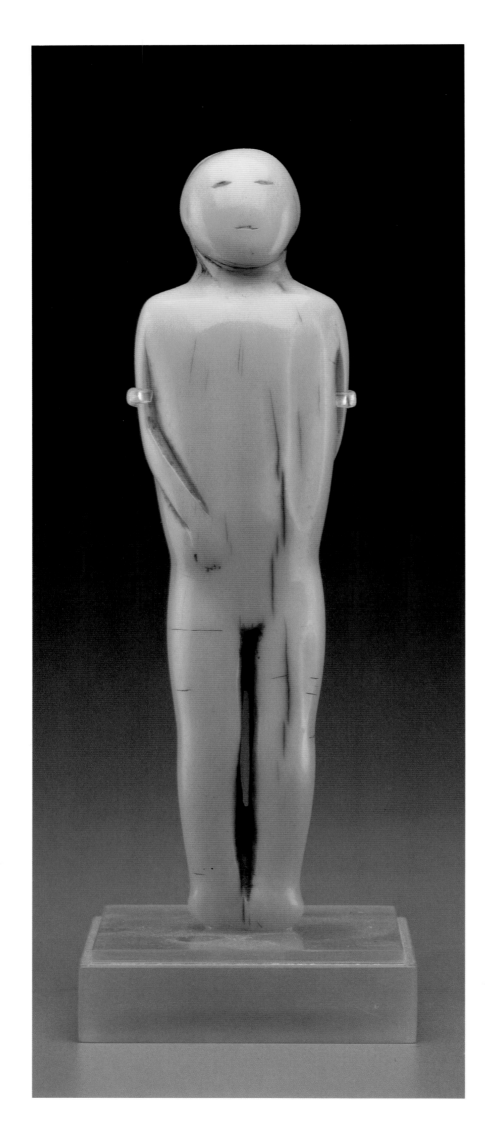

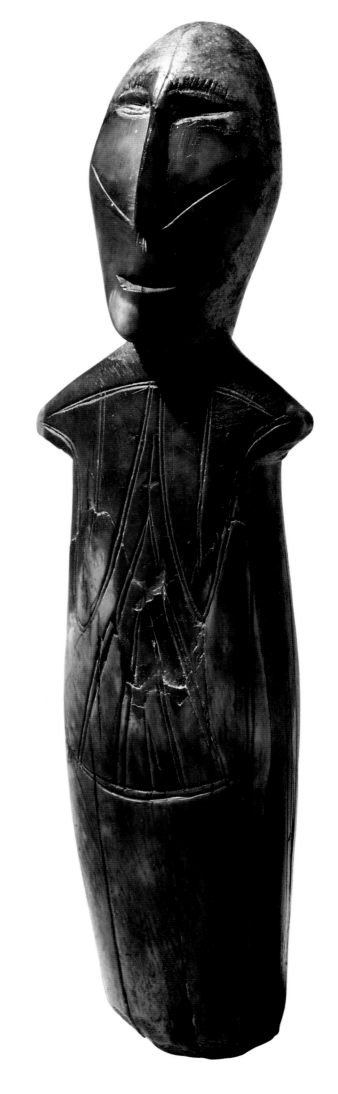

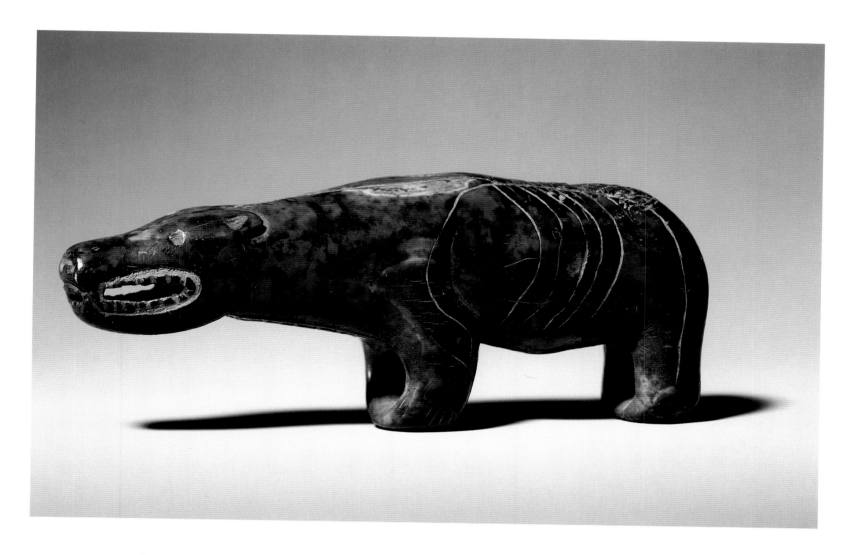

OPPOSITE LEFT: *Figurine.* Late Thule (Eskimo). Seventeenth or eighteenth century. Western Alaska. Walrus ivory. Height: 4½ in. The Detroit Institute of Arts.

The refined and reductive aesthetic of Arctic sculpture is well represented in this small ivory figurine. The figure stands upright with the hands gesturing asymmetrically, one on the abdomen and the other concealed behind the back. The legs were separated with a string saw, the feet joined together at the bottom of the carving. The purpose of such figurines is unclear. Many undoubtedly served as playthings for children; others had protective attributes.

OPPOSITE RIGHT: *Figurine.* Okvik culture, 100 B.C.–A.D. 100. St. Lawrence Island, Bering Strait, Alaska. Walrus ivory. Height: 7⅜ in. Private collection.

Solemn and mysterious figurines carved from walrus ivory stained dark with graphite pigments in the soil have been recovered from excavations at St. Lawrence Island. The oldest, dating to the Okvik occupation of the island, show particularly refined features, with their tall, narrowed brows and delicate engraving. Historic period figurines made of ivory served as children's playthings, but these ancient figurines are often found accompanying burials of the dead along with abundant additional treasures of walrus ivory carving. Their interpretation is uncertain, but they may represent spiritual beings, or perhaps possess other ritual properties.

ABOVE: *Polar Bear Effigy.* Okvik culture, 200 B.C.–A.D. 100. Bering Strait region, Alaska. Walrus ivory. The Thaw Collection, Fenimore House Museum, Cooperstown, New York.

The Eskimo have always recognized the polar bear as the consummate hunter-carnivore and aspired to equal its power and skill. This small effigy of a polar bear may have functioned as an amulet conceived to assist the Okvik hunter.

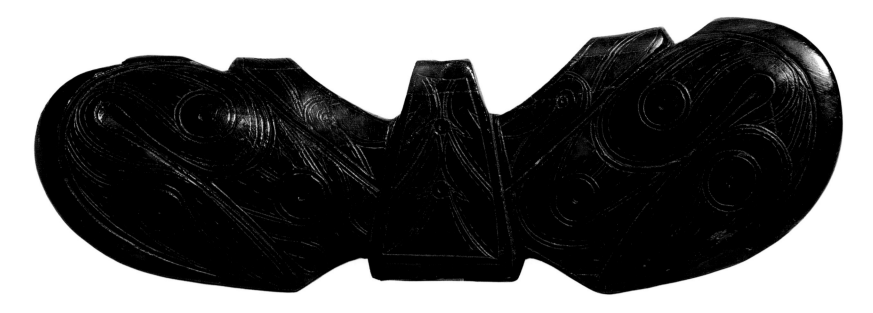

ABOVE: *Winged Object (harpoon counterweight)*. Old Bering Sea III culture, A.D. 300–600. St. Lawrence Island, Bering Strait, Alaska. Walrus ivory. Width: 7⅝ in. George Lois Collection.

The ivory engraving style of Old Bering Sea III represents a high point of Arctic graphic arts. Meticulous engraved double lines underscored with faint hatching twist and bend within the winged form, which is anchored by circular bosses raised in gently swelling relief.

BELOW: *Winged Object (harpoon counterweight)*. Old Bering Sea II culture, A.D. 100–300. St. Lawrence Island, Bering Strait, Alaska. Walrus ivory. Length: 7 7/16 in. The Detroit Institute of Arts.

A "winged object" was one of several walrus ivory components to an Old Bering Sea harpoon. It served as a counterweight to the foreshaft and its socket, and the toggle-point. All ivory elements of Old Bering Sea harpoons were elaborately decorated with incised designs.

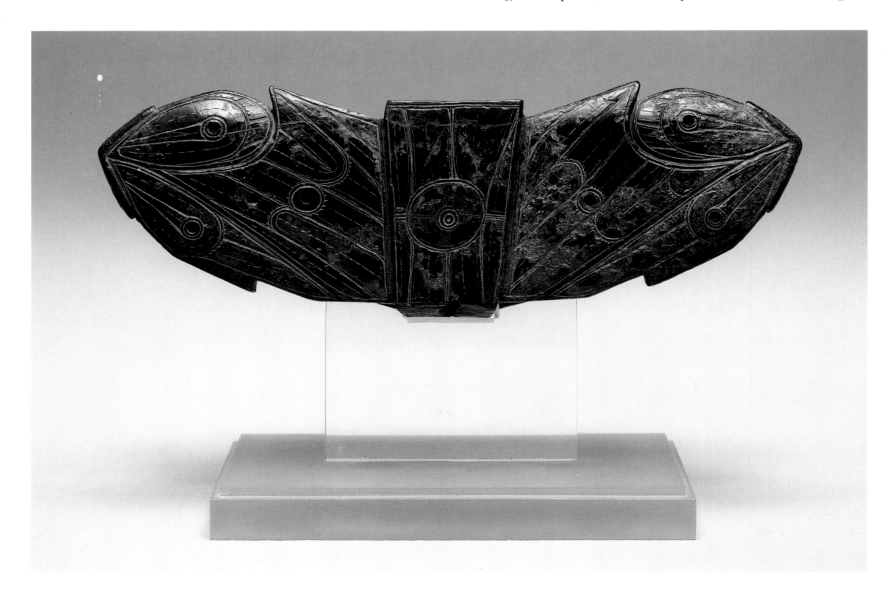

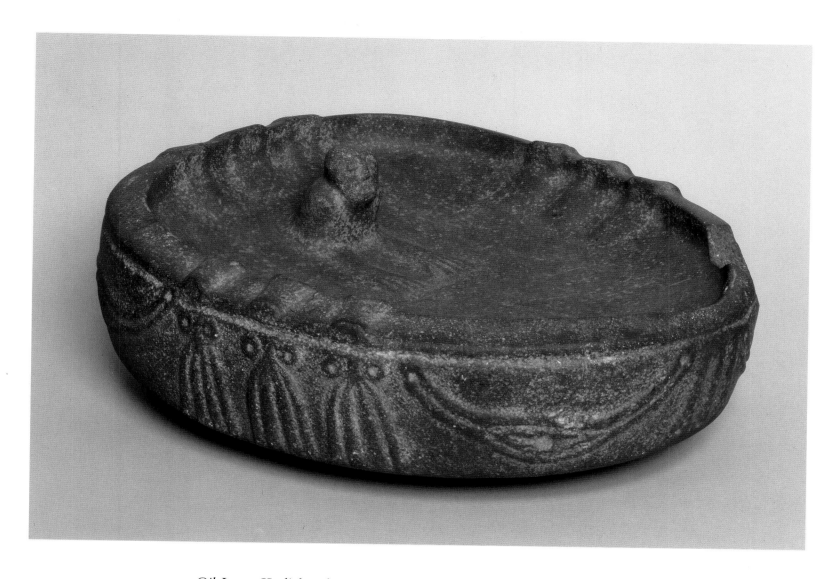

Oil Lamp. Kodiak culture, 500 B.C.–A.D. 500. Cook Inlet, southern Alaska. Stone. Length: 16½ in. National Museum of the American Indian, Smithsonian Institution, New York.

This massive stone lamp shaped like a shallow bowl burned oil with wicks rendered from sea mammal blubber, providing warmth and light. The torso of a human figure seems to rise up from the bottom of the bowl as if partially submerged, his hands resting on the bottom. When his hands emerge from the oil inside the lamp, it is time to add more fuel. Pecked stone lamps with imaginative carvings are a distinctive artifact of the Kodiak cultural tradition, which settled in the Kenai Peninsula and Kodiak Island offshore bordering Cook's Inlet, south of present-day Anchorage.

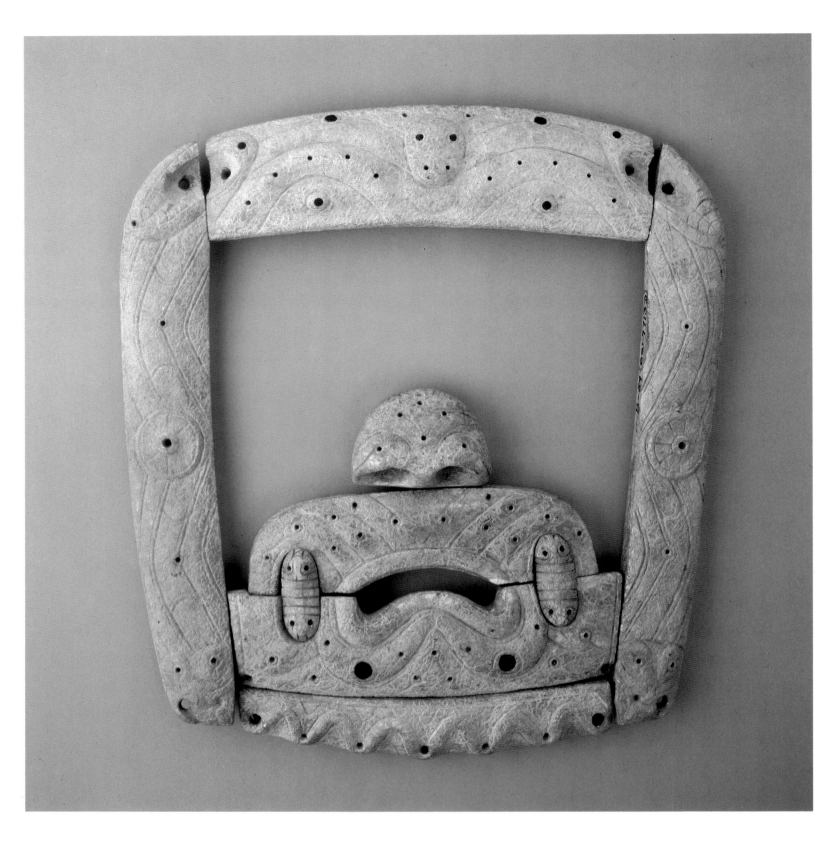

Burial Mask. Ipiutak culture, A.D. 100–600. Point Hope, Alaska. Walrus ivory. Height: 12¼ in. American Museum of Natural History, New York.

This mask was constructed from several pieces of carved walrus ivory lashed together. It was found disassembled, buried with its owner in the Ipiutak cemetery at the Point Hope site. Scientists speculate that it had been worn by the deceased during mortuary ceremonies that took place between the time of death and later burial. The mask framed the face of the dead with the feathery tracings of Ipiutak ivory engraving.

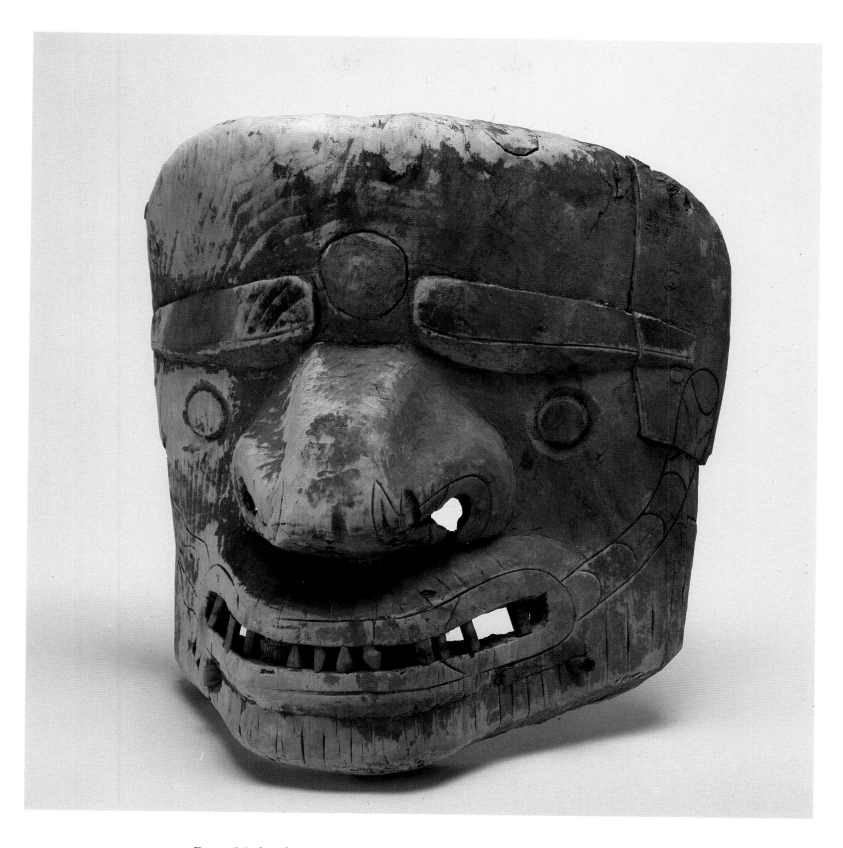

Dance Mask. Aleut. Sixteenth or seventeenth century. Unga Island,
Aleutian Islands. Wood. Height: 9 in. National Museum of Natural
History, Arctic Studies Center, Smithsonian Institution, Washington, D.C.

*This mask was one of several recovered from a burial cave on Unga Island, of
the Aleutian chain. Masks like this were made only by the early Aleut; their
function and meaning remains a mystery. They may have been the possessions
of a powerful shaman, like those of the Alaskan mainland, who represented
their spirit powers with the help of masks.*

TOP LEFT: *Bucket Handle.* Punuk. A.D. 500–1200. Bering Strait region, Alaska. Walrus ivory. Length: 10⅛ in.; height: 1 in. The Thaw Collection, Fenimore House Museum, Cooperstown, New York.

Three whales are carved along the length of this Punuk era bucket or bag handle. The carver reveals an intimate knowledge of the bulk and form of a whale's body. It is possible that these kinds of buckets with carved handles may have functioned as whaling gear on board an umiak, *an open skin boat used for hunting whales.*

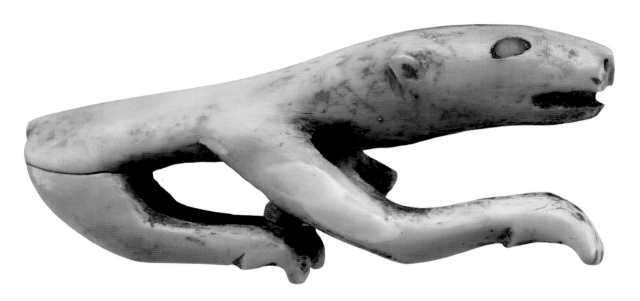

BOTTOM LEFT: *Polar Bear Toggle.* Eskimo. Nineteenth century. Northeastern Alaska. Walrus ivory, glass beads. Length: 3⅜ in. The Detroit Institute of Arts.

The polar bear is the most powerful carnivore of the Arctic region and is much admired and respected by Eskimo hunters. This carving emphasizes the deadly reach and quickness of the bear's forelimbs as it claims its prey. The eyes were created with Russian blue trade beads. A hole drilled through the rear of the carving which divides into two holes beneath the shoulders identifies this object as some kind of toggle.

OPPOSITE TOP: *Snow Goggles.* Punuk. A.D. 600–1100. St. Lawrence Island, Bering Strait. Walrus ivory. Length: 4¾ in. Private collection.

Snow goggles protected the eyes from the glare of open water or pack ice. Without them one risked painful snow blindness. Typically, Eskimo often transformed necessity into art, as is the case with these elegantly engraved snow goggles. The Punuk engraving style is far simpler and more angular than the preceding Old Bering Sea styles. The engraved channels are wider and deeper, revealing the use of iron tools that were imported from Asia.

OPPOSITE BOTTOM: *Caribou Spirit Carving.* Eskimo. Nineteenth century. Bristol Bay, Alaska. Wood, sinew cord, human (?) hair. Length: 26 in. National Museum of Natural History, Arctic Studies Center, Smithsonian Institution, Washington, D.C.

This carving was intended to represent the inua, *or spirit soul, of caribou, rather than any specific caribou. To convey this idea the carver visualized a humanlike face, painted a glowing red, on the rudimentary caribou's body. This carving probably hung from the ceiling of the* qasgiq, *or ceremonial house, during the "bladder festival," along with the caribou and seal bladders, strips of caribou skin, and carvings of other game animals. The "bladder festival" was the occasion when hunters honored the* inua *of all game animals killed that year and asked them to return to give their bodies to human beings again.*

OVERLEAF: *Shaman's Drum.* 1881. Nelson Island, Lower Kuskokwim River, Alaska. Presumably collected by the Reverend Sheldon Jackson. Wood, walrus stomach. Diameter: 19½ in.; length: 15 in. The Sheldon Jackson Museum, Sitka, Alaska.

Accompanied by drums like this one, the people would dance and sing in the qasgiq, *a ceremonial structure in which the animals slain during the year were honored during the annual "bladder festival."*

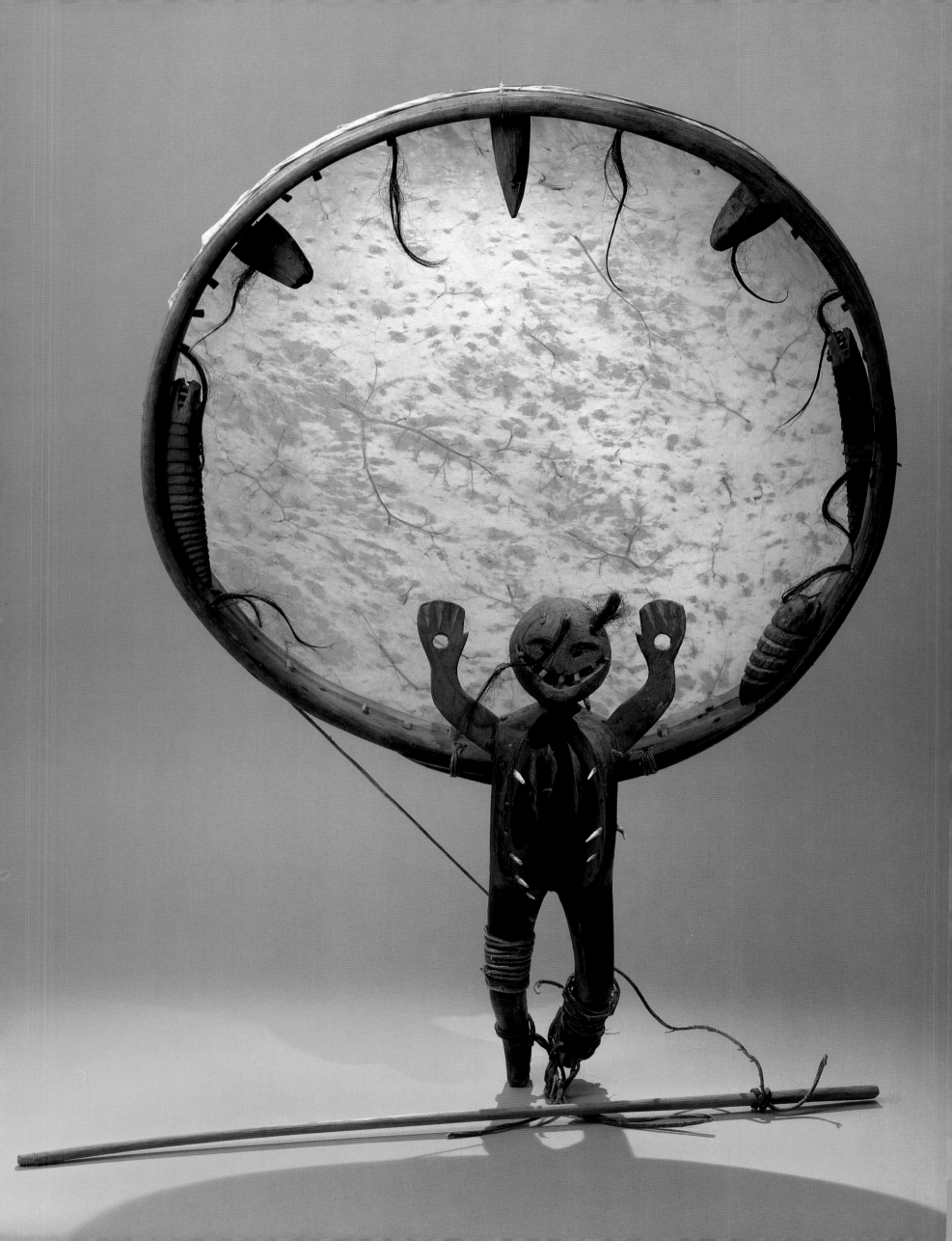

HAPPY JACK

The famous Eskimo carver named Angokwazhuk, but better known as "Happy Jack," was born around 1870 in a village called Ayasayuk located on the coast near Cape Nome. He grew up schooled in the ways of an Arctic hunter, but he suffered a tragic mishap at a young age. He and a companion had become stranded on the ice in sub-zero temperature. His companion perished and Angokwazhuk's feet were frozen by the time he found his way back, so that large portions of them required amputation. Thereafter he always walked with a limp.

During his convalescence he began to carve walrus ivory and it was not long before it became clear that he was a great talent. In 1892, the first officer of a whaling vessel convinced him to sign on board as a cabin boy so that he could produce ivory carvings for sale. It was probably here that Angokwazhuk learned the techniques of ivory engraving from the whalers who made scrimshaw. He used watchmaker's tools with a magnifying glass attached to his thumb. Graphite rubbed into the engraved design darkened it permanently.

After spending a winter on the whaler, Angokwazhuk moved to Nome to pursue a livelihood making art from ivory. Here he took the name "Happy Jack," and by employing European-American pictorial conventions in his images, he moved the engraving tradition in a new direction.

Eventually Happy Jack became the most famous of Nome's carvers, and he was responsible for teaching many younger Eskimo artists. He combined the commercial engraver's technique and style with images drawn from Eskimo life, such as village scenes, walrus hunts, and animal scenes. This Jewish New Year's greeting engraved on ivory with the word "Nome" was most likely a special commission. It demonstrates the cosmopolitan character of the Nome community on the one hand, and the great flexibility of Happy Jack's art on the other.

Happy Jack
Glenbow Archives, Calgary, Alberta.

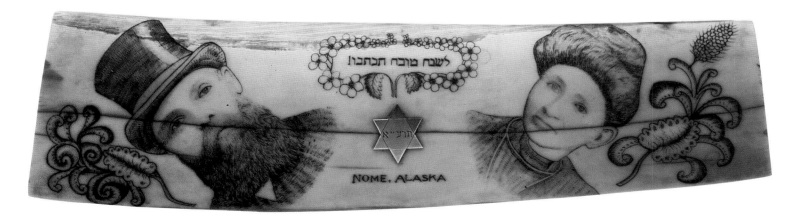

HAPPY JACK (Eskimo). *Jewish New Year's Greeting.*
1910. Nome, Alaska. Engraved walrus tusk with gold inset. 10 x 1 in.
The Jewish Museum, New York.
Gift of the Kanofsky Family in memory of Minnie Kanofsky.

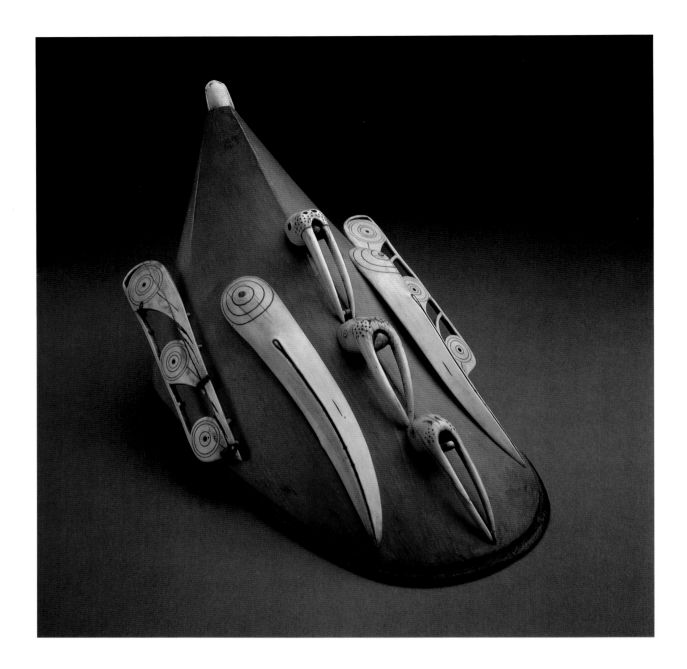

ABOVE: *Hunting Hat.* Eskimo (Yupik). Late nineteenth century. Norton Sound, Alaska. Wood, walrus ivory, leather. Canadian Museum of Civilization, Ottawa.

The hunting hat was at once a visor necessary for coping with the glare when hunting from a kayak on the open ocean and a symbolic expression of great hunting prowess. The ivory carvings attached to the hat convey the birdlike attributes of the successful hunter, who is able to seek out and capture its prey. The walrus head and seal carved in ivory represent the hunter's quarry. Only accomplished Eskimo hunters wore such impressive headgear.

OPPOSITE: *Gutskin Cape.* Aleut. Early nineteenth century. Aleutian Islands, Bering Strait. Gutskin, painted skin, hair, sinew, feathers, yarn. Length: 60¼ in. National Museum of Natural History, Arctic Studies Center, Smithsonian Institution, Washington, D.C.

This rainproof outer garment is tailored from the prepared intestine of a sea lion. Tufts of red and green wool and human hair decorate the seams. Appliqué patterns of painted hide edged with black cormorant feathers and white caribou hair were used for the elegant borders along the lower hem, the side edges, the shoulder cap, and the collar. This garment was collected during the famous United States Exploring Expedition of the Pacific led by Charles Wilkes in 1840.

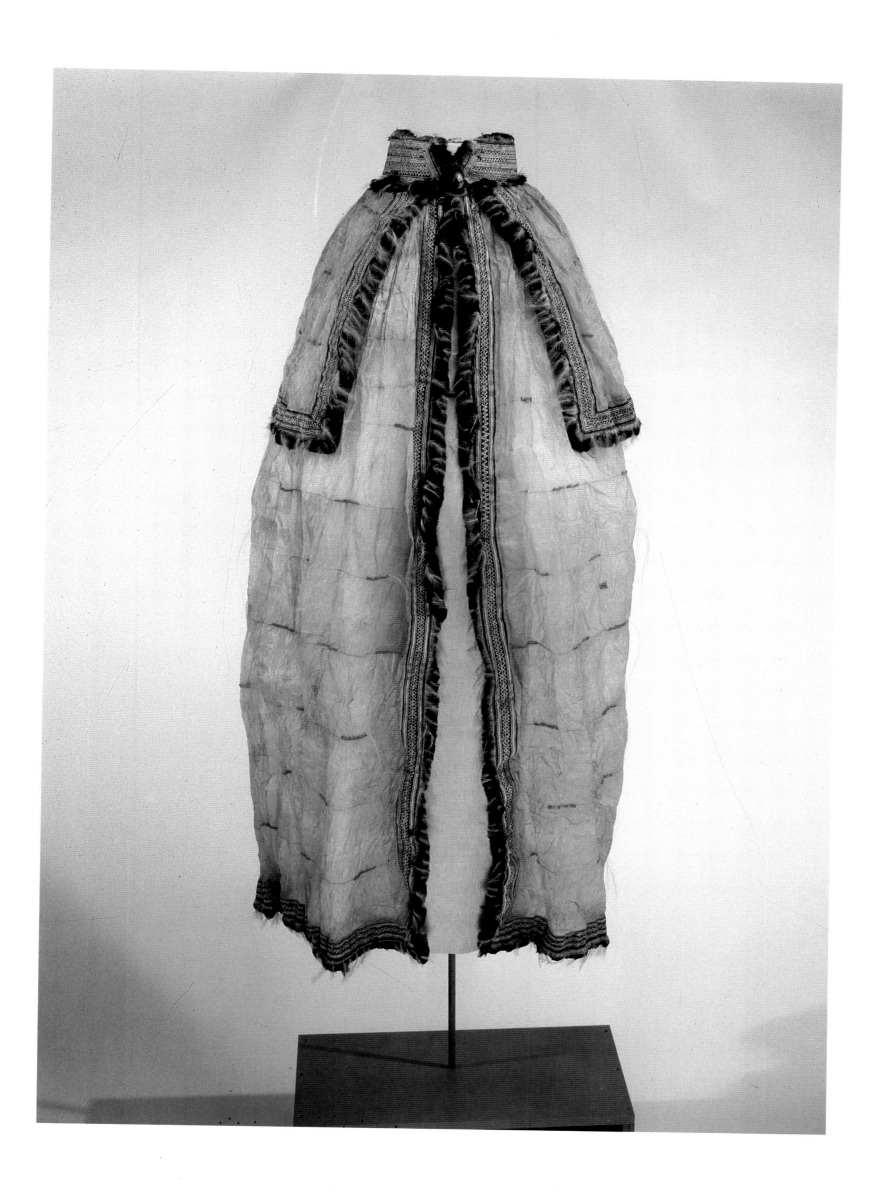

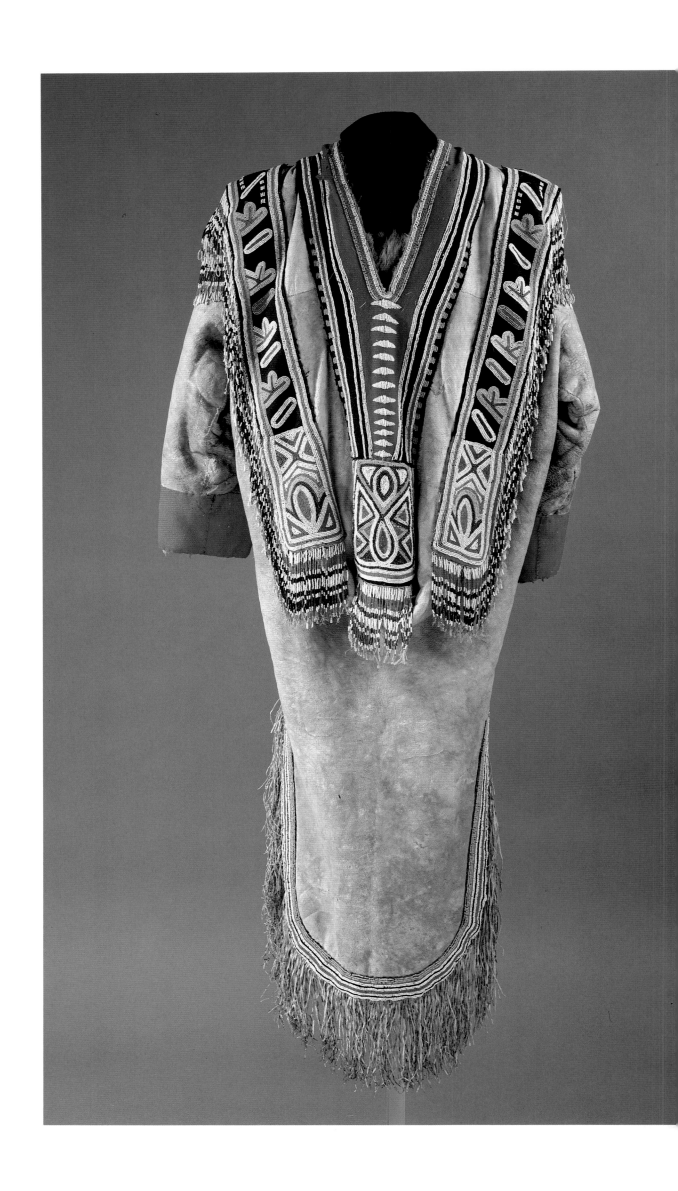

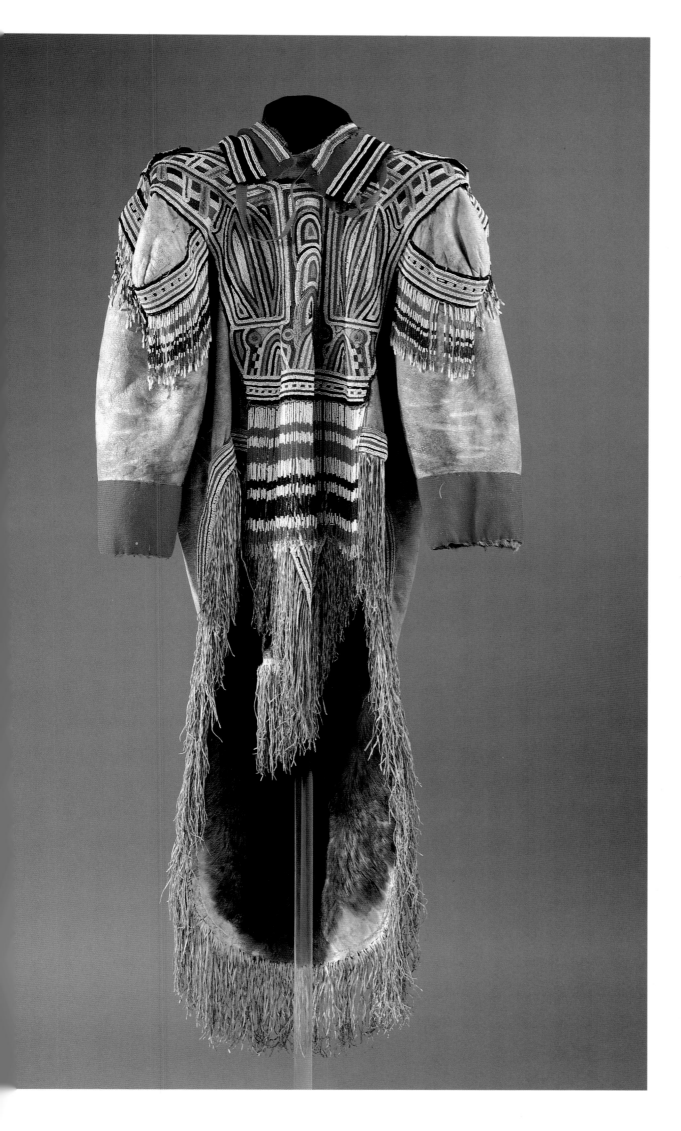

OPPOSITE AND LEFT: *Woman's Parka.*
Caribou Inuit (Padlimuit). 1938.
Eskimo Point, Hudson's Bay,
Northwest Territories, Canada.
Caribou fur, wool cloth, glass beads,
caribou hide, caribou teeth. Length:
48 in. Royal Ontario Museum,
Toronto.

*The Padlimuit Inuit lived on the west
shore of Hudson's Bay with good access to
the Hudson's Bay Company trading post.
The plethora of glass beads used to decorate
this woman's parka testifies to the close
relationship the Padlimuit enjoyed with
traders early in the twentieth century. As in
other parts of North America, years earlier,
the availability of trade goods permitted
unprecedented innovation and creativity in
the area of the visual arts.*

THE TWENTIETH CENTURY

"WHO'S GONNA RIDE YOUR WILD HORSES?"

"Who's gonna ride your wild horses?
Who's gonna drown in your blue sea?"

To consider the progression of Native American art in the twentieth century is to trace the evolution of tradition and change in art within the Native American culture: from decoration; to a visual language with symbols of Plains warrior society; to research data for anthropologists; to traditional American Indian painting and the arts and crafts of the Southwest; to modern painting; to post-modernism; to contemporary Native American photography, performance, and installation; and finally to be able to see art as a substantive expression of the Native American artist's own power. Perhaps questions surrounding the issue of What is American Indian art? can be answered by facing its history and examining its evolution—questions like What makes American Indian art "authentic"? Who represents Native Americans—the traditionalist or the modernist? How do Native American artists deal with the possibilities of exploring their unique history and tradition? How do these artists incorporate the forceful changes brought on by reservation life as well as express their own personal histories and individual feelings?

Prior to 1900 Native American artworks were classified as "artifacts," objects and images that reflected the many cultural characteristics of the hundreds of various tribes throughout the U.S., Canada, and the Arctic. In fact, within the Native American culture there is evidence that no word existed for "art" or "artist," with the exception, perhaps, of those within the Northwest Coast tribes who were sought out as expert carvers of totem poles and other objects; they were recognized as "artisans."

Among the Plains Indians there existed a rich artistic tradition in the form of a visual or symbolic language relating to the warrior society. This visual language was created through both color and symbols. War shirts, leggings, and shields were painted, beaded, and took on an added spiritual dimension which became an individual's statement of his power and protection as well as an informative record to be read in battle by his opponent.

The year 1900 marked the end of the Indian wars, the last days before the greatest change that was to affect all aspects of Native American life—the beginnings of reservation life and the accompanying U.S. government policies of acculturation and assimilation. In 1875, the U.S. Army forced tribal leaders in the Oklahoma area to

OPPOSITE:
Fritz Scholder (Luiseño, German and French).
Red # 8. 1994. Acrylic on canvas. 80 x 68 in. Collection of the artist.

By the early 1970s, Scholder was known as the founding father of modern Indian painting, and continued as a prolific painter and excellent colorist into the 1980s. After a thirteen-year hiatus, he has returned to the Native American image.

select seventy warriors to trek to Fort Marion in St. Augustine, Florida. Among these young warriors who had just begun to acquire their reputations and who had been raised to believe that they would find honor in battle and in long life, it was reported that perhaps two who found this humiliation too burdensome committed suicide. The Fort Marion prisoners—most of them Cheyenne, Arapaho, Kaddo, and Kiowa—were incarcerated for three years.

To help the prisoners adjust to confinement, an officer at the fort, Richard H. Pratt, gave them paper and colored pencils. Ledger drawings were not unfamiliar to these men; ledger books had been used as visual records of warriors and their deeds. These ledger drawings created a kind of focus that allowed the warriors to relive their past lives, and became a meaningful step in helping the Indians make the transition from a free, nomadic life to a sedentary reservation experience.

When the Fort Marion prisoners were released in 1887, most of them returned to Anadarko, Oklahoma, to live out their lives, and this city subsequently became an important center for Native American art. In 1880, two Indians named Silver Horn and Carl Sweezy were influenced by the Fort Marion artists and began to make drawings and paintings. This creation of art on paper was the beginning of Native American art as we know it today in the Oklahoma area.

In 1914, in Anadarko, Father Isadore Richlin and Sister Olivia Taylor, teachers at St. Patrick's Indian School, a boarding school for children from the ages of four to eighteen, encouraged the students to do art. In 1916 Susan Peters, a field matron for the Kiowa Agency, arrived at the school and by 1918 she was teaching art classes to a group known as the Kiowa Five artists. These five young artists were Monroe Tsatoke, Stephen Mopope, Spencer Asah, James Auchiah, and Jack Hokeah. These artists were influenced by Silver Horn and Carl Sweezy, and by the Fort Marion prisoners, to whom some were related.

The Kiowa Five style of painting represented stylized, self-taught art, with a flat, two-dimensional design, and without shading or a sense of volume. The subjects of the paintings, however, were often exciting—singers, dancers, and powwows. As the students at St. Patrick's graduated, they were given special scholarships to the University of Oklahoma in 1926. In 1928 an exhibit of their work traveled to Prague, Czechoslovakia, and throughout Europe, marking the first ever international showing of Native American art.

At about the same time, a second center of Native American art had been developing in the Southwest. In the Santa Fe area in 1849, in a kiva in Jemez Pueblo, U.S. army surveyors had accidentally discovered a ceremonial kiva and copied a mural painting that was inside. This discovery piqued the interest of anthropologists doing research on the cultures of the area. The scientists needed "informants" to draw pictures to validate ceremonial clothing styles. Thus, by 1890, and continuing later, Hopi men were being commissioned to draw Kachinas, or gods. In this first instance in which indigenous people were asked to produce art—clothing and drawings of dances, for example—their work was not looked at as "art" but simply as research data. Among this first group of self-taught artists were Alfredo Montoya, Crescencio Martinez, and Awa Tsireh (also known as Alfonso Roybal), all of the San Ildefonso

Pueblo. Their artwork most often showed very crude, single, floating figures—perhaps as many as four of them—in ceremonies.

What happened to this first group, however, was that the tribe believed that the artists were giving away secrets and ostracized them. Because they had lost their place in the community, they moved away to the city, thus creating a new Indian art colony in Santa Fe between 1910 and 1920.

The most important school of anthropology was the School for American Research, also located in Santa Fe, strengthening that city's influence as an art center. Ties to this research organization led to the later formation of a second group of self-taught Native American artists. Perhaps the most important difference between this second group and the first was that this group consciously chose to be artists rather than simply to respond to the commissions of scientists. The members of the second group were more Americanized, and the artists began to do more realistic drawings and paintings, some involving as many as twenty to thirty figures in ceremony or ritual dances.

Some of the most important artists of this group were Fred Kabotie and Otis Polelonema (Hopi), Velino Shije Herrera (Zia Pueblo), and Julian Martinez (San Ildefonso Pueblo). Otis Polelonema began to deal with his Hopi culture and rituals. Fred Kabotie was most refined in more detailed, realistic drawings and paintings. Velino Herrera's work with the circle and semicircle created a sense of depth within his paintings. Because of their more intense involvement with ceremony and ritual, some of this second group were also ostracized by the tribe, with the exception of another artist, Julio Martinez, who worked more with plants and animal figures. One common element among this group, however, was the idea that they were working for a living as individual artists rather than for the tribe as a whole.

In the 1920s one person, Dorothy Dunn, would emerge as the most important force for change in the world of Native American art. After an initial period of teaching in Santa Fe, Dunn returned to and studied at The Art Institute of Chicago for her art degree, which she received in 1928. In 1930 she returned to Santa Fe, and in 1932 created The Studio and a new style of painting, the first to recognize and define traditional Indian painting.

Dorothy Dunn and her Studio were enormously influential in the widespread dissemination of Native American artistic ideas and concepts. In 1930 Susan Peters arranged for a trip for the Kiowa Five to be exhibited at intertribal ceremonials in Gallup, New Mexico. Jack Hokeah, accepted as an adoptive grandson of San Ildefonso potter Maria Martinez, stayed in the Southwest, took classes from Dorothy Dunn's Studio, and eventually brought The Studio technique back to Oklahoma. Style and techniques in traditional Indian painting were therefore firmly established in both of the major, separate Indian art centers—the Pueblo artists of the Southwest and the artists of the Plains groups in Oklahoma.

One of Dorothy Dunn's most striking accomplishments was that she achieved a policy reversal that the government was also trying to achieve. Prior to the establishment of The Studio, it had been recognized as official policy that the Indians were prohibited from depicting their native culture in painting. In 1932 Commissioner of

Indian Affairs John Collier lifted the ban, and in 1934 the Indian Reorganization Act made that policy official.

Dorothy Dunn had four basic goals:

1. to foster appreciation of Indian painting among students and the public, to establish it as one of the fine arts of the world;
2. to produce new paintings in keeping with high standards already attained by Indian painters;
3. to study traditional Indian art to evolve new motifs, styles, and techniques in character with the old; and
4. to maintain tribal and individual distinctions.

Within a five-year period, from 1932 to 1937, four Navajo artists—Harrison Begay, Gerald Nailor, Quincy Tahoma, and Andrew Tsinajinnie—created the largest body of work at The Studio. What was truly exciting was the new focus on landscape. This art might appear somewhat illustrative from today's perspective, but at the time it was well received. Even more striking is that Dunn created this revolution with high school students in such a short period of time. In fact, it was to protect these young people from the ostracism that had been suffered by previous Native American artists that she led them to paint landscapes rather than scenes depicting ceremony or ritual. What she did achieve above all else was to create a new, technically sophisticated style, and to instill in the young artists an awe-inspiring level of professionalism. After 1937 she left, creating a period of stagnation or little growth; the artists seemed unable to take their next step.

One Native American artist did try unsuccessfully to break this stranglehold of stylistic stagnation. Oscar Howe was a Lakota Sioux who had left The Studio to create his own style of painting, which was labeled neocubism. In South Dakota in 1946, however, when the Philbrook Museum of Art in Tulsa, Oklahoma, created the first juried show, Howe's work was rejected simply because it was said to be too individualistic, too far from the traditional style created by Dunn, which had become an overriding standard for all forms of native art.

In 1962, as a federal program of the Bureau of Indian Affairs and its art director, Lloyd Kiva New, the Institute of American Indian Art (IAIA) was founded in Santa Fe. Following the model of Dunn's Studio, the institute focused on the education of high school students. Unlike most previous examples of Indian art, which had taken the form of drawing on paper or with watercolors or poster paints, for the first time Indian art used paint on canvas; sculpture, printmaking, and jewelry making also began. Moreover, the institute's Native American students came not only from the Southwest but from across the United States and Alaska. This was truly the start of a new era, during which IAIA students were mandated to create new art forms.

Into this atmosphere in the Southwest in 1964 came Fritz Scholder, who became a faculty member at the IAIA. He was influenced by the dilemmas of his students, who were dealing, like other young people in the 1960s, with all the critical issues of social unrest as well as considering the concepts of the modern art of the '60s. Scholder watched his students struggle to express their cultural identity as well as master the new

artistic techniques available to them. By closely observing his students' efforts, Scholder himself was encouraged to paint the Indian, and soon his career was off and running.

Fritz Scholder became the founder of modern Indian art. From the mid-1960s to the 1980s, he was probably the most sought after, the most renowned Native American artist. Two other Indian artists at the time, T. C. Cannon, a student of Scholder's whose art was quite radical, and R. C. Gorman, whose 1980s paintings were of Indian women, were also commercially successful.

As for influences in Native American art outside the Southwest, two major forces that began in the mid-1970s continue to the present. One force has been the art schools, and the other has been university systems that encourage and train art students. In addition, in the 1970s in New York City, Lloyd E. Oxendine created the American Art Gallery, the first gallery devoted exclusively to contemporary Indian artists. Native American artists were also the exclusive focus of the July/August 1972 issue of *Art in America*. It was said then that for the first time a generation of articulate and well-educated Indian artists had a positive identity to which to relate. This new solidarity also focused on Native American art in a whole new way. In 1973 a second museum space for contemporary Indian art was created with the founding of the Carl N. Gorman Museum at the University of California at Davis, a facility that was connected to the Native American Studies program. Despite limited funding over the past twenty years, this museum has remained a respected professional center of interest for much that has happened in the world of Native American art.

Two major Native American artists first recognized in the 1970s have also advanced the prominence of Native American art as a whole. These artists are Jaune Quick-to-See Smith and Edgar Heap of Birds. In her own works, moving from pastels to canvas in a kind of sophisticated pictograph to special commissions, Smith has always wanted her art to be accessible to the art world and the Indian community. In her recent series of paintings called *I See Red*, Smith began to look at the history and issues that have so strongly impacted the lives of Native Americans. Smith formed a loose-knit group of students called Grey Canyon in 1973, offering artistic and social support to young artists. Above all, Smith has been an influential advocate for Indian artists, helping them to get started and arranging for them to be included in exhibits. In 1984, it was Smith who was instrumental in laying the groundwork for the Indian Biennial through The Heard Museum in Phoenix, Arizona.

Edgar Heap of Birds is also among those native artists since World War II who have examined what it truly means to be a Native American artist. Acting largely as an individual, Heap of Birds began as a painter, but abandoned painting to incorporate more and more native and American language into his works. Labeled a deconstructionist, Heap of Birds has focused on how words are both influential and intimidating, especially in terms of issues related to Native American history. In his piece *Telling Many Magpies*, for example, Heap of Birds used language to illustrate the ongoing conflict between the origins of Native American philosophy and the perceptions of those concepts by non-Native Americans. He hoped to encourage non-natives to recognize that native words, images, and objects are grounded in deeply held cultural values and traditions, and must not be considered merely as token reminders of a distant past.

Edgar Heap of Birds
(Cheyenne Arapaho).
Telling Many Magpies.

Heap of Birds uses words to convey the struggle between Native American cultural tradition and the careless ways non-natives view these deeply held concepts. Words become images that call attention to this continuing problem.

Both Jaune Quick-to-See Smith and Edgar Heap of Birds were Native American artists working to be fully accepted into the fine arts world. In this regard, the period from the mid-1970s to the present has been one of transitions. At the beginning, Indian artists were considered "minority" artists; in the 1980s, they were reclassified as

 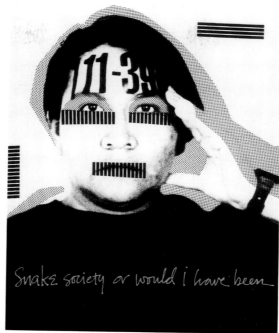 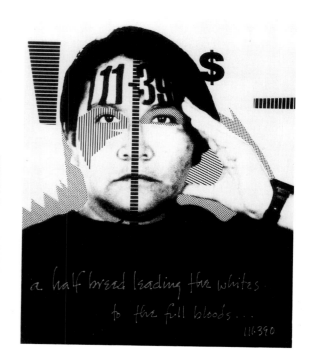

Would I have been a member of the Nighthawk,

Snake society or would i have been

a half breed leading the whites to the full bloods...

116390

"ethnic" artists. Both terms nevertheless marked Native Americans as separate and isolated from the mainstream art world. The 1990s trend towards "multiculturalism," however, has been somewhat less demeaning and more inclusive. The Decade Show in 1990, for example, exhibited by three institution galleries in New York City—the Museum of Contemporary Hispanic Art, the New Museum of Contemporary Art, and the Studio Museum in Harlem—was the first important show that addressed the issue of multiculturalism by exhibiting a tremendous amount of art by artists of all cultures. Lucy Lippard's book *Mixed Blessing* (1992) examines the same issues of multiculturalism and its effects upon the fine art work of New York.

Just at the point of the Decade Show, a time when many Native American artists seemed on the threshold of being accepted into the fine arts mainstream under the term *modern* artists, a new movement was created labeled post-modernism, which dealt with issues of political and social commentary and focused on such artists as Brazilian-born Sabastiao Salgados and Chilian artist Alfredo Barr. This jump to post-modernism left many native artists out of the mainstream. The artists Edgar Heap of Birds, Jaune Quick-to-See-Smith, and James Luna seem to have successfully made the transition, with others ready to take center stage.

James Luna's career as a sought-after performance and installation artist as well as a photographer is probably at its highest point. He uses poignant and powerful images in his art to confront the issues of how natives and others perceive Native Americans. In his piece *Four Sacred Colors*, he presents a white female, a Chinese female, an African-American male, and Luna himself; these four figures represent the four basic sacred colors and the four races of the world.

Many Native American artists are dealing with social issues in order to redefine themselves, to make a younger generation aware of the lies in the world, and to heighten the focus on these issues in order for others to work to correct the injustices.

In the early 1990s, a central event in the United States was the Quincentennial. For many, this was a period of celebration of the five hundred years of non-Indian achieve-

Hulleah J. Tsinhnahjinnie (Seminole, Creek, Navajo). *Would I Have Been a Member of the Night Hawk Snake Society or Would I Have Been a Half Breed Leading the Whites to the Full Bloods.* Photograph. 40 x 90 in.

ments since Columbus. In 1992 many events and exhibits connected with the Quincentennial involved native artists who made the public and the art world aware that, for them, the event was not one of celebration. This was one time at least when people heard the voices of Native Americans loudly and clearly. Thus, the Quincentennial has really brought into focus for the art world the historical and political struggles of Native Americans, as well as the issues of violence and discrimination and identity that are confronting the United States and the world at large today.

Native American artists have been focusing in several areas. The most prevalent forms of Native American art currently are installation performance and photography, through which Native Americans are dealing with their own personal concerns, among them the stereotypical image of American Indians who use photography as their tool of expression. Photography, in fact, is now providing the major focus for Native American artists, many of whom are women.

One major issue currently stirring up controversy in the Indian art world is the existence of Public Law 101644, which technically applies only to Indian arts and crafts. To be "authentic," the law states, Native American crafts must be produced by Indians who have documents "proving" that they are Indian because they were recorded as "enrolled" at the time of their birth on a reservation. Without the enrollment documents, Native Americans cannot, legally, sell their arts and crafts as authentic. The penalty fees for breaking this law range up to five million dollars. One watchdog group has been attempting to apply the same criteria to fine arts pieces with even more divisive responses. The major artist addressing this issue is Hulleah Tsinhnahjinnie through her photography.

The art of the Southwest, so often considered traditional Indian art, continues today in the high-quality artistry of the area's craftsmen. The two-day Santa Fe Indian Market, usually held the third week in August, is probably the year's most successful showcase for Native American artisans. In the realm of fine arts, some Native American artists have been able to achieve some measure of recognition through the gallery system. The Native American art that is produced in the Southwest in Santa Fe both in the Indian Market or the gallery scene is done for a certain audience who is more attracted to romantic image than to issues of a political nature.

In conclusion, it should be noted that most Native American artists today function on the basis of cultural information: that is, they know and understand their history and culture, and from that knowledge they derive power. Native American history and art has been a continual process of change and survival.

Respect for that art and its artists is illustrated by George Longfish's print "*Who's Gonna Ride Your Wild Horses?*" Five Sioux Indians represent members of Big Foot's band of 380 old men, women, and children massacred in 1892 at the Battle of Wounded Knee. The Sioux are pictured as they are about to begin the Ghost Dance, which was viewed as a fanatical attempt to reclaim lost lands, but is perhaps better viewed as an attempt to claim the spiritual power of their religion that comes from "owning" one's cultural legacy even in the face of death. Above the Indians is printed "Freedom of Religion," and below them "The Ghost Dance, Wounded Knee."

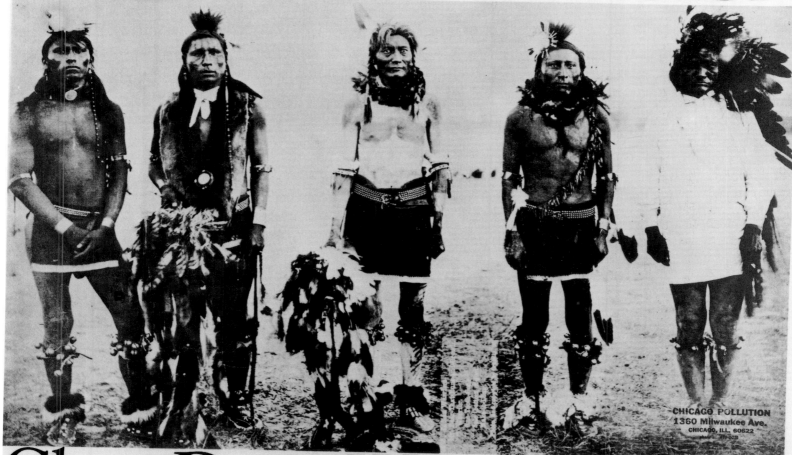

FREEDOM OF RELIGION

Ghost Dance Wounded Knee

These Native Americans were going to ride their wild horses, no matter how great the cost.

Throughout Native American history from 1900 on, it has been the artists—sometimes thought of as troublemakers or radicals, whether their art has been modern or traditional—who have always been willing to ride the wild horses. They all deserve our respect.

GEORGE C. LONGFISH

George Longfish (Iroquois, Seneca, Tuscarora). "*Who's Gonna Ride Your Wild Horses?*" 1994. Working photograph for painting in progress. 10 x 14 ft. Collection of the artist.

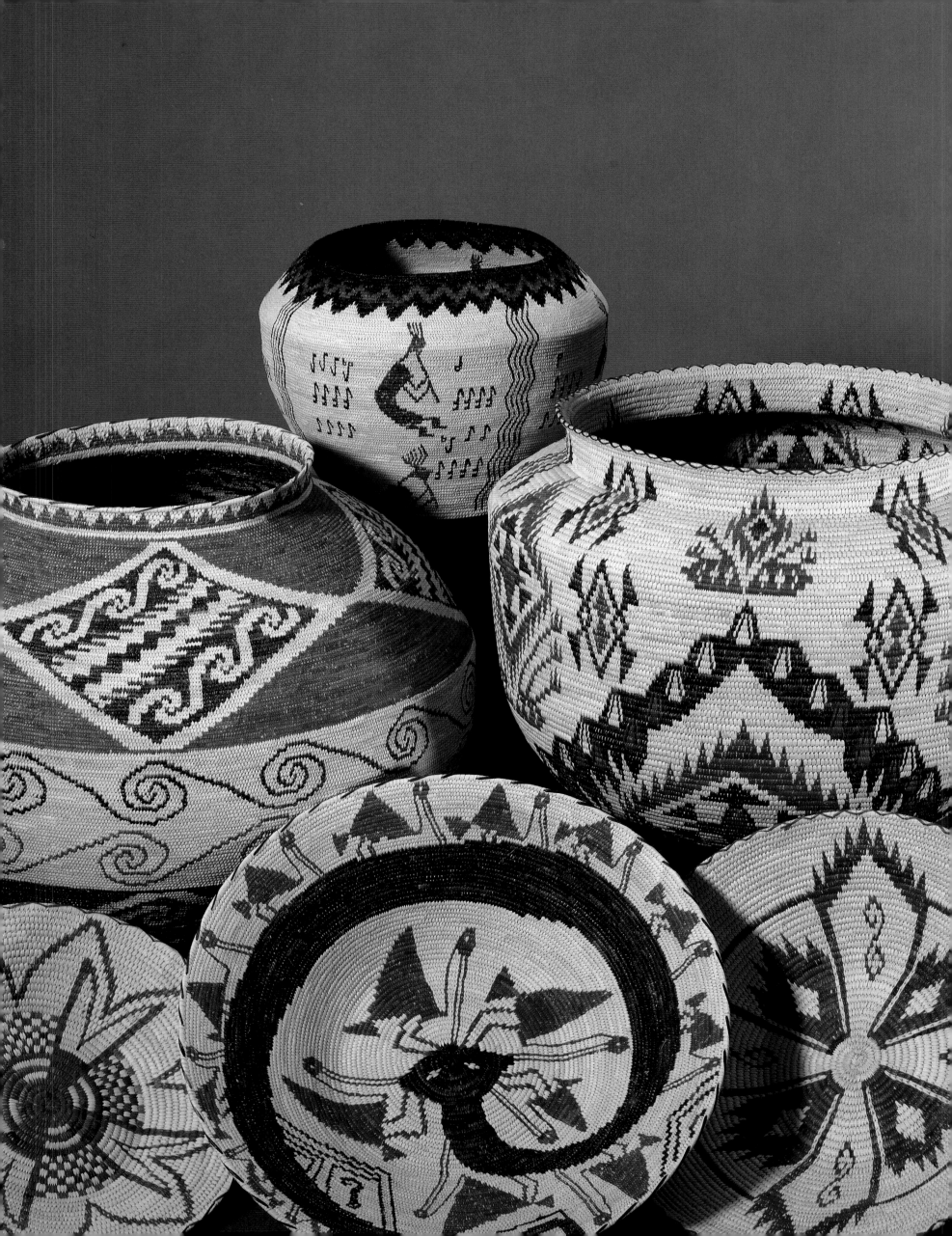

OPPOSITE: *Man's Necklace.* Lakota. 1920s. Otter fur, commercial and native leather, rawhide, quills, brass tacks, ribbon, tin cones, feathers, mirrors. Length: 48 in. The Denver Art Museum.

RIGHT: Eva McAdams (Shosone). *Beaded Moccasins with Traditional Floral Motif.* Private collection.

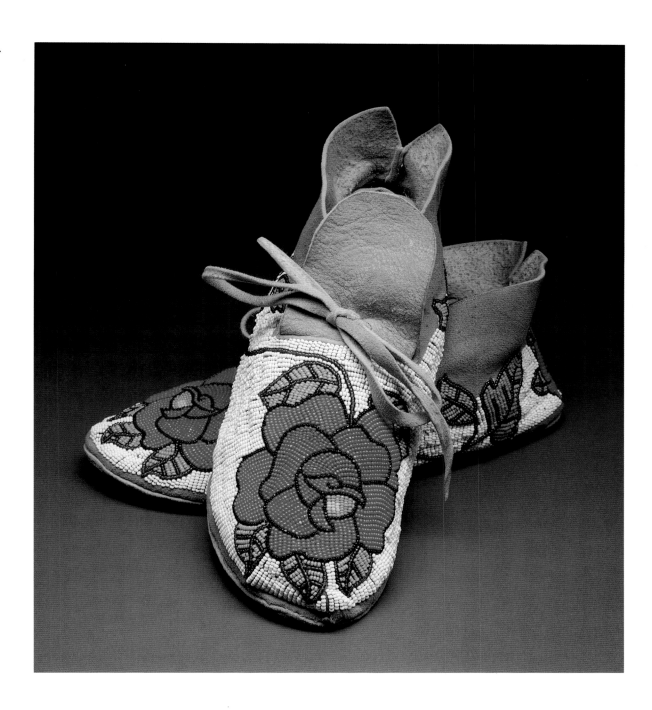

BELOW: Terri Greeves (Kiowa, Comanche). 1992. *Beaded Tennis Shoes with "Jackalope" Design.* Private collection.

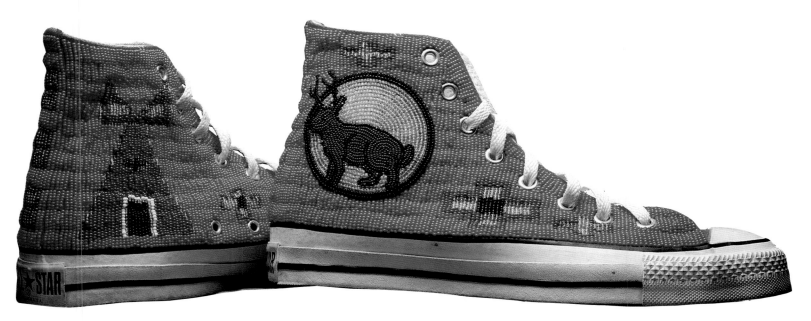

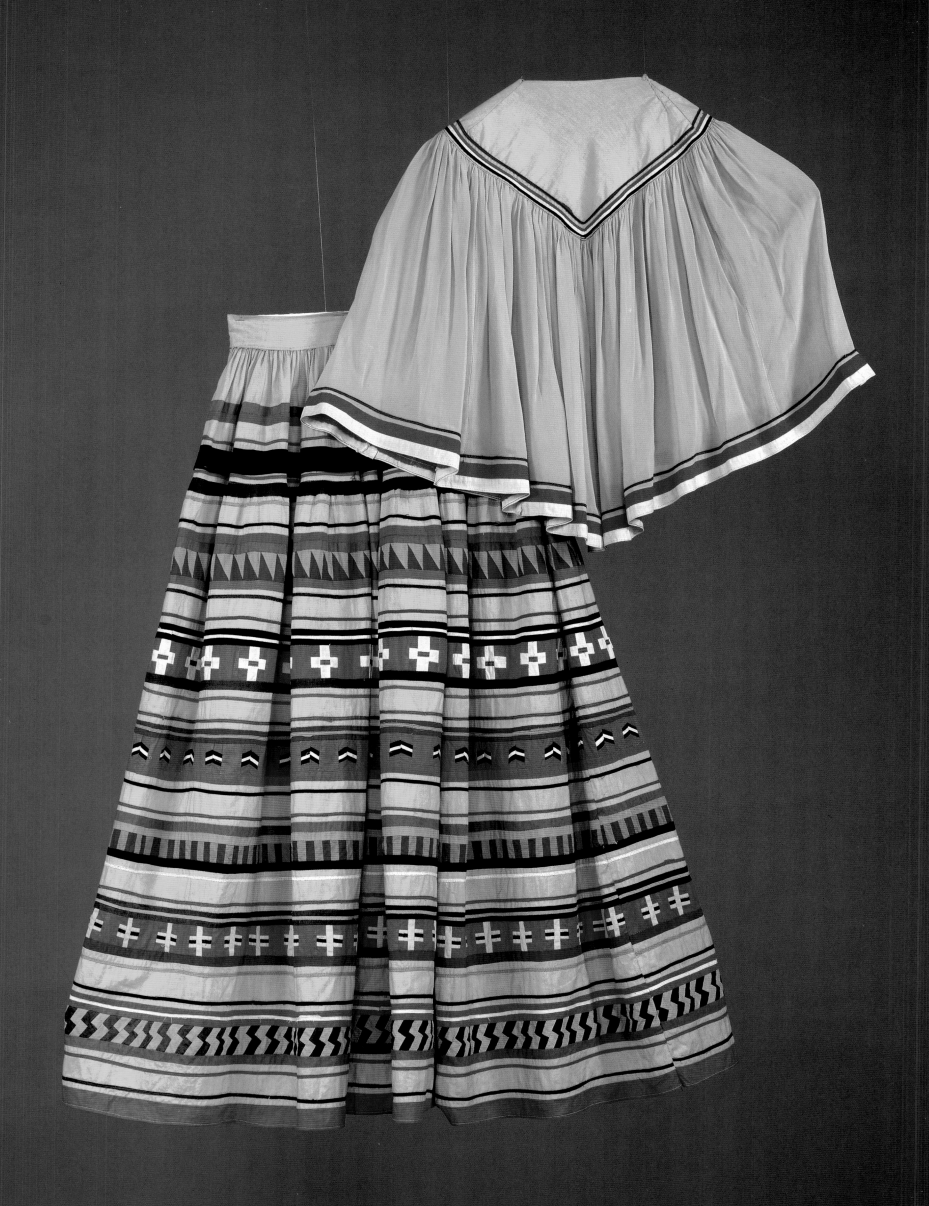

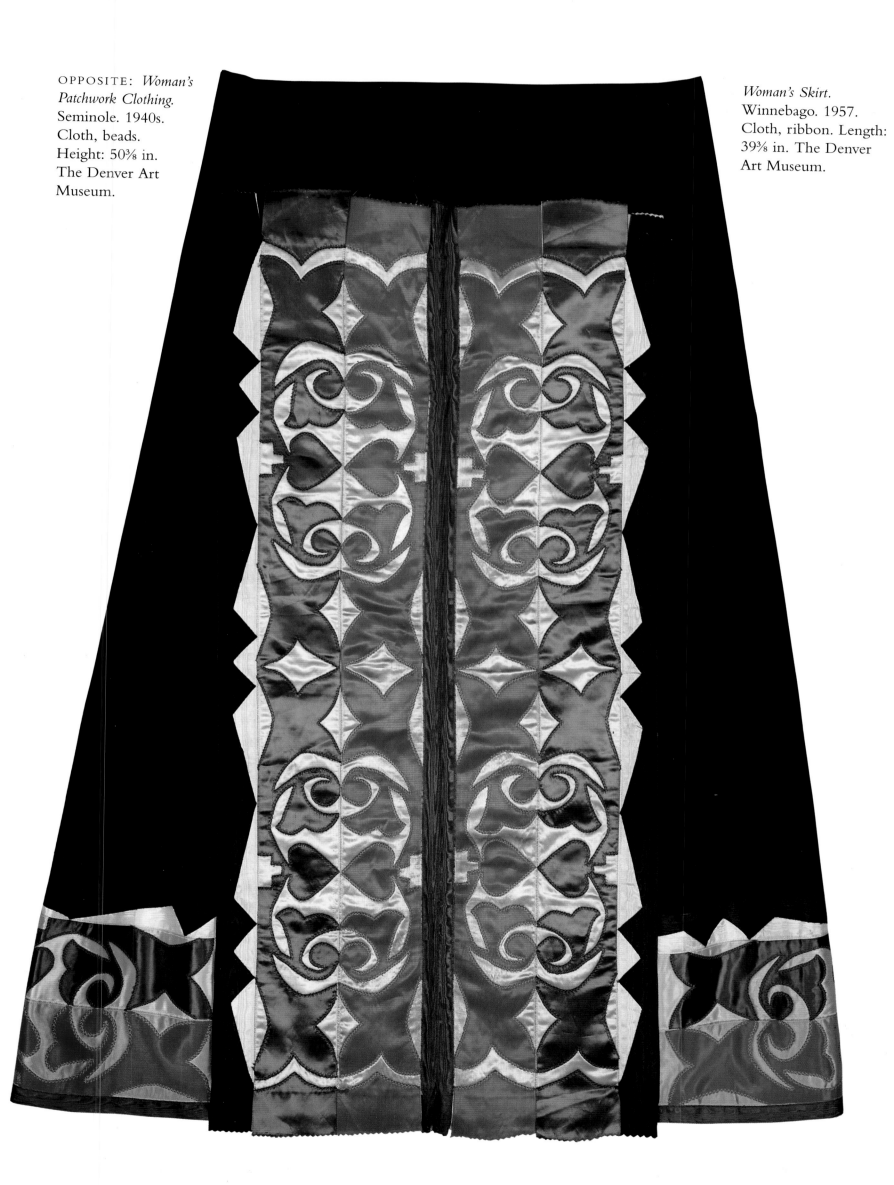

OPPOSITE: *Woman's Patchwork Clothing.* Seminole. 1940s. Cloth, beads. Height: 50⅜ in. The Denver Art Museum.

Woman's Skirt. Winnebago. 1957. Cloth, ribbon. Length: 39⅜ in. The Denver Art Museum.

PRECEDING PAGES:
Asan Yellowhair (New
Mexico). *Bird and
Cornstalk Rug.* 1983. Wool
and commercial dyes.
94 x 131 in. The Denver
Art Museum.

Sadie Curtis (Navajo).
Ganado Rug. 1989.
Cristof's Gallery, Santa Fe,
New Mexico.

Victoria Keoni (Navajo). *Burnt Water Rug
with Yei Figures in Center.* 1985. 36 x 46 in.
The Heard Museum Gift Shop, Phoenix,
Arizona.

ABOVE LEFT: Florence Benedict (Mohawk). *Sweetgrass Ball.* 1985. Black ash splint, sweetgrass. Diameter: 15 in.; height: 18½ in. Collection of the artist.

ABOVE RIGHT: Florence Benedict (Mohawk). *Untitled.* 1985. Black ash splint, sweetgrass. Diameter: 15 in.; height: 18 in. Collection of the artist.

RIGHT: Mary Adams (Mohawk). *Pope's Basket.* 1984. Black ash splint, sweetgrass. Diameter: 16 in.; height: 10½ in. Collection of the artist.

BOTTOM RIGHT: Jake Arquette (Mohawk Iroquois). *Black Ash Splint Basket.* Schoharie Museum of the Iroquois Indian.

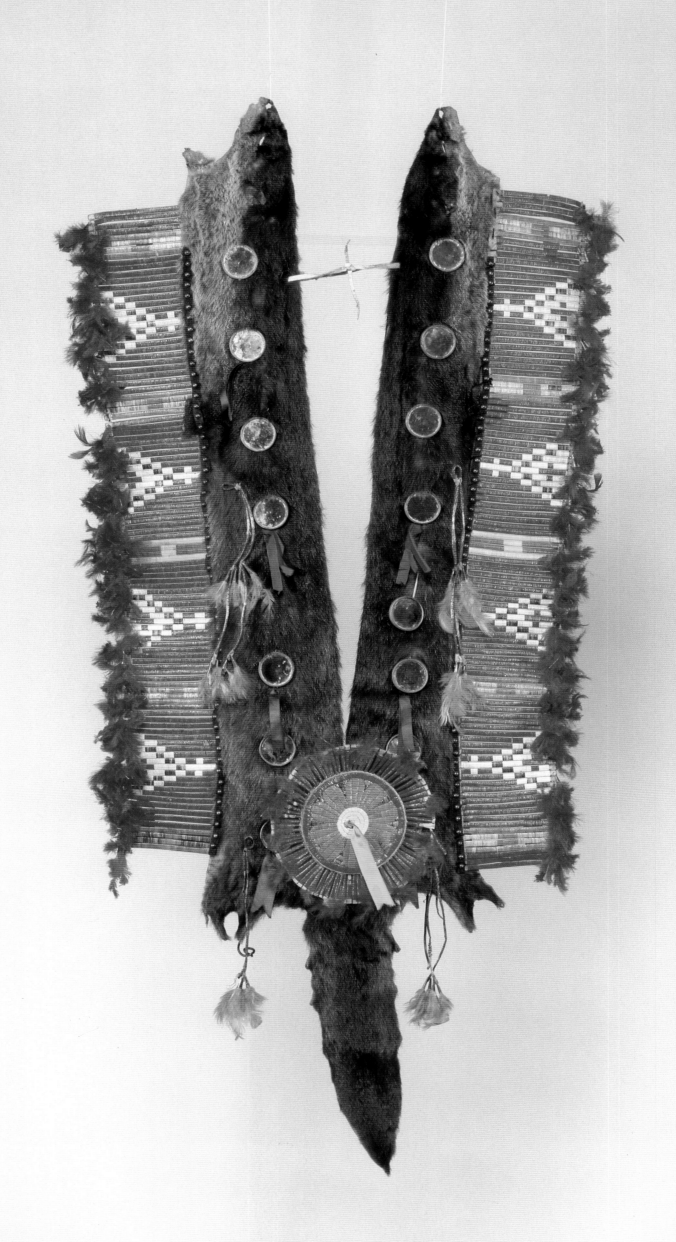

OPPOSITE: Annie Antone (Tohono O'Odham). *Basket Group Incorporating Ancient Hohokam Motifs.* 1992. Heights: 12 to 20 in. Courtesy C&R Traders, Casa Grande, Arizona.

ABOVE: Margaret Tafoya (Santa Clara Pueblo). *Bowl.* c. 1984. Carved and polished earthenware. Height: 7½ in.; diameter: 14 in. Museum of International Folk Art, a unit of the Museum of New Mexico, Santa Fe.

LEFT: Lois Gutierrez de la Cruz (Santa Clara). *Tall Pot with Lady Bugs and Salamander.* 1986. Height: 10 in. Courtesy Gallery 10, Scottsdale, Arizona.

OVERLEAF: Dorothy Torivio (Acoma Pueblo). *Pottery Group.* Heights: 1½ to 8¾ in. Courtesy Gallery 10, Scottsdale, Arizona.

OPPOSITE: Seferina Ortiz (Cochiti Pueblo). *Storyteller Doll.* 1992. Ceramic. Height: 14 in. Private collection.

Tammy Tarbell (Mohawk, Turtle clan). *Medicine Bear.* 1994. Coiled clay, beads, feathers, leather, bear fur. Height: 22½ in. Collection of the artist.

"Creator came to see his people, disguised as an old man dressed in rags. He went to each clan house for food and water and was refused entrance. When he came to the Bear Clan, the woman let him in and gave him comfort. The Creator thanked her greatly and gave her the gift of the medicine."—Tammy Tarbell.

Charles Navasie (Hopi). *Pottery Group.* 1992. Heights: left: 5¾ in.; center: 7½ in.; right: 8¼ in. Courtesy Frank Lentz.

Coleen Bins (Seneca). *"Four Direction Series" (traditional Iroquois brooche).* Sterling silver, glass beads. Diameter: 2½ in. Collection of Geraldine Green.

OPPOSITE: Artists unknown. *Early Navajo Silverwork.* 1900 to 1930s. The Heard Museum, Phoenix, Arizona.

ABOVE: Philip Long (Hopi). *Bracelet and Rings with Images of Hopi Kachinas.* c. 1960. Turquoise, silver. School for American Research, Santa Fe, New Mexico.

LEFT: Sonwai (Hopi). *Pendant, Bracelet, and Ring.* 1991. Gold, set with fossilized ivory, jet, turquoise, coral, and seegilite. Courtesy the Lovena Ohl Gallery, Scottsdale, Arizona.

OPPOSITE: Alica Quam (Zuni). *Cluster Jewelry Set with Sleeping Beauty Turquoise.* Turquoise, silver. Courtesy Turquoise Village, Zuni, New Mexico.

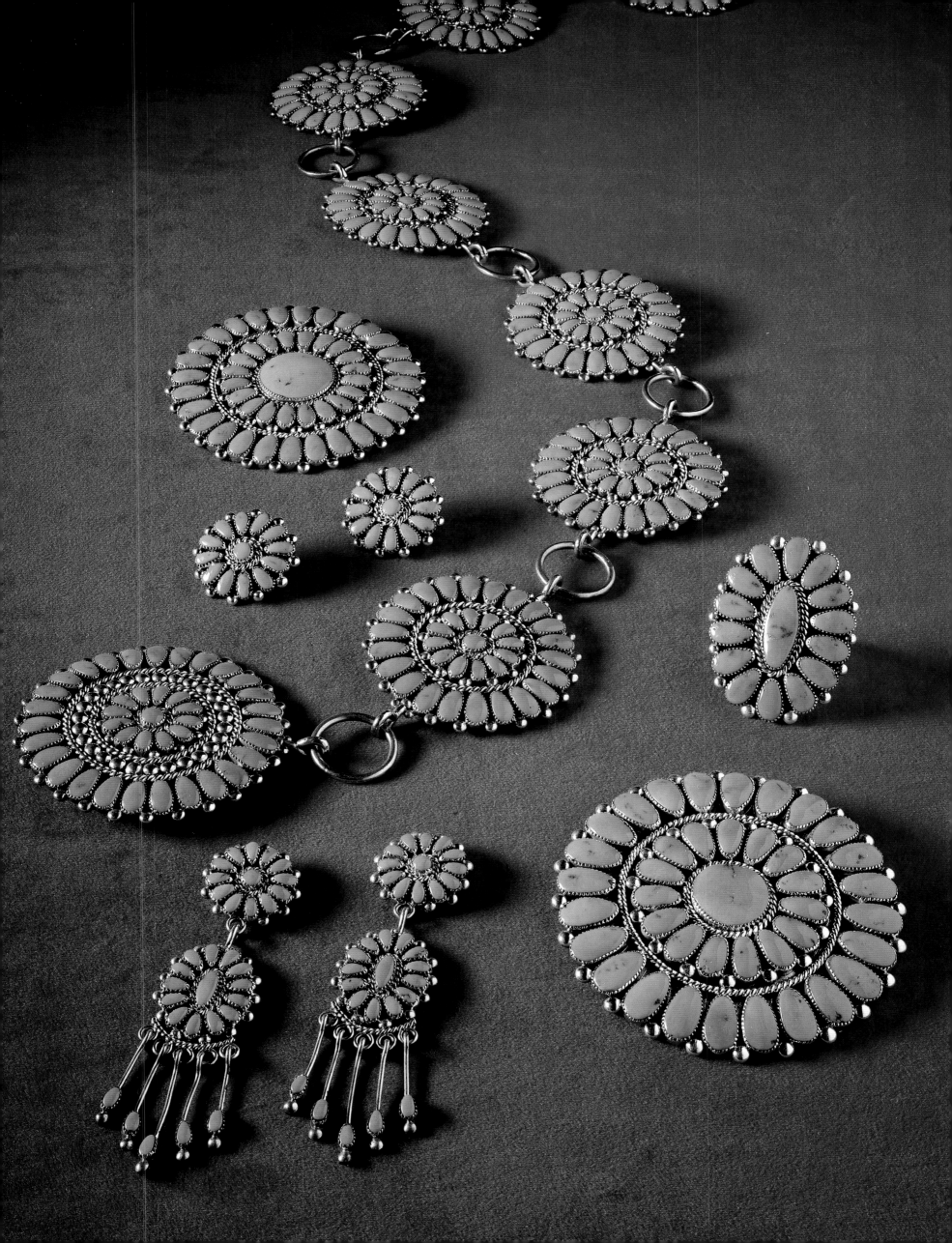

OPPOSITE: *Dance Mask.* 1952. Nunivak Island, Alaska. 18⅞ x 22⅞ in. Painted wood, feathers. The Denver Art Museum.

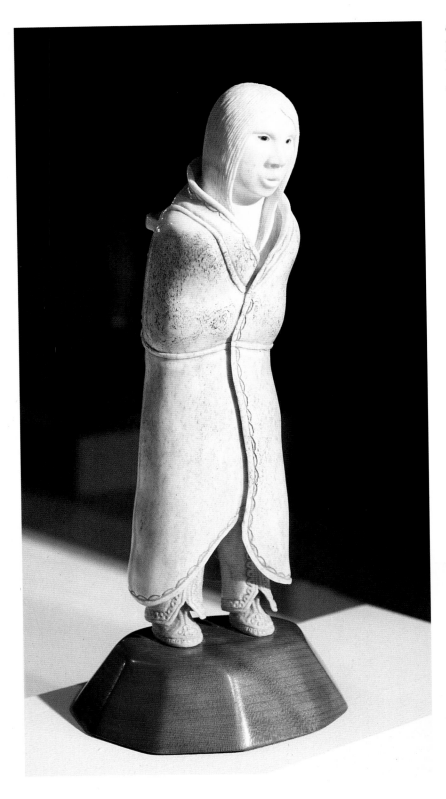

BELOW: R.E. Bartow (Yurok). *Salmon Mask.* 1987. Mixed media. 18 x 12 x 8 in. The Heard Museum, Phoenix, Arizona.

This mask is reminiscent of traditional Northwest Coast masks, and perhaps was made as a tribute to those carved masterworks.

ABOVE: Stan Hill (Mohawk). *Woman with Cradle Board.* 1985. Elk antler mounted on wood. Collection of the artist.

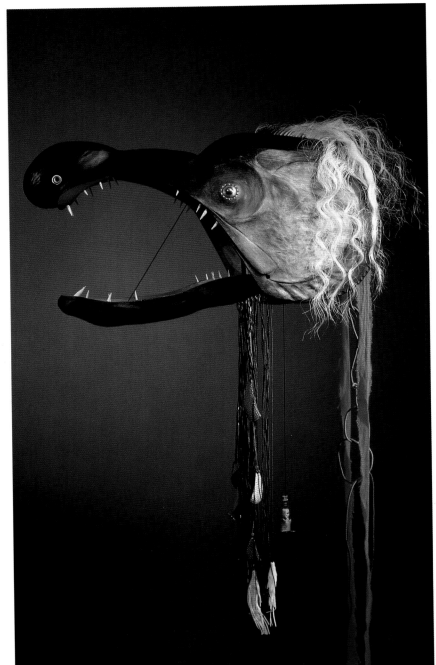

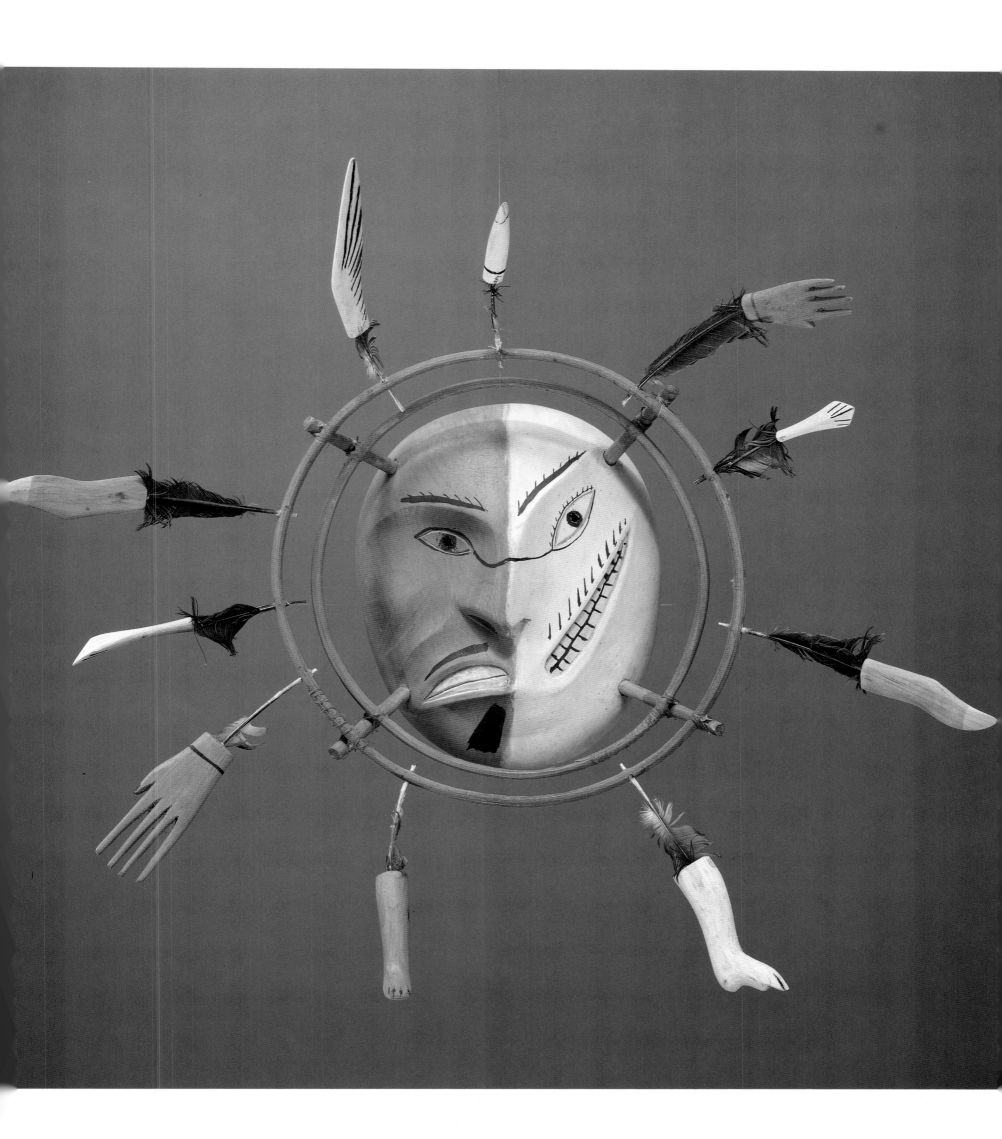

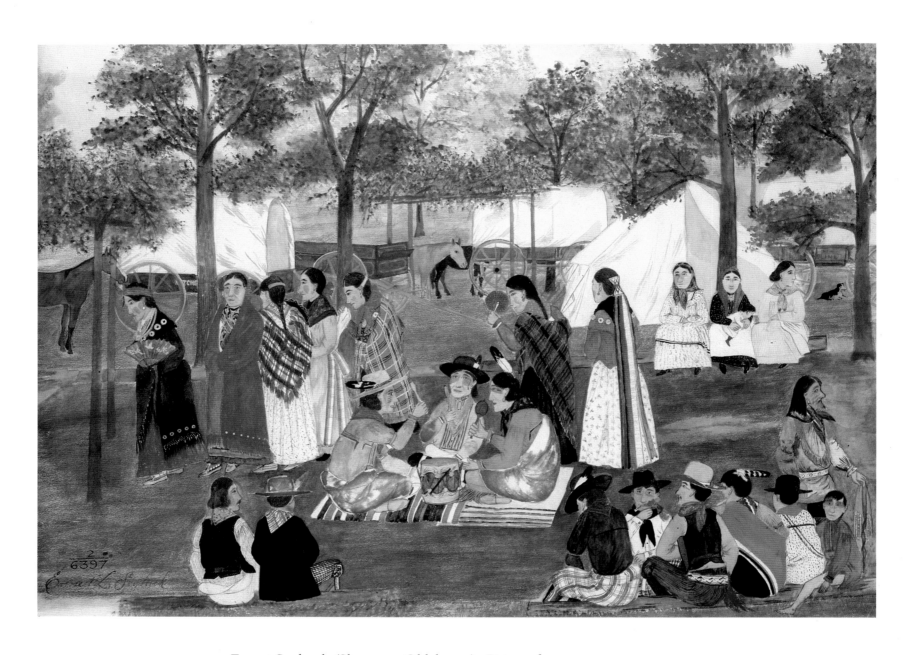

Ernest Spybuck (Shawnee, Oklahoma). *Picture of Chicken Dance.* National Museum of the American Indian, Smithsonian Institution, New York. Collected by Mr. Harrington.

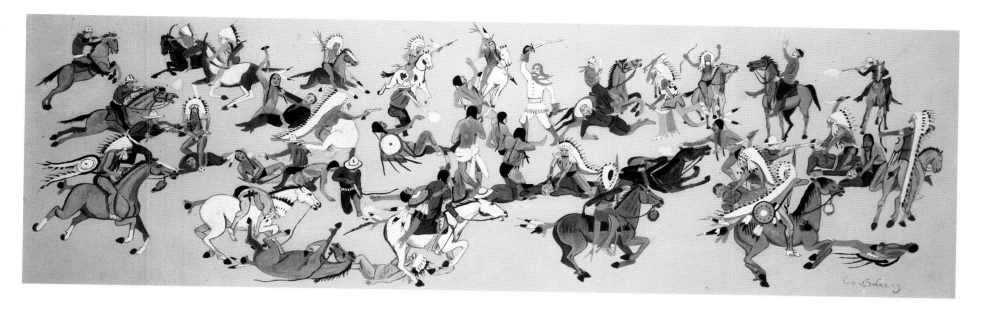

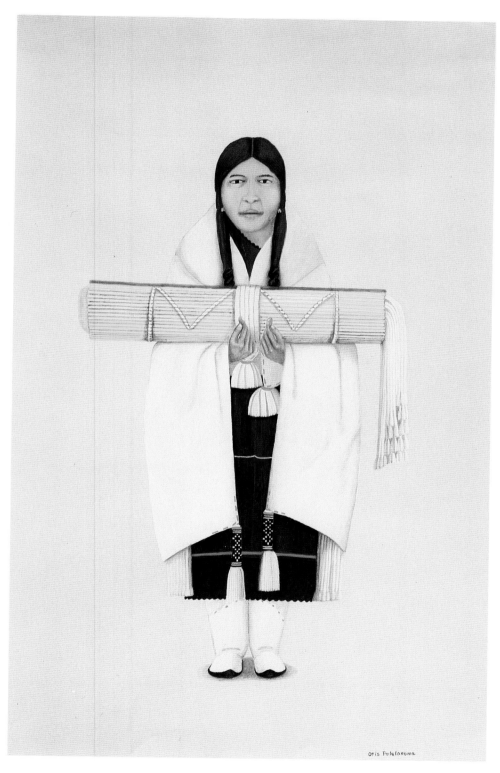

ABOVE: Carl Sweezy (Arapaho). *Indians Fighting White Men*. Before 1942. Housepaint on board. 12 x 38 in. Photograph courtesy The Heard Museum, Phoenix, Arizona.

This painting depicts General Custer's defeat at the Battle of the Little Bighorn from the Indian viewpoint.

LEFT: Otis Polelonema (Hopi). *The New Bride Woman*. c. 1930. Watercolor on paper. 19 x 12 in. Photograph courtesy The Heard Museum, Phoenix, Arizona.

Hopi life is powerfully rendered in Polelonema's work. He and Fred Kabotie created the "Hopi" style of painting, which became a style highly respected and often employed by other artists.

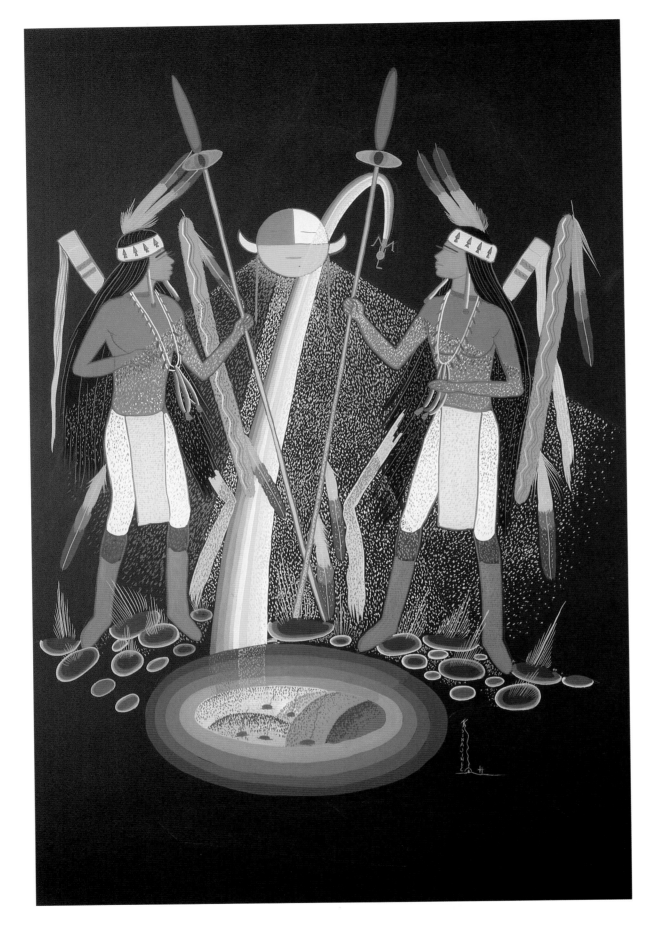

LEFT: Andrew Tsinnajinnie (Navajo). *Slayer of Enemy Gods—Nayeinezani.* c. 1962. Tempera on watercolor board. 30½ x 20 in. Photograph courtesy The Heard Museum, Phoenix, Arizona. The Collection of James T. Bialac.

OPPOSITE: R.C. Gorman. (Navajo). *Navajo Woman.* 1973. Watercolor on paper. 28¾ x 23 in. Photograph courtesy The Heard Museum, Phoenix, Arizona.

Gorman's primary subjects are women, whom he portrays as strong, earthy, and appealingly remote. His style is clear and straightforward, qualities perhaps influenced by the time he spent in Mexico.

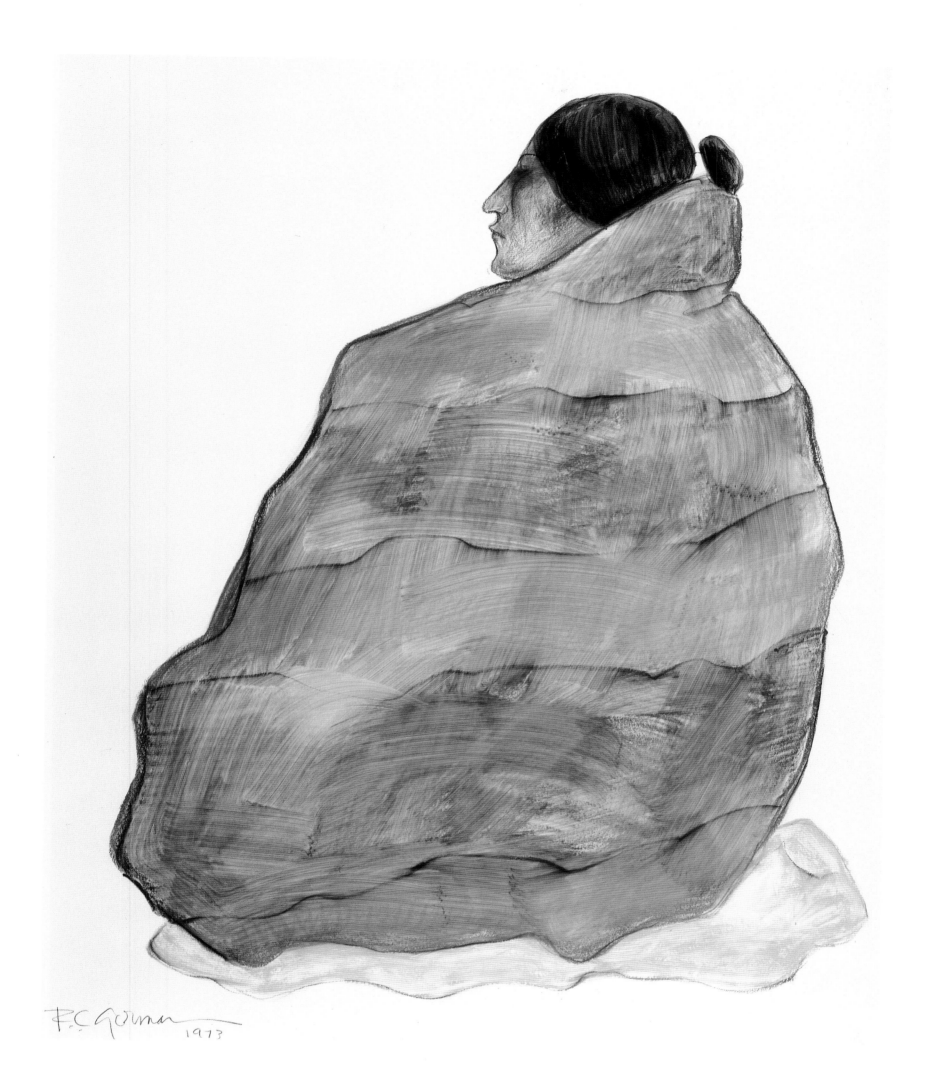

R.C Gorman
1973

Bill Soza (Apache). *Ghost Dance (Mission)*. 1969.
Triptych. Oil on canvas. Clockwise: 50 x 40 in.;
60 x 50 in.; 50 x 40 in. Institute of American
Indian Arts, Santa Fe, New Mexico. Permanent
collection.

*The spirituality of the Ghost Dance was an essential
part of life among the Plains Indians. This sacred ritual
was said to inspire visions in which the participants
would find themselves reunited with their dead, where
the buffalo would once again be plentiful, and the land
would be free from the encroaching soldiers.*

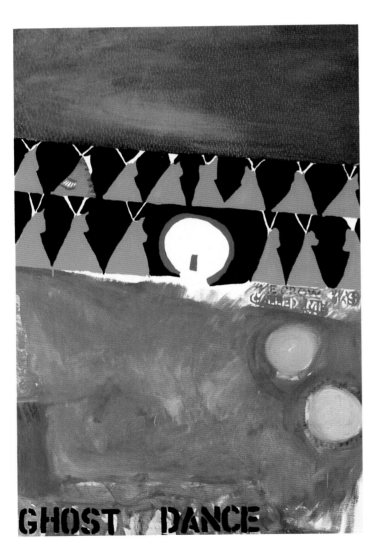

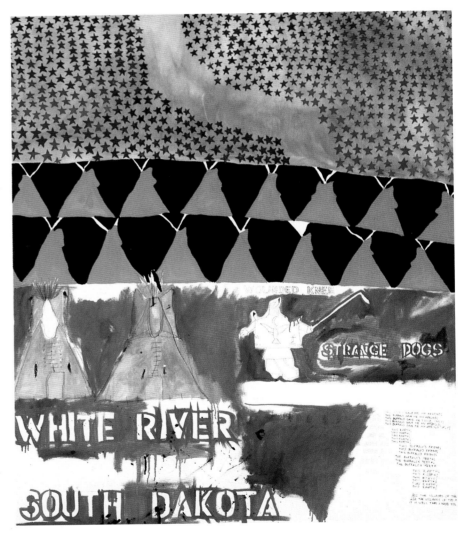

BELOW: Joe Feddersen (Colville). *Birth of Venus.* Mixed media. 22 x 36 in. Private collection.

ABOVE: Frank La Pena (Wintu Nomtipom). *Spring Spirit.* 1987. Acrylic on canvas. 48 x 36 in. Collection of the artist.

LEFT: Marty Avrett (Coushatta, Choctaw, Cherokee). *Morning Mounds Memory.* 1985. Oil on canvas. 36 x 40 in. Collection of the artist.

A childhood fascination with the mysterious and enigmatic in nature became an important part of Avrett's life work and his commitment to combat man's encroachment upon the landscape.

OPPOSITE: Roxanne Swentzell (Santa Clara). *The Emergence of the Clowns.* 1988. Coiled and scraped clay. Heights: 7 to 23 in. The Heard Museum, Phoenix, Arizona.

Swentzell's remarkable sculptures are evidence of her mastery over the expressive possibilities of her medium, as each figure seems to change position and appearance each time they are viewed.

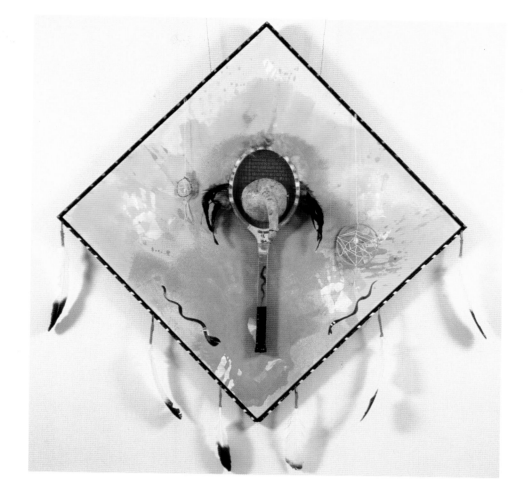

Lloyd E. Oxendine (Lumbee). *Warrior Shield.* 1990. Mixed media. 40 x 40 in. Collection of the artist.

Mario Martinez (Yaqui). *Yaqui Flashback II.* 1991. Mixed media, acrylic on canvas. 72½ x 59½ in. Collection of the artist.

Yaquis came to the United States as political refugees from Sonora, Mexico, at the turn of this century, and were not officially recognized as American Indians until the late 1970s. Yaquis use their art to create things of beauty, but its primary function is to express their religious convictions and cultural values.

Bob Haozous (Apache, Navajo, English, Spanish). *Border Crossing.*
1991. Steel, paint. 8 x 12 x 4 ft. Courtesy David Rettig Fine Arts,
Santa Fe, New Mexico.

*Haozous expresses his love for the land and its people by dealing honestly with
reality in his art. He both celebrates the beauty and exposes the ugliness in life.*

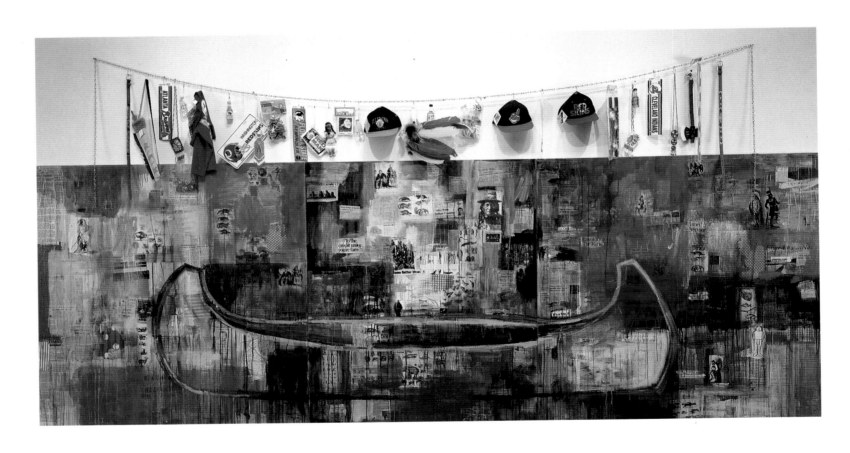

Jaune Quick-to-See Smith (Flathead). *"Trade" (Gifts for Trading Land
with White People).* 1992. Oil and mixed media. 60 x 170 in.
Collection of the artist.

JAUNE QUICK-TO-SEE SMITH

Jaune Quick-to-See Smith is a painter who exhibits internationaly, the founder of two artists' cooperatives, has served as a board member of several art galleries and institutions, and has been the curator of numerous touring exhibits of Native American art. All of these professional accomplishments stem from her fervent desire to combat the ills afflicting her people by spreading a message based on pride and filled with hope.

Smith lectures extensively and is a visiting artist at colleges and universities nationwide, where she talks about her art, her life, and her heritage—all vitally important to her and all inextricably linked together. Her paintings, most recently appearing in Mexico in a major survey of painters in the Western Hemisphere, are powerful statements that vibrate with energy and vision.

Smith's work extends beyond the canvas. She has completed public art projects, and her knowledge and artistic sensibilities have contributed to the design of a cultural museum on the Flathead Reservation as well as the National Museum of the American Indian.

Smith's art, whether committed to canvas, taught in the lecture hall, or incorporated into collabortative projects, serves to express the enormous pride she has in her people and their traditions.

Jaune Quick-to-See Smith (Flathead).

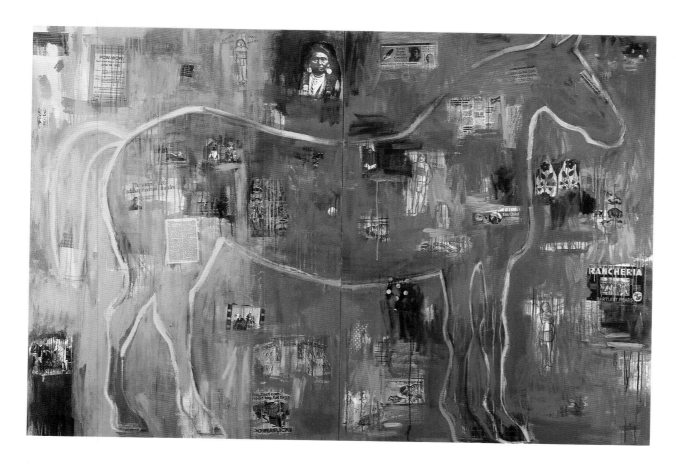

JAUNE QUICK-TO-SEE-SMITH. *Indian Horse.* Oil, mixed media, collage on canvas. 66 x 96 in. Collection of the artist.

OPPOSITE TOP: Phil Young (Cherokee). *I Cannot Speak (But I Can Write Jeep Cherokee)*. 1991. Acrylic, sand, conté, pencil, and color xerox on paper. 15 x 22 in. Collection of the artist.

James Lavadour (Walla Walla). *New Blood*. 1990. Oil on linen. 18 x 92. Private collection.

James Lavadour's multi-canvas paintings are illusionistic landscapes. The thinly applied paint allows for other-worldly images to appear.

OPPOSITE BOTTOM: Kay Walkingstick (Cherokee, Winnebago). *Where are the Generations?* 1991. Copper, acrylic, wax, oil on canvas. 28 x 50 in. Collection of the artist.

"In 1492 we were 20 million. Now we are 2 million. Where are the children? Where are the generations? Never born."—Kay Walkingstick.

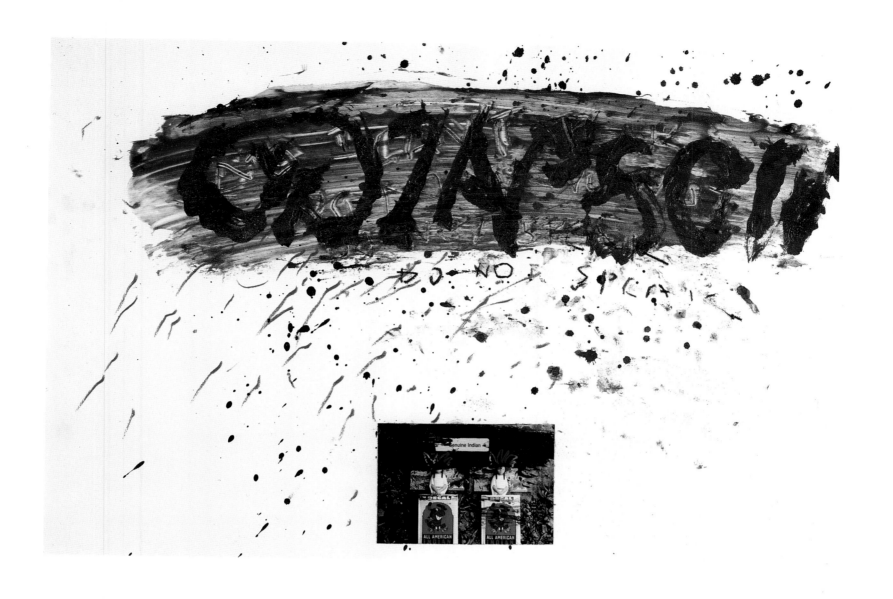

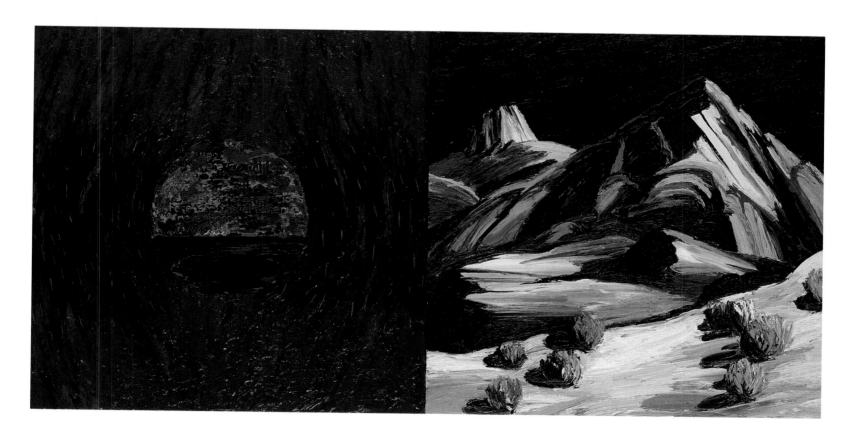

James Luna (Luiseño). *Four Sacred Colors.* Color photo serial.

James Luna works to make the public aware that Native Americans are very much alive and well—vital and contributing citizens of the United States and the world.

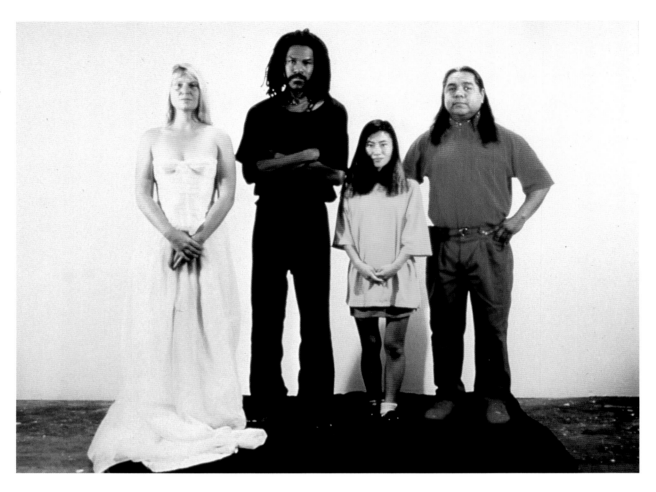

George Longfish (Iroquois, Seneca, Tuscarora). *The End of Innocences.* 1992. Triptych. Acrylic on canvas. Total measurement: 10 x 25 ft.

Panel I: Appropriate Good—In Appropriate Goods. If you play the government game, you get support. If not, no support.

Panel II: Spiritual Power, Confrontations at Oka, Canada: one death, Natives own their cultural

information, revert to fight Elk Society (warriors).

Panel III: Past, Present, and Future History— History Repeating Itself. South America and Rain Forest next.

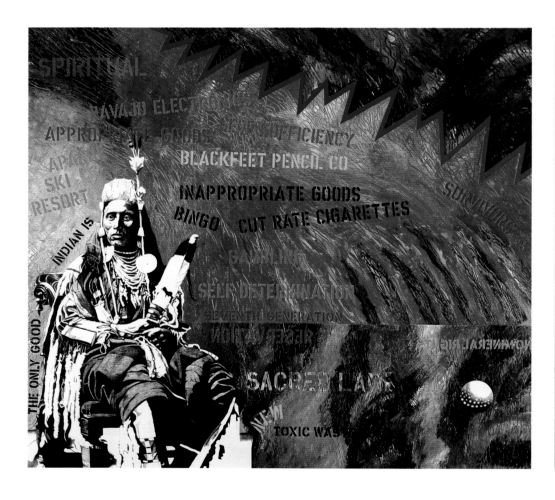

ABOVE: Jolene Rickard (Tuscarora).
I See Red in the 90s. 1992.
Ekta Color and black and white silver prints.
33 x 42 in. Collection of the artist.

"They say that Sky Woman fell on the backs of fowl as she entered this world to give us all life. She took her place in eternity as Grandmother Moon. This is how our world began. In 1992 I am thinking of how it will end. The disease-filled Hudson Bay blanket is just a metaphor for all of the threats against the Indian way. But, we are strong and will survive as long as any human does."—Jolene Rickard.

Jesse Cooday (Tlingit). *Clear Cut Columbus* (detail). 1993. Mixed media. Collection of the artist.

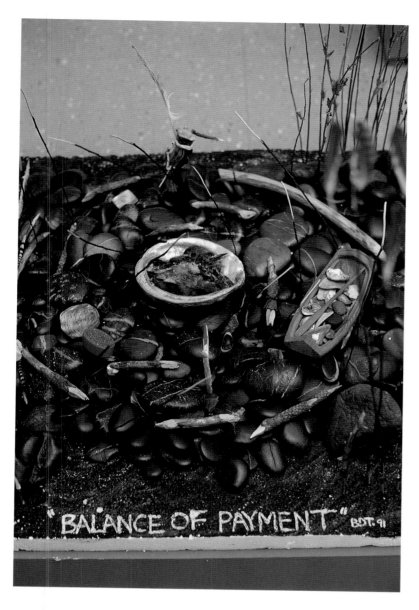

Brian Tripp (Karuk). *Balance of Payment.*
1991. Installation piece.

Lillian Pitt (Warm Spring–Yakima
Tribe). *Fragments of a Whole II.* 1993.
Ceramic with river rock, copper, and
cotton thread. 13 x 14 x 3 in.
Collection of the artist.

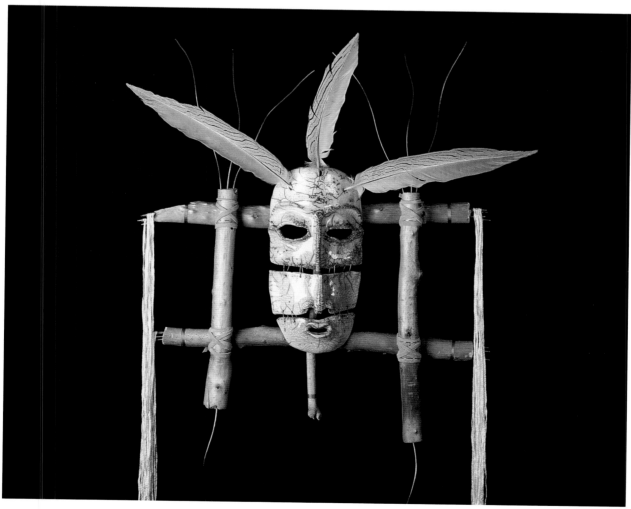

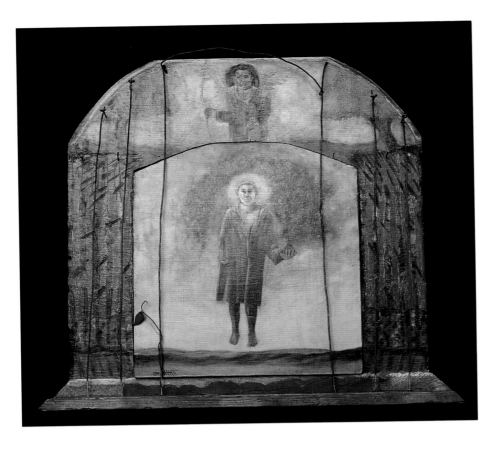

LEFT: Frank Tuttle (Yuki, Wailaki, Concow Maidu). *What Wild Indian.* 1992. Oil, wood, mixed media. 18 x 20 in. Collection of the artist.

OPPOSITE TOP: Ric Glazer-Danay (Caughnawaga Mohawk). *Veteran.* 1993. Acrylic on board with collage. 31 x 43 in. Collection of the artist.

OPPOSITE BOTTOM: Frank Day (Maidu). *Ishi and Companion at Iamin Mool.* Oil on canvas. 24 x 35⅞ in. Private collection. Photograph courtesy The Heard Museum, Phoenix, Arizona.

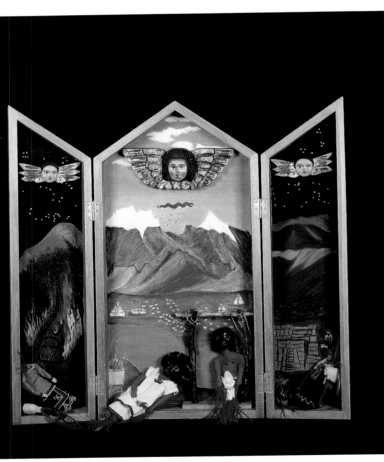

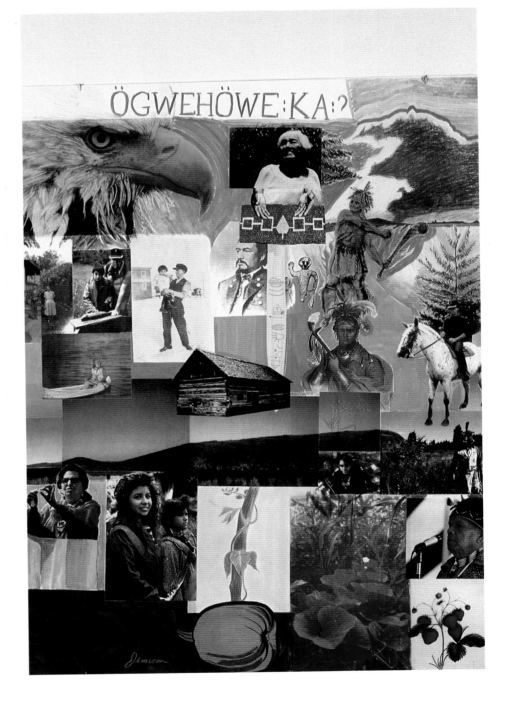

ABOVE: Gail Tremblay (Onondaga, MicMac). *The Things Colonial Angels Witness.* 1992. Mixed media. Collection of the artist.

RIGHT: G. Peter Jemison (Seneca). *Õgwe Õ: Weh: Kaa. (Indian Way of Life).* 1992–1993. Mixed media. 38 x 50 in. Collection of the artist.

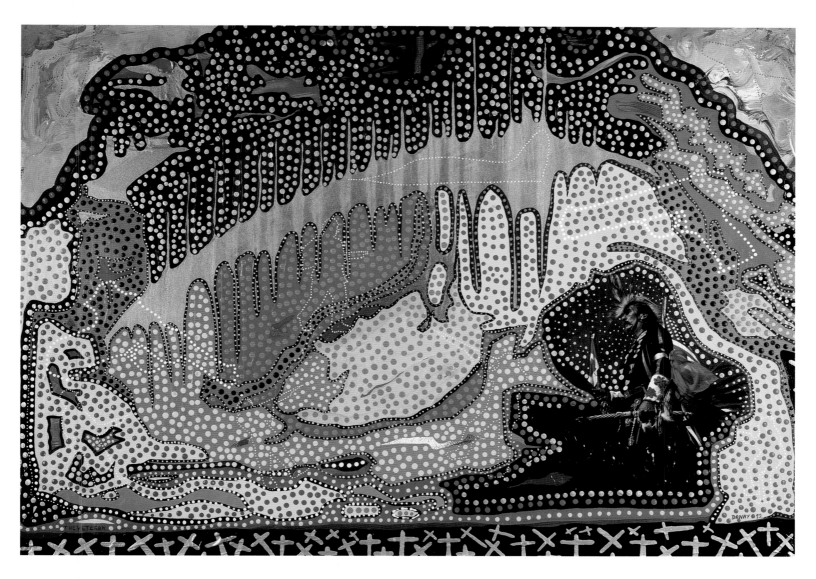

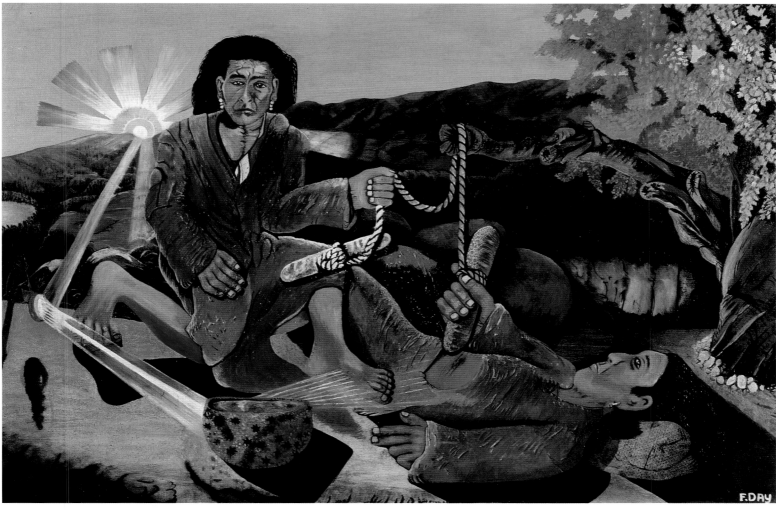

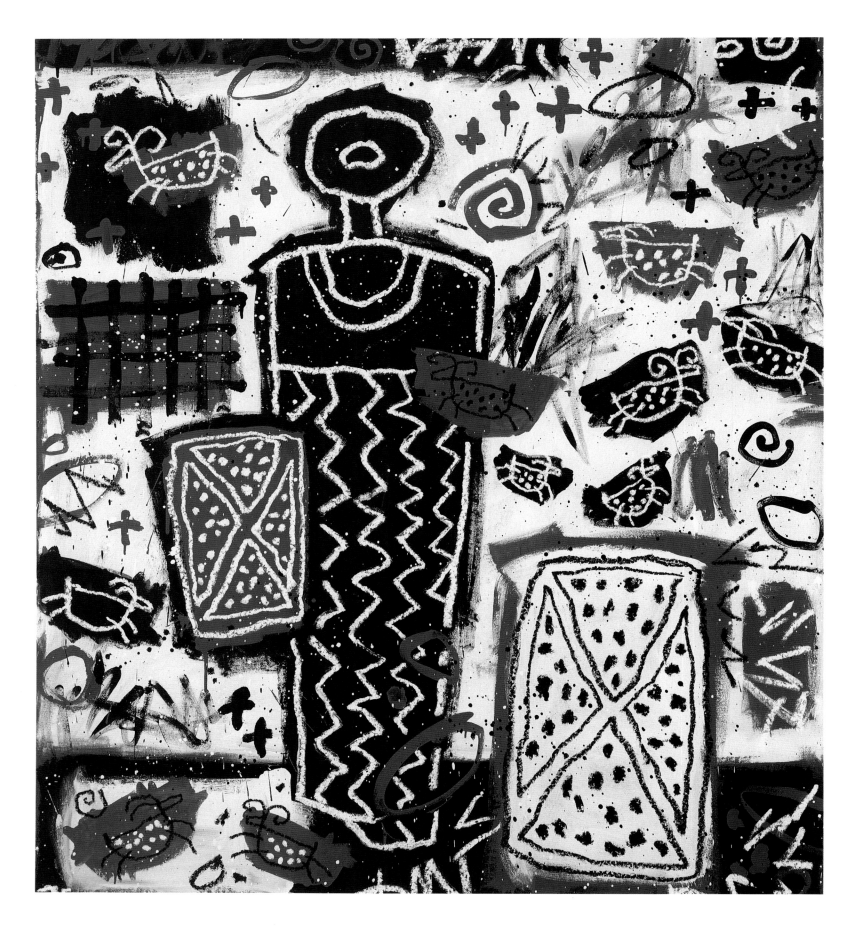

Harry Fonseca (Maidu). *Stone Poem.*
Collection of the artist.

In the Stone Poem, Fonseca says he "confront[s]
a world where the blacks and whites are slowly,
very slowly, turning into grays—grays with all
their shades of uncertainty, fear, growth, and
wonder."

OPPOSITE: Jean Lamarr (Paiute, Pit River).
Some Kind of Buckaroo #4. 1991.
Mixed media, barbed wire on canvas. 48 x 48 in.
Collection of the artist.

Lamarr's work is intended to speak to the non-Indian
audience with the central message being the need to
preserve the earth and its native peoples in order to insure
the survival of generations to come.

PHOTOGRAPHY CREDITS

University of Alabama Museum of Natural History: Dirk Bakker, photographer: p. 33, accession no. WL101.

American Museum of Natural History, N.Y.: Dosseter, photographer: p. 203. E.W. Merrill, photographer: p. 204. Lynton Gardiner, photographer: p. 208. K. Perkins and J. Beckett, photographers: p. 214 (bottom). J. Beckett and R. Raeihle, photographers: p. 232. Stephen S. Myers, photographer: p. 217. A. Anik and J. Beckett, photographers: p. 248.

Arizona State Museum, Tucson: Jerry Jacka, photographer: p. 143.

University of Arkansas Museum of Natural History, Fayetteville: Dirk Bakker, photographer: p. 30 (bottom), accession no. WL128.

Joshua Baer & Company, all reproduction rights reserved: p. 158.

The Brooklyn Museum: p. 135 (top), accession nos. 03.325.4527 through 03.325.4534; p. 154, accession no. 03.325.4631; p. 185 (top), accession nos. 08.491.8807 and 08.491.8802; p. 185 (bottom), accession no. 08.491.8925. Dirk Bakker, photographer: p. 28 (bottom), accession no. WL43; p. 31 (top), accession no. WL8. Justin Kerr, photographer: p. 193, accession no. 06.331.7923.

Buffalo Bill Historical Center, Cody, Wyoming: Dirk Bakker, photographer: p. 92, accession no. CP106; p. 94, accession no. CP217; p. 95, accession no. CP218; p. 98, accession no. CP143; p. 101(right), accession no. CP113; p. 119, accession no. CP118.

Thomas Burke Memorial Washington State Museum: Eduardo Calderon, photographer: p. 210 (top); p. 213 (right); p. 231.

C&R Traders, Casa Grande, Arizona: Jerry Jacka, photographer: p. 276.

Cranbrook Institute of Science, Bloomfield Hills, Michigan: Robert Hensleigh, photographer: p. 54 (bottom), accession no. CP2; p. 60 (left), accession no. CP29; p. 64, accession no. CP24. Dirk Bakker, photographer: p. 75, accession no. CP151.

Cristof's Gallery, Santa Fe: Mark Nohl, photographer, p. 274 (top).

Dallas Museum of Art: p. 141 (bottom), accession no. 1991.336.FA; p. 142 (top), accession no. 100.FA.

The Denver Art Museum: p. 152, accession no. 1953.512; p. 157 (bottom), accession no. 1939.329; p. 190, accession no. 1944.50; p. 192, accession no. 1948.135; p. 194 (bottom), accession nos. 1942.274 and 1952.458; p. 268, accession no. 1985.116; p. 270, accession nos. 1949.3696 and 1949.3697; p. 271, accession no. 1967.128; pp. 272–273, accession no. 1984.4; p. 287, accession no. 1952.381.

The Detroit Institute of Arts: p. 22 (bottom), accession no. 52.224.1; p. 32, accession no. 1986.43; p. 34 (bottom), accession no. 1984.39; p. 42, accession no. 81.219; p. 67, accession no. 81.181.1; p. 112 (left), accession no. 1983.63; p. 122, accession no. 79.179; p. 137, accession no. 76.87; p. 147, accession no. 59.24; p. 215, accession no. 80.47; p. 251, accession no. 1984.1. Dirk Bakker, photographer: p. 31 (bottom), accession no. 1991.115; p. 38, accession no. 1987.1; p. 39

(left), accession no. 1986.21; p. 70, accession no. 81.265; p. 71 (bottom), accession nos. 81.236 and 81.278; p. 72 (top), accession no. 1991.205; p. 73, accession no. 51.9; p. 74 (right), accession no. 81.280; p. 78 (bottom), accession no. 1991.1022; p. 103, accession no. 1988.39; p. 111(top), accession no. 81.490; p. 112 (bottom), accession no. 81.497; p. 120 (bottom), accession no. 1988.43; p. 246 (bottom), accession no. 1983.7. Robert Hensleigh, photographer: p. 57 (top), accession no. 81.37; p. 59 (top), accession no. 81.802.1; p. 61, accession no. 81.216; p. 62 (left), accession no. 81.65; p. 63 (bottom), accession no. 81.76.1; p. 65 (top), accession no. 1990.266A; p. 66, accession no. 81.435; p. 69, accession no. 81.644; p. 88 (right), accession no. 1988.44; p. 101 (left), accession no. 1988.41; p. 102, accession no. 1988.54A; p. 104, accession no. CP126; p. 107 (top), accession no. 76.144; p. 111 (bottom), accession no. 81.273; p. 115 (top), accession no. 81.233.3b; p. 159, accession no. 1987.93. Marianne Letasi, photographer: p. 89, accession no. 1988.27.

Etowah Mounds Archaeological Area, Parks and Historic Sites Division, Georgia Dept. of Natural Resources: Dirk Bakker, photographer: p. 29, accession no. WL180.

The Field Museum of Natural History, Chicago: Dirk Bakker, photographer: p. 58 (bottom), accession no. CP33.

Gallery 10, Scottsdale, Arizona: Jerry Jacka, photographer: p. 277 (bottom); pp. 278–79.

Thomas Gilcrease Institute of American History and Art: p. 22 (top), accession no. 6123.1153; p. 28 (bottom), accession no. 5434.4702.

Bobby Hansson, photographer: p. 235; p. 244 (right); p. 246 (top); p. 250.

The Gordon Hart Collection: Dirk Bakker, photographer: p. 21(bottom), accession no. WL50; p. 40, accession no. T1987.146; p. 71 (top), accession no. T1987.149; p. 194 (top), accession no. T1987.145.

The Heard Museum, Phoenix: Jerry Jacka, photographer: p. 140; p. 274 (bottom); p. 282. Craig Smith, photographer: p. 182. Alfred Jacobs, photographer: p. 286(bottom).

Phoebe Hearst Museum of Anthropology: E. Goddard, photographer: p. 178.

Herbst Collection: Toby Herbst, photographer: p. 168(top and bottom).

Mike Hills, photographer: p. 293 (top right).

Robert Hobbs Collection: Mark Tade, photographer: p. 79 (bottom).

Illinois State Museum: Dirk Bakker, photographer: p. 27 (left), accession no. WL31.

Los Angeles County Museum: p. 160, accession no. 5141.42-38.

Frank H. McClung Museum, University of Tennessee, Knoxville: Dirk Bakker, photographer: p. 34 (top), accession no. WL125; p. 37, accession no. WL4.

Bill McLemore, photographer: p. 258.

Milwaukee Public Museum: Sumner W. Matteson, photographer: p. 132; p. 149 (top). Mel Scherbarth, photographer: p. 149 (bottom).

Missouri Historical Society, St. Louis: p. 121 (bottom), accession no. 1882.181.1.

Museum of Indian Art and Culture,

Laboratory for Anthropology, Santa Fe: Douglas Kahn, photographer: p. 134 (bottom).

National Park Service, Hopewell Culture National Historical Park: Dirk Bakker, photographer: p. 26, accession no. WL121.

Mark Nohl, photographer: p. 269 (top and bottom); p. 280.

Ohio Historical Society: Dirk Bakker, photographer: p. 23 (top), accession no. WL113; p. 25, accession no. WL114; p. 27 (right), accession no. WL41; p. 36, accession no. WL116.

Lovena Ohl Gallery, Scottsdale: Jerry Jacka, photographer: p. 284 (bottom).

Peabody Museum of Archaeology and Ethnology, Harvard University, Cambridge, Mass.: Hillel Burger, photographer: p. 72 (bottom), accession no. T1231; p. 191, accession no. T1220.

Jeanne Penney Collection: Dirk Bakker, photographer: p. 170 (top).

The Philbrook Museum of Art, Tulsa: Dan Wheeler, photographer: p. 173.

Collection of Richard and Marion Pohrt: Robert Hensleigh, photographer: p. 74 (left), accession no. CP153; p. 91 (top), accession no. CP131; p. 91 (bottom), accession no. CP132; p. 114, accession no. T1988.867. Sumner W. Matteson, photographer: p. 85. Dirk Bakker, photographer: p. 100, accession no. CP145; p. 105 (left); p. 106, accession no. CP212; pp. 108–109.

Royal British Columbia Museum: Wilson Duff, photographer: p. 216 (right).

James and Kris Rutkowski Collection: Dirk Bakker, photographer: p. 78 (top).

Seattle Art Museum: Paul Macapia, photographer: p. 214 (top); p. 218 (bottom), accession no. 91.1.95; p. 227 (top); p. 229; p. 230 (top).

Schoharie Museum of the Iroquois Indian: p. 275 (bottom right), accession no. 744.1.

School for American Research, Santa Fe: Mark Nohl, photographer: p. 284 (top).

The Sheldon Jackson Museum, Stika: Sam Kimura, photographer: p. 252.

Smithsonian Institution: National Museum of the American Indian, New York: Dirk Bakker, photographer: p. 10; p. 21 (top), accession no. WL156; p. 39 (right), accession no. WL6; p. 41, accession no. WL5. Robert Hensleigh, photographer: p. 68 (left), accession no. CP44. National Museum of Natural History, Washington, D.C.: Dirk Bakker, photographer: p. 30 (top), accession no. WL174; p. 35, accession no. WL167. National Archives of Anthropology: Alexander Gardner, photographer: p. 83.

The St. Louis Art Museum: p. 139 (top), accession no. 175.1981; p. 139 (bottom), accession no. 172.1981.

The Thaw Collection: John Bigelow Taylor, N.Y.C., photographer: p. 188; p. 212; p. 221 (bottom); p. 223; p. 245.

Turquoise Village, Zuni, N.M.: Jerry Jacka, photographer: p. 285.

Janis and William Wetsman Collection: Dirk Bakker, photographer: p. 181 (bottom); p. 183 (bottom).

Whitman College Collection: Sam Wong, photographer: p. 209 (bottom).

Yosemite National Park Collection: Robert Woolard, photographer: p. 186.